D0143323

Daniel Palmer's *Photography and Collaboration* impa
tional views, and it does so with substantial force. Th
important new arguments about collaboration in ph
synthesizes a great deal of material in ways that compel us to reimagine mucn oi
what we thought we knew about the history of photography.

ALEXANDER ALBERRO, *Barnard College/Columbia University, USA*

Daniel Palmer's new book, *Photography and Collaboration*, is a fascinating and
invaluable contribution to the literature on contemporary art and to the history
of photography. It is remarkable for his attention to the actual practice of pho-
tography. This is important because understanding how to take photographs is
a problem, a learned craft and a set of rules to be flouted that all artists nego-
tiate in different ways but for precise reasons. Palmer explains the sequence of
reasons why photographers negotiated collaborations through photographs and
why artist collaborations chose particular photographic methods. He writes with
impressive lucidity and authority.

CHARLES GREEN, *University of Melbourne, Australia*

Palmer's book makes a valuable and timely contribution to discussion about
photographic practice now, situating it within a framework of collaboration and
social encounter influenced by the writings of Azoulay. He brings his examples
of recent practices together in a distinctive way and within a tightly framed argu-
ment that makes a strong pitch for fundamentally rethinking about photography
as a medium. Incorporating a broad theoretical overview and closely argued
case studies, this will be a really useful book for anyone studying the subject at
university level.

JOANNA LOWRY, *University of Brighton, UK*

By focusing on the surprisingly little-studied area of photographic collabor-
ation, Daniel Palmer gives us a new framework through which to understand a
remarkable breadth of photographic practice, both contemporary and historical.
Photography and Collaboration addresses a lively and timely set of issues of key
importance to artists today—from the ever-increasing relevance of social prac-
tices to the seemingly ubiquitous state of networked imagery—and offers fresh
insights on canonical histories.

KATE PALMER ALBERS, *University of Arizona, USA*

There has always been a collaborative effort and spirit connected with photog-
raphy. This is particularly true since 1960. In his new book *Photography and
Collaboration*, Daniel Palmer admirably brings this tradition to light. With insight
and skill, he pulls together a diverse and international cadre of photographers
and artists who help us see that the study of collaboration does, in fact, augment
our study of photography.

JAMES R. SWENSEN, *Brigham Young University, USA*

PHOTOGRAPHY AND COLLABORATION

PHOTOGRAPHY AND COLLABORATION

From conceptual art to crowdsourcing

DANIEL PALMER

Bloomsbury Academic
An imprint of Bloomsbury Publishing Plc

B L O O M S B U R Y
LONDON · OXFORD · NEW YORK · NEW DELHI · SYDNEY

Bloomsbury Academic

An imprint of Bloomsbury Publishing Plc

50 Bedford Square
London
WC1B 3DP
UK

1385 Broadway
New York
NY 10018
USA

www.bloomsbury.com

**BLOOMSBURY and the Diana logo are trademarks
of Bloomsbury Publishing Plc**

First published 2017

British Library Cataloguing-in-Publication Data
A catalogue record for this book is available from the British Library.

ISBN: HB: 978-1-4742-3346-0
PB: 978-1-3500-0831-1
ePDF: 978-1-4742-3348-4
ePub: 978-1-4742-3347-7

Library of Congress Cataloging-in-Publication Data
Names: Palmer, Daniel (Professor of art), author.
Title: Photography and collaboration: from conceptual art to crowdsourcing /
Daniel Palmer, Monash University, Caulfield, Australia.
Description: London, UK; New York, NY, USA: Bloomsbury Academic,
an imprint of Bloomsbury Publishing Plc, 2017. |
Includes bibliographical references and index.
Identifiers: LCCN 2016052285 (print) | LCCN 2016054495 (ebook) |
ISBN 9781350008311 (pbk.) | ISBN 9781474233460 (hardback) |
ISBN 9781474233484 (ePDF) | ISBN 9781474233477 (ePub)
Subjects: LCSH: Photography–Philosophy. | Photography, Artistic. |
Group work in art. | Photography–Social aspects.
Classification: LCC TR183 .P226 2017 (print) |
LCC TR183 (ebook) | DDC 770–dc23
LC record available at https://lccn.loc.gov/2016052285

Cover design: Nick Evans
Cover image © Adam Broomberg & Oliver Chanarin

Typeset by Newgen Knowledge Works (P) Ltd., Chennai, India
Printed and bound in Great Britain

CONTENTS

FIGURES

ACKNOWLEDGMENTS

Like its subject, this book has been a collaborative effort, enjoying the support of many individuals and organizations along the way. My research assistant Kate Warren has been extraordinary, continuing the work started by Shelley McSpedden. Both were essential to the preparation of this manuscript over several years. I would like to thank my institutional base, Monash University, and in particular my colleagues at Monash Art, Design & Architecture (MADA). Research for this book was sparked by an internal research grant for a different topic entirely, as is so often the case.

At Bloomsbury I would like to thank Davida Forbes, Molly Beck, Ariadne Godwin, Frances Arnold, and Clara Herberg for believing in the project and assisting its realization. I would also like to thank two anonymous readers, who offered useful suggestions at a crucial stage in the writing of the manuscript.

David Bate, Geoffrey Batchen, Susan Bright, Naomi Cass, Charles Green, Martin Lister, Nikos Papastergiadis, and Patrick Pound deserve thanks for influencing my thinking about collaboration in various ways and for otherwise supporting my research. Of course this book would not exist without the artists, and I especially thank Simon Terrill and Anthony Luvera whose work helped to inspire the project.

Some of the writing here has been presented in earlier versions elsewhere. Part of the introduction was presented as "The Collaborative Turn in Contemporary Photography" at Helsinki Photomedia 2012: Images in Circulation, later published in the journal *Photographies*, 6:1 (2013): 117–125. Part of Chapter 4 was presented as "Photography as Social Encounter: Micky Allan's *My Trip*" at Together Apart, the Art Association of Australia and New Zealand 2012 Annual Conference. That paper was later developed into an article published as "Photography as Social Encounter: Three Works by Micky Allan, Sophie Calle and Simryn Gill" in the journal *Australian and New Zealand Journal of Art*, 14:2 (2014): 199–213.

My biggest thanks goes to Kate Rhodes, who provides the most creative collaboration I could ever hope to be part of, and to our children, Rem and Rainer, who are still too young to appreciate what I have been doing all these months in my study. This book is dedicated to them and to all future collaborations.

INTRODUCTION

Nobody can commit photography alone.

<div align="right">(McLUHAN 1964: 183)</div>

This book examines the prevalence of collaboration in photographic art since the late 1960s—that is, forms of expanded authorship in photography from conceptual art to our contemporary moment. More radically, it seeks to reconceive the act of photography as inherently dialogical and thus always potentially collaborative. By emphasizing photography as a social rather than solitary act I want to test the Canadian communications theorist Marshall McLuhan's declaration, made in reference to what he calls "corporate and collective art forms such as the film and the press," that "nobody can commit photography alone" (McLuhan 1964: 183). And by considering various forms and agents of authorial involvement, my approach goes against the grain of conventional art-historical accounts of the medium. In canonical histories of the medium, in museum collections, art-school pedagogy and art-market discourse, photography is framed, almost without exception, as an art of individuals who produce discrete works. Very little is said about the circulation or reception of photographs. In other words, discourse on the photographic author mirrors popular mythology around the figure of the artist in Western culture since the concept of the isolated genius emerged in the Renaissance, and a particular conception of the photograph as a self-contained work of art.[1]

Just as media representations of the artist-as-genius have proved remarkably durable, the figure of the lone photographer is an enduring myth. The popular reception of the recently discovered introvert photographer Vivian Maier reveals our culture's deep psychological investment in the idea. Maier is an exemplary street photographer not only because of her photographs of mid-twentieth-century Chicago, but because as a professional nanny she made her work in such an isolated, even alienated, manner that few even noticed her doing it. Unsurprisingly, as a result, her most celebrated and compelling works are her self-portraits. Meanwhile, the very different figure of the intrepid, typically male, photojournalist is tied up with narcissistic fantasies about the photographer-as-lone-adventurer. Think, for example, of Sean Penn's character in the film *The Secret Life of Walter Mitty* (2013). Just as his mysterious and swashbuckling

ways operate as a stand-in for the title character's daydreams, the photographer-adventurer who bears witness to the world's most beautiful and horrific truths has become something of an ego ideal or phantasm haunting all users of the camera. Men, apparently, are particularly prone to its seductive power.

Photographers are often most active while travelling in foreign places, which serves to reinforce the popular perception of photography as an existential act of wrangling with an alien world. In this view, as Susan Sontag (1977: 119) recognized, photography is "an acute manifestation of the individualized 'I,' the homeless private self astray in an overwhelming world—mastering reality by a fast visual anthologizing of it." This emphasis on the individual photographer is understandable in other ways as well. Photography's indexical quality—its referential link to physical reality—encourages the photographer to "bear witness" on the grounds of individual testimony. The medium's "I was there" quality also makes it inextricably linked to personal memory making, a fact reflected in camera design and marketing. Cameras are the result of a chain of human engineers, and their various forms influence the way we think about the authorship that results (McCauley 2006: 420). Popular cameras are designed so that only one eye fits behind the viewfinder (now a screen) and only one finger presses the shutter release button. Camera usage, in turn, is driven by the illusion of individual photographers imprinting on a recording surface their unique view of the world. The leisure technology of the camera is treated as a neutral mechanism for the translation of that vision, but the design, promotion and use of the "image machine" is, in reality, caught up in a consumerist ideology of possessive individualism. As photographer Allan Sekula surmised in 1978, "the camera hobbyist … is invited to participate in a delimited and therefore illusory and pathetic creativity, in an advertising induced fantasy of self-authorship fed by power over the image machine, and through it, over its prey" (860). Even more broadly, the practice of photography can be understood as part of the "modern industrial age's narcissistic privileging of its own mastery of nature" (McCauley 2006: 423).

Ways of seeing are irreducibly social, as decades of cultural theory have revealed (Berger 1972). Moreover, as Vilém Flusser (2000) has argued, the camera is a highly standardized technical apparatus that can be said to program its operators to see in a certain way. From this perspective, the camera captures not only its subjects but also the photographer. For instance, the automation of variables like focus and exposure are typically sold to photographers on the basis that they enable them to concentrate on responding instantly to the world around them, rather than investing unnecessary energy in mastering unwieldy technology. The stated aim, as a typical Minolta advertisement from the 1970s put it, is to allow you to "quickly and easily translate the vision in your mind to your film." Here, the camera functions as prosthetic device, one of the great innovations in ways of thinking about photography in the twentieth century, brought on by the mobility offered by the small format 35mm camera in the 1920s. The great French photographer Henri Cartier-Bresson immediately established a non-human

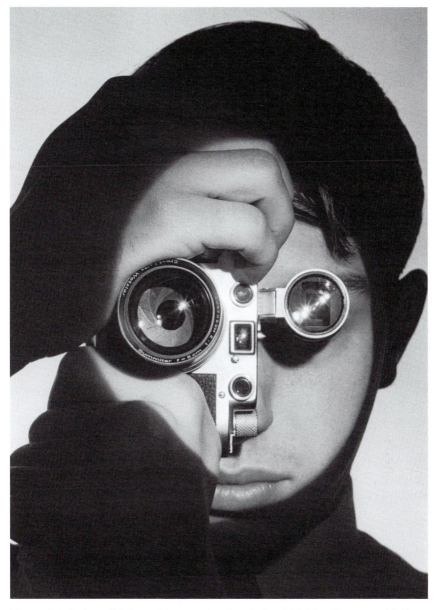

Figure 0.1 Andreas Feininger, *Photographer Dennis Stock Holding Camera to His Face*, 1951. The LIFE Picture Collection/Getty Images.

poetics of the small camera with his idea of the photographer prowling the streets like a cat, "ready to pounce" for the "decisive moment." A great symbol of this marriage of camera and photographer is Andreas Feininger's melodramatic 1951 staging of photojournalist Dennis Stock with a camera wedged in front of his face (Figure 0.1). Like a mechanized insect, the eye of the photographer is depicted

here as a synthesis of man and machine, expressively aligned. Likewise, Minolta's advertising tagline—"When you are the camera and the camera is you," and its promise of effortless ergonomics ("The controls are so logically positioned that your finger falls into place naturally")—reminds us that this celebration of individual freedom is an implicitly masculine fantasy. Automation naturalizes one's illusory relation to the world ("Everything works with such smooth precision that the camera feels like a part of you") (Figure 0.2).

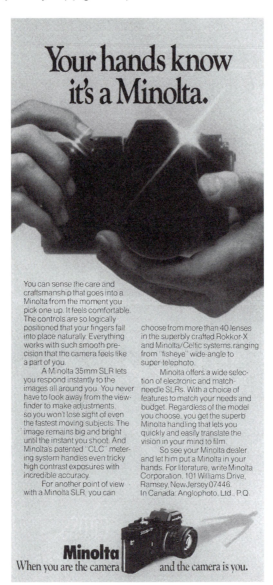

Figure 0.2 Minolta advertisement, "Your hands know it's a Minolta," c. 1976.

The labor of photography: Between the camera and the art market

The lone camera artist has always been a paradoxical figure. But the mechanical apparatus of capture is only one of the reasons for the solitary reputation of photography. The practice of photography conventionally involves at least four fundamental stages of which the act of seeing and recording an image is only the first. The other stages include the selection of the latent image through a process of editing, the translation of that negative (or digital file) into a finished print (or viewable image), and its circulation through physical or virtual display. Each of these stages can and often does involve other people. For the photography historian Geoffrey Batchen, writing about analogue photography, the primary split between the taking and making of a negative and a print fundamentally ruptures the illusion of a photograph's instantaneous production. "When is a photograph made?" he asks, noting that this question "immediately impinges on prevailing notions of intention, authorship and value" (Batchen 2000: 83). The art market's attempt to bridge the gap between conception and realization of an image is the "vintage print," the one made by the hand of the photographer closest to its time of conception. The vintage print embodies all of the fetishizations of art objects: a single point of origin, a singular artistic vision, and the artist's crafting hand. But as William J. Mitchell asks, "Who is the author of a print made from the negative of some long-dead photographer?" (1992: 48). As Batchen notes, histories of photography invariably "privilege the moment of taking over that of making, the private moment over the public, the origin over the journey, the aesthetic decisions over the social" (2000: 105–6). Implicit in this statement is the idea that these histories struggle to allow for the possibility that photographic images are frequently the result of multiple authors over many years. In reality, as Batchen (2012) points out, the authorship of individual photographs is "often a collective enterprise stretched over a considerable time period."

Until the 1880s, many photographers were responsible for each step of the photographic process. As the photography historian Helmut Gernsheim put it, "the photographer needed a darkroom and had to be thoroughly acquainted with the rules of focusing, and the relation of lens aperture to light, spending weeks learning developing, fixing, printing, toning, and mounting before he could show good results" (1955: 310). In practice, however, few photographers performed all the manual work themselves, and authorship within photographic studios was often exceedingly complex. As Batchen (2012) suggests:

> it was common for commercial studios, like those established in London by Richard Beard or Antoine Claudet, to claim a single authorship for all the studio's photographs—even though it is likely that Beard never took any

photographs during his entire career and that Claudet, who was frequently away in Paris, had many of his taken by anonymous subsidiary operators.

In the nineteenth century, photographers were often anonymous, as indicated by the term camera *operators*. In this situation, authorship could be "a function of publication, with copyright held by the various companies" (Krauss 1982: 314). Alexander Gardner's work during the American Civil War represents an interesting case. He first started working with Matthew Brady, but parted company in 1863 because of disputes over the attribution of authorship (Brady claimed credit for the work of his employees). The younger photographer Timothy H. O'Sullivan also joined Gardner's studio, and had forty-four photographs published in Gardner's *Photographic Sketch Book of the War* (1865–66), the first collection of Civil War photographs. Gardner, unusually concerned with the accurate attribution of photographs, presumably as a result of his experience with Brady, lists the name of the maker of both the negative and the print below each image. The most famous photograph of the book, *A Harvest of Death*, is recorded as "negative by T. H. O'Sullivan and positive by A. Gardner." Such careful attribution of collaborative processes is exceptional, even if "photography is perhaps the only one of the visual arts where partnering is invited and welcomed," as the curator Weston Naef (Featherstone et al. 1999: 139) once claimed.

In 1888, Kodak effectively industrialized a division of labor by divorcing the capturing of the image from its printing. Kodak introduced a form of commercial outsourcing, rather than collaboration as such, summed up by their famous slogan "You press the button, we do the rest." A photographer could now simply take a roll of photographs, and send off the entire camera to one of the new developing and printing firms, who returned it with prints and a reloaded roll of film. For Gernsheim, this represented a loss: "The ardent amateur gave way to the new machine man, content to follow manufacturers' instructions implicitly, and relying on camera and D & P firms to make the pictures for him" (1955: 310). In popular photography this division between taking and printing photographs dominated the twentieth century—interrupted only by ardent amateurs and Polaroids. In our digital era, when images are primarily viewed on screen, users can introduce printing effects such as filters, now built into photography software and camera phones alike. The more serious amateur, imitating a traditional if largely outmoded idea of the professional, might still pride themselves on being in full control of every aspect of the photographic process. This might now take the shape of mastery of sophisticated software such as Lightroom and Photoshop to bring out the finer qualities of RAW digital files. The stage was set for this desire for full individual control by the emergence of the aesthetic movement in photography at the end of the nineteenth century known as Pictorialism, formed partly as a response to the industrialization of photography and the growing ease of snapshot photography enabled by Kodak. As we will

see in the following chapter, the Pictorialists campaigned for photography as a fine art, and produced highly worked prints as a way to distinguish their work from the status of mass-produced images.

The legacy of the idea that printing one's negatives is an essential part of the creative process remained throughout the twentieth century, particularly in black-and-white photography where it was practical for a keen photographer to establish a darkroom of their own in a converted room of their home. The darkroom, in various accounts, is an alchemical place where individual fantasies of possession are realized—and even its traditional red safety-light seems to hint at a quasi-erotic experience. The darkroom scenes in Michelangelo Antonioni's *Blow-up* (1966), a film about a British fashion photographer who becomes convinced he has seen something in an enlarged fragment of a photographic print, underscore the obsessive and almost hallucinatory potential of images appearing out of the developing bath. Alternatively, one thinks of the story of Lee Miller assisting her mentor and lover Man Ray to accidentally "discover" the solarization effect in 1929, when a mouse ran across her foot in the Paris darkroom and she reached for the light during the processing of his negatives (Amaya 1975). Man Ray and Miller savored the unexpected beauty of the resulting tonal reversal, and went on to make numerous other experiments using the procedure, whose essentially uncontrollable effects might be understood as a metaphor for such unintentional collaboration. Later, in 1951, Robert Rauschenberg and his then wife Susan Weil turned their entire New York apartment into an impromptu camera-cum-darkroom, collaborating to make a series of life-size blueprints, or direct cyanotype impressions, with a nude model and a sun lamp (Lobel 2016).

The ideal of the creative mastering eye was embodied by one of the best-loved and most influential photographers of the twentieth century, the American landscape photographer Ansel Adams. In his widely read educational books, Adams advanced a dialectic between the photographer and technology, writing that "the photographer and his work must dominate his equipment, not the other way around" (1968a: 7). He advised the "creative photographer" to master the craft of photographic technology and the darkroom in order to be free to express themselves through the finished print. Although associated with a sharp-focus aesthetic, Adams's ethos is nevertheless Pictorialist insofar as he was adamant that his aim was not to reproduce the scene as it appears to ordinary human vision. His attempt to establish artisan credentials for photography relied instead on a commitment to what a guru of subjective photography, Minor White, later called "pre-visualization." This modernist impulse is overwhelmingly concerned with the form of the image, its transformation by a singular artistic vision. And yet, Adams (1968b: v) also famously claimed that the negative is the equivalent of the composer's score, while the print is the performance—a metaphor that nicely captures the fact that both involve skill and creative interpretation. The dance of dodging and burning in a darkroom might on occasion resemble a

performance of sorts, but just as composers typically rely on others to perform their music, scores of celebrated photographers have entrusted the printing of their negatives to others. Cartier-Bresson famously avoided developing his own prints, instead working with trusted collaborators to realize his vision.[2] Likewise, Garry Winogrand was too busy manically taking photographs to bother with the time-consuming demands of printing, and often allowed editors and curators to select work from his piles of contact sheets. Color photography, now dominant in the art world, is almost always printed by specialist printers. Photography books often involve elaborate collaborations between photographers, editors or publishers, and on it goes.[3]

Shared authorship can be a family affair; photographic businesses have often comprised siblings, no different from other trades (Figure 0.3). Edward Weston's son Brett printed his father's work for decades, while the North American identical twins Doug and Mike Starn and British twins Jane and Louise Wilson produce photographs together under a joint artistic identity. In this book, I am not primarily interested in forms of instrumental collaboration such as when a printer is paid to draw out a photographer's vision. Just like other artistic mediums, such as painting and sculpture, with their much longer histories of studio apprentices, photographic assistants perhaps only require mention in exceptional circumstances.

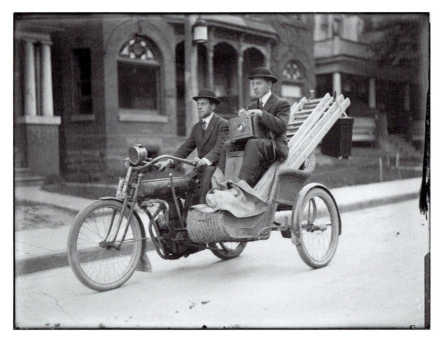

Figure 0.3 *Photographers Bill and Joseph James on a Motorcycle*, 1912. City of Toronto Archives, Fonds 1244, Item 3501.

However, these more technical forms of collaboration still serve to underline the point that the labor of photography is not as solitary as we tend to imagine. Professional photographic production, in particular, can be highly impersonal, involving many hands in the separate functions of taking, editing, retouching, and printing or otherwise distributing a photographic image. For instance, portraiture and fashion work has long relied on post-production techniques such as hand coloring and retouching. Even as early as the 1840s, daguerreotypes were hand-tinted to mimic painting and flatter the client. As the art historian and critic Lady Elizabeth Eastlake ([1857] 1980: 67) noted in an influential review in 1857:

> There is no photographic establishment of any note that does not employ artists at high salaries—we understand not less than £1 a day—in touching, and colouring, and finishing from nature those portraits for which the camera may be said to have laid the foundation.

If this work of touching and coloring has traditionally been invisible, it is also no accident that it has often involved the labor of anonymous women (whose wages have often been lower than men's).[4] Even today, it is rare for the names of retouchers to be known. One exception that proves the rule, the Photoshop guru Pascal Dangin, takes Adams's metaphor of print-as-performance to another level. He has been described in a profile in *The New Yorker* not only as a master printer but as "a translator, an interpreter, a conductor, a ballet dancer articulating choreographed steps" (Collins 2008). By all reports, Dangin's special skill lies in being able to channel the style of whatever photographer he is collaborating with (celebrity photographers including Annie Leibovitz, Steven Meisel, Mario Sorrenti and Philip-Lorca diCorcia). And yet, photography curator Charlotte Cotton has claimed that she could identify if a print was made by Dangin, pointing to "a kind of richness to the pixellation." He is, she suggests, "an unwritten author of what is leading the newest areas of contemporary image-making" (Cotton quoted in Collins 2008). Dangin, who prefers "to retouch alone, late into the night," underlines the point that high-end commercial photography is typically a corporate production. The role of stylists in creating such images is well documented, and some collaborative teams consist precisely of a stylist and a photographer (the contemporary duo Inez van Lamsweerde and Vinoodh Matadin being only the most well known).

Within art practice, authorship of individual prints can be even more complex—not that you would know from reading mainstream critics writing on photography. Critics, like collectors, remain stubbornly attached to the conventional connoisseurship of what used to be called the "master photographer." Take, for instance, one of the more problematic books written on the subject in recent years, Michael Fried's *Why Photography Matters as Art as Never Before* (2008). Fried places intentionality and the individual artist at the pinnacle of photographic practice. Focusing

on the photographic tableau, he explores how such canonical artists as Jeff Wall, Andreas Gursky, Thomas Demand, and Hiroshi Sugimoto saturate their photographs with signs of intention. Although photography's importance to contemporary art goes well beyond the pictorial photography that Fried is fixated upon—for instance, as a document of an artistic event or procedure, or part of archival collection of vernacular documents—his extremely selective reading of "auteur" photography expressly reinforces the intentions of single authors. Authorship here is conventionally conceived as the one who presses the shutter-release button, or at least directs its release. Not coincidentally, almost all of the artists he writes about produce large-scale prints. As Olivier Lugon has demonstrated, since the end of the nineteenth century, "the large print" has been "an expression of rarity and exclusivity: one producer, one viewer, and one single image contemplated at any one time" (2015: 392). In effect, many of the key figures associated with the market boom for art photography in the 1990s and 2000s—the artists who concern Fried—exhibit in their "neo-Pictorialist" images a form of exaggerated or melodramatic authorial control. Made explicitly for the gallery wall, their work belongs to the convention of grand painting, and like that tradition tends to conceal the collaborative labor of its production behind a single signature.[5] While there is nothing wrong with this, it is also not the whole story. To a large degree, it is a function of the art market's embrace of photography since the 1970s (Lifson and Solomon-Godeau 1981)—the world of signed and numbered prints—and the valorization of a photographer's career in terms of a name brand associated with a distinctive aesthetic. This logic flows through to the resulting bias toward individualized commentary in journalistic and art-historical accounts. As we know, the production of artistic signatures is itself a collective exercise (Owens 1992).

Photography in the discourse of artistic collaboration

This book concerns collaboration in photographic art since the late 1960s. This is a period in which photography and contemporary art merged in significant ways, and in which collaboration became a relatively common strategy within artistic practice more broadly. While the art world still valorizes individual authorship as the normative position, conceptual artists in the 1960s and 1970s regularly worked in teams, as the examples of Gilbert & George, Abramović and Ulay, Christo and Jeanne-Claude, and Fischli and Weiss demonstrate. Furthermore, artistic and critical interest in collaboration returned to prominence in the late 1990s, with Maria Lind identifying what she called "the collaborative turn" in contemporary art in 1997. Around the same time Nicolas Bourriaud influentially schematized the importance to contemporary art of "[m]eetings, encounters,

events, various types of collaboration between people, games, festivals and places of conviviality, in a word all manner of encounter and relational invention" ([1998] 2002: 28). Out of this, a relatively advanced discussion of collaboration in contemporary art has emerged over the past two decades, within which it is widely appreciated that the practice of artists working together represents a paradigmatic interrogation of artistic production. That interrogation involves the redefinition and renegotiation of conventional notions of authorship and aesthetic autonomy. The discussion also recognizes that significant precursors to contemporary collaborations exist, even if they took shape in different forms under radically different political circumstances (the collective action following the Russian Revolution of 1917 being the most famous instance). Many advocates of collaboration in contemporary art propose that the current political situation and the atomizing tendencies of neoliberalism demand collective artistic efforts as a response. Curiously, little of this critical and political enthusiasm for collaboration has spilled over into photographic discourse, although there are promising signs of such an interest.[6]

Strikingly, none of the bourgeoning critical literature around artistic collaboration does more than allude to photography. Since the medium of photography performs such a pivotal role within collaborative art practice—with the camera and photograph often operating as enabling vehicles—this is an omission that needs analysis. Given that contemporary art often relies on photographers, who are frequently not credited by name, to document ephemeral and performance-based works, one might even suspect an unconscious bias or even deliberate erasure.[7] Thus, in 1984, Cynthia Jaffee McCabe curated a major exhibition called *Artistic Collaboration in the Twentieth Century* for the Hirshhorn Museum in Washington, D.C. The exhibition was designed to demonstrate the prevalence of collaboration in avant-garde art practice, and McCabe argued convincingly that collaboration challenges the cherished notion of the artist as solitary creator or lone genius. In the catalogue, McCabe and other writers remind us that collaborative practice calls into question the romantic notion of the isolated individual artist. This exhibition was produced in the postmodern critical climate of Rosalind Krauss's (1985) influential writing on "modernist myths" such as "originality," and the catalogue essayists enthusiastically cite collaboration as "one of the surest means to expropriate the myth of origin and authenticity" (Shapiro 1984: 57). Pointing out that for connoisseurs, collaboration has been seen as antithetical to "great art," the curator refers to the generative importance of Dada and Surrealist artists (the exquisite corpse being an exemplary collaborative act). McCabe proposes that "the concept of artistic collaboration involves two or more painters, sculptors, printmakers, performance artists, or video artists gathering together, pooling ideas, and with equal participation creating an object" (1984: 15). The notable absence of *photographers* from this defining list of practitioners is a curious oversight, given that the photomontage work by Dada artist John Heartfield

as well as Bernd and Hilla Becher are actually included in her survey. The exclusion is perhaps telling, suggesting that the curator has so internalized the solitary idea of the photographer as to be blind to the evidence of photography as an enabler of collaboration. In addition, like most discussions of artistic collaboration, McCabe confines her discussion to collaboration between artists rather than, as I propose below, also between artists, the subjects involved in artworks and their viewers.

A 1990 exhibition in New York by Independent Curators Incorporated called *Team Spirit* sought to explore collaborations "sustained by the existence of a collective persona" (Sollins and Sundell 1990: 7). The curators Susan Sollins and Nina Castelli suggested that since the mid to late 1960s "collaboration as a mode of production and self-definition has become increasingly visible in the international art world" (1990: 7). Linking this development to a period of social idealism, they pointed to "a new order of cooperation" (1990: 9) for society as a whole, which in turn "demands the redefinition of the concept 'artist'" (1990: 13). Specifically, they made the claim that "collective entities ... operate as meta-artists" (1990: 8). Irit Rogoff (1990: 38), also in the catalogue, celebrated collectivity as an interrogation of artistic identity, "rupturing the authority previously held by the aura of the unique individual known as 'the artist'." The curators (1990: 7) open their text with the idea that "[m]ost forms of art—theatre, film, dance, architecture, music—are inherently collaborative" and then also speak of "inherently collaborative media such as performance or video." In other words, they are alert to different collaborative potentials within distinct media. However, even as they name the nineteenth-century photographic partnerships of Hill and Adamson and Southworth and Hawes (Sollins and Sundell 1990: 8), and photomontage is cited again, the medium of photography is never addressed. The question of why video, say, is more "inherently collaborative" than photography, is never raised. Moreover because of the exhibition's focus on gallery-based contemporary art, the curators also ignore experiments within radical documentary in photography and video since the 1970s—even though it aims for precisely the kind of collective authorship they valorize.

Charles Green, in his 2001 book *The Third Hand: Collaboration in Art from Conceptualism to Postmodernism*, offers a compelling account of what he describes as "a very selective history of artistic collaborations after 1968" (x), specifically those involving unorthodox models of authorship. Green is less interested in the politics of collaboration per se, suggesting that collaboration "has not in itself been a radical act since early modernism, when Russian constructivists or the French surrealists, for vastly different reasons and in different media, used artistic collaborations to escape the constricting consequences of existing individual production methods" (2001: xiv). Instead, Green focuses on the construction of artistic identity, arguing that the self-conception of the artist

necessarily shifts as artistic labor is redefined in different production methods. Moreover, he is particularly concerned with the manner in which conceptual artists have consciously manipulated artistic identity through the negotiation and conflation of single authors. For Green, "collaboration is a special and obvious case of the manipulation of the figure of the artist," since it involves "a deliberately chosen alteration of artistic identity from individual to composite subjectivity" (2001: x). Out of this he constructs a new "model of authorship," a phantom figure he dubs the "third hand," allegedly generated when artists set about working jointly. Green touches on photography when he briefly discusses the work of Bernd and Hilla Becher, but his interest in their work focuses on its relationship to historical memory. He also explores the crucial role of photographic documentation in relation to Christo and Jeanne-Claude's works of temporary public art. Again, Green is exclusively concerned with photography's role in the preservation of memory, rather than how it might contribute to his argument about collaborative practice.[8]

Grant H. Kester is specifically concerned with socially engaged art practice—particularly community-based activist projects in the United States—in the context of the rise of neoliberalism. In his book *The One and the Many: Contemporary Collaborative Art in a Global Context* (2011), Kester seeks to broaden the discussion beyond the artist-to-artist collaborations that concern Green. He focuses on projects that "challenge the traditional perception of the work of art as an event or object authored beforehand and subsequently presented to an audience" (2011: 3). In other words, building on his earlier book, *Conversation Pieces: Community and Communication in Modern Art* (2004), Kester argues that conventional notions of aesthetic autonomy are being redefined and renegotiated. Importantly, this entails a shift in the concept of art as something envisioned whole by the artist and placed before the viewer, to the concept of art as a process of reciprocal creative labor. That is, Kester relates the proliferation of collaboration and collective practice to the movement toward participatory experiences in art (2011: 7). Kester makes a distinction between what he calls "collaborative" and "textual" approaches, which he describes as "predispositions" within contemporary art practice. The "textual," in this model, is a "mode of production in which the artist fashions an object or event that is subsequently presented to the viewer" (2011: 8). While Kester discusses photographic documentation throughout his writing—and also discusses the motif of the blind beggar in photographs by Jacob Riis and Paul Strand in relation to Santiago Sierra's work (2011: 155–63)—photography falls clearly on the side of the textual rather than the collaborative in his model, being too closely related to what he describes as the exhausted semiotic or representational emphasis of postmodern art. For Kester, as for the writer Nikos Papastergiadis (2012), collaboration represents a largely unrealized political and ethical potential within art, but not photography iself.

Claire Bishop has earned a reputation for her skepticism toward socially engaged participatory art in a series of articles and in her book *Artificial Hells: Participatory Art and the Politics of Spectatorship* (2012). Bishop's position, a direct reaction to proponents like Kester and particularly the relational aesthetics of Bourriaud, responds to what she views as the rise of instrumental forms of participation in certain forms of community art in the context of British New Labour in the late 1990s. Taking this trajectory as a rule, she writes (2012a: 16), "The dehierarchising rhetoric of artists whose projects seek to facilitate creativity ends up sounding identical to government cultural policy geared towards the twin mantras of social inclusion and creative cities." Adopting the ideas of philosopher Jacques Rancière among others, she takes issue with the emancipatory claims often made for participatory projects, stating a clear preference for avant-gardist aesthetic criteria in the reception of artwork—in terms of "negation, disruption and antagonism" (189). Bishop effectively treats "participatory art" as a medium, rather than a potential available to all art mediums, and thus expresses no specific concern with photography or indeed any other medium per se. Nevertheless, she is alert to the importance of photographic documentation within participatory art and performance. She is interested in how photography mediates between participants' first-hand experiences and the viewers of photographic documentation. Specifically, Bishop points to the typical inadequacy of such artifacts, writing that "[t]o grasp participatory art from images alone is almost impossible" and adding a dismissive reference to "endless photographs of people" (8). To be fair, she also points to how this very inadequacy can become generative, notably in relation to the Moscow Conceptualist Andrei Monastyrsky (160) and also Tino Sehgal, who famously forbids documentation of his work. Finally, Bishop refers to changing technical conditions of visual production, noting in relation to a discussion of British community art of the 1970s, that its "dehierarchising agenda" has "less urgency" in the age of social media (190). In effect, Bishop treats photography as a passive medium of documentation. Once again, photography's active role as an enabling medium of participation and collaboration is rendered invisible—another motivation for the current research.

Defining collaboration in photography

This book spans the roughly fifty-year period since the rise of conceptual art in the late 1960s to today's culture of digitally networked images, and what I have come to think of as explicit forms of collaboration in photographic art. However, precisely under what circumstances photography could be said to be collaborative is an open question. The literal meaning of collaboration is "to work together,"

in "conjunction with" another, to engage in a "united labor" (Kester 2011: 1–2). This is clearly most obvious and straightforward in the case of photographer-artists who consciously collaborate with each other to produce photographs, which is indeed where I begin. A comprehensive history of such partnerships and teams in photography remains to be written, and would be a worthy pursuit. However, in what might appear a paradoxical decision, I devote far more space in this book to the photographic projects of individual artists. Why? My rationale is that collaboration in the medium of photography pertains not only to artistic coauthorship but also to the relationship between photographers and their subjects, and also between photographs and viewers. In other words, if we move beyond the authorship of individual images and consider photography as a social and communicative activity, which unfolds over time, it turns out that most photography is collaboratively authored at some level. That said, my focus in this book is directed to photographic art in which this more expansive collaboration is consciously and even conspicuously encouraged as part of the work's aims.

Chapter 1 examines in more detail the various and at times contradictory ideologies of authorship that continue to inform the art world's valorization of individual photographers. It engages with key moments in the history and theory of photography for what they reveal about assumptions in photographic authorship. I analyze how art-historical approaches to photography—both modernist and postmodernist alike—have neglected and even repressed various forms of collaborations that have in fact always been part of photographic image making. Finally, this chapter presents an alternative approach to photographic authorship inspired by the work of photography theorist Ariella Azoulay, who asks us to understand the potential for collaborative meaning-making within the nature of the medium itself. As Azoulay has reminded us, photographs are *relational*—they "bear the traces of the meeting between photographed persons and the photographer" (2008: 11). In short, a photograph is a product of an encounter and the start of a conversation. Crucially, Azoulay's attention to the interrelation between photographers, subjects, and spectators provides an expanded model of authorial agency that enables us to consider collaboration as extending beyond the literal coauthoring between photographers themselves.

Four thematic chapters form the core of this book, spanning distinct approaches to photography. Each chapter focuses on three key artists, and close readings of a small number of their projects, rather than attempting to offer a comprehensive overview. My examples include North American, British, German, French, and Australian practitioners, who are contextualized in light of other examples, in the hope that the outlines of a broader history of collaboration in photography emerge. Some of the key examples are canonical figures and have been written about extensively before. However, brought together here under the umbrella of collaboration for the first time, new connections are drawn

between them. I focus on work where the collaborative dimension is more than simply a means to pool skills but has something to tell us about the medium of photography. Inevitably, many artists and tendencies have been left out, particularly as my geographical scope is largely delimited by artists responding directly to the Western modernist framing of photography as an individual medium. Three of the twelve examples are Australian-born artists, reflecting my own location in the world and my method, which wants to understand the photographic act in terms of production and reception—how photographs are both made and encountered—rather than the traditional art-historical emphasis on the formal or aesthetic qualities of individual images. For this reason, even as a reliance on artist's biographies can easily reinforce ideas around the singular intentionality of meaning-making that this book questions, I frequently rely on interviews with, and statements by, artists to help understand a project's life cycle.

Chapter 2 focuses on artists whose work complicates the idea of the expressive vision of the photographer by means of a decisive conceptual gesture, namely by consciously removing conventional marks of photographic authorship through a reliance on the medium's automatism or through techniques such as seriality and recontextualization. In effect, the artists I explore in this chapter treat the photograph as a complicated form of readymade. Unlike the other chapters, my case studies in this chapter are all artist-collaborators: the German husband-and-wife team of Bernd and Hilla Becher, whose highly systematic, impersonal approach to industrial architecture is famous for eradicating either artist's individual subjective vision; the North Americans Larry Sultan and Mike Mandel, whose book *Evidence* (1977) is made up of images sourced from the photographic files of government, science, and industry; and London-based duo Adam Broomberg and Oliver Chanarin, who consciously distance themselves from the tradition of the "genius photographer" through their collaborative conception of images. This chapter touches on the merging of artistic identities discussed by Green (2001), but focuses on how the camera's mechanical nature has underpinned distinctively anti-subjective, contextually dependent collaborative approaches.

Chapter 3 explores the work of artists who recruit multiple voices in the production of photographs, with the aim of creating more inclusive forms of documentary-style records. Collaboration is utilized here in a specific attempt to democratize the making of documentary photography by involving communities in their own representation. The three case studies addressed in this chapter are North American photographer Wendy Ewald's pioneering work over forty years in teaching children to document their lives in photographs; London-based Australian artist Anthony Luvera's collaboration with homeless people; and Simon Terrill's choreographed images with specific communities and residents. These representative examples of art practice are evaluated in light of a broader context for the work, such as radical British community photography in the 1970s and the contemporary anthropological research method, PhotoVoice.

Rather than assuming collaboration's emancipatory or progressive potential, adopting Azoulay's (2008) concept of photography as a "civil contract" among citizens, I argue that the most effective examples of photography made in the name of community simultaneously explore the ethics of social documentary while also questioning the rhetoric of community itself.

Chapter 4 focuses on artists who use collaborative methods within photographic portraiture as a means of eliciting novel forms of social encounter. This work often extends the concerns of Chapter 3 around the power relations involved in portraiture, but is more playful in its forms. My three case studies are North American conceptual artist Douglas Huebler, whose instructional photography often relied on collaboration and participation; Australian artist Micky Allan, and specifically her work *My Trip* (1976) in which she took a photograph of everyone who spoke to her on a seventeen-day road-trip, and then offered the camera to the same subjects to photograph anything they chose; and French artist Sophie Calle, notably her work *The Shadow (Detective)* (1981), in which she hired a private detective to follow and take pictures of her as she went about her everyday life in Paris. Each of these works represent examples of what I term relational photographic portraiture, particularly insofar as they involve interactions between strangers. Contextualized in relation to more recent examples of portraiture that involve collaboration between photographers and their subjects, it appears that women have been especially drawn to such methods. I suggest that this fact may be accounted for once we understand that collaboration puts the conventional separation of public and private identity in question.

Chapter 5 explores contemporary artists' use of found and crowdsourced photography, specifically personal snapshots, which I argue can be interpreted as an unusual but important instance of collaboration with often absent and anonymous photographers. The three case studies addressed in this chapter are German artist Joachim Schmid, who has been working with found photographs since the 1980s and whose collections of books reveal recurring patterns in the vast archives of popular photography; North American artist Penelope Umbrico, who is best known for *Suns (from Sunsets) from Flickr* (2006–), an ongoing aggregation made by searching for the word "sunsets" on Flickr; and fellow American artist Richard Prince, whose series *New Portraits* (2014) controversially appropriates users' Instagram images in a way that tests the boundaries of authorship between social media and the art world. I argue that—especially in the context of the dematerialization of images online—contemporary artists' interest in found photographs has become a means to publicly recontextualize amateur production, and to draw out often gendered narratives within such images, reinvesting them with authority and pathos in a collaborative rather than simply appropriative act. In each of my examples in this chapter, artists extract and concentrate cultural value from large bodies of photographs made by multiple authors, increasingly sourced

from the Internet. More broadly, photosharing represents the latest develop-
ment in photography's collaborative manifestations, in which the authorship
of photographs online is inherently unstable and even "unfinished" (Rubinstein
2009: 139).

The goal of this book is not simply to point to the ubiquity of collaboration in
photographic art since the 1960s. Nor is it an attempt to shore up a different
form of legitimacy for photography within contemporary art on the basis of its
collaborative credentials. My argument is essentially an intervention into think-
ing about photography as art in the first place. To think of photography only
as a solitary act of intention leading to individual images that can be assessed
according to their formal qualities is to radically simplify how photographs can
and do function as art. Yet while I am critical of the conventional art-historical
approach, this is nevertheless a book about photography in and as art. This
is not because photographic art is more important than other forms of pho-
tography. However, the testing ground of artistic experimentation enables an
advanced discussion about photographic authorship (paradoxically, even as
the art market valorizes individuals, the work of individual artists often ques-
tions authorial convention). Through the examination of specific examples,
what I hope becomes clear is that collaboration in photography has taken
particular forms in response to certain unique qualities of the medium—such
as the fact that it now requires little or no training or skill to produce images
with a camera. Ultimately, to focus on collaborative efforts in photography is
to question our understanding of the medium as art. For at the most general
and most ambitious level, *Photography and Collaboration* describes a shift
from a concept of photography as something that begins and ends with an
individual photographer's vision of the world to the concept of photography
as a social process involving the co-laboring of photographers, their subjects,
and viewers over time.

1
IDEOLOGIES OF PHOTOGRAPHIC AUTHORSHIP

Announcing the invention of the daguerreotype, in a speech to the French parliament in 1839, the noted astronomer and member of the French legislature François Arago famously praised its simplicity and proposed that it could be performed by anyone, since it "presumes no knowledge of the art of drawing and demands no special dexterity" ([1839] 1980: 19). Arago was establishing what has become a recurring idea in the discourse of photography, namely, that the medium is democratic and deskilled. Indeed, one of the factors that makes photography so interesting and problematic for the historian is that this quality is viewed as a virtue in some contexts and a problem in others—depending on the writer's investment in the dominant ideas around authorship that are in play at any given moment. This chapter seeks to make a link between the various ideologies of photographic authorship that have historically sustained the medium and the devaluation of collaborative labor that I touched on in the introduction. For while photography historians and theorists have had until very recently almost nothing to say about collaboration, the issue of authorship has long been a central fixation. Bound up with the construction of the modern author more generally—and related anxieties around originality and intentionality—it is difficult not to read this fixation as stemming from the idea that photography can be performed by anyone. Unease about photography's democratic promise has, particularly in the hands of art historians, been overcompensated for in the figure of the bloated author.

This book is concerned with collaboration in photographic art since the rise of conceptual art in the 1960s. However, to appreciate the significance of the practices I chart in the chapters that concern these past fifty years, it is necessary to contextualize them in relation to a longer history of ideas around authorship. Most particularly, we need to understand the emphasis, in the modernist art histories of photography that still dominate the way photography is understood, on the formal qualities of individual images taken by individual photographers. As a

multitude of writers since the 1970s have demonstrated (Sontag [1977]; Sekula [1978]; Phillips [1982]; Tagg [1988]; Solomon-Godeau [1991]; Batchen [2000]), this emphasis has prevented a better understanding of how photographs circulate and operate in the world, and severely limited the type of photographs considered worthy of study. Less obviously, it has fuelled the powerful stereotype of the solitary photographer. One of the reasons is that photographers themselves, eager for their own activities to be viewed as art, have often contributed to the writing of those histories. Another reason is that major art museums such as New York's Museum of Modern Art (MoMA) have played an important role in reaffirming these histories, helping to fuel the emergence of a serious art market for photography in the 1970s (as I have already argued, the art market demands scarcity through limited and vintage editions, reinforcing the idea of the individual "visionary"). In this chapter, I conceive of seven dominant ideologies of photographic authorship: *nature*, *law, subjectivity*, *worker*, *medium*, *cultural codes* and *software*. I approach these ideas historically and chronologically, although they overlap. Like all ideologies, they are often drawn upon unconsciously. My purpose is to give a broad sense of the competing ideas fuelling authorship—particularly for readers who may not be so familiar with the history of photography—in order to better understand the conspicuously collaborative work I examine later in this book. I conclude with the productive account of authorship offered by the contemporary theorist Ariella Azoulay.

Nature as author: The sun as collaborator

The inventors of photography conceived of the medium as both an art and a science, in which the sun was the authoring agent. In 1827, in his claim to the Royal Society in England, the Frenchman Joseph Nicéphore Niépce, an avid enthusiast of the new art of lithography, gave the name *héliographie* to his earliest photographic experiments, from *helios*, meaning "sun" and *graphein*, meaning "write." For the official inventors of photography, Louis-Jacques-Mandé Daguerre and William Henry Fox Talbot, the primary author of photographs was also the sun, and more broadly nature itself (Figure 1.1). As Daguerre wrote in 1838, "The Daguerreotype is not merely an instrument which serves to draw Nature; on the contrary it is a chemical and physical process which gives her the power to reproduce herself" (quoted in Batchen 2000: 11–12). Photography historian Geoffrey Batchen has argued that photography is here "something that allows nature to be simultaneously drawn and drawing, artist and model, active and passive" (2000: 12). Talbot, in his paper presented to the Royal Society in January 1839, depicted photography as "the art of photogenic drawing" in which "natural objects may be able to delineate themselves" (quoted in Batchen 2000: 10–11). The almost ghostly drawing metaphor is underscored in Talbot's

Figure 1.1 William Henry Fox Talbot, *The Open Door*, late April 1844. Salted paper print from a Calotype negative, 14.9 x 16.8 cm (5 7/8 x 6 5/8 in.). The J. Paul Getty Museum, Los Angeles. Digital image courtesy of the Getty's Open Content Program.

book *The Pencil of Nature* (1844), which acted as a kind of prospectus stating the practical possibilities for photography and began with a notice to the reader that the plates are "impressed by the agency of Light alone without any aid whatever from the artist's pencil. They are the sun-pictures themselves, and not, as some persons have imagined, engravings in imitation" ([1844] 1969: n.p.). Photography, which is based on the Greek words meaning "light writing," has always been a complex marriage of nature and culture (Batchen 1997).

Inventors who wanted to celebrate the miraculous possibilities of nature spontaneously reproducing itself understandably downplayed human effort, or the workings of the human hand. Crucially, within this "fantasy of autogenesis" (Edwards 2006: 42), it was precisely photography's apparently *objective* quality that made it such a powerful medium. Indeed, the "mechanical objectivity" of the camera was recognized as valuable in the nineteenth century as part of an "insistent drive to repress the wilful intervention of the artist-author" (Daston and Gailson 2007: 121). In all sorts of contexts outside of art—in science, criminology, industry, medicine, surveillance, and other instrumental uses—the suppression of individual authorship continues to give photography its authority. In the nineteenth century, even dramatic landscape "views" were often presented

anonymously, such that "the natural phenomenon, the point of interest, rises up to confront the viewer, seemingly without the mediation of an individual recorder or artist" (Krauss 1982: 314).

By the same token, photography's mechanical nature, and the associated claim that it represented the objective manifestation of nature, prevented it from even being confused with fine art in the eyes of many influential nineteenth-century commentators. For the poet Charles Baudelaire, as for others who conceived of art as an expression of human imagination, photography's seemingly objective nature was found fundamentally lacking. Photography was a soulless, mechanical copying of reality, both too technical and too easy to ever resemble fine art. Later, in the 1920s, the Surrealists and other avant-garde artists exploited photography's mechanical and automatic quality—in, for example, the embrace of the photogram as a route to the unconscious. The photogram in fact continues to offer a profound metaphor for the complications of photographic authorship (Batchen 2000: 161). And yet, as Rosalind Krauss observes, the photogram "only forces, or makes explicit, what is the case of *all* photography" (1977: 75), namely that it is "the result of a physical imprint transferred by light reflections onto a sensitive surface." All this is to come. In his salon review of 1859, Baudelaire memorably dismissed the new class of pseudo-artists flocking to the camera as "sun-worshippers" ([1859] 1980: 87). But there was already a more generous way of thinking about the sun's role. The nineteenth-century French poet and political minister Alphonse de Lamartine initially accused photography of plagiarizing nature by optics (quoted in Gernsheim 1962: 64). However, he later publicly changed his mind—declaring that photography "is better than an art, it is a solar phenomenon in which the artist collaborates with the sun" (quoted in Gernsheim 1962: 65).

Law as author: The legal codification of authorship

Perhaps the most important ideology of authorship is that set down by law. As Jane M. Gaines puts it, "How do we find the author in the photographic work in order to establish that he, rather than the machine, created the photograph itself?" (1991: 44). In France, copyright law had existed since the Revolution, with the landmark law on author's rights being enacted in 1793 (Nesbitt 1987: 230). But as the French legal scholar Bernard Edelman observes, "The eruption of modern techniques of the (re)production of the real—photographic apparatuses, cameras—surprised the law" (quoted in Gaines 1991: 45). Edelman puts it in the following way: "For French law, the crucial question was whether or not the mechanical product could be said to have anything of 'Man' in it at all. An

authored work (it was argued) is imbued with something of the human soul, but a machine-produced work is completely 'soulless'" (quoted in Gaines 1991: 46). Not surprisingly, given this test, photographers who wanted the legal protection offered by copyright law needed to prove somehow that their work was artistic. In other words, the relations of production demanded they set themselves up as artists, since "a soul had to be found in the mechanical act" (Gaines 1991: 47). What was a machinic act involving the duplication of the world needed to become an original production in the form of intellectual property (Gaines 1991: 47).

Photographers began testing the law immediately, and by around 1862, the French courts translated the idea of the creative soul into the concept of the "imprint of personality" (Gaines 1991: 47). Likewise, in Britain and the United States, the investment of personality became the crucial authorial deposit for intellectual property. Photography, as Gaines suggests, had been domesticated according to "existing conceptions of the world" (1991: 47). Or, as John Roberts put it more recently, "All aestheticized theories of photography as art stem from the legal codification of the photographer as creator, although this legal codi-fication does not in itself produce the ideology of aestheticization. Aesthetic ideology and the concept of the modern, autonomous artistic subject preexist this new legislation" (2014: 175 n.2). Gaspard-Félix Tournachon, who went by the name Nadar, represents a clear example here. The entrepreneurial portrait photographer—who was a student of the painter-cum-photographer Gustave Le Gray (more on whom later)—became the best-known and most notorious photographer working in France in the nineteenth century. First opening his pho-tographic studio in Paris in 1853, he had the artistic and intellectual aristocracy of France virtually lined up to sit for him. As he wrote of his portrait photography in 1857: "The theory of photography can be learnt in an hour, the first ideas of how to go about it in a day … What can't be learnt … is the feeling for light—the artistic appreciation of effects produced by different or combined sources [and] the instinctive understanding of your subject" (Scharf 1976: 106). In other words, Nadar maintained that he was not simply an operator of photographic equip-ment, but an artist sensitive to the nuances of personal character and the artistic effects of light (Warner 2002: 89). Notably, he did not recognize any contribution from the photographed subjects toward the representation of their own image.

Once thousands of people began to depend upon photography for a liv-ing, issues around the protection of copyright became paramount. The most famous copyright case pertaining to photography in the nineteenth century involved the preeminent New York studio photographer Napoleon Sarony and his cabinet photographs of the visiting Oscar Wilde taken in 1882. Wilde's visit to New York was a spectacular success, so much so that his image was widely sought and copied. Sarony sued a printer, Burrow-Giles Lithographic Co., for infringing his copyright by reproducing at least 85,000 unauthorized copies of the image (Gaines 1991: 52). The district court in New York in 1883 found

the defendant guilty of piracy, but on appeal to the Supreme Court in 1884, Burrow-Giles argued that photographs were ineligible for copyright protection (granted by an 1865 amendment that had specifically added photographs to the list of copyrightable forms) because the Constitution only protected authors' writings, while the photograph is a "mere mechanical reproduction" (Gaines 1991: 55). For his part, Sarony argued, among other factors, that the draperies, light and shade, Wilde's expression, and above all his *pose* belonged to an "original mental conception" (Gaines 1991: 54). Indeed, Sarony dissociated himself from the mechanical apparatus—referring to how he deftly relayed his ideas to the camera operator (Gaines 1991: 72). The court agreed with Sarony that his portrait of Wilde was "an original work of art, the product of plaintiff's intellectual invention, of which plaintiff is the author, and of a class of inventions for which the Constitution intended that Congress should secure to him the exclusive right to use, publish and sell" (Tuchman 2004). An author, according to the court ruling, is simply the one "to whom anything owes its origin" (Tuchman 2004). As Gaines (1991: 51) points out, "originality is elaborated as a defense of Sarony's photographic artistry," but the test of originality is a paradoxical one, rooted in both the Lockean philosophy that "man is the origin of property" (58) and the romantic individualized notion of authorial creation, rather than in the work itself.[1] In this model, the rights of the *photographed* subject over their image are limited to an original contract (there is no evidence that Wilde knew of the court case). In short, in the photographer's "choice" of subject and style of framing, "we have the human investment of labour … the private property-producing gesture" (Gaines 1991: 68). This legal codification of photography remains highly relevant to authorship today, as we will see in relation to Richard Prince's work (Chapter 5).

Subjectivity as author: Pictorialist and modernist sensibilities

In significant respects, the history of photography has been one of applying traditional art-historical categories such as originality and style to the medium, in the face of claims that photography lacks artistic intentionality due to its mechanical nature. As we have already established, photography's ease has always been a challenge to its status as art. If so many untrained people can take photographs, how can it be as exclusive as art? The nineteenth century is punctuated by the emergent notion of the artist-photographer, based around subjective response. In France, the landscape photographer Gustave Le Gray—who studied painting in the studio of Paul Delaroche (the painter who apocryphally claimed, upon first seeing a Daguerreotype, that "from today painting is dead")—wrote in 1852 that

"it is my deepest wish that photography, instead of falling within the domain of industry, of commerce, will be included among the arts. That is its sole, true place, and it is in that direction that I shall always endeavor to guide it" (Naef 2004: 32). In attempting to establish photography as an art form—many would-be artist-photographers argued for an analogy between painting and photography.

The English photographer Henry Peach Robinson is arguably the most emblematic nineteenth-century art-photographer. Robinson was influenced—like Julia Margaret Cameron, who could equally claim this title—by the Pre-Raphaelite painters, and started with sketches for his pictures, working out elaborate and highly detailed scenes (Figure 1.2). *When the Day's Work Is Done* (1877), like his most famous work, *Fading Away* (1858), involved the use of models and the seamless combination of multiple separate negatives to produce a work of fiction that preempts the pictorial imagination enabled by Photoshop today. In his influential essay *Pictorial Effect in Photography: Being Hints on Composition and Chiaroscuro for Photographers*, published in 1869, Robinson advised reworking the image by hand as if it were a drawing or painting. Robinson would have been keenly aware of the Sarony case, and in 1891 was the central figure in the formation of the Linked Ring, a group of primarily British photographers committed

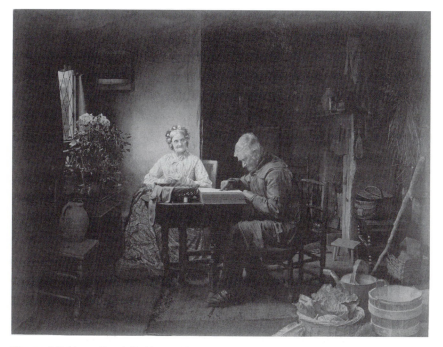

Figure 1.2 Henry Peach Robinson, *When the Day's Work Is Done*, 1877. Albumen silver print, 56 x 74.5 cm (22 1/16 x 29 5/16 in.). The J. Paul Getty Museum, Los Angeles. Digital image courtesy of the Getty's Open Content Program.

to advancing photography as an art form. Its annual Photographic Salon looked for evidence of "personal feeling," out of which emerged the Pictorialist movement, alongside rival figures such as Peter Henry Emerson. For all their considerable differences (Robinson advanced a more "naturalistic" or impressionistic approach), all of these photographers were inspired by the methods of painters and aspired to be known as artists. Pictorialists were fundamentally interested in subjective impressions, or the idea of photography as a medium of individual expression. Their self-conscious aestheticism—the use of soft-focus effects and atmospheric lighting—and emphasis on printing techniques, using difficult processes such as platinum prints and photogravures that only the most dedicated could access, represented a clear attempt to distinguish their labor from the new breed of amateurs born of the Kodak revolution, and what Alfred Stieglitz, the leading American exponent of Pictorialism, memorably called the "fatal facility" of photography in 1889 (1980: 117). For the Pictorialists, photography's ease of use represented a clear threat to the medium's reputation. However, this very same quality has been crucial to its deployment in art since the 1960s, as we will see, and has been particularly relevant to photographic collaborations.

Even as Pictorialists such as Stieglitz and Edward Steichen came to denounce the "artiness" of their own approach at the turn of the twentieth century, they established the terms for what became modernist art photography in the United States. The new "straight" approach, which became dominant in artistic photography from the 1920s, managed to link the highly subjective approach of Pictorialism with a new respect for the "purity" of the medium, shorn of the trappings of painting. Stieglitz is considered the father of modern American photography, not least because by 1915 he was promoting the sharp focus photography of Paul Strand in his journal *Camera Work*. Strand stressed the "honesty" of the medium and its ability to produce "tonal values which lie beyond the skill of human hand" ([1917] 1980: 142). The various formalisms that emerged, based on the supposed purity of the technical medium, such as Ansel Adams's f64 group, all exalted the individual vision of the photographer. Even more crucially, from our perspective, this emphasis on a photographer's unique sensibility was consecrated by twentieth-century written histories of photography. In these modernist histories of the medium, in which individual photographs are celebrated as markers of a photographer's unique genius, the artist photographer becomes a means to selectively navigate the sprawling history of the medium.

Beaumont Newhall's *The History of Photography*, initially written as a catalogue for an 800-work exhibition at MoMA in New York in 1937, *Photography, 1839–1937*, established the basic canon of art photography. Newhall was appointed by Alfred H. Barr as the Museum's first curator of photography in 1940, with Ansel Adams in the background, and played a major role in institutionalizing modern art photography in the art gallery (Phillips 1982: 36). His canonization of

the "masters" of photography installs Stieglitz as *genius loci* (Phillips 1982: 35), detaching photographic practice from social, political, and cultural historical contexts. And, as Batchen (2000: 106) argues, the resulting book publication, particularly the 1949 revised version, "establishes a canon of masterworks and an emphasis on formal qualities and stylistic analysis that has been imitated ever since." In Britain, the German art historian Helmut Gernsheim followed suit in 1955 with the publication of his book, *The History of Photography: From the Earliest Use of the Camera Obscura in the Eleventh Century up to 1914*, which became an instant bestseller. The book is organized by technical developments in the history of photography, but like Newhall's history it privileges individual masters. The tone of Gernsheim's text was established by his earlier 1942 volume *New Photo Vision*—which included photographs taken by the author— the notes of which were written while he was in internment in Australia as a German Jew. In the foreword to that volume, Gernsheim opens with the claim that "[n]either camera, nor lens, nor film determine the quality of the picture; it is the visual perception of the man behind the mechanism which brings them to life" (1942: n.p.). Inside, we read that "the creative photographer does not collect facts" and "[t]he secret of the few great masters of photography is that they are not only photographers but also artists who have chosen photography as the *medium of their expression*. Their photographs bear a personal note, their personality and style, which distinguishes them at once from the countless anonymous 'machine-made' pictures. The artist impresses his will upon the object" (Gernsheim 1942: 9).

In Gernsheim's 1955 history, the individual is endowed with a lyrical sensibility, capable of overcoming mechanical alienation through poetic defamiliarization. He concludes that: "The modern photographer scans the world for a different kind of beauty—the beauty of everyday life, the beauty of form … which reveals itself only to the man [*sic*] whose aesthetic sense has not been blunted by preconceived notions" (1955: 356). In this art-historical approach to photography, we are given a history of stylistic achievements, where pictorial expression is opposed to mechanical record. Implicitly, "good photographers" are in the business of transcending or overcoming photography's documentary basis through expression (Gernsheim 1955: 356). As Batchen (2000: 106) points out, "What this [art-historical] method represses, apart from the complications of actual historical evidence, is the schizophrenic identity of all photographs." Batchen (2000: 106) refers to a photograph's various possible physical manifestations and its "semiotic mobility." Both qualities help to account for why the old distinction between the expressive ambiguities of art and the certainties of documentary has long since broken down in contemporary art.

Newhall and Gernsheim have no problem accounting for nineteenth-century commercial partnerships, or collaborations between photographers and writers—such as those in the 1930s between Margaret Bourke-White and

novelist Erskine Caldwell, or between Walker Evans and writer James Agee—since neither threatens the emphasis on the individual photographer. The collaboration between Niépce and Daguerre that marked the invention of the medium is well documented, as are commercial partnerships such as those of the Boston daguerreotype studio of Albert Sands Southworth and Josiah Johnson Hawes (Southworth and Hawes, from 1843–63) and Samuel Bourne and Charles Shepherd in India (Bourne and Shepherd, established in 1863), as well as scientific partnerships such as the apparently inseparable French optician-astronomer brothers Paul and Prosper Henry in the 1880s. Meanwhile, one of the first and most successful collaborations in the history of photography, the team of Scottish painter David Octavius Hill and engineer-turned-photographer Robert Adamson in the 1840s, represents a fascinating case of accounting for the artistic role of individual figures within partnerships. In only four and a half years, between 1843 and 1847, before the untimely death of Adamson aged twenty-six, the pair produced over 1,500 calotype portraits in the Scottish outdoors. Since Hill was the older and more established partner and trained as an artist, Adamson tends to be recognized only for his technical contribution in historical accounts. Paul Strand ([1922] 1980: 147) and Walter Benjamin ([1931] 1999) speak *only* of Hill in their effusive celebrations of the work, with Strand proposing that the photographs "remain the most extraordinary assertion of the possibility of the utterly personal control of a machine, the camera." More recently, scholars have recognized the synergy of their partnership, and their different talents. But the split between the creative figure and the technician lingers. Hill was apparently the one who posed the subjects, he was more sociable and playful, appearing in several of their images (more than any other figure in fact) (Figure 1.3), while Adamson operated the camera and is linked to "chemical manipulations" (Lyden 1999: 9). However, the "chemistry that existed between the artist and the engineer" is now viewed as "the essential ingredient in the success of the pictures" (Lyden 1999: 10).

When the foundational histories of photography were written in America and Britain in the late 1930s and 1940s, those countries were going through periods of national crisis: Newhall wrote out of the Great Depression and Gernsheim of the Second World War. Both were affected by the European totalitarianisms of Germany and the Soviet Union, which undoubtedly helps account for the humanist emphasis they placed on individual expression. After Newhall became curator at MoMA, he organized an exhibition with Ansel Adams simply called *60 Photographs: A Survey of Camera Esthetics* (1940), claiming that "[e]ach print is an individual personal expression" (Phillips 1982: 37). As Christopher Phillips notes, this was the "ultimate guarantee against the charge that the photographic process was merely mechanical," but often constituted an anachronistic and ahistorical projection (1982: 37). Meanwhile, the more politically oriented, impersonal, and collectivist approaches common in Europe in the period between the wars

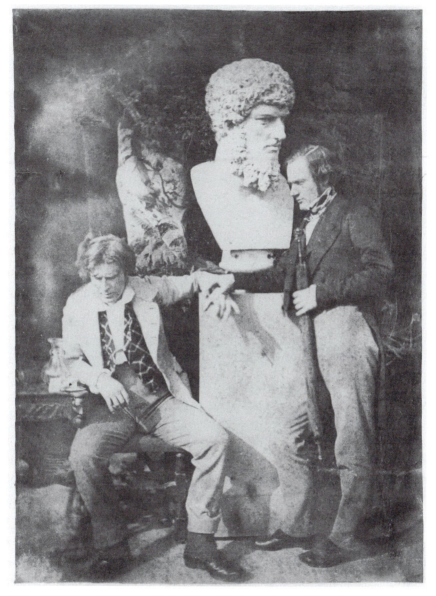

Figure 1.3 Hill and Adamson, *D. O. Hill and Professor James Miller*, 1843–1847. Salted paper print from a Calotype negative, 20 x 14.6 cm (7 7/8 x 5 3/4 in.). The J. Paul Getty Museum, Los Angeles. Digital image courtesy of the Getty's Open Content Program.

were largely overlooked. Indeed, as the art historian Abigail Solomon-Godeau (1983) tersely observed, radical formalism was transformed from a "weapon" into a "style." Ironically, as she notes, the "art photography" that emerged in New York following the First World War—which "posited a modernist aesthetic

that insisted on photography as a medium of subjectivity"—emerged precisely at the moment when:

> radical practice in both the Soviet Union and in Germany rejected absolutely the notion of the artist's function as the expression of a privileged subjectivity. This repudiation of subjectivity, personality and interiority was linked not only to revolutionary tenets of collectivism and utilitarianism but to the widespread reaction against expressionism.
>
> (Solomon-Godeau 1991: 56)

It is to this often-repressed political history of collective approaches to photography that I now want to turn.

Worker as author: Collective expression in interwar photography

Bourgeois photographers have often been known as "camera workers." But it was the working class who offered another ideology of authorship in the interwar period, as part of a collective attempt to produce a political documentary practice. The Worker Photography Movement (1926–39) emerged around 1926 in Germany and the Soviet Union with the founding of the magazines *Der Arbeiter Fotograf* and *Sovetskoe foto*, and as Jorge Ribalta (2011) has shown, spread across Europe and the United States, only to decline with the outbreak of the Second World War.[2] As John Roberts (2014: 56) and others (Buchloh [1984]; Solomon-Godeau [1991]; Ribalta [2008]) have argued, the emphasis on the singularity of the photographer's vision in the postwar modernist period can be understood as "part of the general attack on this collective program of documentary practice." This is less because documentary is excluded from the histories of art photography—its innovations are certainly present in those narratives—but because the methods of art history have been unable to accommodate collective practice. Thus while Newhall quotes Grierson on documentary, he excludes what Ribalta (2008: 16) describes as "practices of materialist emancipatory self-representation of the workers' photography movement ... which offered a counter-model to the paternalist Griersonian documentary."

In 1926, the German communist journal *AIZ* (*Arbeiter Illustrierte Zeitung*) published a famous call to amateur worker readers to send in photographs showing their own living and working conditions—marking the official birth of the Worker Photography Movement (Ribalta 2011). Meanwhile, an article in *Sovetskoe foto* from 1926 asserted that "[j]ust as each vanguard comrade should have a watch, so he should be able to master a photographic camera"

(quoted in Wolf 2011: 36). The art historian Erika Wolf (2011: 37) outlines a contest in Moscow in 1927 "intended to stimulate photo amateurism":

> The terms of the competition present a clear ideological vision for worker photography. No individual entries would be accepted, only collective ones. For individuals working in factories or areas without organized photo circles, a factory commission could be assembled to view and select work, thus ensuring a collective aspect for such submissions. No works by photo professionals were allowed.

Writing of this initial period after the Russian Revolution, Roberts (1998: 36) refers to photography's relationship to what he calls "dialogism"—following the literary theorist Mikhail Bakhtin—here entailing a "form of everyday dialogue with the 'other' . . . in collaboration with non-professional groups." Similarly, in the United States, the Workers' Film and Photo League, formed in the 1920s, was at least initially focused on working-class self-representation (although this is entirely absent from Newhall's history). It should be noted, however, that the encouragement of amateur photography was also taken up by the Nazi regime in the 1930s, who promoted photography as an important leisure pursuit for citizens of Germany as a way to gain images for propaganda purposes (Lemagny and Rouille 1986: 153). Self-representation is thus not always a radical act.

It is also important to recognize the photomural as a form in which the collaborative activity of photographers has received very limited recognition. As Olivier Lugon (2015: 392) has argued, the photomural "implied collaboration and production at an almost industrial level." El Lissitzky's influential photo-frieze for the Soviet pavilion at Cologne's 1928 *Pressa* exhibition—24 meters long and 4 meters high—was made up of dozens of individual photographs, taken by different photographers (Figure 1.4). As Lugon (2015: 392) notes, it was designed to "symbolize a new participative form of the Soviet press" and was allegedly made entirely by readers. Indeed, as Ribalta puts it, Lissitzky's new paradigm of photographic exhibition "staged an identification between image and audience [and] implied a psychic collaboration between the work and the audience" (2008: 15). If the photomural in particular was understood as a socialist medium par excellence, it is all the more remarkable that the Farm Security Administration commissioned a giant 30 x 36 meter photomural for Grand Central Station in New York after the United States entered the Second World War in 1941. Designed for mass communication rather than isolated contemplation, this spectacular photomural represented a radically different direction to Newhall's photography exhibitions on show at MoMA a few blocks away (Lugon 2015). Praised at the time for its collaborative nature, it should hardly be surprising to the reader that such collective productions have barely rated a mention in histories of photography

Figure 1.4 El Lissitzky, *Interior of the Soviet Pavilion at the International Press Exhibition, Cologne*, 1928. Heritage Image Partnership Ltd / Alamy.

until recently. Like the Worker Photography Movement, collective approaches to photography have been systematically marginalized in its art histories, both as part of the repression of the Communist experience that took place in the West after the Second World War (Ribalta 2011) and due to a new formalist approach in North America.

Medium as author: Post-war formalism at The Museum of Modern Art

The great global influence of MoMA on how we conceive of fine art photography is hard to overestimate. In its exhibitions, touring, and publications, the museum has functioned, as a well-known critical text called it, as the "judgment seat" of photography (Phillips 1982). In 1942, Edward Steichen was hired by the museum to produce a propagandist wartime exhibition, designed by Herbert Bayer, called *Road to Victory*, which turned the exhibition space into something like the pages of a magazine. Partly as a result of its success, and the promise of more audiences and photographic industry support, Steichen was brought in to replace Newhall in 1947 and undertook a program that was far more focused

on illustrative photography than Newhall's fine print approach (Phillips 1982: 48). Steichen treated photography as a mode of mass communication and art photography as a minor genre within it. His most famous exhibition, *The Family of Man* (1955), in which an open call went out to photographers from around the world to submit images, significantly downplayed individual photographic style in favor of humanist content.[3] Steichen nevertheless retained a conventional approach to authorship, and continued to promote the vision of individual photographers—even if now largely clipped of artistic pretentions. More important, from the point of view of understanding the context for the collaborative approaches I address in this book, is what happened afterwards, when John Szarkowski took over as Director of the Department of Photography in 1962.

Trained as an art historian, Szarkowski quickly abandoned Steichen's media-oriented approach, reviving the conventions of small fine prints, with standard white mattes and wooden frames (Phillips 1982: 53). Szarkowski set about articulating his approach to photography and its history in a 1966 book called *The Photographer's Eye* (based on a 1964 exhibition of the same name). Szarkowski was an eloquent judge, and offered an apparently coherent formalist account of photography based on the medium as the great authorial agent. Szarkowski's five categories—The Thing Itself, The Detail, The Frame, Time and Vantage Point—allowed photographs to be treated as autonomous objects. As Lucy Soutter (1999: 9) describes, the effect was that photographs "made at any time for any reason" could "be judged aesthetically without reference to their original context." Despite the title of the exhibition, Szarkowski was more interested in the way in which the camera sees the world than "personal expression." He was clearly more interested in the camera as a window than a mirror, to paraphrase the title of one of his later exhibitions, *Mirrors and Windows: American Photography Since 1960* (1978). Szarkowski relished the fact that for all the photographer's art of selection, they are, in the end, reliant on the qualities of the *medium* itself:

> An artist is a man [*sic*] who seeks new structures in which to order and simplify his sense of the reality of life. For the artist photographer, much of his sense of reality (where his picture starts) and much of his sense of craft or structure (where his picture is completed) are anonymous and untraceable gifts from photography itself.
>
> (Szarkowski 1966: 211–12)

Szarkowski's "gifts from photography itself"—the history of formal innovations, whether accidental or intentional—form what he calls the "photographic tradition." Regardless of whether a photographer's concerns were commercial or artistic, he said in an interview, "his [*sic*] tradition was formed by all the photographs that had impressed themselves upon his consciousness" (Szarkowski

1994: 58). Notably, this consciousness is singular, an individual in a complex dance with the history of photographs and the way that the camera sees the world, that is, the intrinsic qualities of the medium. Szarkowski's approach, for all its openness to vernacular forms, was essentially a version of Greenbergian modernism—and easily accommodated by an emerging market for art photography in the 1970s. However, at a lecture in 1977, Szarkowski stripped back the photographer's role, proposing that "the function of the photographer is to decide what his subject is ... this is his only function."

In his 1945 essay "The Ontology of the Photographic Image" (1960) the film theorist André Bazin had expressed a similar view. Bazin stressed the unique *automatism* of the camera and made a point of the fact that the lens, in French, is called the *objectif*. For Bazin, the "essentially objective character of photography" made it distinct from painting ([1945] 1960: 7). The implications, in terms of authorship, are summarized in his widely cited remark: "For the first time, between the originating object and its reproduction there intervenes only the instrumentality of a non-living agent. For the first time an image of the world is formed automatically, without the creative intervention of man" ([1945] 1960: 7). Bazin is not, however, blind to a photographer's intention:

> The personality of the photographer enters into the proceedings only in his selection of the object to be photographed and by way of the purpose he has in mind. Although the final result may reflect something of his personality, this does not play the same role as is played by that of the painter. All the arts are based on the presence of man, only photography derives an advantage from his absence.
>
> ([1945] 1960: 7)

Szarkowski would have no doubt agreed. Bazin ([1945] 1960: 8, 9) is alert to the surrealist implications of photography's "production by automatic means"— suggesting that the photograph is "an hallucination that is also a fact"—a quality later picked up by writers like Susan Sontag (1977) and Rosalind Krauss (1977). Both women are fascinated by the causal or indexical correspondence a photograph has with reality. As Sontag (1977: 154) famously writes, "a photograph is not only an image (as a painting is an image), an interpretation of the real; it is also a trace, something directly stenciled off the real, like a footprint or a death mask." Consequently, she is conscious of the contradictions claimed for photographic authorship, observing that as a result of the machinic gaze of the camera, and its dependent relation to the world, "all claims on behalf of photography as art must emphasize the subjectivity of seeing" (1977: 136). Moreover, Sontag points to the often contrived coherence of photographic style: "To be legitimate as an art, photography must cultivate the notion of the photographer as *auteur* and of all photographs taken by the same photographer as constituting a body

of work" (1977: 137), Roughly at the same time, in an essay titled "Dismantling Modernism, Reinventing Documentary," the photographer-theorist Allan Sekula opined that the art world transforms "the photographer, regardless of working context, into an autonomous *auteur* with a capacity for genius" (1978: 860). Sekula observed that in art histories of photography "[a] cult of authorship, an auteurism, takes hold of the image, separating it from the social conditions of its making and elevating it above the multitude of lowly and mundane uses to which photography is commonly put" (1978: 864–5). The stage was thus set for the deconstruction of this modernist mode of legitimating artistic authorship in photography.

Cultural codes as author: The deconstruction of photographic authorship in postmodernism

By the late 1970s, with the market for photography booming in art capitals like New York and London, it was clear that the privileging of individual photographic "visionaries" was the outcome of the long struggle for the mechanical medium to be recognized as an expressive art. As Solomon-Godeau observed in 1983, the battle for photography's legitimation as art has been "consistently waged in terms of the camera's ability to express the subjectivity and unique personal vision of the photographer" (1991: 79). In other words, it was becoming widely understood that the emphasis on personal vision in the history of photography represented a kind of compensation for the impersonality of the medium. In Sekula's 1978 essay he called for "critical realism," praising Martha Rosler's work and return-ing us to the avant-garde example of photomontage, and what he referred to as John Heartfield's "critical *deconstruction*" (1978: 864). The aberrant place of photomontage in histories of photography is just one more sign of the neglect of collaborative labor in the history of photography, which as I have argued here, has the consequence of artificially stabilizing authorship in single photographs, pre-venting us from fully understanding the collaborative dimensions of photographic production. Authorship, in Heartfield's work, is decidedly multiple—he not only, in a form of coerced collaboration, borrowed images taken by other photographers from newspapers and put them to work in new contexts, he also worked exten-sively with darkroom technicians. Heartfield even rejected the term artist in favor of *photomonteur* or *photomechanic*. The very form of photomontage appears to have emerged collaboratively, with Heartfield and George Grosz famously work-ing together in Berlin at the end of the First World War (Figure 1.5).[4]

Walter Benjamin, for whom Heartfield was a pivotal figure, became the cen-tral theorist for postmodern ideas about photographic authorship. Benjamin's

Figure 1.5 John Heartfield and George Grosz, *Leben und Treiben in Universal City um 12 Uhr 5 Mittags (Life and Work in Universal City 12:05 Noon)*, 1919. ©The Heartfield Community of Heirs/Bild-Kunst. Licensed by Viscopy, 2016. ©Estate of George Grosz, Princeton, N.J. /Bild-Kunst. Licensed by Viscopy, 2016. Courtesy of Akademie der Künste, Berlin, Kunstsammlung, Inv.-Nr.: Heartfield 2075; Fotograf: Roman März.

most important ideas on photography are developed in "A Little History of Photography" ([1931] 1999) and "The Work of Art in the Age of Mechanical Reproduction" (or, more literally, "its Technical Reproducibility") ([1936] 2002), which remains the most influential interpretation of the threats and opportunities posed by the mechanical media of film and photography, as part of what he called the withering of the *aura* of art. Benjamin was interested in photography as a new way of seeing, and in his often quoted remarks, wrote of "the tiny spark of contingency, of the here and now, with which reality has (so to speak) seared the subject" ([1931] 1999: 510) and the medium's privileged access to the "optical unconscious" ([1931] 1999: 510–12). He was uninterested in the expressive power of the photographic author, and singled out Karl Blossfeldt's plant studies, published in 1928, as early examples of photography's emancipation from Pictorialism. Benjamin had little sympathy for "creative" photography, famously attacking Albert Renger-Patzsch, and specifically the fundamentally affirmative viewpoint expressed in the published title of his 1928 book *Die Welt*

ist Schön (*The World is Beautiful*). Instead of this "capitulation to fashion" ([1931] 1999: 526), Benjamin drew attention to the importance of the caption and the act of unmasking. Influenced by contemporary events in Germany, his fellow Marxist friend Bertolt Brecht, and the dialectical montages of Heartfield, in a 1934 lecture at the Institute for the Study of Fascism in Paris, "The Author as Producer," Benjamin proposed that the caption is a vehicle through which photographers can turn viewers into *collaborators*, from mere consumers to producers of meaning: "What we require of the photographer is the ability to give his picture the caption that wrenches it from modish commerce and gives it a revolutionary use value" ([1934] 1999: 775).

Postmodern artists such as Barbara Kruger revived photomontage, and more generally what was dubbed *appropriation*, "stealing" preexisting images and asserting the primacy of cultural codes. Some of these practices emerged from the lessons of pop and conceptual art (Chapter 2), others emerged out of feminism, sometimes informed by Marxist psychoanalytical approaches. In the background hovered the recently translated work of Benjamin and Roland Barthes, whose infamous 1967 essay "The Death of the Author" put forward the symbolic "death" of the author as the unitary source of a creative work's meaning and announced the "birth" of the reader. Barthes argued that photographs are polysemic, and that to read a photograph involves a rhetorical analysis of the cultural codes within which it makes sense to readers, including the captions that conventionally serve to "anchor" an image's possible meanings (Barthes 1977b: 39).[5] As Solomon-Godeau went on to say (1991: 115): "Virtually every critical and theoretical issue with which postmodernist art may be said to engage ... can be located within photography. Issues having to do with authorship, subjectivity and uniqueness are built into the very nature of the photographic process itself."

Douglas Crimp (1980: 97), the influential curator of the *Pictures* (1977) exhibition, also claimed to be responding to the museumization of photography, noting that what interested him was:

> the subjectivization of photography, the ways in which the connoisseurship of the photograph's "spark of chance" is converted into a connoisseurship of the photograph's style. For now, it seems, we can detect the photographer's hand after all, except of course that it is his eye, his unique vision. (Although it can also be his hand; one need only listen to the partisans of photographic subjectivity describe the mystical ritual performed by the photographer in his darkroom).

Thus Crimp (1980: 98) summarizes the modernist construction of authorship I have outlined above, and proposes that "the photographic activity of postmodernism operates ... in complicity with these modes of photography as art, but it

does so only in order to subvert and exceed them." He describes this authorial decentering (1980: 98):

> A group of young artists working with photography have addressed pho-
> tography's claims to originality, showing those claims for the fiction they are,
> showing photography to be always a *re*presentation, always-already-seen.
> Their images are purloined, confiscated, appropriated, *stolen.* In their work,
> the original cannot be located, is always deferred; even the self which might
> have generated an original is shown to be itself a copy.

Crimp refers to artists like Sherrie Levine, Cindy Sherman, and Richard Prince who variously quoted, rephotographed and restaged already-existing images, and in whom questions of the artist's subjectivity were both prominent and enig-matic. When Levine rephotographed iconic images by Edward Weston from a poster published by his gallery, or Walker Evans's images from the catalogue of an Evans exhibition (*After Walker Evans*, 1981), the act of appropriation renders those images as double-authored, but the contemporary artist's contribution is ambiguous to say the least (Figure 1.6). When Prince appropriates commercial images from magazines, he puts his own authorship into quotation marks, as Crimp suggests. In short, if the mechanical basis of photography, and its quality of reproducibility, is repressed in the modernist accounts of the medium outlined above, postmodernists celebrate these qualities as a strategy of disruption and deconstruction. But what are the consequences for authorship?

Postmodern photographic practice puts authorship under pressure. However, since it puts nothing in its place but the critique of representation, simulations of authorship quickly became equally valuable in the art market. Grant Kester (2011: 55) therefore questions the claims made for the importance of the post-modern techniques of image appropriation, which have been assumed to "simultaneously undermine the artist's status as the 'author' of photographic meaning, and the referentiality of the photograph itself." As Kester argues, within this model the artist "retains his or her characteristic autonomy at the margins of the dominant culture as a Virgil-like figure laying bare the apparatus of photo-graphic meaning to viewers wandering stupefied through the 'forest of signs'" (2011: 55). In effect, postmodern artists retained their singular authorial control over their photographic appropriation, even if this is now conducted in an ironic mode. In Kester's terms, postmodern photography is thus textual rather than collaborative, wherein authorship of autonomous works remains intact at the level of individual intention. The emphasis on cultural codes turns out, in short, to maintain an ideology of singular authorship, even if it is increasingly focused, in more political versions of postmodernism, on the cultural identity of the art-ist (their gender, ethnicity, and sexuality, in particular). Despite the critique and deconstruction of "straight white male" forms of originality, the privileged conven-tion of single authorship in photographic art remains remarkably durable.

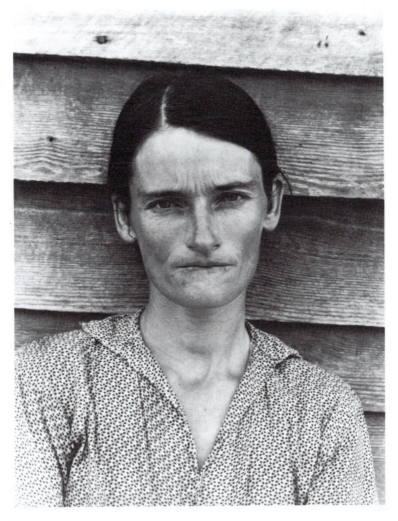

Figure 1.6 Sherrie Levine, *After Walker Evans: 4 [Allie Mae Burroughs]*, 1981. Gelatin silver print, 12.8 x 9.8 cm (5 1/16 x 3 7/8 in.). The Metropolitan Museum of Art, gift of the artist, 1995 (1995.266.4). ©Walker Evans Archive, The Metropolitan Museum of Art. Image copyright. ©The Metropolitan Museum of Art. Image source: Art Resource, NY. ©Sherrie Levine. Courtesy David Zwirner, New York, Simon Lee Gallery, London, Jablonka Galerie, Cologne.

Software as author

Ian Jeffrey, in *Photography: A Concise History* (1981), wrote that it would be possible to write a history of the photograph "in which individuals scarcely appear ... one in which credit is given to impersonal ideological determinants" (1981: 8–9). He is referring to a non-art history of the medium, specifically social and political

factors, but he might have also referred to a technical history of the medium. For the technologies of photographic image making can also become an ideology of authorship, not entirely unlike an earlier emphasis on the mechanical nature of the medium. More specifically, in some recent accounts of the medium—particularly around digital photography—software has come to figure as a quasi-author figure. Vilém Flusser (2000) is an influential figure here, when he posits the photograph as a "technical image" and the camera as a programmable apparatus that, paradoxically, programs the photographers (functionaries) who use it. Flusser (2000: 26) offers a critique of "creative photography" based on the idea that most of what people are doing when they photograph is to reproduce clichés set in place by the apparatus. Unsurprisingly, this is often interpreted as an argument for the primacy of the apparatus. However, Flusser's critique is more complex than often recognized, counterbalanced as it is by his praise for what he calls "experimental photography" and what he describes as the need "to create a space for human intention in a world dominated by apparatuses" (2000: 75).

In 1992, in his classic early study of digital photography, *The Reconfigured Eye*, William J. Mitchell (1992: 51–2) wrote that:

> the lineage of an image file is usually untraceable, and there may be no way to determine whether it is a freshly captured, unmanipulated record or a mutation of a mutation that has passed through many unknown hands. So we must abandon the traditional conception of an art world populated by stable, enduring, finished works and replace it with one that recognizes continual mutation and proliferation of variants ... Notions of individual authorial responsibility for image content, authorial determination of meaning, and authorial prestige are correspondingly diminished. Furthermore, the traditional distinction between producers and consumers of images evaporates.

Mitchell's statement is obviously overly dramatic—most of the art world is still, twenty-five years later, full of "stable, enduring, finished works." Nevertheless, Mitchell's ideas are prescient in light of the participatory Web 2.0. Other writers on digital photographic practice have developed similar ideas since. Thus Fred Ritchin (2009: 180) argues that networked digital media is transforming photography into a hypertextual medium, enabling a "multiplicity of perspectives." Such language obviously opens up the topic of collaborations and coproductions that are central to our concerns here.

Another leading theorist of the digital image, Daniel Rubinstein (2009: 137), proposes that in relation to the conventional understanding of the photographic artist:

> there is no room for such petty considerations as the forces of labour involved in the design, the marketing, the production and the assembly of the

photographic apparatus, nor is there any way to think the photograph as an outcome of collaboration between large numbers of individuals (designers, engineers, assembly-line operators) who contribute various dimensions to the final outcome.

This is a provocative line of argument, and challenges not only authorship but the art-historical emphasis on individual photographs, which Jeffrey (1981: 7) calls its "basic unit of account." However, Rubinstein offers little in the way of an actual model to accommodate all these different human and nonhuman actors in the act of photographic production. In the final analysis, such an antihumanist approach risks overemphasizing the importance of the apparatus, throwing out the artist and the photograph in the process. In other versions of this approach, it is literally a case of relishing the idea, as Lev Manovich's (2013) book has it, that "software takes command." Nevertheless, Rubinstein makes a compelling argument that digital images are inherently unfinished, "because the act of authorship is a never-ending process of assemblage, annotation, manipulation and attunement that can take place at each instance when the data file is presented on the computer screen" (2009: 140).

However, screen-based work represents a tiny minority of photographic art today. Charlotte Cotton (2015: 4), in a recent survey of contemporary art photography, also recognizes that to a certain degree "technologies themselves are 'authoring' the images we see." Noting the "(all too democratically) automated character of 'the digital,'" she points out that "the pervasive automation of photographic rendering has made software the dominant photographic medium" (4). However, Cotton affirms the traditional logic of the art world, celebrating artists who "subjectify the photographic systems in which they operate" through "an immeasurable quantity of active choices," and concluding that "[w]e can now recognize individual artists' signatures through their repeated navigation and articulation of the dynamic behavior of photographic culture at large" (10). Cotton implicitly underlines that for the foreseeable future, the practice of photographic production in art is deeply connected to the whole system of the art exhibition, which demands material closure, naming, and identification. An emphasis on software or other technologies of production alone is not, in itself, sufficient to challenge the paradigm of singular authorship in photography.

Conclusion

Contrary to the presupposition that photography can only be discussed through its product and a photograph can only be seen as the creation of the

photographer, I say that photography is the act of many and a photograph is a sampling or a trace of a space of human relations.

(Azoulay 2010: 251).

In this chapter I have outlined seven ideologies of authorship, which I have suggested offer a context for understanding the significance of the collaborative approaches to photography that I discuss in this book. I now want to conclude by reiterating the relevance of Ariella Azoulay's writing for any consideration of authorship and collaboration in photography. For Azoulay, photography can take place either through the mediation of the camera or the photograph. Both are relational and dialogical in character—and thus the meaning of an image is never possessed fully by any one of what John Roberts calls "the various actants of the photograph" (2014: 6). In other words, Azoulay allows us to consider the many different agents involved in the production and circulation of photographic discourse (the camera, the photographer, the photographed subject, editors, and the spectator), with none of these granted the power to control meaning alone. Moreover, a photograph is an open-ended "space of human relations" (2010: 252):

> a photograph is never merely a product of material in the hands of an individual creator. A photograph is the space of appearance in which an encounter has been recorded between human beings, an encounter neither concluded nor determined at the moment it was being photographed. This encounter might continue to exist or be renewed through additional human beings who were not necessarily present at the time it was photographed.[6]

Crucially, Azoulay thus reconceptualizes the photographic act in terms of the potential future encounters that can never be fully owned or imagined by any single original photographer.

At one level, Azoulay transfers to photography Marcel Duchamp's ([1957] 1973: 140) notion that the "creative act is not performed by the artist alone" but also by the spectator "who brings the work in contact with the external world." Even more recognizably, she adopts Roland Barthes's (1977a: 145, 148) idea that "every text is eternally written *here and now*" and that its "unity lies not in its origin but in its destination." But if for Barthes a literary text is a "multi-dimensional space" of quotations, for Azoulay a photograph is based on an open space of social relations. Crucially, therefore, her thesis not only complicates the singular all-at-once conception of photographic authorship, but also forces us to consider photography as almost inherently collaborative. This includes photographs that were not originally conceived of as collaborative when they were taken but that have become so through their dissemination, reception, and even rejection by others.

2

IMPERSONAL EVIDENCE: PHOTOGRAPHY AS READYMADE

Man Ray and Marcel Duchamp's black-and-white photograph *Dust Breeding* (*Élevage de Poussière*) (1920) is a famously enigmatic image. With its slightly raised perspective and side lighting, it appears at first glance as if it may be an aerial view of a desert landscape at dawn, with fields of patterned lines, clumps of forests and buildings with smokestacks. In fact it is, of course, a close-up document of what would eventually become Duchamp's artwork *The Large Glass* (1915–23) after it had collected a year's worth of dust on the floor of his studio in New York (Figure 2.1). The photograph is the result of an hour-long exposure, and captures the texture and diversity of matter that has accumulated on the glass surface. But who, aside from dust, is the author of the image? American photographer and painter Man Ray was one of Duchamp's close friends, and as members of the New York Dada scene, the two were regular collaborators. Man Ray photographed the scene or, to be precise, he set up the camera and the image was recorded while the artists went out to lunch. He was practicing for a commission to photograph other artworks, and rushed home to process the film and print the image. Duchamp then titled the photograph *Élevage de Poussière*, and together they coauthored an intriguing and much less-known accompanying text.[1] In other words, as one writer puts it, "Duchamp's object becomes Man Ray's subject, which becomes the object of Duchamp's interpretation at the moment he selects the evocative title" (Fardy 2008: 17). The resulting photograph is a contingent one, at once both a document and an artwork. The signatures of both artists appear along the bottom of the photograph in the 1964 edition, but in its complex history of public dissemination the image is regularly, sometimes forcefully, ascribed to one or the other artist in art-historical texts and museum catalogues (Campany 2015). In all these ways and more, it typifies the underlying subject of this book: the often ambiguous and invariably multiple nature of photographic authorship.

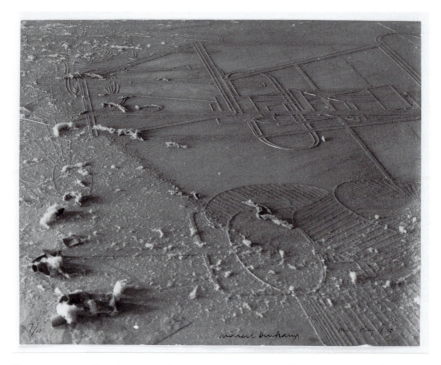

Figure 2.1 Man Ray, *Dust Breeding*, 1920, printed ca. 1967. Gelatin silver print, 23.9 x 30.4 cm (9 7/16 x 12 in.). The Metropolitan Museum of Art, Purchase, Photography in the Fine Arts Gift, 1969 (69.521). ©The Metropolitan Museum of Art. Image source: Art Resource, NY. ©MAN RAY TRUST/ADAGP. Licensed by Viscopy, 2016.

If *Dust Breeding* represents a critical encounter between sculpture and photography (Marcoci 2010), it does so by embracing the latter's characteristic quality of automatism. As Douglas Fogle (2004: 10) notes in his landmark exhibition and book on conceptual photography, *The Last Picture Show: Artists Using Photography 1960–1982*, *Dust Breeding* is "a hybrid object caught somewhere between the realms of photography and sculpture." In this sense it can be viewed in the same light as Brassaï's 1933 *Involuntary Sculptures* — everyday things such as a piece of bread roll or rolled-up bus ticket transformed into strange visceral forms through their documentation as photographs. However, *Dust Breeding* can also be read in terms of the nature of studio production, and the metaphor of dust. Heather Diack (2010: 86), in an evocative reading of the piece, suggests that it "documents artistic work in the studio as passive accumulation" and thereby inverts traditional ideas regarding artistic production. Linking the agency of dust — composed largely of traces of human skin — to the photographic index and embodiment, she suggests that the subject of dust breeding "can be read as an implicit comment on the medium [of photography] itself, as if to take a picture is to do nothing" (2010: 86). David Campany (2005: 48, 51), in a related vein,

reminds us that dust is an "enemy of photography," and that the image is "a trace of a trace" — referring to the work as an example of Duchamp's "canned chance" that constantly "downplayed the mark of the artist's hand." More broadly, chance was a method used by the avant-garde to develop alternative, sometimes collaborative, authorial approaches; think, for instance, of the Surrealist game of the exquisite corpse, by which words or images are collectively added to a composition in sequence, either by following a rule or by being allowed to see only part of the previous person's contribution. The exquisite corpse is an exemplary instance of the Surrealist surrender of authorial power to unconscious desire, where chance operates at the junction between the individual and the collective (Hubert 1994; Brunet 2009).

Surrealist photography often points to the readymade agency of *objects*, and their capacity to disrupt conventional ways of seeing. In this respect it advances William Henry Fox Talbot's charming observation, made in relation to a photograph of his home, Lacock Abbey, that it was the first building "that was ever yet known *to have drawn its own picture*" ([1844] 1969: n.p.). In this chapter, I take up this idea of the authority of objects in relation to how the camera's mechanical nature has enabled distinctive collaborative approaches. My focus rests on three case studies of conceptual artists who have collaborated through photography: the German husband-and-wife team Bernd and Hilla Becher, known for their highly systematic approach to documenting industrial architecture since the 1960s; American artists Larry Sultan and Mike Mandel's 1977 project *Evidence*, which recontextualizes the photographic files of government, science, and industry for the purpose of creating a mysterious open-ended work; and more recent projects by contemporary London-based duo Adam Broomberg and Oliver Chanarin, who are known for their total collaboration. Through techniques such as seriality and recontextualization, the work of these collaborative teams directly complicates the idea of the individual photographer's unique expressive vision.

Conceptual photography

Photography became a paradigmatic form of contemporary art in the late 1960s and early 1970s through the activities of conceptual artists. As the artist Jeff Wall ([1995] 2003: 36) put it, in his influential account of the period, "many of Conceptual art's essential achievements are either created in the form of photographs or are otherwise mediated by them." Conceptual photography, or photoconceptualism, has been written about extensively elsewhere (Fogle 2003; Witkovsky 2011). Nevertheless it is worthwhile to briefly review the broad context for these practices before considering my three case studies specifically. Why did photography appeal to artists whose ideas were increasingly dominated by

the linguistic? The crucial property of photography was its supposed transparency. For Rosalind Krauss, in her 1977 essay "Notes on the Index," artists turned to photography because photography held at its core no convention of style but was instead a physical imprint of things in the world. Citing André Bazin and Roland Barthes, Krauss (1977: 60) praised the "quasi-tautological" condition of a documentary image, a "mute presence" that in her argument liberated artists from authorial mark-making. In one form or another, conceptual artists made a virtue of Bazin's idea about photography that, "[f]or the first time, an image of the world is formed automatically, without the creative intervention of man" ([1967] 2005: 13). *Dust Breeding* was prominently included in the catalogue for *Information* (1970)—the exhibition organized by Kynaston McShine, held at MoMA in New York—which formally established conceptual art as a leading tendency in the United States (Campany 2003: 25).

Conceptual artists embraced the straight photograph at a point when art was shedding itself of the expressionism associated with modernist painting. However, it was not the fine print but the anthropological or quasi-scientific photograph that newly fascinated these artists. Artists were particularly drawn to photography in relation to written text, which—with the crucial exception of photomontage—was largely repressed in art during modernism (Kotz 2006: 514–5). In many of the resulting conceptual works, individual photographs can be considered as illustrations to an essay or idea, rather than as autonomous works of art. As Wall puts it, "What is creative in these works are the written assignments, or programs" ([1995] 2003: 38). As a result, the photography tends to be highly functional in style, emerging out of what Wall refers to as "photoconceptualism's deskilled, amateurist sense of itself" ([1995] 2003: 38). Influenced by pop art and minimalism, and the turn to language, conceptual artists using the camera also refused conventional signs of photographic authorship, or at least put the question of authorship under pressure. As Liz Kotz suggests, referring back to Andy Warhol's groundbreaking use of such media, recording and reproduction technologies "promised a machinelike personality and distance from conventional modes of self-expression" (2006: 213).

A linguistic principle underlying photographic production was famously set to work by Californian painter Ed Ruscha in his book *Twentysix Gasoline Stations* (1963). He first came up with the title in 1962, and only then proceeded to photograph the subjects on one of his road trips from Oklahoma City (his hometown) to his adopted city of Los Angeles. The work of art was the book itself, simply but carefully designed, where the photographs inside showed no apparent traces of aesthetic decision making, as if the artist had merely pointed the camera out the car window in order to fulfill the requirements of the title, which of course alluded to the twenty-six letters of the alphabet. In this, Ruscha was developing what Benjamin Buchloh (1990: 121–2) suggests became an essential strategy of the aesthetic of conceptual art more generally: "random sampling

and aleatory choice from an infinity of possible objects" in which "an arbitrary, abstract principle of pure quantification replaces traditional principles of pictorial or sculptural organization and/or compositional relational order."[2] Quite simply, by photographing twenty-six examples of a gas station, Ruscha undermines the fetishization of the singular photograph. As László Moholy-Nagy already identified in 1932, seriality is tied to the nature of the camera, but "the series is no longer a 'picture', and none of the canons of pictorial aesthetics can be applied to it" ([1932] 2003: 95). When we see a grouping of similar objects, the effect is no longer about the photographer's individual response within a single image, but more about the overall idea and the differences and similarities between the objects themselves and their collective meanings. It is no coincidence that all the projects I address in this chapter adopt a serial approach.

In another book of photographs from 1966 entitled *Every Building on the Sunset Strip*, Ruscha created a fold-out version of the street itself by joining together separate photographs taken out the window of a slow-moving car. Once again, the photographs are uninteresting individually. Ruscha's "iconographic choice of the architectural banal," as Buchloh notes (1990: 122), corresponds to his "devotion to a deadpan, anonymous, amateurish approach to photographic form." In this serial approach, the significance of the individual image is radically diminished, and the notion of the individual masterpiece makes no sense. Ruscha (Coplans [1965] 2002: 23) famously claimed that his banal photographs were not "arty" but closer to "technical data like industrial photography." The pictures "are simply a collection of 'facts' . . . a collection of 'readymades'" (Coplans [1965] 2002: 26). Ruscha's reference to Duchamp's idea is significant, since it speaks to the logic of simply conferring artistic value through an act of pointing or recontextualization. While we should be careful not to take such rhetorical statements at face value, the fact that Ruscha did not always take the photographs supports the claim—for instance, he hired a professional photographer to photograph car parks from a helicopter for *Thirtyfour Parking Lots* (1967). As he said, "It is not important who took the photos" (Coplans [1965] 2002: 25), thereby displacing the traditional—or at least modernist—sense of photographic authorship based on individual vision and craftsmanship. Or in other words, Ruscha's books transferred authorial significance from the creation of individual images to a mass reproducible conceptual gesture.

Conceptual artists who turned to photography claimed to be uninterested in the history of photography as a fine art. Photographic conceptualism negated the technique and imagination of traditional fine art photography by substituting a pose of amateurism or blank professionalism, often indistinguishable from bureaucratic documents—as part of an informational turn and what Buchloh (1990) memorably called an "aesthetic of administration."[3] The work also explicitly undermined the kinds of heroic subjectivity represented by modern photojournalism, offering instead a parodic "reportage without event" (Wall [1995] 2003: 39).

This entailed various forms of instructional procedures, often based on strikingly simple or deliberately harebrained ideas. As Douglas Huebler (1969: 29) famously claimed, in a statement emblematic of a certain kind of working method: "I use the camera as a 'dumb' copying device that only serves to document whatever phenomena appears before it through the conditions set by a system." John Baldessari famously parodies the whole notion of "good" photographic technique, including rules of composition found in the postwar proliferation of how-to books, in his 1967 self-portrait *Wrong*, a photo-canvas work that shows him standing with a palm tree coming out of his head and a single capitalized word below it that says "WRONG." In his iconic serial work, such as *Throwing Three Balls in the Air to Get a Straight Line: Best of Thirty-Six Attempts* (1973), Baldessari lampooned the decisive moment in photography. Thirty-six is of course the number of frames in a standard roll of film. As Robin Kelsey argues (2011: 142), Baldessari and other conceptualists made art "in an era marked by, on the one hand, the impossibility of relying on artistic subjectivity to sustain aesthetic value and, on the other, the impossibility of basing art completely on objective principles, including chance." The work reminds us that "depicting something through photography can seem like little more than pointing to it, cutting out this portion of the visual field and not that" (Kelsey 2011: 141). Kelsey draws attention to Baldessari's irreverent humor and the work's dialogue with Alfred Stieglitz's *Equivalents* (1922–35), noting that it deflates "the operatic pretension of Stieglitz's heavenly forms" (2011: 141). Moreover, in a typically invisible instance of collaborative labor, Baldessari's then wife Carol Wixom actually took the photographs of the balls in mid-air.

Bernd and Hilla Becher: Impersonal aesthetics

> We just travelled around, photographing this and that. And after a while, when you have a lot of images, you have to sort them out.
>
> (Hilla Becher quoted in Weaver 2013: 28)

Bernd (1931–2007) and Hilla Becher (1934–2015) are one of the best-known collaborative partnerships in the history of photography. Their names are synonymous with their black-and-white images of industrial architecture, typically presented grouped together by type and function (water towers, blast furnaces, grain elevators, coal mines, and cooling towers among others) (Figure 2.2). Contrary to the casualness suggested by Hilla's quote above about having "just travelled around," they rigorously researched their itineraries. Since it is impossible to distinguish who was responsible for what in the production process, and

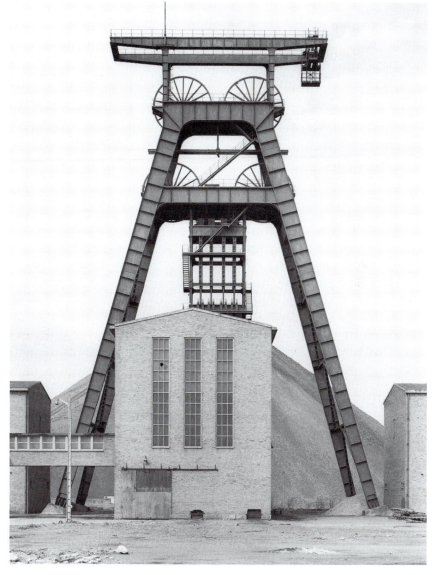

Figure 2.2 Bernd and Hilla Becher, *Winding Tower, Fosse Noeux, no.13, Nord, F*, 1972. ©Bernd and Hilla Becher, courtesy Schirmer/Mosel, Munich.

their work appears so systematic, almost anyone who writes on their archival project has observed "the irrelevance of psychology to their work" (Birnbaum 2004: 203). Thus for Daniel Birnbaum, "the Bechers believe in a kind of neutrality of photography that deletes all subjective traces" (2004: 203). For Thierry de Duve, "They eliminate all personal style from their photos—or sculptures—only to better release their impersonal aesthetics" (1999: 15). Gordon Hughes

(2007: 63) goes further, suggesting that the Bechers' collaborative method "suppresses their individualities," while Matthew Biro asserts that "[e]verything is done to reject the personality or particular sensibility of the photographer" (2012: 354). Sarah James summarizes that:

> Above all else, the photographic world of the Bechers is committed to *objectivity*. Their consistent, arguably impossible, aim has been to evacuate their own subjectivity from the work, to remove themselves as expressive agents as much as is humanly possible from the photographic act.
>
> (2009: 875)

Perhaps as a result of this overt objectivity, comparatively little attention has been given, within the extensive scholarship on their work, to their collaborative relationship. They are simply referred to as a couple—the Bechers—and often nothing more is said. However, various published interviews have shed new light on their biographies in recent years, and we can draw out a number of insights about photography and collaboration from their extraordinary example.[4]

Even as we should be wary of false insights retrospectively suggested by biographies, it is worthwhile to begin with an account of how the Bechers came to work together. Hilla Wobeser began photographing at the age of twelve when her mother, who had herself studied photography in Berlin in the 1920s, gave her a camera. A native of Potsdam, Hilla came into some darkroom equipment from her uncle, a keen amateur. She photographed her teachers in high school, and printed and sold them at postcard size (Weaver 2013: 20). Dropping out of high school, she then became an intern for the professional photographer Walter Eichgrün between 1951 and 1953. Among other things Eichgrün specialized in architectural photography, and his studio boasted an archive of historical photographs (Zweite 2004: 12–13). After this apprenticeship, Hilla defected with her family from East to West Germany in 1954, arriving first in Hamburg where she endeavored to capture the industrial landscapes around the port. Hilla moved to Düsseldorf to take up a job in an advertising agency, taking pictures of products for sale. She met her future husband, Bernd Becher, in 1957, when she was twenty-three, at the Troost Advertising Agency, where he had a summer job. Bernd had trained as a decorative painter in his father's company, then studied painting and drawing at the State Art Academy in Stuttgart. He moved to Düsseldorf in 1957 in order to study typography, and became interested in the demolition of industrial buildings in the area during this time (Zweite 2004: 11–12). Bernd started to use a camera in 1957, to collect source material for paintings (Ziegler 2002: 97). He began to document industrial structures in Ruhr in meticulous graphic illustrations, suggesting an early interest in exact description. Bernd also worked with collages of photographic images, but as Hilla put it

(Seymour 2015), Bernd "was not a photographer, but an artist with a brush or pencil":

> He only used photography once in a while, because his subjects were disappearing and he wasn't fast enough to record them. He started making photo-montages, but they were quite messy, I must say. I was a little more conceptual I think.

By most accounts, Bernd's youthful obsession with the industrial plants that surrounded his home in the Siegerland region held the seeds to the content of their work—his interest in disappearing industry—while Hilla's technical training was instrumental in defining its pictorial qualities (Lange 2007).[5] However, as Hilla put it, "the collaboration arose only from the interest that could be shared" (Ziegler 2002: 97): in her case, aided by a love of photographing metal (Weaver 2013: 23).

The Bechers married in 1961, and the collective moniker "the Bechers" suggests that they merged into one professional entity at this time. However, although their long collaborative project began in 1959, they undertook independent professional projects to make money to support their art, and were not initially treated as an artist couple. In March 1963, Bernd and Hilla Becher held their first solo exhibition at the Ruth Nohl bookstore and gallery in Siegen. But the exhibition was titled *Bernhard Becher: Fotos*. As a result, in 1964, Volker Kahmen published a short essay on Bernd Becher only (Kahmen 1964: 42ff; Zweite 2004: 20). By 1965, the title of the exhibition had shifted from the artist to the subject, *Anonymous Architecture*, shown at Pro Gallery in Bad Godesberg. However, in the accompanying essay by Kahmen, only Bernd was referred to in the title (Kahmen 1965: n.p.; Gronert 2003: 95). Stefan Kuhn (1995) confirms that, until 1965, the two photographers' work was known only under Bernd Becher's name. Not until 1967 were both artists' names mentioned in the *Neue Sammlung* exhibition in Munich (Kuhn 1995: 17 [n. 44]; Zweite 2004: 33 [n. 100]). The early exclusion of Hilla, undoubtedly tied up with the patriarchal values of the period in general, is particularly ironic given that Hilla had taught Bernd the basics of the darkroom (Weaver 2013: 24). However, it is also important to note that collaboration on a single artistic project was highly unusual in the 1960s. Moreover, at the time, many people could not appreciate their work as art and saw it as mere documentation (James 2009: 885).[6] To understand how radical the Bechers' project was, we need to understand the context of photography in Germany in the 1950s and 1960s when photographers were still under the sway of *Subjektive Fotografie*. This was an international movement, founded by the photographer Otto Steinert in 1951, which championed photography that explored the inner psyche and human condition rather than the outside world. Subjective photography suited the culturally specific experience of West Germany during the postwar years, in

which freedom of expression was equated with political freedom (James 2009). Steinert published a founding manifesto in 1951 in which he wrote that subjective photography "means humanised, individualised photography" (quoted in Schmalriede 1984: 22). This so-called creative photography—as Jean-François Chevrier (2003: 120) describes it, thus echoing Vilém Flusser (2000)—was preoccupied with the "criterion of 'vision' [which] authorized the 'autobiographical' blending of formalism and pseudo-lyricism." By contrast, the Bechers are noted for rediscovering New Objectivity (Zweite 2004: 15), and celebrating the object rather than the photographer, as their iconic title, arrived at by 1969, *Anonymous Sculpture*, clearly suggests (Lange 2007: 69).

The Bechers' return to prewar photographic influences—including, most notably, August Sander, Karl Blossfeldt, and Albert Renger-Patzsch—has been well discussed in the critical literature. Their serial approach was inspired by nineteenth-century zoology (Ziegler 2002: 99) and the consistent frontal view influenced by often-anonymously produced industrial photographs.[7] Seeking to record a passing era of industrialization and honor a host of anonymous architects, the Bechers approached their subject directly to emphasize similarity of vantage point. Uninterested in context—such as the background or the workers—they approached their subjects with the exacting and exhaustive discipline of a botanist, developing a categorical and rigorous approach (Figure 2.3). The conceptual framework for their work was established early on, with "famously invariable criteria" adhered to almost without deviation (Hughes 2007: 63). Some of this was the result of the use of a large-format camera, which set basic conditions for their preferred method of photography, providing detail and straightening out the lines. Among the characteristics—or what Blake Stimson calls "procedural rules"—were their standardized choice of angles and viewing distances, flat lighting conditions (capturing their subjects during overcast skies), and the uniform presentation of their photographs in grids. The consistency of their serial method, which gave rise to a catalogue of industrial types, served to "de-emphasise subjective shot decisions and permit easy comparisons between different photographs and photographic groupings" (Biro 2012: 354). In the viewing experience, repetitions of form and comparisons between these forms become crucial. Over time, they created a system of presenting these industrial catalogues: groups of nine, twelve, or fifteen examples of objects that belong to the same families. Hence the term *typology*, which was first used in the subtitle to their seminal 1970 publication *Anonymous Sculptures: A Typology of Technical Constructions*.[8] Notably, this book established the model whereby the only text included was of a matching, hyper-objective kind, a pure description of the industrial objects themselves.

It is sometimes incorrectly assumed that the Bechers' work was a minimalist-inspired activity (Hobbs 1984: 75). To be sure, it was the serial and objective quality of their work that made it appealing to American artists and curators—the

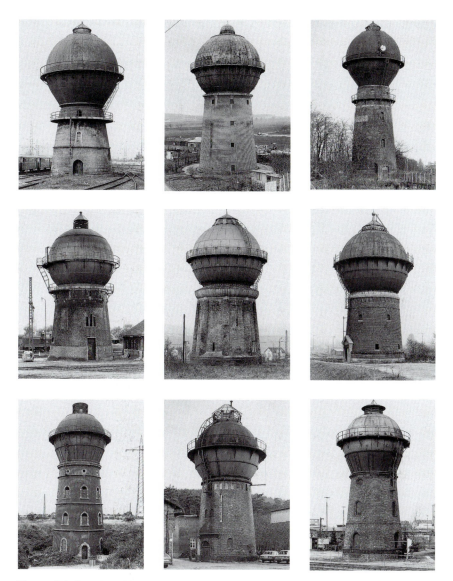

Figure 2.3 Bernd and Hilla Becher, *Water Towers*, *Germany*, 1965–1982. ©Bernd and Hilla Becher, courtesy Schirmer/Mosel, Munich.

very same quality that was so alien to the world of expressive art photography. As Hilla notes, "The world of photographers, back then, rejected our photography totally. It was simply regarded as 'not artistic'" (Ziegler 2002: 100). However, artists Richard Long and Carl Andre recognized the Bechers' position as explicitly artistic, and helped their work attract interest in the United States.[9] Andre, in particular, found a common ground between the Bechers' work and the minimalist

and conceptualist art that had recently come to prominence, writing an enthu-
siastic statement on their work in *Artforum* in 1972, "A Note on Bernd and Hilla
Becher," heralding them as conceptual artists (Andre [1972] 2005: 65–6). Their
work was also included in important group shows, including *Information* at
MoMA in 1970. Perhaps more remarkably, their work also crossed over into the
world of American art photography. In 1975, they were the only non-Americans
included in the influential exhibition *New Topographics: Photographs of a Man-
Altered Landscape*, curated by William Jenkins at the International Museum of
Photography at the George Eastman House.

How did the collaboration between the Bechers actually work? Due to finan-
cial reasons, in the first few years of collaboration, the Bechers only had one set
of equipment. However, they went on to own at least two sets, enabling them
to work independently of each other at different locations in the same plant or at
different places altogether (Lange 2007: 31). Both were involved in all aspects
of producing the work, including scouting sites, negotiating with the owners and
other authorities, setting up the cameras, and printing. In a 1989 interview with
Michael Köhler (quoted in Zweite 2004: 13), the Bechers state that:

> There is no division of labor in the sense that one person was always in charge
> of the one aspect or stage of a work. Each of us did everything, sometimes
> this, sometimes that, or once again the other way round. In other words, for
> us it does not play a role who pressed the shutter release for a particular pic-
> ture. And actually it is often the case that we have forgotten who did what by
> the time the films are developed and we are able to study the contact prints.

Nevertheless, Lange (2007: 33) argues that a certain division of labor persisted,
that "[w]hilst Bernd Becher concentrates more strongly on capturing the object
photographically, Hilla Becher handles most of the later laboratory tasks." The
teaching career of the Bechers supported this division. Following international
recognition of their work, Bernd was given a job teaching at Düsseldorf Art
Academy in 1976, the first professor of fine art photography at a West German
art institution. The Dean wanted "the master."[10] There were no precedents for
joint positions, so Hilla, as a matter of policy, was excluded.[11] As Hilla explained
in a recent interview, "We didn't teach together; he was the master, and that was
the time" (Seymour 2015). According to former students, the two were almost
inseparable (Green 2001: 104). However, as a consequence of Bernd's teaching,
and her technical mastery of the craft, Hilla ended up doing a large part of the
darkroom work for their exhibitions.

In light of this knowledge, one is thus tempted to read something into a snap-
shot of Bernd taken by Hilla in 1966, which depicts him photographing in a min-
ing town in Northern England, facing towards the industrial structure, next to the
large camera on a tripod (Figure 2.4). He seems oblivious to a group of children

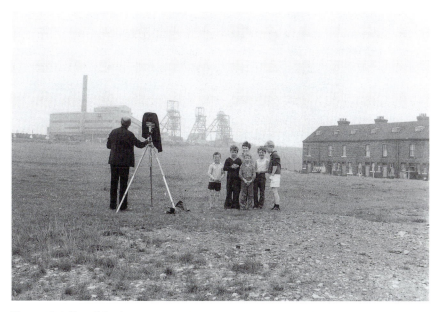

Figure 2.4 Bernd Becher photographing in a mining town in Northern England, 1968. Photo: Hilla Becher. ©Bernd and Hilla Becher, courtesy Schirmer/Mosel, Munich.

who have assembled next to him in response to Hilla's camera, and are included in the snapshot. The image seems to suggest a gendered division of labor in which Bernd is the aloof conceptualist and Hilla something of a humanist. And yet, in the final analysis, one agrees with Lange who concludes that despite the division of darkroom labor: "The choice of motifs and vantage point, and even the discussion of the quality expected in the prints are essentially the product of an intensive exchange of information, of long standing experience, and a mutually championed concept" (2007: 33). In other words, the Bechers' collaboration has the character of a research team (Sollins and Sundell 1990: 8)—which explains why for most critics their collaboration is simply a matter of fact. As Hobbs puts it, "Their shared identity is an *a priori* not an *a posteriori*, an established fact, not an essential outcome" (1984: 75). That is, their identities merge, but there is no concept of a new collaborative self.

Photography's mechanical nature is the enabling factor in the Bechers' collaboration. Their programmatic method is facilitated by the supposed objectivity of the medium. It enables the consistent look of the images, and their relentless focus on the object. As Hughes surmises (2007, 63), "their use of pre-established and famously invariably criteria ... functions as a means to cancel the traditional markers of a singular, aesthetically intuitive, or expressive style." Thus, in a 1978 edition of *Kunstforum International* dedicated to artist duos, in which the Bechers figure prominently, Michael Schwarz (1978: 102) writes that "the

Bechers have managed to conceal their respectively personal signatures behind the discernible regularities of the medium in which they work." Indeed, you could say that the technology of the camera is as much the author of the images as the Bechers, who aspire to a condition of authorlessness (Zweite 2004: 9–10). However, their project is nevertheless distinct from the poker-faced conceptual photography discussed earlier. As Stimson notes, "The Bechers never engaged in a deadpan neutralization of their own subjective artistic perspective" (2007: 68)—such as Ruscha and many other conceptual artists—and neither did they have any concern for inventing arbitrary ordering systems. Instead, their project is rooted in sincerity: captivated by their subjects, they understood neutrality as the best way to portray them. For Sarah James, their project represents a "mimetic attempt to redeem expression through the frail objectivity and historicity of things" (2009: 891). For this reason, they had no use for snapshots; most obviously because they required the detail provided by large format photography, but also because the snapshot is too personal, its field of view too indiscriminate and contingent. As Bernd (quoted in Ziegler 2002: 100) has said: "We wanted to take these objects with us ... Reduce them photographically." Only by being objective, and focused on the object, could they fully approach this task of addressing buildings "like human subjects" (Stimson 2007: 70). And yet, in collecting portraits of aging industrial structures, as abstract forms organized taxonomically, they produced a morgue—a "portrait of a lost world" (Emma Dexter quoted in Stimson and Struth 2007: 67). Notably, people are completely absent from this world of heavy objects.

Larry Sultan and Mike Mandel's *Evidence*: The viewer as author

Unlike the Bechers' photographs, people frequently appear in the collaborative work of Larry Sultan (1946–2009) and Mike Mandel (1950–). However, they are invariably depicted in an indeterminate relation to the objective world of things. This is certainly true in their most famous collaborative work, *Evidence*, a book of black-and-white images in which men, or their hands, are pictured measuring things with various instruments or holding out ropes, cables, and other objects to be photographed by the camera. At the same time, men are constantly on the verge of disappearing; men in hardhats wade into a vast landscape of foam, and a protective bodysuit lying face down on an office floor may or may not contain a living human. Sometimes people appear as props to be cropped out, holding up plain colored backgrounds behind objects. Often, only the mysterious traces of human activity remain, such as the opening image with footprints and pencil (Figure 2.5). The images are often inexplicable, and invariably enigmatic, but we get the sense that something is awry: several

Figure 2.5 Mike Mandel and Larry Sultan, *Untitled*, from *Evidence*, 1977. ©Mike Mandel and Estate of Larry Sultan.

Figure 2.6 Mike Mandel and Larry Sultan, *Untitled*, from *Evidence*, 1977. ©Mike Mandel and Estate of Larry Sultan.

photographs depict explosions and fires, or their aftermath, and landscapes made strange with unidentified technological artifacts or events (Figure 2.6). As curator Sandra Phillips (2003: n.p), who has worked closely with the images, concludes, "Pictures of men entrapped or commanding technology, assuming they have the upper hand, form the core, the tragic motif of the book." In almost every case, the men in the photographs—the world of *Evidence* is overwhelmingly male[12]—seem to be somehow estranged from the tools or technologies they are apparently testing or observing.

Evidence is sometimes described as one of the most important books in the history of photography.[13] It was certainly a precursor to subsequent postmodern strategies of appropriation, and effectively invented a new genre: the found image book (Lord 2015). Crucially, Sultan and Mandel remove all captions and any other contextualizing information about the individual photographs that make up *Evidence*, with the exception of a three-page introductory list of all the offices and agencies the pictures were gathered from. No form of explanation is offered for why this particular group of images has been collected. The artists simply took documentary photographs from the archives of corporate, scientific, government, and law-enforcement agencies (some presumably outtakes) and presented them, without comment, one to a page. They are deadpan records, whose original authors are insignificant, made and "used by these agencies specifically to document procedures, processes and tests" (Larry Sultan quoted in Fischer 1977: 34). Intended as objective documents, by the careful selection and recontextualizisation of the photographs as a book and exhibition, the two artists show how visually ambiguous such "evidence" can be. For, in the absence of captions, the images become indecipherable visual puzzles, making *Evidence* a thoroughly ironic title. The work underlines the now commonplace idea that the meaning of a photograph is determined by its context, or, as Sultan put it at the time, "how the context of the information conditions the way the information will be perceived" (quoted in Fischer, 1977: 34).

Sultan and Mandel collaborated for twelve years on over nineteen projects. Both grew up in the San Fernando Valley in Northern California, and both were graduate students at the San Francisco Art Institute (SFAI) where their collaboration began in 1972. As Phillips (2003: n.p.) notes, Sultan and Mandel chose collaboration "in part as a statement in opposition to the kind of photography they were taught in school [as a form of aesthetic self-expression]; it was a challenge to the old romantic idealism of 'originality' and artistic authorship." In practice, their collaboration is matter of fact, a means to an end rather than an end in itself, based on adapting imagery sourced from archives or from popular media, often twisting its meaning or emphasizing its banality. One can speculate as to their respective temperaments—that "Mandel's analytic personality responded to the more private and literary Sultan" (Phillips 2003: n.p.)—however, the collaboration appears to be a pragmatic and equal partnership. As they said in

1985: "Collaboration is not an easy way of working ... We play devil's advocate for each other's excesses. And we've evolved a common vision that is the foundation for the work" (quoted in Cotton 2012: 8).

Sultan and Mandel both continued with solo careers during and after their main collaborative period from 1973 to 1985. Early in his practice, Mandel self-published a book called *Myself: Timed Exposures* in November 1971, a series of thirty-four self-portraits made alongside strangers, using the camera's self-timer. A typical image shows the long-haired and bespectacled Mandel sitting on a bench with his legs crossed, staring straight at the camera, with two white grandmothers and a young black girl, who appear to be waiting for a bus. Living on the West Coast, Sultan and Mandel were already acutely aware of Ruscha's recent publications, and the wry photography of Lee Friedlander. Both were also "avid postcard collectors, and lovers of the language of vernacular photography" (Cotton 2012: 11). According to Charlotte Cotton (2012), Sultan was heavily influenced by the teaching of pioneering visual anthropologist John Collier, who had once been a photographer with the Farm Security Administration (FSA) in the 1940s, and was then teaching at SFAI. Specifically, Sultan took from Collier the "challenging credo that a photographer needed to be in command of the context and the 'life' of an image and not just focused on the making of a photograph" (Cotton 2012: 10).[14] Another key influence and supporter was Robert Heinecken, then an influential photography educator at the University of California, Los Angeles (Cotton 2012: 11). Heinecken was an early adopter of what came to be called the appropriation of mass media images, and from him they undoubtedly took away a sense of humor towards the myth of artistic genius. Thus in 1974, Mandel published his second book, *Seven Never Before Published Portraits of Edward Weston*, a selection of filled-in questionnaires and photographs of the seven men he found in the phone book with the name of the famous photographer. A play on the idea of fame, the book indicates the irreverent nature of the artist's work, and his interest in playfully undermining modernist conventions of photographic authorship. In the same year, Mandel was working on *The Baseball Photographer Trading Cards* (1975), a project that saw him travel the country to photogrpah parodic ID profiles, accompanied by questions such as favorite camera, developing chemical, and so on, gently mocking the new celebrity status of art photographers (including Ansel Adams, Imogen Cunningham, and William Eggleston as well as younger contemporaries).

Sultan and Mandel's first collaborative project was a public billboard realized in 1973. Their turn to the billboard appears to have been motivated by an interest in critiquing commercial culture as much as a desire to reach non-art audiences beyond the gallery system. After a series of false starts, Sultan and Mandel eventually secured a series of ten commercial billboards for *Oranges on Fire* in 1975, an enigmatic image–text work featuring a graphic silkscreened hand holding flaming oranges (Cotton 2012: 15). With no suggested narrative or clear

meaning, the work is pure connotation, to use the semiotic language of Roland Barthes (1977b). In a crucial step, one that indicates their interest in ambiguity and the important role of audience interpretation in their work, the artists posed as newsmen to interview passersby about the meaning of the billboards, whose responses were understandably diverse (Cotton 2012: 17). Sultan and Mandel produced a self-published book project in 1974, *How to Read Music in One Evening, A Clatworthy Catalog* which spoke to their interest in recontextualizing images, and the chance nature of their collaborative desires. The book was composed of found instructional illustrations, including images of disembodied hands and other body parts sourced from medical manuals and cheap mail-order catalogues advertising inventions that "carried the utopian promise to perfect lives … [but] visually functioned in unsettling and alienating ways" (Cotton 2012: 18), especially when drawn out of context, and juxtaposed into sequences. The sequences came together over the course of a few evenings, inspiring them to also curate an exhibition of rephotographed and enlarged medical photographs, *Replaced*, in 1975, "many of which carried an erotic charge" (Cotton 2012: 19). The influence of Surrealism and pop art on these works is clear. As Cotton notes (2012: 19), Sultan and Mandel had, within two years of their collaboration, developed a method of taking "the visual economies of commercial image making" and creating "elliptical, distinctly unauthored (by art's standards) and quietly incendiary projects."

Evidence was the result of extensive investigation into a range of public and private archives that stored photographs made as documentation of research projects, scientific procedures and government activities. Undertaken over two years, the hunting began at NASA's Ames Research Laboratory before spreading to engineering and high-tech companies in the area (Jet Propulsion Laboratory, Lockheed Aircraft, and General Atomic all proved to be rich sources). Early on in the project, the artists divided their labors for the efficient hunting of material (Cotton 2012: 21). By all accounts, they were not looking for spectacular images, but strange, banal ones. They were looking for photographs that functioned as a record, but also had "bizarre and uncanny connotations" (Cotton 2012: 21). Having established a core group of images, they were awarded a National Endowment for the Arts grant to further investigate the photographic files of government, science, and industry. They also showed what they had found to the curator of photography at the San Francisco Museum of Modern Art (SFMOMA), John Humphrey, and were surprised by his enthusiasm (Cotton 2012: 22). With the confidence of the grant and the possibility of exhibition, they drafted an official-sounding letter that they sent to dozens of private companies and state-run organizations requesting access to their photographic records.

Sultan and Mandel claim to have looked at over two million photographs at seventy-seven archives during 1975 and 1976 to find the images they wanted. Having assembled around 500 photographs, the artists then spent three months

editing and sequencing a book containing sixty-one duotone images. The result-
ing selection has been described as "a visual conundrum of incalculable mys-
tery" (Parr and Badger 2006: 220), collected inside a book whose quality itself
conveys a "cool and anonymous quality, like a document" (Cotton 2012: 22).
Rather than the convention of the dust jacket, then customary for art books, the
cover is plain blue cloth. The only essay in the publication, an afterword, never
mentions the artists by name.[15] Everything points to "a kind of legal author-
ity and detachment" (Phillips 2003: n.p.). However, the book was printed by
the same printer responsible for Ansel Adams's photographic books, on high
quality stock (Cotton 2012: 23). The sharpness, detail and even illumination of
the images, provided by large-format film and flash lighting, is crucial to their
evidentiary, forensic quality. The images are "thoroughly 'professional' in their
clarity and focus," as a reviewer noted at the time (Albright 1977: 38). Thus meet-
ing the "formal parameters" of the institutional archives, the images are made
"all the more obtuse for being clearly lit, focused, developed and printed" (Lord
2015). No doubt the artists appreciated the formal aesthetic provided by the
four-by-five inch images, given a new "archaic, deliberate, crafted quality" with
the then recent shift to 35mm documentation (Phillips 2003: n.p). As Sultan said
at the time, "We are using the photograph's primary relationship to the real world,
exploiting its credibility" (Fischer 1977: 34).

The image sequence is crucial, with each facing image working off the other.
However, right from the first picture of the book—depicting a footprint with a
pencil, topped by other footprints facing in the opposite direction—a reader
realizes that things are not going to be predictable. The book starts with pho-
tographs that depict the traces of human activity with unknown purpose, and
builds to a climax of fires and then landscapes in disarray. Mandel (2013) has
recently said that the artists understood the book as being "divided into chap-
ters," which opens with:

> the initial idea of evidence as police-oriented in the first pictures, then segues
> to institutionalized versions of evidence, then the high-tech world, then how
> the landscape has changed through this high-tech world, then falls apart,
> then the last picture—rocks under confined wire, it's kind of like nature has
> been controlled and is in jail.

However, the collection defies easy logic and coherence. Similarly, for the accom-
panying exhibition at SFMOMA in 1977, Sultan and Mandel selected eighty-nine
photographs, simple 8 x 10s held against the wall by a simple sheet of glass, like
a book on a wall: "Just the facts," as Sultan described it in 2008.

As Thomas Albright (1977: 38) put it in a review of that exhibition, "Every
photograph is, in a sense, a 'found object' with a frame around it." In using found
photographs, *Evidence* thus relies on an idea of photography as a readymade.

Moreover, Sultan and Mandel appear to have taken seriously Douglas Huebler's famous statement, made in 1969 and which they were sure to know, that "The world is full of objects, more or less interesting: I do not wish to add any more."[16] Indeed, asked in an interview if they were doing any "camera work" themselves, Sultan responded in language that combines conceptual art's fetish for information with the nascent postmodern language of appropriation: "The whole use of information, the decoding or recoding of existing information is much more exciting to us than going out and making pictures" (Fischer 1977: 34). Nevertheless, one of the photographs in the *Evidence* exhibition—a series of poles in the desert—was actually taken by Sultan. As Carter Ratcliff (2006) points out, this image was a fake piece of evidence, a "ringer." In an apparent reference to Walter De Maria's *The Lightning Field* (1974–77), Sultan "found the poles readymade and took the picture himself" (Ratcliff 2006: 61). Ratcliff is one of many commentators to observe echoes of earthworks by artists like Robert Smithson and Michael Heizer in *Evidence*. For one contemporary reviewer, the choice of images was inflected by the post-Minimalist aesthetic of "earthworks, process and performance art and their photographic documentation—plus a strong dose of old-fashioned Surrealism" (Albright 1977: 38). The landscape images in *Evidence* also resemble what was happening in mid-1970s American art photography among new topographic photographers like Robert Adams and Lewis Baltz (Parr and Badger 2006: 220). Meanwhile, technology imitates avant-garde art: one striking image of three men observing the water spraying from a circular disk bares more than a passing resemblance to Duchamp's *Rotary Glass Plates (Precision Optics)* (1920).

Where the Bechers' industrial objects operate as readymade sculptures, Sultan and Mandel take institutional photographs as their readymade. In a classically Duchampian procedure, they turn institutional photographs into art "by displacing them to the art world," sans captions, where they are "[l]iberated from documentary servitude" (Ratcliff 2006: 59). In this transfer, Sultan and Mandel make no attempt to retain any sense of the original photographers' intentions, or otherwise acknowledge their hidden labor (although the photographer's presence is occasionally signaled by a shadow). The artists therefore can hardly be said to be collaborating with the original photographers, as is sometimes the case with artists working with found photography (Chapter 5). On the contrary, Sultan and Mandel claim authorship themselves, repeatedly referring to their work as a kind of "poetry" or a "visual novel" (Mandel et al. 2008). This sense of them authoring something new from something given to them by official institutional culture was clear even during the production of the work: "The photographs we've gathered from the files can be played off of each other to release associations ... It's our poetry built on their facts" (Sultan quoted in Fischer 1977: 34). A statement by the artists accompanying the 1977 exhibition, reproduced in SFMOMA's press release (quoted in Phillips 2003: n.p.), underlines this intention:

By definition these images are records and by implication they are cultural artifacts. This is not a compilation of photographs that define any specific place in time but rather a poetic exploration upon the restructuring of imagery.

In an interview thirty years later (Mandel et al. 2008), Sultan speaks explicitly about their understanding of the work's authorship:

Mike and I, through the act of selection, became authors of pictures we didn't make, because we felt we saved them from the dustbin of history. Their function was once documentary and now they were pure connotation—they no longer had their specific instrumental function. They could mean whatever we could nudge them into meaning through context and visual association … It was very controversial, because we had claimed authorship. At that time, the word "appropriation" hadn't been used in an art context. It came out of a Duchampian strategy of the found object, in this case the found photograph.

Mandel also suggests, however, that they were attempting to undermine the expectation of originality: "We were trying to break out of the modernist requirement of the artist as 'creator'. We were recognizing the cultural functions of photographs" (Mandel et al. 2008). The fact that Sultan actually took one of the photographs in the exhibition without drawing attention to this authorship is therefore important. By de-authoring his own work, *Evidence* collapses the distinction between the found and the observed.

Evidence forces viewers to come up with their own meanings for the images, and short-circuits the desire to know the photographer's intention behind each image. Indeed, the absence of captions arguably "makes us aware of ourselves as interpreters" (Ratcliffe 2006: 67). As the artists' statement accompanying the 1977 exhibition suggests—in language that echoes Roland Barthes's famous 1967 essay "The Death of the Author"—*Evidence* is, "above all, a carefully designed invitation to participate in the closure of the meanings of the images." As Mandel (2013) has put it recently, the removal of the captions means that "there's no way to provide any anchorage, as Barthes would say, on the meaning of the pictures. You have to provide the meaning of the pictures." Audience response, in other words, the reception of the photographs, is built into the work. Just as their billboard works were not simple critiques of advertising, but opened up a space for the viewer to think, the ambiguity of *Evidence* makes it a radically open work and thus also a highly contemporary one (Soutter 2013: 27–8). As Mandel (quoted in Fischer 1977: 32) put it at the time, "We are very interested in this quality of participation encouraged by confusion." As Benjamin Lord (2015) recently surmises, *Evidence* is one of the crucial points in the late-twentieth-century process of the reevaluation of photography's relationship to *artistic agency*—where the notion of intention is "relocated to the

aesthetic space of presentation and of the viewer." Its "working method" is the "viewer as author" (Lord 2015).

Sultan and Mandel were criticized in some quarters for having removed the captions and being guilty of indulging in "poetics," or what Walter Benjamin decried as "free-floating contemplation" (Ratcliff 2006: 63). But although the original context is lost, the selection of images and their sequencing in *Evidence* is highly intentional, directing the viewer to consider the content of the photographs as well as their form.[17] Of course I am referring to that "tragic motif," at once comic and melancholic, of our alienated relationship to advanced technology, perhaps only made more acute by the passing years.[18] Indeed, in a working note during the archival research, the artists tried to articulate to each other what they were searching for, referring to "The amputation of human sensitivity into the service of technological development" (Cotton 2012: 22). The artists reiterated this point in a 1977 interview:

> As we worked it became clear that the most intriguing images are those which deal with the most advanced technology. Strange looking machinery and tools. The human element is pretty much objectified. People exist as factors in technology.
>
> (Fischer 1977: 34)

The period from which the images are drawn—primarily the 1960s, when the artists were growing up—was of course a moment of ambiguous utopian promise, of the Space Age but also the Cold War.[19] It is the period, in short, that witnessed the maturation of what President Eisenhower famously called the military–industrial complex. The project speaks to how that world represents itself, from the perspective of early ecological thinking. While the narrative is open-ended and the artists stop short of overt social commentary, it is impossible not to read the work as a satire of the absurdist rationality of white, male, technocratic culture "where hard hats are often worn with suits and ties" (Ratcliff 2006: 58).[20] As the writer Brian Dillon (2006: 149) has put it, referring to one particularly bizarre photograph of a foam blob (Figure 2.7):

> *Evidence* now looks like the record of an era in America that was as horrified by the material world it had made as it was enthralled by its commodified forms. Matter, here, is monstrous and unruly.

Published at precisely the moment and in the geographical location that was about to witness the rise of personal computing, Sultan and Mandel's work speaks to the imperative of technology to shape and control.[21] It deliberately evokes the language of authority, and yet, like the artists' approach to mass-media imagery in other projects, is decidedly anti-authoritarian in its collaborative invitation to viewers to make sense of the evidence.

Figure 2.7 Mike Mandel and Larry Sultan, *Untitled*, from *Evidence*, 1977. Gelatin silver print; 8 x 10 in. (20.32 x 25.4 cm). San Francisco Museum of Modern Art, purchase through a gift of Mary and Thomas Field, the Accessions Committee Fund and the Foto Forum Fund. ©Mike Mandel and Estate of Larry Sultan.

Adam Broomberg and Oliver Chanarin: Anti-photojournalism

> Our strategy has evolved in opposition to "the shooter" approach. The days of the adrenaline fueled, male war photographer bringing back the news from the frontline, are over.
>
> (Broomberg and Chanarin quoted in Lehan 2006)

If the Bechers worked like an archaeological research term, and Mandel and Sultan adopt the method of forensic archivists, London-based collaborative duo Adam Broomberg (1970–) and Oliver Chanarin (1971–) operate more like activist anthropologists. Having met aged twenty as "road-tripping sociology and philosophy students" in Wuppertal, a tiny missionary town in South Africa's desert Cape, they started working together as photographers and then "creative editors"

of *Colors*—a magazine "about the rest of the world"—in the late 1990s (Davies 2013).[22] The fact that Broomberg and Chanarin came to photography through a graphically innovative humanistic magazine is important, as is the fact that they had grown up Jewish in South Africa while it was under apartheid.[23] Using a wide variety of means, their practice concerns itself with how history and current events are perceived through images, and in the process reevaluates and challenges traditional ideas of photography as a tool for documenting the social condition. They are particularly interested in the ethics of photography and its role in classifying and ordering the world. Very often, this involves challenging the notion of photographic evidence itself, directly positioning themselves against the classical idea of photojournalism and its reliance on the photographer "being there" (Broomberg and Chanarin 2008b). This view was articulated in their 2008 essay "Unconcerned but not Indifferent," occasioned by their bemused participation as jury members in the 2007 World Press Photo awards. In the selection process, caption information is withheld, which results in a situation whereby "each image must be judged on aesthetic grounds, outside of the context for which it was created, severed from words of explanation" (Broomberg and Chanarin 2008b).

In all of their work together since they began collaborating in the 1990s, Broomberg and Chanarin have consciously sought to distance themselves from the individualist ethos of photojournalism. As Broomberg put it:

> Photography's so full of those kinds of biographies of the "genius photographer," the lone predator with the sharply tuned eye and amazing sense of timing. It's very male, athletic, macho and sexy.
>
> (Lass and Smyth 2010: 42)

Their earliest work drew from *Colors* and played with documentary conventions, especially the ethical dilemma of representing people from non-Western cultures. Even their choice to photograph entirely on large-format color negatives presented a riposte to the tradition of black-and-white 35mm. Their first book, appropriately titled *Trust* (2000), comprised a series of close-up portraits of men, women and children completely immersed in unseen activities (at the cinema, beautician, or in prayer, some even undergoing surgery)—mouths open, eyes closed—but all seemingly unaware of the camera. This sensitivity to a penetrating physiognomic examination of the lens continued in *Ghetto* (2003), which documented gated communities, from a maximum-security prison in South Africa to auto-portraits of the mentally ill in a psychiatric hospital in Cuba (Figure 2.8). In *Ghetto* they handed over the shutter release to their subjects to make self-portraits and also included their words, as a way to overcome or at least make transparent the power relations inherent in such photographic set-ups. As they rather poetically put it: "They are pictures of people being photographed. We the photographer are present in the image in their gaze" (Burbridge 2011).

Figure 2.8 Adam Broomberg & Oliver Chanarin, *Rene Vallejo Psychiatric Hospital, Cuba*, 2003. Original in color. Courtesy of the artists.

Broomberg and Chanarin's collaboration is total, and the person who finally clicks the camera shutter is a minor detail in a long process of conceptualization and negotiation. As Broomberg puts it (Lass and Smyth 2010: 47), "All the discussions that lead up to the moment [of pressing the shutter] inform the outcome." In other words, the clicking of the shutter is the result of a conversation and discussion, leading to conceptually informed decision making rather than

lone intuition.[24] Once again, in certain respects, the collaboration is matter of fact. However, Broomberg suggests that they "push each other's moral position" (Lass and Smyth 2010: 47). British curator Val Williams (2008: 120) describes "a free-ranging thought process contained within very particular boundaries of carefully tempered and organized working practices." And yet, Broomberg and Chanarin are also a playfully self-conscious partnership. To some extent they "perform" their collaborative project when asked to appear in public, undoubtedly alert to the fact that "artists are increasingly being asked to behave more and more like brands" (Campany 2011: 80). Giving public talks, they always take turns in speaking, delivering their pre-prepared text semi-robotically. Likewise, in various photographs of the artists that accompany magazine articles about their work, they often appear either in a fictional guise (such as faux-nineteenth-century figures with beards in one black-and-white image), or looking off in separate directions (Milliard 2011: 15–16). It would be too much to suggest that "Adam and Olly," as they call each other, are performance artists—in the manner, say, of Gilbert & George—but they are certainly attuned to a performative element in the promotion of their work.

The idea of performance is also crucial to one of their most famous bodies of work, *The Day Nobody Died* (2008), which has come to stand as an emblematic critique of embedded war photojournalism (Figure 2.9).[25] In June 2008, Broomberg and Chanarin traveled to Afghanistan to be embedded with British Army units on the front line in Helmand Province. To gain access, they lied to the Ministry of Defence, claiming they were photojournalists rather than artists, taking appropriate cameras with them as a decoy.[26] However, they came back with a set of abstract photograms, produced by exposing color photographic paper to sunlight over a series of days, using a Land Rover as an improvised darkroom. Various seven-meter sections of paper were exposed to the sun for twenty seconds, each time something appeared "worthy of recording," as suggested by the titles. However, the resulting swathes of lyrical color suggest the impossibility of portraying "the horror of war," denying the viewer what they call in an artist statement "the cathartic effect offered up by the conventional language of photographic responses to conflict and suffering" (Broomberg and Chanarin 2008a). The statement calls the images "action photographs," and refers to the work as a "critique of conflict photography in the age of embedded journalism and the current crisis in the concept of the engaged, professional witness" (Broomberg and Chanarin 2008a). To be sure, their photographic paper bears witness; the resulting images are "indexical," but of course offer nothing in the way of a conventional account or explanation. As Val Williams suggests (2008: 125), they are "anti-documents, accidents, uncontrollable."

Essential to understanding the abstract photograms is an accompanying twenty-four-minute documentary. This film depicts the passage of a long

Figure 2.9 Adam Broomberg & Oliver Chanarin, *The Day Nobody Died*, 2008. Film still. Original in color. Courtesy of the artists.

cardboard box containing the fifty-meter roll of photographic paper in its transit from their studio to Afghanistan, starting with a view out the boot of a taxi journey in London and then to an airport baggage carousel in the Middle East, then to a military 4WD, then through various army checkpoints. The artists themselves never appear in the video, although their presence behind the hand-held camera is felt in their sometimes audible voices or glimpses of their hands as they occasionally pick up the box. Effectively, the box becomes a *relational object*, as it is handled by various individuals, usually soldiers, who put it over their shoulders, on their laps in a plane, under their arms, and even fall asleep next to it. From the video it is clear that the artists consciously sought to leave the box on its own, sometimes in somewhat stranded circumstances, giving it a certain Surreal and potentially explosive charge—remembering that this was a moment of extreme anxiety around so-called Improvised Explosive Devices. Others have suggested associations with the unseen coffins returning from Afghanistan (Soutter 2013: 50). Indeed, video, unlike the abstract images, does in fact depict a reality of war, or more specifically the transportation to and within a war zone, and various banal moments in between, waiting around. As their

artist statement puts it (Broomberg and Chanarin 2008a), the film's production amounts to:

> an absurd performance in which the British Army, unsuspectingly, played the lead role. Co-opted by the artists into transporting the box of photographic paper from London to Helmand, these soldiers carry the box from one military base to another, on Hercules and Chinooks, on buses, tanks and jeeps.

Williams (2008: 123) refers to the work as a "collaborative improvisation" as, in effect, the project became its own documentation (Soutter 2013: 62). If we continue with the idea of conceptual artists using photography to give agency to objects, the object here, ironically, is a box of photographic paper. We are never shown the moments when the artists open the box and expose the paper to light. Eventually, the box simply appears with black masking tape and it is clear the artists are on their way home with the "evidence."

Broomberg and Chanarin have always been interested in the relationship between authorship and authority. For instance, referring to their early autoportraits made in a Cuban psychiatric hospital, they said: "The history of photographing mentally ill people just felt like a very *non-collaborative history*. So we were trying to readdress that balance" (Burbridge 2011). Likewise, more recently, the artists visited Moscow to research a new form of 3D surveillance portraiture in which the subject is unaware that their face is being scanned (quoted in Andreasson 2014):

> What scares us is that this technology operates in what its developers call the non-collaborative mode: the subject is not aware of the camera, they never look into it, or engage with it. Yet historically, photography has always been about collaboration: there has always been a relationship between subject and photographer. Sometimes it's been romantic, sometimes problematic. This undoes all of that narrative.

Such algorithmic data-based imaging challenges Ariella Azoulay's notion of the "civil contract" of photography that has inspired Broomberg and Chanarin, even as multiple agents remain responsible for the eventual production of photographic meaning. The artists recount a portrait they once took of Palestinian leader Yasser Arafat in Ramallah. On the way out of the country their film was seized by the Israeli Defense Force and put through the X-ray machine, back and forth, in an attempt to destroy it. Returning to England, they found the marks of the machine on the image. At first they tried to retrieve the original image but then realized that "the mark was more interesting than the portrait" and that the Israeli Defense Force were "active authors in the work" (Wright 2014; see also Burbridge 2011).

Figure 2.10 Adam Broomberg & Oliver Chanarin, *Fig. 14*, *Fig. 29*, *Fig. 54* and *Fig. 75*, 2007. Originals in color. Courtesy of the artists.

Fig. (2007) is a pivotal work in Broomberg and Chanarin's practice (Figure 2.10). Featuring ninety-five still lifes, portraits, and landscapes, and alluding to an era of Victorian collecting, the work explores the limits of classification, objectification, and description. Many of the still lifes are generated from specimens and curiosities found at the Booth Museum of Natural History, Brighton, which was originally a Victorian collector's private museum, and now describes itself as "all about birds, butterflies, fossils, and bones" (Booth Museum n.d.). These historical objects—including a stuffed magpie, a Merman's body, and a unicorn's horn—are complemented by the artists' own collection of contemporary "artifacts": floral arrangements from a hotel in Rwanda associated with the genocide, a group of evenly lit portraits of diverse women (a series examining idealized beauty), painted ex-voto images (Catholic stories giving thanks for miracles) discovered in Italian churches, and "a single leaf blown from a tree in Tel Aviv by the blast of a Palestinian suicide bomb." Violent histories of colonialism and anxieties around war underpin the images, particularly the relationship

between Britain and Africa. The book commences with seemingly innocuous landscapes of "beacons" in the United Kingdom and ends with a view of Europe from Morocco, and includes a series of triumphalist self-portraits made by a game hunter in Africa. All of these disparate images are accompanied by short and sometimes oblique captions written by the artists—which make a series of unexpected connections between them. The whole complex collection is infused with the conventions of museology, and evokes the idiosyncratic tradition of the cabinet of curiosities. The title, *Fig.* itself alludes to the abbreviation of the word figure used in museum catalogues and the conventional use of images to represent scholarly evidence.

In exhibition, *Fig.* is presented as a series of 5" x 4" contact prints, contrary to the "characteristic inflation in size of art prints" (Stallabrass 2007: n.p.). Housed in white box frames, the images are displayed evenly spaced in a single line along the wall of the gallery in a quasi-scientific manner. This rigorous serialization draws attention to the limits of photography, and its "process of framing" (Burbridge 2011), as the world is reduced to the size of the print, miniaturized— much like the Bechers' collections of industrial architecture turned into little objects. Similarly, the highly detailed images are cool, descriptive—blurring the boundary between the concrete factuality of ethnography and the clean, decontextualizing aesthetics of fashion photography—which, as Julian Stallabrass (2007: n.p.) notes in his introductory text for the book, downplays the "artistry," and "subjectivity of the artists." Up close, a little dot and number is attached to each image, which cross-reference corresponding titles and captions contained in a freely available booklet. In this way, the work activates viewers to make associative connections, and it can be engaged with in a linear or nonlinear way. Stallabrass (2007: n.p.) suggests that this shuttling between image and text is "a revival of an older practice of looking," while the artists speak about the work as a puzzle (quoted in Foster 2007). The words are absolutely critical to making sense of the work (Foster 2007). When transferred to book form, the sense of narrative is even stronger.[27] The artists refer to the work as a poem through their own practice, an edited or curated collection that in some ways deconstructs their own residual efforts to documentary.

Fig. traces a series of links between photography and the colonial impulse to acquire, collect and measure. As we have already seen, the artists are acutely aware that "the history of photography is intimately bound up with the idea of colonial power" which they view as "very much a kind of male practice traditionally, and very much a kind of colonial and European one" (Foster 2007).[28] Photography, in short, is linked to trophy hunting. And indeed stuffed animals and skeletons feature prominently, as might be expected given the focus of the Booth Museum on ornithology and taxonomy, including an empty plinth that once showed a "native skull" and an archival box ominously labeled "human." The empirical impulse to measure the world is directly mocked in two

images—an image of a hand, referred to as a photograph of the tallest man alive, and a colored scale rule, rendered redundant as a photograph (one is reminded of Sultan and Mandel's interest in measuring devices). An acute self-reflexivity about photography is most obvious in a series of passport photographs of a British man responsible for servicing passport photograph machines, followed by a series of images from Rwanda of discarded photographs that have had passport size images cut out of them. Everything appears interlinked. And yet, crucially, the evidence gathered by Broomberg and Chanarin in *Fig.* is willfully deceptive. The artists refer to themselves as "unreliable witnesses" and the work as "a muddle of fact and fantasy" (Foster 2007). The images and the "captions" are constantly in tension, and the relationship between each picture is sometimes dubious since, as the artists suggest (Foster 2007), "each piece has an element of fantasy in it." A set of footnotes offers little help, instead plunging us into a "maze of information and truths and half-truths" (Williams 2008: 122). In this sense, the work recalls a Surrealist collection of fantastical objects from museum collections, complete with unconscious sexual charge (explicit in the case of a pin-up collection). There is also a dark humor to the work—as fake car crash casualties are counterposed with the real traumas of colonialism and war, the contemporary struggles of asylum seekers and HIV-AIDS in Africa.

As Gordon MacDonald (2007: n.p.) points out in his "editors note" at the back of the book: "Rather than starting with an archival document and subverting its original intention (in the style of Sultan and Mandel's *Evidence*) … Broomberg and Chanarin create a new archive of documents that, when positioned alongside text, vigorously question their own authenticity." It is interesting to speculate on how the artists' collaborative method plays into this approach, particularly since their more recent work has explored archives of photographs. For instance, they worked with Belfast Exposed, an archive set up to document "the Troubles" in Northern Ireland over the past thirty years, to produce *People In Trouble Laughing Pushed To The Ground* (2011). This work was inspired by the fact that whenever an image in the archive had been selected for use, a colored dot had been placed on the surface of the contact sheet as a marker. The artists decided to explore what was subsequently obscured from view, resulting in a series of circular images. Characteristically, the artists express it best: "Each of these fragments—composed by the chance gesture of the archivist—offers up a self-contained universe … a small moment of desire or frustration or thwarted communication that is re-animated here after many years in darkness" (Broomberg and Chanarin 2011: 111). In other words, the artists were fascinated by an accumulated history of engagement with the archive by historians and others. The artists echo Azoulay in referring to the importance of a succession of different viewing moments, rather than the single moment of capture alone.[29] We might also speak of the work as bringing to light a multiplicity of authors of

photographs that were often anonymously produced. Broomberg and Chanarin have also produced work within the space of existing books; *War Primer 2* (2011), in dialogue with Bertolt Brecht, and *Holy Bible* (2013) both involve the insertion of images sourced from Google into the physical pages of the books. In an interview (Ladd 2013), the artists summarize their approach:

> We've always been more interested in the ecosystem in which photography functions rather than in the species itself; more intrigued by the economic, political, cultural and moral currency an image has than in the medium. We're fascinated by how images are made but also how they are disseminated, and how that affects the way they are eventually read.

They add that they "still take photographs" but do not "radically discriminate between images we take and those that we find," being "equally mistrusting of both" (Ladd 2013). Here, then, we find a certain culmination of conceptual photography and its relation to the world of objects: Broomberg and Chanarin create work that questions the task of the photographer, the medium itself and its role as a political instrument. By rupturing the ritual of the act of photographic capture and focusing on the dissemination of images, their work reinvents the responsibility of both makers and viewers of photographs.

Conclusion

We have travelled some distance from the joint authorial production of Marcel Duchamp and Man Ray's 1920 photograph *Dust Breeding*. Each of the examples discussed in this chapter, however, demonstrate the complex and multiple nature of photography's authorship in contemporary art. Each works with the notion of the readymade quality of photography, linking objects and objectivity. The readymade, of course, fundamentally concerns the question of artistic labor, or its apparent absence. As John Roberts (2007: 19) has argued, the readymade is "the founding event of the critique of value and the modern dialectic of skill and deskilling in twentieth century art." Photography has long been recognized as a deskilled technology of reproduction. And yet, like the act of selecting and presenting a readymade, photography is also a productive act. Importantly, the work of all three collaborative partnerships I have looked at here can be described as seemingly authorless in style, even embracing "the aesthetic of anonymity" (Buchloh 1990: 139). If there is a "third hand" (Green 2001) produced by the collaboration between the artists, it is simply that of analytical precision built upon a common reliance on serial photography. As Stimson (2006: 55) has argued, "Serial photography … push[es] representation toward objectivity, rather than subjectivity, toward lived sociality rather than

lived individuality, by distancing itself from the temporalities of personal experience." My argument is not that individual artists could not have produced the photographs produced by the partnerships I have examined here, but that the mechanical quality of photography has enabled the particular collaborations to develop in the way they have. The artists draw on photography's vernacular forms and rely on a number of the medium's particular characteristics—what the curator Kate Bush (2003a: 63) describes as "its descriptive precision, its serial nature, its stylistic neutrality and authorial impersonality." It unfolds that pointing at photographic "things"—both observed and found—is not only tantamount to Duchampian authorial intention, but reminds us that photography is a fundamentally social act.[30]

The collaborative work of the Bechers, Sultan and Mandel, and Broomberg and Chanarin is nonetheless paradoxical. For while resolutely anti-subjective, each achieves its force through a certain melancholy. As Stimson notes (2004), the Bechers' work "gains its emotional power, its expressive force as art, from the extent to which it conveys that sense of loss [of an idealized past] to the beholder."[31] Sultan and Mandel's *Evidence* is an anxiety-infused but nevertheless melancholy ode to the postwar America of their childhood. Broomberg and Chanarin's *Fig.* has also been described as "a deeply melancholic document, which looks at the ways in which the human condition is dominated by blind faith, by the accidental, by fragments of meaning" (Williams 2008: 122). Once again, the camera's mechanical nature facilitates this melancholic mood, which is perhaps at bottom a longing for a lost order. The notion of evidence, as Sophie Berrebi (2014: 52–3) has written, "cannot stand to be obstructed by the idiosyncrasies of a photographer." To acknowledge this fact is not to reintroduce "the shadow of the author in the form of technology" (McCauley 2007: 420). The artists in this chapter, by removing conventional marks of photographic authorship, extend the privileges of authorship to the objects photographed. Photography, Walter Benn Michaels observes (2007: 447), transforms "the natural object into the intentional one," allowing the photographer's subject to become the art object. But contrary to Michaels' high anxiety about this transferal of artistic agency onto the object, the artists discussed in this chapter embrace this displaced intentionality in order to complicate photographic meaning. Their work's particular blend of restrained artistry, factual precision and semantic obtuseness opens up a generous space for the viewer's interpretations. By simply pointing at things in the world—or pointing at photographs of things—each makes a virtue of the multiple agents involved in the social production and reception of photographs over time, beyond that of a singular expressive moment. In this way, the conventions of photography are subtly shifted. The most seemingly decisive of mediums is exposed as radically indeterminate, and the instability of photography as a fine-art medium and its dependence on specific contexts of reception is recognized as a strength rather than a weakness.

3

COLLABORATIVE DOCUMENTS: PHOTOGRAPHY IN THE NAME OF COMMUNITY

This chapter explores art projects that recruit multiple or collective photographic voices with the aim of creating more inclusive documentary forms. The artists examined closely are North American photographer Wendy Ewald, for her pioneering work teaching children to document their lives in photographs, and two Australian-born artists now working in the United Kingdom: Anthony Luvera, for his "assisted self-portraits" of homeless people; and Simon Terrill, for his collaboratively choreographed images of local communities and residents. In each case, the artists utilize forms of collaborative participation, involving individuals and communities in their own representation in an attempt to democratize photographic image making. This is by no means an uncontroversial or simple action. For if it is in a documentary mode that collaboration in photography has been most widely practiced and discussed, this is not only because of documentary's ambitions to represent "others" but also due to various criticisms of how this has been achieved. Ewald, Luvera, and Terrill each, in different ways, attempt to overcome the perceived power relations associated with documentary photography by giving photographed subjects a "voice." In this sense, they draw on practices in anthropological fieldwork since the pioneering experiments of Sol Worth and others, who gave Bolex cameras to Indigenous people to produce a series of films from 1966 called *Navajo Film Themselves*.[1] This progressive form of visual anthropology, aiming to understand the perspective of its research subjects, operates under the sometimes naïve assumption that "only self-representations can solve the problem of unequal power in the photographic transaction" (Rosler [1999] 2004: 227). Drawing on a history of the critique of photographic representation, my analysis of the three artists in this chapter focuses on this complex relationship between self-representation and empowerment.

Documentary photography emerged as a genre at the end of the nineteenth century, with social reformer photographers such as Jacob Riis showing the upper class how the lower class lived, and Lewis Hine exposing child labor in the United States. In the 1930s, when the term "documentary" gained currency—out of the writing of influential British filmmaker John Grierson—it was closely associated with the involvement of photographers in the Depression-era Farm Security Administration and their depiction of ordinary people temporarily down on their luck. Since that time, documentary photography has endured several bouts of criticism, but the most persistent is that the photographer enjoys a chronically exploitative power relationship with their subjects. Indeed, photographers are, to varying degrees, in control of matters like pose, angle, and setting—that is, how people are seen—and also who their photographs are seen by and in what context. These last points are crucial, since it can be argued that the products of a documentary photographer's labor—such as images of poverty and suffering—are typically circulated in a voyeuristic way that only entrenches this exploitative relation further by extending it to viewers. Meanwhile, the reasons for poverty and suffering tend to be addressed superficially if at all, or, as Roland Barthes (1972) famously argued in relation to Edward Steichen's romanticized framing of the postwar world in *The Family of Man*, generalized into a sentimental story of humanity. In the more sophisticated critiques of documentary—which often come from photographers themselves—the idea is retained, but the conventional practices of documentary are questioned. Here we might cite the celebrated, self-reflexive account of the Depression era offered by Walker Evans and James Agee in *Let Us Now Praise Famous Men* (1941), which took issue with the simplistic framing of poverty by photographers like Dorothea Lange and sought to let the visual facts speak for themselves.

Martha Rosler, in her renowned series, *The Bowery in Two Inadequate Descriptive Systems* (1974–5), attempted to question the stereotypes associated with documenting urban poverty by introducing absences into dichotomies of image and text. In an important essay published in 1981, Rosler ([1981] 2004: 179) wrote that: "Documentary, as we know it, carries (old) information about a group of powerless people to another group addressed as socially powerful." Crucially, as she observed, "Documentary testifies, finally, to the bravery or (dare we name it?) the manipulativeness and savvy of the photographer" ([1981] 2004: 180). Rosler's close collaborator Allan Sekula (1978: 867, 875) was similarly critical of "the often expressionist liberalism of the find-a-bum school of concerned photography," in which pity "supplants political understanding." By the time postmodernism was in full swing in the 1980s, documentary photography was seen by many as an impossibly compromised mode, in which a typically white, Western male photographer documents the lives of others less fortunate, who are placed in a passive position as objectified subjects to be surveyed. Much of this anxiety echoed the influential and generalized

denunciation offered by Susan Sontag (1977: 4) in *On Photography*, that "to photograph is to appropriate the thing photographed. It means putting oneself into a certain relation to the world that feels like knowledge—and, therefore, like power." And yet, as we have already seen in Chapter 1, the history of photography is scattered with important moments of collaborative forms of documentary involving participation by the subjects of the camera (such as the worker photography in Germany and the Soviet Union between the wars). Meanwhile, since the 1960s, various artists have worked to counter the uneven power relations seemingly inherent to the photographic act by openly collaborating with their subjects. By pioneering new and sometimes radical modes of collaborative practice, they simultaneously take inspiration from and complicate simple criticisms of documentary photography.

Wendy Ewald: Co-creation with children

> Their work led me to wonder if I could consciously merge the subject of a picture and the photographer, and create a new picture-making process.
>
> (Ewald 2000: 17)

North American photographer Wendy Ewald (1951–), indisputably a central figure of what we might call collaborative documentary photography, was only seventeen years old when she first worked with children to generate photographs. Born in Detroit but now based in New York, Ewald had learnt photography at high school, taking inspiration from Walker Evans's Depression-era work. Straight after graduating in 1969, Ewald took a summer job teaching photography to Naskapi children on a Native American reservation in eastern Canada. She had heard that Polaroid Corporation were giving cameras and film to people who were working with "underprivileged" children, as they were called then (Ewald 2000: 21), which inspired her first grant proposal. With the help of the grant, Ewald gave cameras to her young Inuit students to document their daily lives and surroundings. She admits she was naïve and had few preconceptions, but as she has said, "When I saw their first pictures, I knew they had a raw power that I had yet to see in photographs" (Ewald 2000: 17). Realizing that the photographs the children took were more intimate and sophisticated than any she could have taken as an outsider, she devoted the next four summers between college studies to the task. As she later observed of the process, in a text often used to frame the reception of the work in an exhibition setting:

> I took pictures of the children and their families, working selectively and cautiously. The children, on the other hand, took pictures of everything they saw: the chief, drunk, trying to saw a board; a young couple fighting; a tea pot

on a windowsill; a great-aunt in her white Sunday dress sitting on the rocks by the shore. The children's pictures were more complicated and disturbing than mine, and closer, I realized, to what their life was like.

(Ewald 2000: 21–2)

On the one hand, Ewald's use of the terms "complicated" and "disturbing" belong to a long tradition in the avant-garde that values the aesthetics of complexity and shock. At the same time, her desire for the images to be "closer" to the subject's actual life expresses the more classically anthropological orientation of social documentary. In a more recent interview (Harford 2013), Ewald simply says that "[t]he photos the kids took were remarkable and more interesting than what I did." The photographs are like visual secrets, telling insider stories otherwise unavailable to Ewald as an outsider.

Ewald developed and extended the idea of collaborating with children in her next body of collaborative photographs, *Kentucky* (1975–82). Moving from San Francisco to a small town in the Appalachian Mountains, she says she wanted to make a document of her "new community that had the soul and rhythm of the place, but the camera seemed to get in the way" (Ewald 1985: 11). So once again she turned to teaching children, aged between six and fourteen, to take pictures. Polaroid again assisted, followed by support from the Kentucky Arts Commission. As Ewald (1985: 13) recalls, she asked each student to buy a cheap ten-dollar Instamatic camera from her in the hope that this would help the student value it. Ewald (1985: 17) speaks of the varied commitment, interest, and talent among her subjects, and the influence of her instructions, which evolved from simply photographing their surroundings to capturing their inner lives, hopes, and fears:

When they made self-portraits they learned that they could be subjects of their own photographs and create characters for themselves. The assignment to photograph their dreams brought into play their imaginary world.

The resulting body of work consists of a series of small black-and-white images of poor white children taking photographs of their everyday lives.[2] Crucially, the images are accompanied by diary-like captions written by the children, which usually tell some kind of story. These range from the amusingly banal—a self-portrait called *I took a picture of myself with the statue in the backyard*—to the immensely poignant, such as a child who takes a self-portrait holding a framed photograph of his "biggest brother … who killed himself when he came back from Vietnam." Like so much art since the 1960s, the process of making the work is just as crucial as the final image, which embeds this layered process.[3] To be sure, some of them are unremarkable as images, but others, especially those that attempt to recreate dreams—such as those by Denise Dickson—exhibit

an uncanny quality, reminiscent of Sally Mann's later photographs of her own family in the 1980s. Throughout her career, Ewald has been drawn not only to the honesty and directness that children are able to capture in their pictures, but also the spontaneous and unexpected dimension of the images—how children see the world differently, and not necessarily more innocently, than adults. As Ewald (1985: 11) described this body of work, "The world they present is small and intimate, but their perception of it is detailed, accepting and complex." In the resulting book, *Portraits and Dreams: Photographs and Stories By Children of the Appalachians* (1985), Ewald reflects wistfully on her affection for, and identification with, some of the students, who she worked with over several years, and the likelihood that they would grow out of their fascination for photography. "We were like accomplices in a secret game," she says, referring to efforts "to trick the adults into letting us take the pictures we wanted" (1985: 19–20).[4]

Inspired by the results of these early experiments, Ewald successfully applied for a Fulbright Fellowship in 1982, enabling her to travel to Ráquira, Colombia, where she lived and taught photography to children for nearly two years. The pictures taken by these children in the Andean mountain village offer a moving and sometimes vulnerable account of everyday subjects and scenes. In *Magic Eyes: Scenes from an Andean Girlhood*, a book of the Colombian work published in 1992, Ewald's photographs are interspersed with those of her student collaborators and stories told by two local women to form an evocative portrait. Some images, such as the flash-lit interior by Alirio Casas, *My mother drinking coffee in the kitchen after she made dinner* (1982–3), seem to return us to Jacob Riis's images of tenement buildings in the 1880s or Walker Evans's economical documents of the interior of tenant farm families in the 1930s. Other images evoke conceptual art practice, particularly in the literal, descriptive titles of seemingly insignificant actions. Individual pictures such as Alirio Casas's *A drunk friend sleeping* (1982–3), or Carlos Andres Villanueva's *The chickens run behind my mother* (1982–3) (Figure 3.1), could easily be mistaken for work by conceptual artists.

Ewald has since taught children all over the world to document their lives in photographs. She has given cameras to kids in contexts as diverse as India, South Africa, the Middle East, the Netherlands, and Great Britain—exploring issues of racial and ethnic identity, and increasingly in unstable situations. Ewald positions herself as an advocate for and educator of children, immersing herself in their communities and producing work with and alongside them (Figure 3.2). At an early point in her career she realized that her own work and her students' work could be combined, rather than happening side by side as two separate things. The actual procedure has varied over the years, but tends to involve the co-creation of images and some kind of pedagogical operation. Here, we might detect the influence of Brazilian educator Paulo Freire's classic book *Pedagogy of the Oppressed*, published in English in 1970.[5] Ewald similarly embraces the

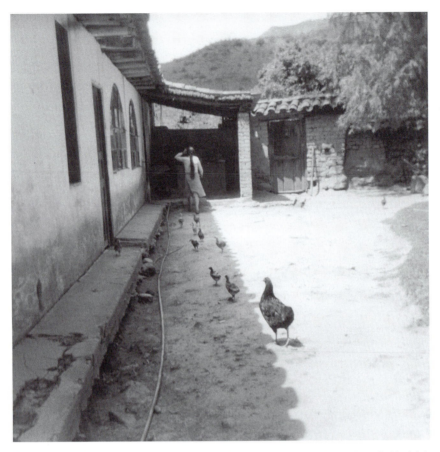

Figure 3.1 Wendy Ewald, Carlos Andres Villanueva, *The Chickens Run Behind My Mother*, ca. 1982–3. ©Wendy Ewald.

principle of experiential learning and views teaching as "a political act" (Ewald 2000: 326). Typically, she works with children who have no previous connection to photography, who during the project learn to develop and print their own images. Indeed, in 2001, Ewald co-wrote a book that outlines how to teach photography to children, *I Wanna Take Me a Picture: Teaching Photography and Writing to Children* (2002). Importantly, as Ewald (2013) put it in a recent interview, she is not trying to turn the kids into photographers. Instead:

> The aim is two-pronged. For me, as an artist it's a way of making images that are meaningful and revealing, aesthetically relevant. For the children and the communities I work with, it's a self-expressive tool that they can use to talk about who they are, with each other. I start by asking them to make self-portraits, then to photograph their families, their community, then finally their

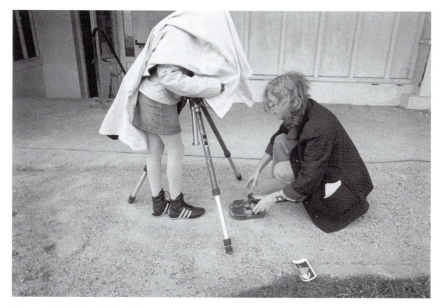

Figure 3.2 Wendy Ewald at work, from *Towards a Promised Land*, England, 2007. Photo: Pete Mauney. ©Pete Mauney.

dreams and fantasies. It tends to give kids a self-confidence; they have the decisions, what to photograph and not, which is a power, because the camera is a powerful machine.

In other words, by encouraging the creativity of her subjects, Ewald allows them to gain a certain amount of control and confidence as human beings. In several projects, such as *Netherlands* (1996), Ewald has asked children to mark or write on negatives that she has made within the communities she works, thereby seeking to challenge, or at least complicate "who actually makes an image, who is the photographer, who the subject, who is the observer and who the observed" ("Wendy Ewald," *Literacy Through Photography*, n.d.). In short, in Ewald's work, the participation of subjects is the condition of collaboration. And yet, as she also reflects, the projects are driven by her own needs and desires. As she admits in the last words of a retrospective survey book: "Sometimes I think I disguise myself as a teacher in order to make the pictures I need to see" (Ewald 2000: 326).

Ewald can be described—and is now cannily positioned by her New York commercial gallery—as a conceptual artist whose approach to photography probes questions of identity and cultural difference. As I noted above, the combination of text and straightforward images by children can indeed resemble conceptual documents, and the projects' connection with "lived reality" is common to much conceptual art of the time (Neri 2006: 30). In the 1970s, however,

Ewald was far more removed from the mainstream art world and simply called what she was doing a "collaborative art" (Neri 2006: 30), a description that now seems highly prescient. Of course, to understand the context for Ewald's work we need to appreciate the social climate of the 1960s in the United States, such as the Civil Rights Movement. Following the dramatic five-day race riots in Detroit in 1967, Ewald had actually worked as a teenage volunteer in a cultural program involving young black children, designed to keep them off the streets. As art theorist Margaret Olin has observed of this moment, increasingly "social reformers and concerned photographers saw the domination of photographers over subject as a problem and sought new ways of allowing their subjects to talk back" (2012: 133). For instance, Danny Lyon helped to redefine photojournalism by becoming fully immersed in his subject, working in an insider manner—akin to "new journalism"—spending months in a biker gang, building up telling and detail-packed portraits of their lives. To make his book *Conversations with the Dead* (1971), Lyon spent fourteen months photographing inside the Texas penitentiary system, befriending the prisoners, and the drawings, letters and testimony of an inmate named Billy McCune are as important as the artist's intimate photographs (the original printing of which was supervised by another inmate). Several other "collaborative" projects made innovative use of the relationship between the image and text. In a seminal work started in 1977 and published as *Rich and Poor* in 1985, Jim Goldberg pointed his 35mm camera at the homes of the affluent and the impoverished in San Francisco. When he showed his subjects their portraits, he was so impressed by the depth of their responses that he asked them to annotate the prints. These handwritten comments—in careful cursive or hasty scrawl—remark on the subjects' economic and social standing, implicitly or explicitly revealing hopes and dreams, and in some cases offer observations about the way Goldberg portrayed them. Goldberg came to describe this form of "photo-interviewing" in terms of "total documentation" (Schuman 2011), and his work can be compared to an earlier experiment in using a subject's own words in photographic essays—Bill Owens's classic depiction of the American dream, *Suburbia* (1973). Owens's approach was more opportunistic: "When I went back to get the releases, people would sometimes comment on the photograph, and I would write those comments on the back of the picture" (Lang 2000). By contrast to Owens's careful editing of often boastful or painfully clichéd statements from people commenting on their domestic situation—driven by an ironic and ambivalent sensibility—Goldberg's subjects were free to write what they choose, giving them far more agency over their own representation.

Ewald's method of putting camera equipment in the hands of the marginalized was thus only one possible method of what Olin (2012: 140) in *Touching Photographs* has called "photographic empowerment."[6] As Olin argues, such work reflected a particular social climate, in which "[t]o give photographic voice to the dispossessed and silenced became a strategy—and a romance" (133).

Olin points out that one of the implicit ambitions of such work is to enable view-ers to "see through another's eyes" (149). Indeed, in Ewald's case, this is both a motivating aim and a source of constant tension. As she says:

> It is aesthetically interesting to see an image made by someone who lives in a certain situation, because the choices of composition—that is, where she stands in the world and literally where she stands to make the picture—add other layers of meaning to the image.
>
> (Ashford et al. 2006: 73)

This statement reveals Ewald's sensitivity to aesthetics, gained from her art school training (she studied photography with none other than Minor White, a master of subjectivism). However:

> with each new situation I worry that I'm not asking the right questions and not clearly seeing from an inside perspective, which, for me, is essential to the success of the project.
>
> (Ashford et al. 2006: 76)

This anthropological desire to see from an "insider" perspective has come under criticism as a romantic impossibility (Foster 1996; Downey 2009). Ewald is clearly conscious that although the children are co-creators of her work, her editing and framing will ensure it remains hers. Although the children are individually identi-fied as authors of images, Ewald is named as the instigator of the project. As Olin (2012: 141) suggests, in a sense, "the child photographer acts as a medium or a tool for the teacher."

Photography is a uniquely democratic mode of expression. It requires rela-tively little skill to record an image unlike, say, drawing or painting, which require practiced hand-eye coordination. This point was made in François Arago's fam-ous 1839 speech about the daguerreotype, in which he lauded its simplicity and claimed it "can be performed by anyone. It presumes no knowledge of the art of drawing and demands no special dexterity" (Arago [1839] 1980: 19). Most importantly, photography's mechanical nature means that it can be learnt very easily. Photography's referential quality is also considered widely accessible. It is for this reason that is has so readily lent itself to pedagogical projects with mar-ginalized people. But in the 1970s and 1980s, it was still a radical act to teach the means of producing photographic prints in a darkroom. And indeed precisely this kind of progressive thinking inspired the 1988 Australian documentary work *After 200 Years* (Taylor), a photographic project that sought to overcome problems associated with photography's role in the creation and perpetuation of negative images of Aboriginal people. Of twenty-one participating photographers, eight were Aboriginal, and all were required to engage with local communities through

a series of protocols, including a period of living with Aboriginal people without taking photographs (McQuire 2013: 230). In some instances, remote Aboriginal Australians were given cameras and taught how to use darkrooms. The collaborative nature of the project was designed so that the participants could direct the work of the photographer, as well as determine the selection of images and accompanying texts. The ceding of individual authorship was thus used to gain trust and overcome traditional power relationships between photographer and subject in a quest for a more meaningful record than the clichés then provided by either tourist imagery or sensationalist photojournalism.

Today, with the almost ubiquitous availability of simple camera phones, there is arguably no need to teach people how to take photographs. Digital cameras are almost foolproof, and mistakes cost nothing: one simply deletes and takes the picture again and again. In the film era, by contrast, each exposure involved a cost; the material cost of film and its development and printing. Thus, even as late as 1996, it was still remarkable for Chilean-born artist Alfredo Jaar to hand out a thousand disposable cameras to the residents of a poor neighborhood of Caracas, Venezuela, in a work called *Camera Lucida* (1996), as part of the opening of a controversial new museum in the area. As Jaar (n.d.) describes:

> We invited the people of Catia to photograph their community, their friends, their parents, their school, in complete freedom … Once they returned the camera, we gave them ten days to come back and pick up their prints, but when they picked up their prints, we asked them to select one print that would be shown at the museum's opening.

More than 750 cameras were returned, and 407 people came back to select their favorite image. The museum opened with an exhibition of these photographs "taken and selected by the people of Catia" (Jaar n.d.). Jaar also created a sculptural work from the "skeletons" of the cameras, which he called *The Eyes of Catia*. As the artist observed of his practice in 1999, in language that echoes French curator Nicolas Bourriaud's ([1998] 2002) influential thesis of relational aesthetics: "Each work must suggest and try to create a new model, a paradigm of social participation" (Durden 2000: 36). More trivially, around the same time in wealthier parts of the world it was briefly fashionable at wedding receptions for hosts to put disposable cameras on every table—in the hope of capturing a different, looser, and more authentic portrait of the event than the images provided by an official professional photographer. This exercise has since become unnecessary in an age when almost everyone has a camera phone in their pocket, wherein multiple guests participate in such informal documentation.

Ewald has always been suspicious of just giving cameras to her subjects. She is more interested in the dialogue that ensues during a pedagogical process around the making of the images. As she has written (2000: 325–6):

The active dialogue between the photographer and the subject (and inevitably the viewer) became for me the essential point of a photograph. Beyond aesthetic choices, I came to see photography as a language to which everyone has access.

Ewald is not here suggesting that photography is a "universal language" (a much criticized idea closely associated with *The Family of Man* exhibition from 1955). Clearly, however, what makes photography a collaborative form of expression for Ewald is its relationship to visual literacy.[7] Ewald's aspirations accord with Ariella Azoulay's insistence that photography contributes to a collective space that creates conditions of citizenship and participation.[8] Of course, it must be acknowledged that not all critics are convinced that the resulting photographs overcome the power dynamics between her and her subjects. As one reviewer suggested (Hooper 2013): "The more Ewald's voyeurism is disguised, the more pronounced it starts to feel." This skeptical response is perhaps more of a reaction to the promotional rhetoric framing her work than a response to the work itself. Similarly, Ewald's description of her students as "fellow artists" (Bembnister 2002), although meant as an equalizing gesture, invites accusations of romanticism (alongside Joseph Beuys's famous declaration that "everyone is an artist") as if to assume that her goals and interests are mutually shared with her collaborators.

In practice, Ewald is highly sensitive to the fact that collaboration opens up unexpected possibilities that do not always coincide with the artist's plans. While initially premised in instruction and imitation, her subjects inevitably take the learning in directions of their own making. As Ewald describes:

When I go somewhere to work, I often leave the equipment that I brought. I work with people in the community so that they can see what I do, and they can choose to continue the work. And it may be completely different. In India, I worked with a union of home-based workers. Their concern, which was very different to mine, was to use photography as an organizing tool . . . To me, the value is in starting something.

(Ashford et al. 2006: 70)

In some cases, the meaning of Ewald's work has also been transformed by the response of audiences. Thus in 2005 she undertook a project with Artangel in the United Kingdom, called *Towards a Promised Land*, which involved children affected by war and poverty in Margate, a somewhat forsaken seaside town that has long been a destination for immigrants and asylum seekers (but where there is also a National Front presence). The project involved large-scale three-by-four meter outdoor banner portraits of the children positioned on the cliffs so that they faced out to where many of the kids had come from (Ewald and

Morris 2006).[9] Ewald made the portraits, but the children were asked where and how they wanted to be photographed, and they also wrote parts of their life stories on the images. Just prior to the launch of the banners, in July 2005, the London transport system was bombed by Al-Qaeda. The next week, some of the images in Margate were vandalized: two images of a Muslim girl from South Africa were burned after petrol bombs were thrown directly at the images. The banners nevertheless remained on display for two years.

Ewald's work has evolved in parallel to developments in self-reflexive ethnography, which have in turn been influential for activists involved in radical photography projects.[10] Her first work coincided with the reception of John Collier's classic 1967 textbook *Visual Anthropology: Photography as a Research Method*, which defined and codified a science of culturally sensitive observation, as Benjamin Lord (2015) surmises:

> Collier emphasizes photography's exploratory dimensions and describes various techniques, including that of the photo-interview ("photo-elicitation"), in which documentary photographs of a culture are shown to members of that culture in order to elicit their viewpoints, feedback, and sometimes even their participation in making new photographs.

The idea of using photography to work with disadvantaged children has now become common outside of art—through organizations such as Fotokids in Guatemala (1991–) (originally called Out of the Dump) and Kids with Cameras in India (2002–). More broadly, the logic of photographic self-representation has been formalized as an anthropological and sociological research method in the form of PhotoVoice (1992–), originally called "photo novella." PhotoVoice builds on Collier's ideas and is now a widely used technique in community development and social research, which involves participants, such as refugees, taking photographs in response to a particular issue.[11] Dubbed "participatory photography for social change," the ideas in the images are drawn out through group discussion and "clarified with captions" as a means to bring them to the attention of a broader audience and policy-makers in particular. Inexpensive digital cameras have obviously assisted the popularity of this research method, which is essentially a form of listening that seeks to avoid the problem of the hero-narrative in which a Western photographer aims to rescue and redeem "disadvantaged" subjects from lives otherwise unseen (Hesford 2011).

Ewald is clearly aware that her art practice combines elements of visual anthropology, education and fine art photography (Ewald 2000: 325).[12] Like the projects of Lyon, Goldberg and Jaar, her work extends beyond ethnographic documentation by virtue of its encouragement of the creative inclinations of its recruits, the creative editorial oversight of the artist photographer and the final context in which the work is presented. As Neri puts it, "If we accept the

definition of anthropology as an 'investment in social portraiture', as a model of sketching life in all its complexity, then Ewald is an artist in an anthropologist's skin" (2006: 32). In particular, Ewald's decision to ask children to photograph their *dreams* turns the collaboration into an original creative project. Ewald describes how she came to the decision to ask the children to photograph their dreams or fantasies in Kentucky in the 1970s, after wondering how to find a photographic method to match their playful visions. The process also involved shutting themselves in the darkroom together, sitting on the floor, and telling each other about "our scariest dreams" (Ewald 1985: 17). Precisely for this reason, Ewald's work has been aptly described as "a delicate kind of collaborative dreaming" (Weinberg and Stahel 2000: 10). While her extended commitment to collaborative exploration through photography has always kept the question of authorship in the foreground, it is these unexpected qualities that have sustained her practice with children over more than forty years. Crucially, as Ewald states, "By working with others, the finished piece contains several layers that wouldn't exist if it was made by a solo artist" (Luvera and Ewald 2013: 53). That is, she has developed a way of making documents that are more complex than an artist recording a single vision.

Anthony Luvera: Assisted self-portraits and the collaborative archive

Anthony Luvera (1974–), an Australian-born contemporary artist living in London, has been engaged in participatory and collaborative forms of photography since 2001—most notably in producing what he calls "Assisted Self-Portraits" with the homeless. Luvera has also helped to establish a contemporary discourse around the notion of photography and participation, through an active involvement in writing and the organization of a series of talks on the topic at The Photographers' Gallery, London, in 2010. In important respects, his work can be understood as an extension of the British "community photography" movement in the 1970s, which Ewald was briefly involved in as a young woman when she lived in London.[13] The situation in Britain in the 1970s, however, was more clearly motivated by a sense of class-consciousness than North America. Fundamentally, the work was driven by the idea that self-representation by and for the working class was a political act in itself. This desire to make visible people who were invisible (or misrepresented in the mainstream media) produced a variety of projects that aimed to promote the photographic recording of local history and political struggles by people themselves, in some cases with the help of professional photographers. Feminism was another key ingredient in the British situation, fuelling additional belief in the potential of photography for empowerment and demystification of everyday life. Crucially, as the name suggests, community

photography was posited in place of an exclusive perspective on the authorial and authorizing "I" pervading both amateur and professional photography. In this sense, it is highly relevant for understanding the role of collaboration in contemporary photography, and Luvera's work in particular.

Undoubtedly the most influential of British community ventures was the Half Moon Photography Workshop in East London, which was borne of the merger of two collectives. Half Moon ran a gallery in a venue that also hosted a public theatre. Meanwhile, Jo Spence, who like Luvera started as a commercial photographer, cofounded what she called the Photography Workshop in 1974 with lifelong collaborator Terry Dennett. The Workshop, initially a roving platform, merged with the Half Moon Gallery in 1975, thus cementing "a common belief in the emancipatory potential of photography" (Vasey n.d.). It had an explicit goal of democratizing the practice of photography and collectivizing practice, working with community groups and unions, and providing darkrooms, workshops and in some cases cameras to the working class (Braden 1983: 29).[14] Half Moon also produced an influential magazine called *Camerawork* from 1976, which introduced photographers to theoretical and politically engaged forms of practice.[15] In a text Spence wrote for the first issue, "The Politics of Photography" ([1976] 1995: 35), she decried the elitism of the profession and argued passionately that community photography "puts photography into the hands of a lot of people who will eventually be able to dispense with the experts." The workshop and the magazine were informed by Marxist theory and the writings of Walter Benjamin, notably his freshly translated 1934 essay "The Author as Producer" which famously encouraged artists to develop modes of mass participation:

> What matters therefore is the exemplary character of production, which is able, first, to induce other producers to produce, and, second, to put an improved apparatus at their disposal. And this apparatus is better, the more consumers it is able to turn into producers—that is, readers or spectators into collaborators.
>
> (Benjamin [1934] 1999: 777)

Together with Benjamin, a key source of inspiration for the Photography Workshop and politicized documentary circles was the awareness of historical worker photography (Chapter 1), a movement they sought to revive.

Since those involved in British community photography regarded cultural production as an agency of class-consciousness, they also sought to dismantle, in Jessica Evans's terms (1997: 11), the orthodoxies "which claimed for photography the status of art with its ideological baggage of expressive individualism." As Su Braden argues in her 1983 historical account of radical photography, *Committing Photography*, Half Moon's policy was at least in part a reaction to the creation of photographic galleries such as The Photographers' Gallery in

1971, which focused on photography as an individualized art form (1983: 29). By contrast "community photographers" understood authorship as shared, and sought "to bring the possibility of producing and distributing photographs into the context of community life" by setting up "facilities and training opportunities in contexts which they felt were more accessible to working people" (Braden 1983: 30). That is, their commitment lay in forms of collectivity and education. Braden (1983: 88) explains the political rationale underlying the need for "an iconography of self-representation," premised on notions of visual literacy based in Freire's educationalist philosophy:

> The implication of seeing photography as a collective activity is revolutionary. It implies a process of co-learning and integration on the part of the photographer and photographed and, often, co-ownership of the tools: camera, darkroom and means of publication of the images through posters, slide shows, books or magazines.
>
> (Braden 1983: 17–18)

Crucially, in other words, community photographers were interested not only in empowering participants but also in the politics of distribution and publication, as a struggle against what they saw as the domination of mass media and its investment in retaining the status quo. However, this project became significantly more difficult after Margaret Thatcher came to power in 1979 and set about slashing arts funding and repudiating political identifications in favor of individualist aspiration. Under these new circumstances, the success of Spence's turn to "phototherapy" in the 1980s, which asked subjects to act out personal narratives and claim agency for their own biography, reflects a general loss of faith in the earlier documentary projects.[16] Phototherapy was collaborative, but it was stage-managed—a "phototheatre of the self," as Spence described (Spence and Martin 1995: 165). Increasingly, through to her death from breast cancer in 1992, which she famously documented in graphic detail, Spence turned the camera on herself to produce raw and confessional self portraits—often photographed by collaborators. While her work critiqued women's role in the family and society, and challenged expected codes of behavior, Spence no longer focused on empowering others to photograph.

It is out of this background context that Luvera's work needs to be understood. Luvera initially worked as a fashion and portrait photographer before moving to London in 1999. By this time, the community photography movement had long since collapsed. As Spence's work suggests, photographers had moved on to other concerns by the mid-to-late 1980s; the postmodern critique of representation viewed documentary realism with suspicion, while Thatcher's cuts to local councils meant that money was no longer available for community projects. Nevertheless, by 2001, when Luvera began to work with people who

had experienced being homeless, the politics of self-representation raised by community photography—although poorly recognized in mainstream histories of photography and hardly fashionable—were being rediscovered by a new generation.[17] As Luvera tells it (Luvera 2006), when a friend suggested he "get involved as a photographer at Crisis Open Christmas, the annual event for homeless people in London" he was initially unnerved, and thought to himself, "I'd much prefer to see what the people I met would photograph." When he decided to undertake a project, it was initially motivated by the idea of a participatory archive. He sourced one thousand cameras and processing vouchers and invited the homeless and ex-homeless "to collect cameras to take away and photograph whatever [they] liked" (Luvera 2006). Participants ranged from the ages of nineteen to nearly ninety, and extended conversations around communal tables ensued. Luvera was learning on the spot. In 2005, when the images were exhibited for the first time, it was notably in a public venue rather than an art gallery. Selected color photographs from the archive were exhibited across the London Underground at a dozen tube stations, along with a portrait of each participant and contextual information about the work.[18]

In Luvera's words (2006), the purpose of the portraits was to recognize "the individual creators of the images," or "to create representations of the contributors to the archive." However, the nature of the portraits is particularly interesting in light of Braden's critique of differentials in the quality of equipment between ordinary participants and professional instigators. Unusually, Luvera set out to approach the acknowledgment of the authors of the photographs with the type of professional camera normally reserved for epic landscapes. Braden (1983: 30) is critical of what she calls "token" forms of participation—which involve no collective discussion, or in which locals use snapshot cameras while professional photographers use more sophisticated equipment. By contrast, following a year of experiments with a variety of technical set ups to establish a production methodology for the portraits, Luvera (2010: 230) eventually:

> met with each participant over the course of a number of meetings to teach them how to use a 5 × 4 field camera with a tripod, handheld flashgun, Polaroid and Quickload film stock, and a cable shutter release. The final image was then edited with the participant.

Luvera coined the term "Assisted Self-Portraits" to describe this production process (Figures 3.3 and 3.4). Although it bears a striking similarly to aspects of Ewald's approach, Luvera's slightly more straightforward aim is:

> to invest in the participant a more active role in the creation of their portrait representation than is usually offered in the transaction between photographer and subject. Each *Assisted Self-Portrait* is the trace of a process that

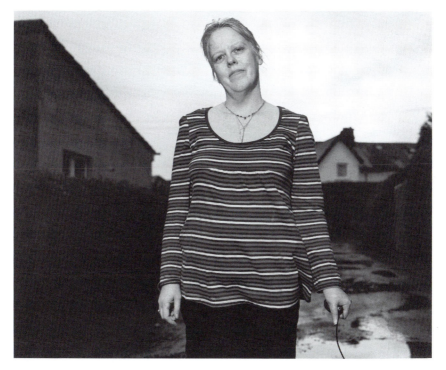

Figure 3.3 *Assisted Self-Portrait of Angela Wildman* from *Residency*, 2006–8, by Anthony Luvera. Original in color. Courtesy of the artist.

attempted to blur distinctions between the participant as a "subject" and me as the "photographer" during the photographic sitting.

(Luvera 2010: 230)

Such self-reflective language about what he calls "the photographic transaction" (2006) underlines the fact that Luvera's work has always been motivated by what he calls "the problems of documentary representation and in exploring the potential of finding ways for participants to express aspects about themselves" (Luvera 2013: 47).[19] In terms of the collaborative dynamic between the artist and the homeless participants, the practical result is that Luvera—the professional photographer—becomes "an assistant to their image making" (Luvera 2006).

Luvera has been specifically drawn to groups or communities who he says "are generally spoken for"—such as the homeless, people dealing with addiction and more recently the queer community (Griffin and Luvera 2015). But his long-term commitment to the project of working with the homeless is clearly related to his interest in people's experience of *place*, "and how this impacts on their lives" (Griffin and Luvera 2015). Indeed, this interest in place is embedded into his working process. When he creates a portrait, he asks each participant to take him to

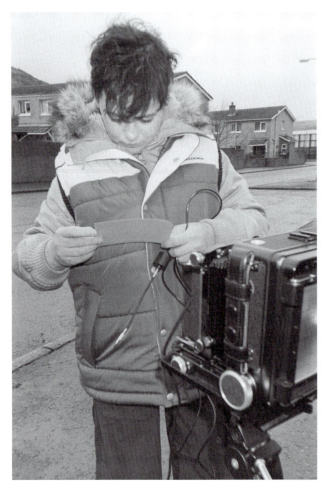

Figure 3.4 Documentation of the making of *Assisted Self-Portrait of Caroline McDonnell* from *Residency*, 2006–8, by Anthony Luvera. Original in color. Courtesy of the artist.

"places that have some kind of personal significance to them" (Griffin and Luvera 2015). Of course there is an additional poignancy here in that homeless space is confined to the public sphere. More than one of his subjects have photographed cardboard boxes, a view of home on the street. But there are other examples:

> For a participant called Angela Wildman it was the nostalgic pull of an address that was once a family home; a place she had not revisited for over a decade. For Caroline McDonnell it was a green space next to a housing development on the very edge of the city where she had spent much time as a youth.
>
> (Luvera 2010: 230)

These examples are from *Residency* (2006–8), which Luvera created with homeless people living in Belfast. He went to Belfast to study an archive of photographs called Belfast Exposed, a grassroots organization established in the early 1980s by a collective of local photographers unhappy with how "the Troubles" were being represented by the media, who put out an open call to the communities of Belfast to submit photographs.[20] But one of the effects of the visit was to sharpen his sense of being a cultural and political outsider (Griffin and Luvera 2015), leading to his volunteering in a homeless support service, the Welcome Organisation, cooking and serving breakfast, lunch, and dinner. In thus earning participants' trust, he then invited people he met "to take cameras away and to photograph the things they were interested in, and to share their photographs" (Griffin and Luvera 2015). In this way, photography also becomes a vehicle for Luvera to make a social connection with strangers.

As noted, Luvera's collaborative approach is sensitive to, and even motivated by, the problematic "ethics of witnessing" associated with documentary photography (Griffin and Luvera 2015). He is, for example, aware that the participatory methodologies of production—in his own work as well as Ewald and others discussed here—can have certain limitations. In her important essay "Post-Documentary, Post-Photography?" originally published in 1999, Martha Rosler's "great admiration" for projects motivated by what she calls "equalization theory" is "tempered by some concerns":

> Freire's methodology was pedagogical, meant for use within a learning group, where his technique has repeatedly been shown to be powerfully effective. With work that circulates publicly, however, relying on giving the camera to the subjects underestimates the shaping effect of institutions and the context of reception, which are likely to reimpose the unequal power relationship banished from the photographic transaction.
>
> (Rosler [1999] 2004: 228)

Rosler points out that the projects gain "credibility for external observers from the subjects' sharp investedness [and] possibly from photographic naiveté (many such projects employ children)" ([1999] 2004: 228). But for Rosler (228), such work is too easily recuperable or at least "vulnerable to those with no desire to change political realities," and easily comes to be seen as "therapeutic or cathartic." Moreover, in her view, although "[t]he best of these undertakings project a powerful idea of the subjects' desired self-image . . . in routine applications the skills of the facilitating photographer are not put to full use" (228). The danger, as Rosler sees it, is a form of "positivism" where "one obtains testimony but only limited analysis" (228). Luvera is acutely aware of this critique.[21] In response, he sees himself creating a public archive, directed

towards the future, about the homeless and other marginalized groups. As he argues:

> in order to expand the possibility of providing a more replete representation of people who might otherwise be forgotten, excluded or spoken for, the archival record must be supplied with a greater diversity of sources, accounts and representations of those individuals.
>
> (Luvera 2010, 238–40)

In Luvera's view, inevitably, this archive is always partial and histories always incomplete, but documents nevertheless take on a form of "authority" (Downey and Luvera 2007).

In 2014, Luvera was commissioned to produce a work to celebrate the cultural heritage of the queer community in Brighton (and Hove), as a way of preserving a social history of a place otherwise poorly represented in mainstream accounts.[22] His artistic project, *Not Going Shopping* (2013–14), extended his interest in inviting the people he works with "to contribute to making or saying something about themselves and the places they live in" (Griffin and Luvera 2015).[23] Taking its name from the protestors' chant—"We're here, we're queer and we're not going shopping!"—the work involved a collaboration with eleven residents to create photographs expressing personal perspectives on being queer. Over nine months, Luvera created collaborative portraits which were then exhibited as temporary large-format posters in outdoor public spaces across Brighton in February 2014. They comprised four separate images, two Photobooth self-portraits, a site-specific assisted self-portrait, and a handwritten statement (combining moving confessions and political defiance, such as "I don't have to explain myself," "Just another person," and "Never apologise"). In addition, he distributed 3,000 copies of a free newspaper, incorporating social media and blog discussions that chart the collaborative working process. Thus, in its attention to public distribution, Luvera's work takes up one of the key challenges laid down by British community photography in the 1970s, now updated to a new media era. Positioned as a consciousness-raising exercise, and a way to raise the visibility of queer people, the project also became a celebration of Brighton as the unofficial "gay capital of the UK." Importantly, as a gay man himself, Luvera included himself as one of the subjects, further blurring his role as the photographer–artist and subject, and—even as he is insistent that his intention is not for his work to be therapeutic for participants—perhaps linking his work back to the example of Spence's phototherapy (Figure 3.5).[24]

Luvera's handwritten text asks "Are we a community?" To this question we might add: what does community mean? Community is a term frequently used in relation to the work discussed in this chapter, but its meaning is by no means self-evident. As Braden observed back in 1983, "'community' has become a

Figure 3.5 Anthony Luvera, *Collaborative Portrait of Anthony Luvera* from *Not Going Shopping*, 2013–14. Original in color. Courtesy of the artist.

confusingly fluctuating and ambiguous term" (1983: 66) often marked by nostalgia in relation to place. For Evans (1997: 26), looking back in 1997, one of the reasons for the demise of community photography in Britain was the realization that "'the community', previously imagined as stable and self-evident was as much the object of the photographer's imagination as it was of any community photographed." As she argues, "[t]he discourse of community was often based on the assumption that identities are just there, ready-formed and waiting to be found" (1997: 29). This problem of idealizing community as a false unity has been articulated repeatedly over the past two decades by writers interested in community and public art, not to mention philosophers and social theorists. It poses a particular conundrum for artists seeking to collaborate, since the idea of

community can all too easily become instrumentalized (Ashford et al. 2006: 63). Thus in a well-known critique by the art historian Miwon Kwon:

> an unquestioned presumption designates the community as a group of people identified with each other by a set of common concerns or backgrounds, who are collectively oppressed by the dominant culture, and with whom, in the context of community-based art, artists and art agencies seek to establish a collaborative relationship.
>
> (2002: 145)

For Kwon (2002: 7), writing about the North American context, this mode of identifying communities in advance of potential collaborations has popularized a bureaucratized and formulaic version of community-based art, in which the notion of the community is rhetorically elevated but remains "a phantom." Kwon is interested in the ways in which artists can help engender different types of community. She questions the presumption that an artist's insider status guarantees a project's success (2002: 135), but supports the idea that an art project can be a catalyst for the development of new alliances and coalitions, however temporary. Claire Bishop (2012a: 179), writing on participatory authorship and the collapse of British community art, is similarly critical of its co-option by government agencies as ameliorative, and what she considers an excessive "emphasis on social process rather than outcomes." Although Bishop (2012a: 190) makes no direct reference to community photography, she makes a revealing reference to its aspirations:

> Today, when the majority of people in the West have the means to be a producer of their own images and to upload them to a global audience via Flickr, Facebook, and so on, such a dehierarchising agenda arguably has less urgency—even while the bases of these networks are unquestionably commercial, and access to technology is also a class issue.

To be sure, the desire to empower people with cameras might now seem almost quaint, given the ubiquity of networked camera phones, without processing cost or limits to distribution.[25] Beyond photography, the idea of "empowerment" itself has also been de-politicized as it has become institutionalized and individualized, associated with a shift in the language of political change to that of the personal development and the self-confidence of individuals (Bertrand 2015). And yet, the act of physically collaborating with marginalized people remains important to artists like Ewald and Luvera, just as the physical materialization of their images in public spaces remains distinct from online display (which is not to say that artists like Ewald and Luvera do not also engage in new distribution platforms). To their credit, Ewald and Luvera are conscious of the dangers of

speaking on behalf of the individuals they work with, or for an imagined community. As Ewald notes, in an interview with Luvera (2013: 53), "I ask my collaborators to represent their community, which is difficult because it's largely something that can't be photographed." Luvera simply holds open the possibility of the development of fluid forms of community, in a photographic practice he modestly describes as based on "co-production, facilitation and degrees of collaboration" (2010: 240).

Simon Terrill: The amorphous community

In the work of London-based Australian artist Simon Terrill (1969–), a collaborative approach to photography becomes a vehicle for a discussion about what community means in relation to particular places. Since 2004, Terrill has staged an ongoing series of photographic performance events to produce spectacular "portraits" of groups of people at specific urban sites. In each of these "portraits"—which finish up as monumental landscape prints several meters across—people are invited to come together for a photographic event, and given the opportunity to collectively represent themselves. As he describes:

> For each event, a time and place is specified and people are invited to respond to the site, but their specific actions on-site are left undirected and uncontrolled.
>
> (Terrill n.d. "Crowd Theory")

Terrill's invitation to improvise is nevertheless framed as a dusk-lit drama, heightened by the addition of cinematic lighting, smoke machines, and even a soundtrack. This way of working was developed in his first commission with a community center in Footscray, a culturally diverse, traditionally working class suburb in Melbourne's west. When the local neighborhood was invited to participate, people took up their parts with great enthusiasm. The resulting mural-scale image, *Footscray* (2004), foregrounds a series of paths on the banks of the Maribyrnong River, with its incongruous palms, set in front of an industrial backdrop and the cityscape of Melbourne in the distance (Figure 3.6). Artificial lighting draws our attention to various scenes within the tableau, such as a garden bed tended to by some elderly citizens. Certain scenes appear to have been choreographed for the shoot, such as a group of people enveloped in smoke. Although the artist refers to a random orchestration of bodies, observing the sense of drama and play it comes as no surprise to learn that Terrill's background lies in the collective art of theatre.

Southbank (2007) is a photograph of two inner-city middle-class apartment blocks. The artist letter-boxed apartment dwellers with an invitation to appear

Figure 3.6 Simon Terrill, *Crowd Theory, Footscray*, 2004. Original in color. Courtesy of Sutton Gallery, Melbourne.

in his work, leading to more than 300 people voluntarily taking part. They are seen posing on their balconies, lingering on the street below, or simply resting in their lounge rooms with the blinds wide open. We also see a removalist truck, clothes thrown onto a tree, and even a window washer abseiling down the building. All of these elements introduce a degree of drama, though it is unclear which if any are staged for the camera (akin to Jeff Wall's "near documentary" approach, some aspects of the scene were apparently based on events the artist witnessed while making preparatory drawings). *Port of Melbourne* (2008) depicted a site and crowd of a different kind. At sunset on a wintery Saturday evening, around 150 people were driven by bus from nearby Footscray to the restricted working Port zone, as ships were being loaded with crates. Those who participated ranged from people who have worked at the dock, protestors against the then proposed dredging of the Yarra River (a woman with "stop toxic sludge" written on her jacket), people who spent cold days and nights on the docks during a major strike in 1998, interested local residents (one of whom decided to play the trombone), and even a former milkman who had delivered dairy products to the site for two decades. It is a diverse, even potentially divided group of people, as the cracks in the weedy ground almost seem to suggest, and far from the romanticized community of imagined wholeness we are more used to seeing in advertising.

After moving to London, Terrill turned—more by happenstance than design—
to a subject familiar within the history of British community art: the residents
of housing blocks. Thus for one hour in the early evening of November 18,
2010, he focused his large-format camera on the Brutalist Balfron Tower in
East London, a notorious modern housing block designed by Ernö Goldfinger
in 1963 (Figure 3.7). Once again, residents were invited to present themselves
for the picture in the manner of their own choosing. Film lights illuminated the
building, with its futuristic lift tower, as people crowded onto their balconies and

Figure 3.7 Simon Terrill, *Balfron Tower*, 2010. Original in color. Courtesy of Sutton Gallery,
Melbourne.

improvised performances on the grounds below. This work took on added complexity by virtue of its timing during a process of gentrification. Terrill's access to Balfron Tower had come about through an artist residency program (he lived in the building), but the atmosphere changed and tensions were heightened late in the process due to an announcement from the landlord that socially housed council residents were set to lose their right of return after the renovations, contradicting an earlier promise. The status of the project was put into doubt until residents decided that the work would now take on a memorializing function, and indeed the image is on permanent display at the community center at the base of the tower, acting as a kind of memorial to life before the privatization brought on by the conservative Cameron government. None of this is visible in the image itself, of course, elements of which seem to present an idealized image of community (one group of people play in a circle). However an accompanying publication reveals some degree of the complexity of the relationships experienced between the artist and the community depicted. Terrill tends to avoid presenting information about specific residents or the political context of a site, instead wishing to immerse viewers in the details of the final image. However, he has made efforts through publications and forums to encourage transparency and discussion around the work, and it is often shown together with a video interview that contextualizes its making. All of this resulting dialogue is part of the finished work.

Balfron Tower (2010) recalls some of the work of British conceptual artist Stephen Willats. Influenced by Roy Ascott's cybernetics, social systems, and semiotics, Willats's work since the early 1970s has consistently and presciently privileged the audience over the artist as the source of meaning.[26] In one of his best-known works, *Brentford Towers* (1985), Willats collaborated with residents of a West London tower block as part of his interest in the personalization of "authoritarian" institutional space. Willats wanted to understand how people used space; thus a series of photos were taken that characterize key ideas to be represented, and each participant then made a poster-like or collage-like display board from the documentation, selecting the photographs to be used and a quotation from the transcribed recording. Twenty-four display boards were eventually placed on landings in the towers for a month-long period in 1987 (Irish 2004; Kelly 1997). Willats (1983) treated the camera as "a component part in the agencying of social exchange," remarking of such work that:

> The divestment of my traditionally given authoritative position in the origination of a photographic image does not lessen its strength but rather, I have found, ensures its pertinence and meaning; for who are better able in the end to present themselves in the reality they inhabit than the subjects.

Willats thus sought to generate collective meanings in place of the authorizing role conventionally adopted by photographers, while nevertheless remaining a conceptual author and operating at a remove from community art.

Terrill's authorial position is similarly conceptual. On the one hand, he works like a film director, with as many as twenty people behind the camera helping him to establish an ambience. On the other hand, he is strikingly modest about the artifice of this framing, emphasizing that he does want to direct the outcome, but wants it to emerge organically ("Crowd Theory—Behind the Scenes" 2013):

> We know how the image is framed, but beyond that, what is in it, the actual narrative content of what happens down there, I want it to be what it will be, rather than predetermine or direct it.

To be sure, Terrill's work is highly contingent on what he describes as participants "mark[ing] their presence ... etching themselves into the image" ("Crowd Theory—Behind the Scenes" 2013). The language of etching is somehow appropriate, given the ten-second exposures typically involved, in which participants must either stand still or otherwise negotiate a ghostly effect. As a production manager on one of his shoots suggested: "Everyone has a role in the end result, whether they're in front of the camera or behind the camera" (Simon Nugent in "Crowd Theory—Behind the Scenes" 2013).

One of Terrill's stated aims is to explore the complex phenomenon of crowds (the ongoing series is collectively called "Crowd Theory"). He is interested in the fact that crowds are feared when they are an unruly mob and celebrated when they are conformist, such as when cheering on a sporting event. Terrill professes an interest in scientific theories of complexity and the self-generated energy of human crowd behavior. But as cultural historian Chris Healy (2006: 171) has observed, his use of the term crowd is something of a misnomer, given that most of his images are not in fact crowded, and in the case of the Australian sites, this very lack of density even potentially evokes the country's meager population. But as Terrill (n.d. "Crowd Theory") sees it:

> "Crowd Theory" seeks to expand upon accepted definitions and perceptions of what it is that constitutes a "community" and how this converges with the notion and implications of a "crowd."

Terrill could be said to locate the fleeting moments when a group coalesces into a crowd, giving us cause, as one critic has suggested (McFarlane 2005: 31), to reflect on "the nature of inhabitation and the amorphous workings of community." At the same time, in contrast to earlier community photography, Terrill's work seems to suggest the impossibility of picturing community in the age of neoliberalism and its emphasis on the individual consumer. Terrill's images could

not be confused with images of collective political action such as street protest, even if they do represent "common life" (Edwards 2009). Since people in Terrill's work are brought together only for a heavily mediated photographic event, any sense of collectivity appears as knowingly transitory and performative.[27]

Terrill's photographs are the end result of planning, collaboration, and, if we can still use the term, community cooperation. Inevitably, as with so much public art—and as we have seen with Ewald and Luvera's engagement with ordinary people—the process of producing the work is well documented, and that documentation is often included in the exhibition of the work.[28] The documentation underlines the theatrical staging; we see the artist–director standing on a scaffold tower with a megaphone in hand, calculating the scene for pictorial effect. In this respect, Terrill's working method overlaps with Spencer Tunick's kitsch arrangements of naked bodies in public spaces (in which, in return for highly choreographed public exhibitionism, participants are given a small copy of the resulting image). However, while Tunick's bodies are a homogenous mass of passive flesh—disturbingly evocative of photographs of mass graves at Bergen-Belsen—Terrill's participants are absorbed in various forms of activity.

Terrill's participants are aware of the camera, but his work can also be clearly distinguished from Melanie Manchot's invitations to random passersby in Moscow to pose for spontaneous group portraits, in which the subjects are frozen, isolated, staring at the camera.[29] Terrill's images are more like the unpredictable residue of an event involving real people in a place of some significance to them. The final image is both a document and a meta-document. The performative, even fictional, aspect of his project is underlined by the artist's confessed inspiration from the sixteenth-century paintings of Pieter Bruegel, who chronicled the actions of everyday peasant life in the Flemish countryside (Terrill n.d. "Crowd Theory"). While there are no obvious moral lessons in Terrill's photographs, there is a utopian strain in its carnivalesque portrayal of fluid and fleeting encounters, enhanced by visual associations to promotional imagery brought about by their sheer scale and hyperreal quality.[30] To be sure, the spectacle of Terrill's large-scale color prints—which bear a superficial similarity to some of Gregory Crewdson's melodramatically staged cinematic scenes—offers a marked contrast to the gritty and naturalistic black-and-white images associated with an earlier period of community photography.

One of the most compelling aspects of Terrill's site-specific work is the mode of collaboration it establishes between the artist and the community of individuals pictured. As we have established, his photographic events bring together groups of people who may not ordinarily have contact with one another. However, Terrill's way of working does not cede his authorial role to a cliché of community art, in which a community is harmoniously brought together by the artist. Instead, Terrill's images suggest a complex picture of the public, at once isolated and connected to a site. This is particularly apparent in *Crowd Theory Adelaide* (2013), produced

Figure 3.8 Simon Terrill, *Crowd Theory, Adelaide*, 2013. Original in color. Courtesy of Sutton Gallery, Melbourne.

at the city's iconic central public meeting point, Victoria Square (Tarntanyangga) (Figure 3.8). Commissioned by the local Samstag Museum of Art, Terrill put out an open call to anyone with an attachment to the city's central square to gather there, promoting the project widely around town (Terrill 2013). More than 350 people—young and old, even wheelchair bound—accepted Terrill's invitation to be present, to sit, stand, or otherwise perform for the camera. The final image— with its fabulous backdrop making a proscenium view of the town hall and the city's corporately branded towers—also includes an Indigenous elder, Uncle Lewis, sitting quietly, observing, dressed in a red kangaroo-skin cloak (Watson 2014). His presence is easily missed, but significant, given that the site had for centuries been a special meeting place of the local Kaurna people, known as "the Dreaming Place of the Red Kangaroo." This crucial layer of history is overlaid again by the knowledge that Victoria Square was the first place the Aboriginal flag was publicly flown on Friday July 9, 1971, in support of Indigenous land rights.[31] The site's layers of histories—it is also a traditional staging point for rallies and protests—means that many diverse people have a relationship to it. Thus, while it is easy to speak of the pictured collection of people in depoliticized pluralistic terms—"people from all walks of life," as Samstag Museum Director

Erica Green blithely suggests in a promotional video—it is also possible to view the work as a group of historically minded people marking their place in time. This facet is particularly pronounced, as the work was timed to coincide with the square's imminent redevelopment.[32] Indeed, the photographing of *Crowd Theory, Adelaide* took place the very evening before the square's demolition, its coming transformation already signaled by orange witches hats and temporary fencing in the image. Thus, as with *Balfron Tower*, the image takes on a series of memorializing functions, supported by a dedicated website designed for blog posts incorporating personal and political memories and histories of the site. It memorializes the site's current appearance, playing to a moment of transition by marking a moment in time, while celebrating the whole notion of public space that is so threatened by neoliberalism. This ambition fuses with Terrill's general desire, fundamentally collaborative, to "generate an arena for reciprocal viewing" (Terrill n.d. "Balfron") by offering his subjects the opportunity to return the camera's gaze in the manner of their choosing, collectively.

Conclusion

> This is the civil feature of photography—no one can dominate and possess it completely and become its sovereign.
>
> (Azoulay 2010: 256)

Photographs, Sekula reminds us (1978: 863), are "always the product of socially-specific *encounters*." This chapter has looked at the encounters initiated by three individual artists working with cameras who produce collaborative documentary records. In their work, social exchanges, ritualized in various ways, make photographic events happen. In their different ways, Ewald, Luvera, and Terrill's work elicits the interdependence of observer and observed, and willfully conflates authorship in the image between a photographer and his or her subjects as a way to overcome or subtly shift the problematic power relations that normally attend documentary photography. But there are other motivating factors. Ewald (2000: 18) discovers that it is "less interesting" for her "as an artist, to frame the world wholly according to [her] own perceptions" and turns to creating situations in which she allows "others' perceptions to surface with [her] own." Luvera finds a productive tension between artistic control and the ethics involved in making photographs about other people's lives. Terrill invites subjects to participate in the production of his images not by offering up his camera but by asking people to mark themselves in a specific place as it becomes memorialized as an image at a self-conscious moment in its history. Each of these collaborative approaches to image-making thus invite us to question the way we think and write about the documentary image. For the photographic images discussed in this chapter are

not the product of a single vision, but are instead collectively produced with or by others.

There is nothing inherently democratic or emancipatory about collaborative photography. After all, the photographs of prisoner abuse at Abu Ghraib prison in 2004 were a by-product of a group exercise in torture. Nor can the value of collaborative projects be reduced to their ethical purity of their production (Bishop 2012a). The degree of agency of participants does not in itself guarantee a successful artwork or exercise in community building. Nevertheless, attempts to overcome conventional power relations in documentary photography through forms of coproduction or coauthorship have now been incorporated into the arsenal of some of the most interesting practitioners, including Indigenous Australian photographer Ricky Maynard (quoted in Gough 1997: 114), who describes his approach in terms of "convivial photography":

> Standard photographic technique is essentially an act of subjugation, in which people are inevitably reduced to objects for the use of the photographer ... To build an alternative practice, a convivial photography, we need to abolish this oppressive relationship. Co-authorship must be established beforehand.[33]

Similarly, for the artists discussed in this chapter, the physical act of working with others, and indeed the physical dimension of the resulting photographic work, has generated complex bodies of work that extend our understanding of the acts of photographic production and reception. Here, once again, Azoulay's concept of photography as a "civil contract" among citizens is useful, reminding us that photography instigates a bond of mutual responsibility between spectator, photographer, and subject—and that this can take place either through the mediation of the camera or the photograph, or both. Echoing Sekula, Azoulay (2008: 127) suggests that "a photograph is evidence of the social relations which made it possible." But she also introduces a temporal element into the photographic encounter (Azoulay 2010: 252):

> A photograph is the space of appearance in which an encounter has been recorded between human beings, an encounter neither concluded nor determined at the moment it was being photographed ... The renewal of this encounter is a constant capacity of spectators who acknowledge the photographed persons and see themselves as their actual or potential addressees or partners.

Perhaps for obvious reasons, the encounters in this chapter have been primarily portrait-like. However, as we will discover in the next chapter, portraiture also offers up a range of other dynamic possibilities for photography and collaboration.

4
RELATIONAL PORTRAITURE: PHOTOGRAPHY AS SOCIAL ENCOUNTER

Portrait photography, almost by definition, involves the collaboration of subjects. Right from the earliest daguerreotypes through to today's selfies, people have been actively involved in the performance of their own pose. For instance, British photography historian Steve Edwards (1990: 68) describes how the enlightened subject of the bourgeois portrait in nineteenth-century studios "acts as co-author," collaborating with the photographer "to determine the codes of their own appearance, producing a self-image invested with confidence and contentment." Closer to the present, contemporary London-based German artist Wolfgang Tillmans refers to his photographs of friends and lovers as "collaborative" works, proposing that he leaves space for "collaborating with his friends to ensure that they properly 'impersonate' the idea of themselves" (Deitcher and Tillmans 1998: n.p.). As we saw in Chapter 3, however, the degree to which subjects are empowered to participate in the photographic act is closely related to their social power. As a vast body of critical literature since the 1970s has reminded us, the socially marginalized, and people of non-Western cultures, have frequently found themselves the unwilling subjects of the camera's gaze. In these situations, anthropological, legal, or touristic, the informal contract between the photographer and photographed has been skewed towards the presentation of an objectified "other"—a phantasmatic construction of the camera in its classificatory and acquisitive modes. However, even within such portraiture, close inspection of the evidence reveals that people have been more actively involved in their self-representation than is often assumed.

Most portraiture nevertheless still relies on a photographer making the critical decisions as to the form of the final image, and the involvement of the subject is relatively minor in most cases. That said, one can point to innumerable instances

in the history of photography where artists have collaborated over extended periods with particular subjects, usually friends or lovers. A list of memorable examples would include Julia Margaret Cameron with Julia Jackson, Lewis Carroll with Alice Liddell, Alfred Stieglitz with Georgia O'Keeffe, Man Ray with Lee Miller, Harry Callahan with Eleanor Callahan, Lee Friedlander with Maria Friedlander, and Nicholas Nixon with the Brown Sisters. In such cases, the subjects become increasingly involved in the construction of their image over time. Or consider a series like Nixon's *People With AIDS* (completed in 1991), which presents fifteen men and women with AIDS in the form of a long-term photographic observation, with the photographer revisiting his subjects over several years until their death. This approach is clearly based on the participation of the subject (in this case as to how they will be remembered); the images could only be produced on the basis of an open collaboration between the photographer and his subjects.[1] Indeed, Nixon's project also includes written texts to accompany the documentary photographs, along the lines pioneered by Jim Goldberg's *Rich and Poor* (1985).

Certain forms of photographic portraiture emphasize their collaborative dimension, and this chapter is dedicated to such examples. My case studies are more playful and idiosyncratic than the community-minded ambitions of the documentary work featured in the previous chapter. Where they are concerned with power relations, they more often exploit the authority of the camera as a device to gently question broader relations of social power, such as those between men and women. They include the self-consciously absurd ambitions of North American conceptual artist Douglas Huebler, best known for his signature work *Variable Piece #70 (In Process) Global, 1971* (1971–97) in which he famously set out "to photographically document … the existence of everyone alive"; Australian artist Micky Allan, whose work *My Trip* (1976) is the record of a seventeen-day road trip in which she took a photograph of everyone who spoke to her on the journey, and then offered the camera to the same subjects to photograph anything they chose; and the French artist Sophie Calle, who, with a willful sense of mischief, organized for a private detective to follow and photograph her over the course of a day in 1981. None of the works discussed in this chapter are straightforward portraits of an individual's character, although they often entail a degree of self-portraiture. Fundamentally they involve the use of the camera as a vehicle for social encounter, interaction, and exchange between strangers—or what I am calling "relational" portraiture.

Douglas Huebler: The camera as a social instrument

Douglas Huebler (1924–97) had been an expressionist painter, a minimalist sculptor, and also a teacher before becoming a pioneer of conceptual art in his

forties.[2] His sculptural works in the 1960s had already suggested the participatory and collaborative aesthetic that he would develop in his later work; not only did they emphasize the perception of the viewer and their awareness in space, but some of them contained elements that could be moved or repositioned by the viewer. However, in 1968 he abandoned the making of traditional art objects altogether, and in January the following year issued the statement: "The world is full of objects, more or less interesting: I do not wish to add any more. I prefer, simply, to state the existence of things in terms of time and/or place."[3] Huebler's laconic remark epitomizes conceptual art's uniquely self-critical tendencies, and has been described as lampooning "the expectation that artists be prolific" (Miller 2006: 221). Huebler was certainly witty and deadpan—"the less-dry conceptualist," as his friend Joseph Kosuth (1997: 15) suggests—but whether he consciously intended to produce humorous work remains a matter of speculation. Huebler turned to instructional procedures: systems of documentation to record rule-based but unscripted events and encounters, often tasks to be fulfilled within a specified time span and location. The various rule-based "experiments" he set himself and other people related to time and place were documented in works with carefully numbered titles. Like many artists of the time, he borrowed the language of mathematics and collected "data" with pseudo-scientific precision, pushing to a point of parody the technocrat's imperative to objectively measure the world through supposedly random samples (Shannon 2014).

Huebler began to use photography in 1968, though he maintained that he "wasn't a photographer" (Auping 1977: 41) and that he came to the medium by surprise. According to Huebler, photography became useful because it was simply "the most neutral way to bring back the quality of what one would call appearance" (Auping 1977: 38). More simply, prosaic documentary photographs provided a means of documenting various suggestions or instructions, starting with schematic locations on a map. Photography was already virtually present in Huebler's first information-based works involving travel and maps, which transplanted his interest in location from minimal sculpture and the emerging field of what came to be called land art. *Rochester Trip* (1968), for instance, comprised a mass-produced road map with a round trip indicated with a felt-tip pen, and a text directed to the viewer at the bottom that said in part: "The trip need not be taken, but if taken the above route must be taken. Whatever is seen when the trip is taken joins with this map as the form of the work" (Alberro 2003: 68). This "whatever is seen" becomes a kind of leitmotif for Huebler's photographic work, which he divides into three categories: *Duration* (regarding the passage of a chosen period of time), *Location* (at specific sites, sometimes related to "land art"), and *Variable* pieces (including viewer participation). All three are motivated by apparently arbitrary but strict rules, in which the structure is executed largely in the absence of Huebler's subjective input. Most often,

Huebler set up preplanned frameworks determining how and where and when his exposures would be made, allowing him to treat everyday activities as an occasion to produce documentation. According to his collaborator, the dealer Seth Siegelaub, the concept of the work functioned at the level of "primary information," and the documentation as "secondary information" (Alberro 2003: 69).

Huebler was among the first wave of conceptual artists to use text with photography. Text in his work is always written in ordinary language, and consists of declarative statements about the image that simultaneously challenges our perception of what we think we see.[4] However, the text is not strictly a *description* of the photograph(s). Rather, the typed statements are a linguistic directive that both produces the documentation *and* directs the viewer by describing the procedure. As captions, they raise as many questions as they answer. As Alberro surmises, the work "is comprised solely of the idea of the relationship that is signified by the documentation" (2003: 69). For instance, *Variable Piece #4, New York City, November, 1968* (1968) consists of a series of ten black-and-white photographs of pedestrians in Manhattan, supported by a signed text including the following directive:

> With his eyes completely closed the photographer sat on the corner of Vanderbilt Avenue: each photograph was made at the instant that the sound of traffic approaching 42nd Street stopped enough to suggest that pedestrians could cross the street.

John Szarkowski had staged his influential *New Documents* exhibition at New York's MoMA in 1967, celebrating what he understood as the unique photographic sensibilities of Diane Arbus, Lee Friedlander, and Garry Winogrand. By refusing the sense of sight, and surrendering the subjective control of pictorial composition to blind chance, Huebler effectively rejected outright the entire tradition of artistic street photography. Similarly demoting the photographer's eye in favor of the ear, Huebler repeated the idea in *Variable Piece #22, Turin, December 1969* (1969), in which he stood with his eyes closed for ten minutes and each time he heard an "excessively loud, or impatient" car horn turned in its direction and took a photograph.[5] Meanwhile, Huebler's early "Duration Pieces" were preoccupied with temporal regularities enabled by photographic documentation. For instance, in *Duration Piece #4, New York City, February, 1969* (1969), he made ten photographs, that begin at an "arbitrary location" at 8:45am, and then walking around the city doubled the intervals between each shot, making pictures at 8:46, 8:48, 8:52, and so on, ending at 4:16 that afternoon. In each case, Huebler claims that he photographed whatever "appearance existed closest to the camera (immediately to the left of the artist) at the exact instant that each such interval had elapsed." On their own, such works might seem nihilistic. Even more simply, *Duration Piece #7, New York*

City, 1969 (1969), consists of fifteen photographs made at one-minute intervals of "11 geese and an occasional pigeon" milling about a bench in Central Park, together with a characteristic explanatory statement. To make *Duration Piece #5, New York, April 1969* (1969), Huebler took a single photograph in the direction of a birdcall in Central Park, then walked toward the source of the sound until he heard another, at which point he made a picture facing the new birdcall, and so on, until ten such nondescript photographs had been created (Figure 4.1).[6] Huebler's love of nature was well known, as this "collaboration" with birds suggests.

Clearly, the resulting photographs are not important on their own. Indeed from a pictorial point of view it is hard to imagine more banal images, in the sense that composition appears random and nothing of obvious interest is happening within the frame. Huebler regularly spoke of wishing to empty out the photograph of conventional content, in line with his minimalist-inspired ambition "simply to state the existence of things in terms of time and/or place." Huebler famously claimed of his working method, in a statement accompanying a 1969 group show in Germany:

> I use the camera as a "dumb" copying device that only serves to document whatever phenomena appears before it through the conditions set by a system. No "aesthetic" choices are possible. Other people often make the photographs. It makes no difference.
>
> (Alberro 2003: 77)

In this way, the artist becomes a willing slave to the camera, open only to the traces of a process in which everything is treated equally.[7] Huebler's commitment to the equality of appearances reflects his background in minimalist sculpture, his extensive readings in Asian philosophy and his wish for people to "really pay attention."[8] As Alexander Alberro describes (2003: 72), Huebler, like many others of the time, sought to "dismantle the myth of privileged aesthetic experience" that underscored modernist painting, "advocating instead a doctrine of equal access and interaction." Huebler was insistent that his photographs were unimportant, "[r]edundant to the idea," stating in an interview in 1973 that the photographs "don't mean a thing, and they are not art" (Huebler and Kennedy [1973] 2004: 235). His approach established a dialogue with the photoconceptual work of Ed Ruscha and Robert Smithson, whose equally programmatic methods (and journeys) also avoided obvious pictorialism and conventional signs of photographic authorship (Chapter 2). But even as his individual photographs are unimportant, Huebler's work often seems engaged with the history of photography. As Joshua Shannon argues (2012: 91), Huebler seems "to have wanted his art to negate the imperative that modernist photographers grasp condensed nuggets of reality, instants that could be unfolded

Figure 4.1 Douglas Huebler, *Duration Piece #5, New York, April 1969*, 1969. Photographs, statement. ©Douglas Huebler/ARS. Licensed by Viscopy, 2016. Courtesy of Paula Cooper Gallery, New York.

metonymically to reveal organizing truths."[9] Thus the thirteen photographs of clouds in *Location Piece #1, New York–Los Angeles, February 1969* (1969) could be read as a riposte to Alfred Stieglitz's famously expressive series of cloud photographs, *Equivalents* (1922–35). Huebler's work comprised a series of photographs together with an American Airlines map showing the coast-to-coast route between New York and Los Angeles. Huebler took the flight and pointed his camera "more or less straight out of the aeroplane window (with no 'interesting' view intended)."[10]

In one of two works included in Kynaston McShine's *Information* exhibition at MoMA in New York, *Location Piece #6, National, 1970* (1970), Huebler again explored the idea of "interesting" photographs. He sent a letter to newspapers across the country requesting they send him a published photograph of local interest, made by a staff photographer. The image had to be 8 x 10 inches, and did not have to be either "interesting" or "good." Huebler effectively curated a collection of fifteen photographs taken by local photographers in various small towns across the country. Various photographic clichés are represented, from reflections to dramatic clouds to pretty women and furry animals. In this act of dislocation and recontextualization, Huebler did not so much reauthor the photographs as put the work of interpretation onto the viewer, much as Larry Sultan and Mike Mandel were to do with *Evidence* a few years later (Chapter 2).[11] "All of my works," as Huebler put it, "have been directed towards the process or the capacity of a work to generate the making of the work by the percipient" (Auping 1977: 37).[12] Dropping the terminology of phenomenology favored by Huebler, Alberro (2003: 80) surmises that Huebler's work "involved a dialogic relationship between instructions and viewer participation." It marked "a fundamental shift of authorial agency" in which "the spectator now sets the work … in motion" (Alberro 2003: 80). As the critic Clement Greenberg accurately described, but to his obvious dismay, late modernist art was thus "perpetually in process" rather than "a vehicle of expression or feeling" (quoted in Alberro 2003: 82). Tied up in Huebler's way of working was a radical new way of thinking about photography as a text to be enacted, since as he put it (Auping 1977: 37): "There is no past in the image. There is a present and the present is when the person is reading it."

During a ten minute period of time on March 17, 1969, ten photographs were made, each documenting the location in Central Park where an individually distinguishable bird call was heard. Each photograph was made with the camera pointed in the direction of the sound. That direction was then walked toward by the auditor until the instant that the next call was heard, at which time the next photograph was made and the next direction taken.

The ten photographs join with this statement to constitute the form of this piece. April 1969.

Huebler's work was often contingent on collaboration with people, and Huebler found himself drawn to the genre of portraiture. As he put it in hindsight (Auping 1977: 41):

> I found I was giving myself permission to photograph people. I began recognizing myself as a social being, recognizing the camera as a social instrument, in that I could use it as a form of social mediation.

This comment is obviously revealing, and helps to explain why Huebler's pictures of individuals reject the traditions of photographic portraiture as an insight into a subject's interiority. Huebler may not have set out to critique the Cartesian subject, but as Gordon Hughes (2007: 61) speculates, his turn to portraiture, circa 1970, was undoubtedly motivated by an understanding that it is "the nature of the photographic portrait ... to destabilize its subjects." Take, for instance, *Variable Piece #34, Bradford, Massachusetts, December 1970* (1970) (Figure 4.2). For this work, as the typewritten text tells us, "forty people were photographed at the instant exactly after the photographer said, 'You have a beautiful face.'" As Huebler describes it, the work developed:

> out of being in the streets using the camera and finding out the power the camera has and the social reactions that people have to it, how they duck,

Figure 4.2 Douglas Huebler, *Variable Piece #34, Bradford, Massachusetts, December 1970*, 1970. Photographs, statement. ©Douglas Huebler/ARS. Licensed by Viscopy, 2016. Courtesy of Paula Cooper Gallery, New York.

how they cringe and so forth. To pose for your photograph … is to be the most self-conscious that you can be.

<div align="right">(Auping 1977: 42)</div>

Once again proclaiming an equality of appearances—that "any face is beautiful" (Auping 1977: 42)—Huebler says he meant to give his subjects a "gift." Mark Godfrey (2002: 12) interprets such works in ethical terms as "a record of a series of generous actions" rather than merely "a playful investigation of the way photography mediates social behavior."

Huebler's most ambitious portrait project, unquestionably, was *Variable Piece #70 (In Process) Global, 1971* (1971–97), in which he emphatically announces his intention "to photographically document … the existence of everyone alive":

> Throughout the remainder of the artist's lifetime he will photographically document, to the extent of his capacity, the existence of everyone alive in order to produce the most authentic and inclusive representation of the human species that may be assembled in that manner.

This patently absurd proposition accompanies each version of the work, presented in a boxed text format in a standard but separate font, becoming a kind of prospectus for an endless project pursued over his lifetime. It is of course highly self-conscious, for the key phrase "to the extent of his capacity" thoroughly undermines the apparent claims of the project. But despite its impossible ambition, its universality implies a degree of Marshall McLuhan era utopianism, as the term "Global" in the title suggests. Indeed, this work—made at the very start of the information age—could be said to preempt by more than two decades the global dimension of the Internet and social media. Huebler described his "Everyone alive project"—as he referred to it in later versions of the works—as an address to "humanity" (Auping 1977: 42). But he also described it as "a method to create an umbrella or ongoing strategy" where he could "associate certain language clichés and mythic forms with appearance" (Auping 1977: 42). Typical versions of the work include a contact sheet and a street scene with a text such as "at least one person who is most probably more interesting than the artist," "at least one person who the artist knows," "at least one person who may now be dead," and so on. As various writers have observed, it was always "the responsibility of the viewer to decide the person to whom the text referred if they chose to accept the challenge of guessing" (Mark Godfrey 2002: 11). Mark Godfrey (2002: 11) argues that such works "suggest what is at stake in the encounter with a stranger, the fantasies we project onto others, the responsibilities in play at the moment of judgment." Another version of the work from 1975 features an array of 160 faces "individuated through a series of darkroom procedures"—enlarged from the background of images. Perception, like photography, is only ever partial.[13]

If "everyone alive" mocks the archival pretensions of photography and its dream of an all-inclusive repository of human existence (Hughes 2007: 68), it is all the more ironic that in 1972 Huebler made a series of portraits of Bernd Becher while visiting West Germany. *Variable Piece #101, West Germany, March 1973* (1973) plays out Huebler's interest in the mismatch between photograph and text through a parody of the nineteenth century pseudo-science of physiognomy (Figure 4.3). This work stands as a classic example of collaborative portraiture, involving an elaborate game with a subject. As the accompanying

Variable Piece # 101
West Germany

On December 17, 1972 a photograph was made of Bernd Becher at the instant almost exactly after he had been asked to « look like » a priest, a criminal, a lover, an old man, a policeman, an artist, « Bernd Becher », a philosopher, a spy and a nice guy... in that order.

To make it almost impossible for Becher to remember his own « faces » more than two months were allowed to pass before prints of the photographs were sent to him; the photographs were numbered differently from the original sequence and Becher was asked to make the « correct » associations with the given verbal terms.

His choices were :

1 Bernd Becher	6 Policeman
2 Nice Guy	7 Priest
3. Spy	8 Philosopher
4 Old Man	9 Criminal
5 Artist	10 Lover

Ten photographs and this statement join together to constitute the final form of this piece.

March, 1973

Variable Piece n° 101
République Fédérale Allemagne

Le 17 décembre 1972 une photo de Bernd Becher a été prise presque exactement après qu'il lui ait été demandé de se « mettre dans la peau » d'un prêtre, d'un criminel, d'un amoureux, d'un vieil homme, d'un policier, de « Bernd Becher », d'un philosophe, d'un brave type... dans cet ordre.

De façon à ce qu'il soit presque impossible, pour Becher, de se souvenir de ses propres « mimiques », plus de deux mois ont été attendus avant que les épreuves de ces photos lui soient envoyées ; les photos étant numérotées dans un ordre différent par rapport à la séquence originale, il fut demandé à Becher de rétablir les combinaisons originales.

Ses choix furent les suivants :

1 Bernd Becher	6 Agent de Police
2 Brave Type	7 Prêtre
3. Espion	8 Philosophe
4 Vieil Homme	9 Criminel
5 Artiste	10 Amoureux

10 photos et cette déclaration, réunies, constituent la *forme* de cette oeuvre.

Mars 1973

Figure 4.3 Douglas Huebler, *Variable Piece #101, West Germany, March 1973*, 1973. Photographs, statement. ©Douglas Huebler/ARS. Licensed by Viscopy, 2016. Courtesy of Paula Cooper Gallery, New York.

Figure 4.3 Continued

text describes, Huebler asked Becher (who is so absent from his own work) to pose as ten different types of people, including "Bernd Becher," "nice guy," and the professions of "priest," "criminal," and so on, in obvious reference to August Sander's taxonomic portrait project that had so influenced the Bechers (Hughes 2007: 65–6). Two months later, Huebler asked Becher to "make the 'correct' associations with the given verbal terms," although we have no idea how successful he was. Becher's caricatures both contrast with the earnestness of his

work, and reveal what Hughes calls (2007: 61) "the constitutive illiteracy of the physiognomic face." As various critics have observed, Huebler's interest in the notion of appearance and the unstable identity of a face extends to the theme of look-alikes, which recur again and again in his work (Sundell 2002; Hughes 2009). In *Location Piece #17, Turin, Italy* (1973), Huebler even sees his own "artist double" in a snapshot "at an arbitrarily chosen location lying just beyond the limits of human perception"—in sharp contrast to so much street photography of the time, such as Diane Arbus, which sought out "freaks." According to Margaret Sundell (2002: 200), rather than "idealized, if fleeting, instances of human connection":

> Huebler's fascination with look-alikes subtly disrupts our sense of stable, autonomous subjectivities. Instead of a humanist account of individualism, his doubles and resemblances suggest an equivalence (if not flat-out interchangeability) between human subjects.[14]

Indeed, in *Variable Piece #107, London, 1972* (1972), Huebler photographed a mannequin in a store window, and then the first passerby he saw of the same sex, repeating the procedure eighteen times. The unexpected likenesses between the idealized mannequins and the pedestrians offer a clear example of Huebler's interest in chance and game-like rules, while the work "revels in photography's exemplary arbitrariness" and caricatures its supposed authority (Miller 2006: 226). Huebler's fascination with doppelgangers also extended to collaborative works that draw on participation and reciprocity. In one, following an invitation by a university to submit an instructional work, Huebler instructed students to find their (unrelated) look-alike, and photograph themselves with that person. Huebler offered his fee as prize money for the best pair, and the photographs and instructions became *Variable Piece #135, Edinboro State College, Edinboro, Pennsylvania, January 1974.*[15]

Huebler's repositioning of the spectator as a participant in the creation of the work of art also extended to potential owners of his work. Several of Huebler's early works played with the psychology of limited editions, and others required the collector to make the work.[16] For example, in *Location Piece #14, Global Proposal, 1969*, Huebler dictated that twenty-four photographs be taken from a plane window, every hour at fifteen degree intervals to form a "map of the world." The "responsibility for fulfilling every aspect of its physical execution" however, fell to the "future owner of this work" (Harris 2013: 260). Likewise, *Variable Piece #44, Global, 1971* (1971–80)—a work in progress for ten years that documents an individual's transformation over time—is a collaborative work that requires future owners to arrange to have a photograph taken of his or her face, append the photograph within appropriate squares on the work, and also

send a copy of the portrait to the owner directly preceding it and directly following it in the series. As the typewritten instructions, in mock legalese, printed on the work state: it "will become *original* after the owner has completed it."[17] All of these works confirm Huebler's declared interest "in releasing the viewer ... to do whatever he wants to with the image given" (Huebler and Kennedy [1973] 2004: 235–36). Here we again see the influence of Duchamp on Huebler, who in a lecture in 1957 famously declared that the "creative act is not performed by the artist alone" (1973: 140) but is a transaction between artist and spectator. As Huebler's friend Joseph Kosuth wrote (1997: 16), in a reflection upon his death, "[W]e both made art a verb, not a noun: the meaning of a work of art is completed by the viewer." Huebler applied this insight to photography, turning it into a kind of game.

Like so much conceptual art based on external organizing principles that negate subjective artistic decisions, Huebler's work tells us almost nothing about the curious and enigmatic figure of Douglas Huebler the artist—even as he sometimes appears in the work. We can speculate that Huebler brought a wry sense of humor to his work, but the work topples the fixation on the individual artist. Huebler is one of many artists since the 1960s who saw in the medium of photography an opportunity to do more than record events or express emotions. Although his work is often disarmingly simple, its emphasis on the temporal dimension of both its production and reception marks a crucial double shift in traditional ways of thinking about photography. Not only does the use of photography within his work invite the activation of the viewer at the time of their encounter with the work—thus making them a collaborator in the meaning of the work—but Huebler's practice of taking photographs, in its rejection of aesthetic closure, can be considered one of fundamental openness to the world and its constant changeability. Consider *Variable Piece #43, Brussels, March, 1974*, made after a group of boys notice his camera, and rush to demand that he take photographs of them. As the statement tells us, "The artist immediately responded to the playful spirit of the boys by simulating the 'quick-draw' manner of the gunman seen in Western movies." Once again, as Godfrey (2002: 11) suggests of Huebler's street portraiture in general, and in contrast to so much photography of the time, by suspending judgment, "Strangers are encountered as fellow people, not as oddballs." Such examples support the claim that Huebler's work is "a proposition ... of a model of an idealized social interaction" (Mark Godfrey 2002: 13). It also resonates with another of Huebler's stated desires, that of his work's broader accessibility: "to suspend the notion that art is about museums and about all of the things that art has been about ... and open it up for more people" (Alberro 2003: 83). This democratic ambition, together with Huebler's interest in movement and travel, gives his work a great deal in common with my next example.

Micky Allan's *My Trip*: The democratic act of photography

In late 1975, Australian artist Micky Allan (1944–) wanted a break, so she set off alone in her car from Melbourne, immediately after Christmas, with "a map, but no other plans." What followed was a seventeen-day summer road trip around country Victoria. But while the itinerary was loose, Allan took with her a specific project: to take a photograph of everyone who spoke to her, and then to offer those same people her 35mm camera to take a photograph of their choosing. This simple but generative "instruction" is recalled in a handwritten text on the second page of the twenty-page newspaper-cum-artist-book that was the end result of this experimental journey, *My Trip* (1976), which she offered for sale in newsagencies (Figures 4.4 and 4.5). The same text explains that each of its following pages feature various pairings of photographs and text that are the result of these social interactions: "On the left in each pair is my photo of them, and

Figure 4.4 Micky Allan, *My Trip*, 1976. Offset lithographic prints, letterpress, 45.5 x 29 cm (closed). National Gallery of Australia, Canberra. Purchased 2012 ©Micky Allan/Licensed by Viscopy, 2016.

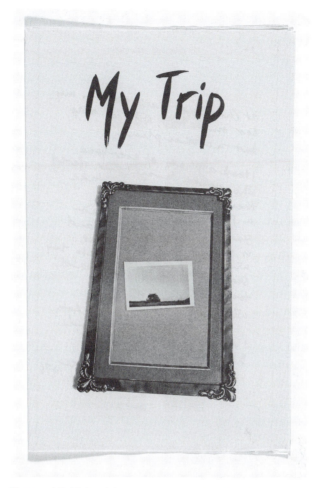

Figure 4.5 Micky Allan, *My Trip*, 1976. Offset lithographic prints, letterpress, 45.5 x 29 cm (closed). National Gallery of Australia, Canberra. Purchased 2012 ©Micky Allan/Licensed by Viscopy, 2016.

what they said to me. On the right is the photo they took, and what they said when taking it."

Trained as a painter, Allan's embrace of photography took place as a means by which she could establish a more socially engaged art practice, focusing on everyday life beyond the artist's studio. Allan understood photography "as a form of social encounter"—her words—and emphasized the importance of the exchange between the photographer and the photographed.[18] Around the same time as *My Trip*, she made a series of hand-colored portrait works, three "life cycles" series—the pastel-colored "Babies" (1976), "Old Age" (1977), and the boldly colored "Prime of Life" (1979–80)—which she spoke of in terms of an

interest in "the process of socialization" and "different social situations."[19] If investigations of subjectivity were central to a lot of art and politics at the time, what distinguished her practice were questions around the position of the female subject. 1975 was the United Nations' International Women's Year, the aims of which were strongly supported by Australia's socially progressive Whitlam Government, and International Women's Day in March of that year produced large and energetic marches in Melbourne and other capital cities. Allan brought to her practice what the critic Memory Holloway (1987: 3) described as "a specific knowledge of the feminist collective, of the need to push art closer to her own experience and thereby to make it relevant to current issues and her own life."[20] *My Trip*—as the newspaper's handwritten title explicitly suggests—drew on prevailing strategies that emphasized the personal and autobiographical.[21] As a feminist action, it clearly departed from the more familiar existential tone of American road-trip photographers such as Robert Frank's *The Americans* (1958) or the epic travelogue of Australian photographer Wes Stacey's *The Road* (1973–5). Nor was it as deadpan as Ed Ruscha's pop-conceptualism in which reportage and the conventions of the photo-essay format were overtly parodied, or as detached and depersonalized as conceptual photography based on programmatic methods. The front page of the newspaper is telling in this regard: it features an image of an old-fashioned picture frame and, loosely positioned on an angle within it, a single photograph of a landscape showing Allan's car on the horizon. The picture frame might once have held a family portrait; now the car indicates the centrality of the vehicle to the artist's method.

One of Allan's ambitions in *My Trip* was to question the border between private and public realms, and the mode of circulating the finished work was critically important in achieving this end. Paired snapshots were reproduced as postage-stamp-sized contact prints in a newspaper format, presented in storyboard fashion with typewritten text for captions and a handwritten introductory note and title. This "newspaper" was self-published in a small run of around 100 copies in April 1976. Allan then placed the work for sale in Melbourne newsagencies as a way to incorporate public participation both in the creation and exhibition of the work. *My Trip* was also included in Allan's first solo exhibition in 1978, a performance installation that would today be described as an instance of "relational aesthetics"—Nicolas Bourriaud's ([1998] 2002) term, coined in the 1990s, to describe art in which the sphere of human relations constitutes the site of the artwork's meaning. Subtitled *A Live-in Show*, Allan's show consisted of an array of domestic furniture and incidental items such as postcards and plastic animals, various photographic series and chalk drawings on paper, and, most notably, the artist herself in residence. Allan literally "lived in" the informal space, going about her daily routine of eating, reading, watching TV, and even sleeping overnight in the gallery. Visitors could interact with the artist while viewing the show, revealing that the domestication of the gallery space, now a common feature

of relational art, was firstly a feminist act. Described in a newspaper review (Holloway 1978) as "an adventurous exposure of the self," the exhibition blurred art and life but went well beyond the diaristic—and thus provides an important context for understanding Allan's unusual approach to photography in *My Trip*.

It is important to historicize Allan's work in terms of Australian art photography in the 1970s. Perhaps the most iconic Australian photograph of the period, Carol Jerrems' *Vale Street* (1975), a staged black-and-white image of a topless woman flanked by two tattooed teenage men, was taken in the same year that Allan set off to make *My Trip*. Jerrems' and Virginia Fraser's *A Book About Australian Women* had been published in 1974. In an unconventional biographical note at the end of that book (Jerrems and Fraser 1974: n.p.), Jerrems encapsulated her own approach and the mood of the era: "You can only see through your own experience and understanding." However, if Allan was also building a body of work based on personal experience, in *My Trip* this involved exposing herself to a series of encounters with strangers. In common with so much conceptual art, her work can then be read as the documentation of a performed event, characterized by an initial instruction and then an open set of encounters. The instruction makes the work happen, and—as with Huebler and the conceptual photography explored in Chapter 2—involves "the partial abdication of authorial control, in favour of accident, chance or unforeseen circumstances" (Iversen 2009: 840). By taking a photograph of everyone who spoke to her on the journey, and then offering the camera to those same subjects to photograph anything of their choice, the camera becomes a prop and a conversation piece, instead of something that a photographer simply "shoots through" for specific subjects. As Holloway suggests (1987: 7), Allan used the camera "as a buffer … as protection and explanation … to test the boundaries of how a female travelling alone in the countryside might be received." A number of high-profile rape cases had appeared in the Australian news at the time. Whether or not Allan set out with this specific intention, the camera thus became a machine for documenting and speculating on social and gender relations.

Photography, as we have established, is a democratic art form in the sense that the camera is relatively easy to use. But photography is also associated with uneven power relations between the photographer and the photographed. In the 1970s, although the comparatively low cost of film and print labs meant that practically everyone in the developed world had access to rudimentary photographic production, the very activity of looking was itself coming under increasing scrutiny. Texts such as John Berger's *Ways of Seeing* (1972), feminist film theory, and Susan Sontag's essay collection *On Photography* (1977)—which originally appeared as a series of essays in *The New York Review of Books*— followed in the footsteps of critical artists who revealed the gaze to be a process of objectification organized by social power and unconscious desire. All of this was contrary to photographic modernism's masculine embrace of the camera as

an extension of the self, in which "man and machine" were considered both neutral and inseparable. The status of women's bodies in media and public spaces became a particular site for political struggle, generating important works such as Laurie Anderson's photo-narrative installation *Fully Automated Nikon (Object/Objection/Objectivity)* (1973). In that work, Anderson took pictures of men who made unsolicited sexual comments to her on the streets of Lower Manhattan over the course of a single day. The piece narrates this process with photographs and texts. Anderson's statement about the work is clear: "I had always hated this invasion of my privacy and now I had the means of my revenge. As I walked along Houston Street with my fully automated Nikon, I felt armed, ready" (1993: 146). The militarized action of pointing the camera became a way for the artist to manifest her objection towards the objectified status of women in public spaces. Anderson's "record of a social encounter," as Joanna Lowry (2000: 11) has perceptively observed, "is the product of a kind of dysfunctional collaboration around the taking of a photograph."

Allan's decision to photograph everyone she meets on her journey can be interpreted as a more willfully democratic gesture. Her offering of the camera, in a process of reciprocal exchange, becomes an act through which she establishes a series of temporary relationships with others. Allan's aim was to record rather than judge. Not only was everything said to the artist recorded verbatim, the artist's and her subjects' images are presented in exactly the same fashion, with none privileged over any other. The photographs are even printed in the same technical way, as the work's opening text emphatically states: "I exposed everything on Agfa 3 paper at f16 for 3 seconds." My drawing attention to this equalizing is not to suggest that *My Trip* presents a romanticized account of her social interactions, nor that it simply embraces a collapse of professional and amateur photographic capabilities. It is simply to emphasize Allan's attempt to neutralize the authorial touch, given that it is the precise verbal and visual recording of human interaction that gives *My Trip* its resonance for the viewer—its clear-cut rendition of the speech and perspectives of the people she encounters. People's responses vary from surprise and modesty to bemusement and complete disinterest. Some are amusing or poignant, but by no means were all of the encounters "comfortable or friendly"—as Virginia Fraser (2012: 12) has pointed out—despite the work's "eloquent between-the-lines silences." Notably, not all of Allan's subjects take up the invitation to use the camera, leaving some spaces blank. Thus *My Trip* presents a slightly estranged perspective on Australian society, in which the camera is deployed—even required—as a device to make contact that would otherwise be absent. The work is situated as social critique but presents neither a sentimental image nor an overtly critical vision of social or gender relations, although we may wish to read that into the work. *My Trip* more simply captures attitudes of the time towards both a woman travelling alone and to photography itself.[22]

The textual dimension of *My Trip* invites comparison with the work of 1970s documentary "empowerment photography" (Chapter 3). It seems unlikely that Allan knew of such experiments, but a desire to democratize representation was certainly part of the Australian cultural mood of the time (for instance, the Whitlam Government established a number of community video access centers). But Allan's aim was artistic, and her approach less ameliorative and more spontaneous than that of community photographers. Just like Huebler's interest in social situations (Godfrey 2002: 14), by emphasizing photography's communicative rather than memorial function, *My Trip* looks forward to, and preempts, a variety of relational approaches to photography adopted by artists since the 1990s. For instance, in the well-known work of a then young British artist Gillian Wearing, *Signs that say what you want them to say and not signs that say what someone else wants you to say* (1992–3), the artist solicited people on the streets of London to write whatever first came into their heads onto large sheets of white paper, and then photographed the person holding up the sign. A young man in a grey suit holds up a sign that says "I'm desperate," while a policeman's incongruous message simply says "Help!" Shown in the gallery or in book form en masse, these declarations by strangers are both slightly embarrassing and curiously moving. Wearing's subjects are collaborating participants, and her crude but effective approach, borne of naïve curiosity, updates the more pious ethos of earlier community photography. Unlike Goldberg, who asked his subjects to write on photographs *after* they were taken, thus providing a context for their interpretation, Wearing's subjects collaborate during the photographic act itself, an intervention with a more ambiguous ethical dimension.[23] Huebler also produced a series of portraits in which he invited people to pose holding a white card with text on it, as part of his everyone alive project in 1975–6. However, in his case the subjects picked a statement at random from a set of eighty cards "on which a characterization appeared." He then grouped people holding the same sign, such as "One person who is beautiful but dumb," "One person who may be culturally dislocated," "One person who may know the artist," and so on. For Huebler, this was a game involving risk and chance.[24] Wearing's approach was more sincere, and in her view marked a conscious intervention into the practices of conventional photographic portraiture, as her artist statement made clear:

> The bizarre request to be "captured" on film by a complete stranger is compounded by a non-specific space; the blank piece of paper, which almost replicates an unexposed film … [The images] interrupt[s] the logic of photodocumentary and snapshot photography through the subjects' clear collusion in and engineering of their own representation.
>
> (Quoted in Campany 2003: 128)

One outcome of Wearing's project is that we are given an unusual insight into a wide range of normally hidden thoughts. Photography critic David Campany (2003: 128) has therefore called Wearing's project a "fragmentary form of sociology."

Photography demands no special dexterity, and yet Allan's manual 35mm camera, and the process of taking photographs, is nevertheless a common subject of her transcribed conversations. "Is this an SLR?" asks one woman. "Which is the focus?" asks another. Insecurity in the face of the level of skill still required to take a "good" photograph using a manual camera is a recurring theme. One man says, "Nah I couldn't. I'd waste your film. You take one for me," reminding us that each frame of film costs money. Some people think they might "break the camera," and others are lost for a subject ("What would I take? Nothing here.") By contrast, the final image in the series—taken on January 12 by a small boy under the instruction of his older friend or brother—is accompanied by a statement that reads as a concise summation of the simple act of photography: "Now then, there's the button. And put your eye there. And when it looks right, press." In this way, photography is demystified, reduced to a set of simple instructions available to all. Today, when every mobile phone doubles as a camera and taking photographs is basically foolproof and free, we have to imagine how unusual it would have been in the mid-1970s to ask a stranger to use a 35mm film camera. Decades later, most of us have probably experienced the familiar tourist request, viewing some monument or picturesque scene and gesturing towards their digital camera, "Can you please take a photograph of us?" Delegated authorship, even in such primitive forms, is everywhere if we pay attention (although mobile devices with reverse cameras and "selfie sticks" reduce the need to rely on strangers for assistance). Allan's *My Trip* is clearly a work of its time; an exemplary work of Australian conceptual art that echoes international practices and yet maps a local social environment with all its attendant dynamics and characteristics. Like Huebler, Allan's unorthodox use of the camera as a vehicle for social encounter prefigured a more widespread relational turn in both art and photography, although in Allan's case, the record of a personal journey can also, as the title suggests, be read as a form of self-portrait. Paradoxically, as we have already seen in some of the work discussed in this book—particularly in Wendy Ewald and Anthony Luvera's work—self-portraiture opens up a number of unique opportunities for collaboration with others.

Sophie Calle: The observer observed

French conceptual artist Sophie Calle (1953–) is well known for her probing explorations of the boundaries between the private and public realms. Her work, most often based in photography or video, constantly tests the limits

of these concepts through intimate and at times invasive portraits of herself, friends, lovers, and strangers. Typically, Calle uses photography in a diaristic mode, presented together with extensive written text. As spectators we are brought into the work's secrets, and often become "unwitting collaborators" in apparent violations of privacy (Tate n.d.). Calle's work can be interpreted as a form of collaborative self-portraiture. At the same time, by incorporating performance elements of disguise, subterfuge, and duplicity she also overturns a number of conventions around the entire notion of portraiture, self-identity, and artistic authorship. Thus, in her emblematic work, *Suite Vénitienne* (1980), Calle followed a man she met at an opening in Paris all the way to Venice, where she disguised herself in a wig and trailed him around the floating city, surreptitiously photographing him with a modified Leica that allowed her to take photographs without aiming at her subject. Calle's surveillance of the man, who she identifies only as Henri B., in a nod towards a literary imagination and perhaps a small concession to privacy, is documented in black-and-white photographs accompanied by a lengthy diary-like text of her ultimately thwarted chase (she is eventually confronted by him). For Jean Baudrillard (1988: 83), who wrote a text for the resulting book, Calle's blind following introduces "a wonderful reciprocity" in which "she who follows is herself relieved of responsibility for her own life."

In what can in retrospect be seen as preparation for Calle's work in the early 1980s, the artist had spent several months in 1979 trailing strangers on the street simply "for the pleasure of following them" (Calle 1999: 69). Those actions apparently unwittingly recast Vito Acconci's *Following Piece* (1969), in which the American artist followed one randomly chosen stranger each day for nearly a month through the streets of New York until he or she entered a private location.[25] Acconci described this activity as "Performing myself through another agent," a phrase which could also be applied to Calle's work (Iversen 2009: 848). His precedent, however, while psychological in inspiration, is less intimate. Acconci provides no diary of his own desires, nor does he speculate on his subjects' personal lives or personality. Unlike *Suite Vénitienne*, his subjects include different genders, and there is no hint in his work of any form of seduction between the artist and the stranger(s) being followed. Moreover, Acconci's work is a documentation of performance, rather than Calle's performance of documentation. Consequently, the photographs that make up Acconci's work are not taken by the artist, but show him trailing his prey as a looming figure clad in a leather-jacket. Acconci used photography to provide evidence of the execution of a preconceived action and specifically his body's occupancy of public space (an enduring preoccupation that preempted his move into experimental architecture). Calle's work, on the other hand, could be read as a feminist reversal of Acconci's "masculine" stalking. However, it is far less overtly critical than Anderson's 1973 work, discussed above, in which she took revenge on aggressive male voyeurs by using her camera as a weapon to photograph and shame them.

The Shadow (Detective) (1981) is a crucial early example of Calle's approach to self-portraiture, in which she organized to be followed for a day by a private detective (Figure 4.6).[26] Her mother hired the detective at Calle's request, as the written text accompanying the work dispassionately announces:

> In April 1981, at my request, my mother went to a detective agency. She hired them to follow me, to report on my daily activities, and to provide photographic evidence of my existence.
>
> (Calle 1999: 122–3)

The phrase "evidence of my existence" evokes a particular kind of existential thinking around photography. Specifically, it echoes Roland Barthes's ([1980] 1981: 87) famous notion, published in *Camera Lucida* in 1980 and undoubtedly

Figure 4.6 Sophie Calle, *The Shadow*, 1981. Nine gelatin silver prints, one color photograph, twelve panels of text, overall dimensions variable. ©Sophie Calle/ADAGP. Licensed by Viscopy, 2016. Courtesy of Sophie Calle and Paula Cooper Gallery, New York.

familiar to Calle, that "[e]very photograph is a certificate of presence." In her work, however, Calle plays with and reverses the desire to capture events that underpins more conventional photographic practices such as photojournalism. She puts a private detective through the same cat-and-mouse ritual that she herself enacted in *Suite Vénitienne*, only now the shadowing photographer is unaware of the rules of the game, and the gender roles are reversed. During the day in question, Calle visited her favorite sites in Paris and wrote an intimate diary that she exhibited together with the photographs taken by the detective and his report on her perambulations.

There is, needless to say, a positive perversity in Calle willingly subjecting herself to being followed by a stranger, and paying for the privilege. However, in making *The Shadow*, Calle led the unsuspecting detective around parts of Paris that were personally important to her—for example, to a cemetery and to a painting by Titian at the Louvre—thereby reversing the expected submissive position of the observed subject. She also wrote about the experience in diary entries throughout the day. In this way, as in so much of Calle's work, she self-consciously plays with her role as "artist" and "subject," inventing a semi-fictional narrative fuelled by desire. Finally, Calle's beautifully written diary entries are exhibited together with the detective's photographs and his detailed "objective" description of her movements to form a disjunctive joint portrait of the artist (Figure 4.7).[27] The detective does his job, noting down descriptions of the people she meets, their physical appearance and the precise time of her comings and goings. However, factual inaccuracies (she does not return home at 8pm, as he writes), and the more fundamental discrepancy between her private musings and the official "report" of "the subject" (as she is referred to) seem to suggest that such surveillance raises more questions that it provide answers for. Meanwhile, Calle shamelessly romanticizes the dynamic between herself and the private detective ("It is for 'him' I am getting my hair done," she writes, "To please him").

Like the documentation of performance art, Calle's own actions determined the nature of the black-and-white photographs that make up *The Shadow*. As a result, we can say that they are coauthored by the artist and the private detective. Of course Calle has edited the resulting images, which she presents in filmic vertical and horizontal groupings. Like the detective's text, they contribute very little toward an authentic portrait of the person pursued (they are taken with a zoom lens at a safe distance, often from behind, and are sometimes blurred). In all of these ways, Calle's project can be read—like Allan's—as a self-reflexive deconstruction of the conventions of photography itself. Aside from the absurd staging of the photographic artist being photographed all day by a private detective, this reading is also prompted by the number of times the culture of photography is referenced in Calle's wanderings. The detective writes that at 1.25pm she "goes into 8 rue de Seine, the shop 'H. Roger-Viollet Documentation Photographique.'"

Figure 4.7 Sophie Calle, *The Shadow*, 1981. Nine gelatin silver prints, one color photograph, twelve panels of text, overall dimensions variable. ©Sophie Calle/ADAGP. Licensed by Viscopy, 2016. Courtesy of Sophie Calle and Paula Cooper Gallery, New York.

This is one of France's oldest photographic agencies, founded in 1938, best known for its collection of photographs of everyday French life, including snapshots of ordinary passersby. Calle writes in her diary that she looked at images of private detectives. At 3.10pm, outside the Louvre, we are informed that, "She has herself photographed by a street photographer" (Calle puts it somewhat differently, noting that "a photographer offers to take my picture with my camera"). Finally, she complicates things further by organizing an accomplice to photograph the detective at a prearranged location and time, "to have a souvenir of the person who would be following me." In the making of *The Shadow*, Calle collaborates, in other words, with an entire network of photographers, some more aware of the set-up than others.

In the same year that she made *The Shadow*, Calle posed as a hired chambermaid at a hotel in Venice in order to surreptitiously photograph the writings and belongings of the guests to produce *The Hotel* (1981). In a work like this one, Calle invites viewers to participate in various intrusions into private lives. In

an earlier work, *The Striptease* (1979), Calle had also put herself in a vulnerable position as the object of the gaze by performing as a stripper in a nightclub. This extreme form of participant-observation resonates in the work of a variety of contemporary artists who have assimilated themselves as interlopers in subcultural, ethnic, or family groups for the purpose of generating artworks. One thinks of Korean-American artist Nikki S. Lee's various "projects," such as *The Tourists Project* (1997), *The Yuppie Project* (1998), *The Hispanic Project* (1998), and *The Hip Hop Project* (2001). To make these works, Lee introduces herself as an artist, and then spends several weeks participating in a group's routine activities and social events. She adopts people's general style and attitude through dress, gesture, and posture, until finally a series of snapshots are collaboratively produced. Lee never actually takes the photographs herself; they are shot by her friends, passersby, and other members of the group, giving them an "anonymous" quality. They also include a date-stamp, characteristic of point-and-shoot cameras of the time, supporting the associations with authentic snapshot photography. As an artist, Lee maintains control of the final image—choosing when to ask for a picture and editing what photographs will eventually be displayed (Kaplan 2005). Lee's position as a Korean woman is arguably the subtext of all her images, but the process of creating the portraits is highly collaborative.

Irish artist Trish Morrissey has also used the camera and her own body as a means to explore social and cultural difference within the activity of group photographic portraiture. For her series *Front* (2005–7), the then forty-year-old artist ingratiated herself into the often-hierarchical family, or groups of friends, on beaches in Britain and Australia (Figure 4.8). Morrissey asked if she could take the place and role of one of the women and borrow their clothes, typically the mother, who then operated the camera set up by the artist. Morrissey appears in each photograph in a different guise, but her pale skin often stands out among the diversity of ethnicities depicted. The results are both humorous and unsettling, underscoring that *Front* refers to the boundaries of our social pose, the artist's assumed identity, as well as the sea front. In a sense, Morrissey's playful intervention extends Malaysian-Australian artist Simryn Gill's injunction to engage with cultural difference in her instructional work *Somewhere Between* (2002), that requests us to:

Approach a stranger who you perceive to be somehow different to yourself.
The difference between yourself and this person could be of any nature, for instance—age, class, lifestyle, politics, skin colour, religion etc etc.
However, the category or categories of difference that you choose should be one(s) that deeply inform your own life.
Ask someone to take a photograph of yourself with this person.
Send in the photo stating the date and the place.[28]

Figure 4.8 Trish Morrissey, *Untitled, December 18, 2007*, from *Front*, 2005–7. Original in color. Courtesy the artist and Impressions Gallery.

Gill's simple proposal, which introduces a cosmopolitan dimension to the idea of photography as a social encounter, implicitly critiques traditional one-way methods of using photography as a means to know others.[29] Morrissey's *Front* series also updates a remarkable group of photographs by the Dutch conceptual artist Hans Eijkelboom, *With My Family* (1973). To make that work, the artist rang on the doorbell of various houses in Amsterdam after husbands had gone to work and somehow managed to convince their wives to let him pose in a family portrait in place of the father.[30] In Eijkelboom's more culturally homogenous precedent, he always looks completely at home—cheekily suggesting the interchangeability of the absent patriarch. His work is all the more striking because the strategic use of the self in collaborative portrait photography is far more associated with female artists, as my other examples in this chapter demonstrate. Working in this manner, privileging social space as the domain of subject formation, turns identity, and thus gender, into a site of negotiation. This may partly account for its appeal to women, who confront people from a position of less social power than men.[31]

In Calle's work more broadly, something private is invariably made public, which has the effect of deconstructing the certainty of a stable public identity. In

the process, the traditionally gendered separation of private and public selves in everyday life is questioned. Calle's work demonstrates a gregarious confidence, but also vulnerability and sensitivity towards her subjects. This is demonstrated in a different manner in the *Blind* series (1986), in which Calle photographed people born without sight and asked them to describe "their image of beauty." The portraits are then exhibited together with a quote summarizing his or her image of beauty and a photograph of that object, person, or place: a voluptuous female form by Rodin, a countryside in Cardiff, sheep, a man's son, a popular French actor, and so on. Crucially, the photographs were not all made by Calle— thus a blind woman took the photograph of Cardiff herself, and Calle bought a commercial image of the French actor, Alain Delon (Dubin 1995). Nevertheless, in the work—as with *The Last Image* (2010) in which she asked people in Istanbul who had lost their sight suddenly to "describe the last thing they saw" and recreated the memory as a photograph—Calle can be said to have collaborated in a vicarious manner with the blind, even as the work inevitably reveals a fundamental lack at the core of all forms of representation. Thus, just as a work like *The Shadow* emphasizes the relational qualities of photography, it also operates, in a fashion typical of Calle's work, at the intersection of the desire to know the world and others, and the invariable frustration of that desire. Ironically, surveillance photography—used as a model in *The Shadow* to reverse the relationship between the photographer and the photographed—also empowers a covert collaboration between the subject and the lens. Even as photography is never the explicit subject of Calle's work, and she often outsources the act of photographing to others, the camera allows her to play with the mastery of seeing and the experience of being seen by others.[32] Few other contemporary artists have revealed such collaboration at the heart of photographic portraiture.

Conclusion

The works discussed in this chapter represent significant examples of portraiture that uses collaborative methods to stimulate interactions between strangers. Separated as they are by distances of time, place, and intention, each work has its specific context and its own ambitions. But despite obvious differences, their connections are clear. The work all belongs to the conceptual tradition of photography (Chapter 2) which gives up a certain amount of agency to rule-bound systems. Each artist undertakes process-driven documentation, visualizing thematic assignments in a systematic way such that the transactional process by which the images were obtained, or how the portraits came about, is more important than the final form of any single authored image. The works are nevertheless personal and diaristic at some level either in their operation or form, by virtue of their embrace of chance and intimacy. Most importantly, in all

of them, conventions of photographic mastery are inverted in favor of a collaborative approach to photography in which artists utilize the camera as a device to make contact with others and initiate a process of social exchange. As we have seen, in their respective efforts to overcome the separation conventionally enacted by the camera's gaze, and to elicit encounters with strangers, they can each be considered exemplary instances of an expanded form of photographic portraiture that we can call relational. This relationality is also characterized, in the work of Huebler, Allan, and Calle, by travel and movement. Of course, one can think of various other attempts by artists to utilize collaborative techniques in related ways. Italian artist Alighiero Boetti's series of photographs of himself with Guatemalans in photobooths springs to mind—*Guatemala* (1974)—as a work designed to generate a social *exchange* of images across cultures, in contrast to the conventional lack of reciprocity in tourist photography.[33]

By exposing the limits of their own position as observing subjects, by situating themselves in the flux of the social and material world, Huebler, Allan, and Calle have made artworks that complicate the conventions of singular photographic authorship in multiple ways. But their response is not the critical negation of the "predatory" nature of photography, as in the moralistic denunciation of Susan Sontag (1977: 14) who famously argued that "[t]o photograph people is to violate them, by seeing them as they never see themselves, by having knowledge of them they can never have." The work of Huebler, Allan, and Calle rejects the traditional mastery associated with professional photography, but it also embraces the camera's openness to the world and its innate unpredictability, revealing the potential that has always been latent within the medium towards collaborative knowing.[34] Photographic scenarios that allow for collaboration and participation necessarily entail degrees of abdication of an authorial position. The pay off is that in collaborative exchanges, the negotiations that always accompany photography—between self and other, one and many, private and public—are made visible. In this way, photography's conventional mode of representation is transformed from one of attempting to fix the meaning of its objects to that of a dialogical space and site of negotiation (Lowry 2000). Ariella Azoulay (2008: 11) argues that photography can be viewed as a "civil contract" among citizens, whereby images are treated as relational objects that "bear the traces of the meeting between photographed persons and the photographer." In the works examined here, by recasting the conventional contract between photographers, their subjects, and viewers, and even blurring that distinction between photographer and photographed persons altogether, the artists reveal that photography is also capable of unexpectedly collaborative forms of social encounter.

5

AGGREGATED AUTHORSHIP: FOUND PHOTOGRAPHY AND SOCIAL NETWORKS

The use of found photography has become a familiar strategy for artists working in the aftermath of conceptual photography. Contemporary artists very often recontextualize existing photographs for their own purposes, and, in doing so, frequently approach authorship in ways that can be considered collaborative. Take the example of *Pictures Collected from Museum Visitor's Wallets* (1998) by American artists Harrell Fletcher and Jon Rubin. In this participatory work, the artists asked visitors to the San Francisco Museum of Modern Art if they could photograph any pictures they kept in their wallets. Having first convinced visitors of the potential interest of their personal photographs to other people, Fletcher and Rubin then rephotographed the often dog-eared and folded prints with a medium-format camera on a stand in the lobby of the museum. During a period of six hours, the artists shot around 150 such photographs, and eventually, ten images were selected, enlarged, and framed to be included in the museum's permanent collection. The images were displayed with captions such as "a long time ago," based on transcription of words from the person agreeing to have the photograph rephotographed. By promoting the nonartist spectator to the position of collaborator, and making private photographs public in an unexpected way, the work radically inverts expectations. The French artist Christian Boltanski, well known for his own memory installations based on found photographs, suggested a similar, if more domestic, *Instruction* from 1993:

1 Get your neighbour's photo album

2 Give the neighbour yours in exchange

3 Enlarge all the pictures to 8 x 10

4 Frame them in some simple fashion and hang them on the walls of your apartment

5 Your neighbour should do the same with your album.[1]

An important part of the logic of such collaborative exercises with personal snapshots is to critique the perceived exclusivity of fine art photography. At the same time, through the simple acts of enlargement and recontextualization, these works serve to multiply and complicate the traditional, singular notion of photographic authorship.

In this book I have already referred to several artworks that utilize existing photographs made by other people. However, the examples I have discussed so far—*Evidence* by Larry Sultan and Mike Mandel, and *Fig.* by Adam Broomberg and Oliver Chanarin—both used images sourced from institutional and commercial archives rather than personal collections. In this chapter, my focus turns to artists' aggregation and recontextualization of personal photographs—or snapshots—which, I argue, come to represent an unusual instance of authorial collaboration with absent and usually anonymous photographers. The three case studies I address in this chapter are German artist Joachim Schmid, who has worked with vast archives of other people's photographs for several decades to reveal recurring patterns in image-taking and the handling of photographic possessions; North American artist Penelope Umbrico, best known for her aggregation of images made by searching for the word "sunsets" on Flickr; and fellow American artist Richard Prince, whose *New Portraits* (2014) series controversially made use of other people's Instagram photographs. Spanning the use of found to crowdsourced images, each of these examples raises distinctly different issues. However, by publicly recontextualizing personal photographs, all three artists draw out unconscious narratives within collections of amateur images, reinvesting them with a different authority and pathos in what I take to be a collaborative rather than simply appropriative act.

Thinking found photography

Artists have worked with anonymous and found photographs since at least the Dadaists and Surrealists, who recognized their potential, as readymade fragments, for dialectical disclosure or straightforward poetic estrangement (Dezeuze and Kelly 2013). Picture postcards have offered a closely related attraction. The American photographer Walker Evans amassed thousands—attracted to the unvarnished, "artless" quality of the pictures and their vernacular subjects—which helped to inform his own "authorless" style. Later, British artist Susan Hiller collected several hundred postcards of the visually seductive British cliché of "rough seas" in her seminal, *Dedicated to the Unknown Artists*

(1972–6), a work which is both a commentary on photography as a social prac-
tice in the age of mass tourism and an archive of desire deferred. Other well-
known projects involving found photographs include the German artist Gerhard
Richter's *Atlas* (1962–97), a sprawling and encyclopedic collection of amateur,
journalistic and advertising photography, and Hans-Peter Feldmann's vast col-
lections of newspaper images (including 100 newspapers printed on September
12, 2001). Since the 1990s, the use of found photographs has become a cru-
cial component of the so-called "archival turn" in contemporary art, in which
artists interrogate the self-evidentiary claims of the archive while simultaneously
inviting spectators into the idiosyncratic visual pleasures of its "real." For the
curator Okwui Enwezor (2008: 16), "[T]he archive is a compensation (in the
psychoanalytic sense) of the unwieldy, diachronic state of photography and, as
such, exists as a representational form of the ungainly dispersion and pictorial
multiplicity of the photograph."

Between artists, photography collectors and institutions of art and photog-
raphy, interest in found photography has reached a kind of frenzy since the late
1990s. Scores of exhibitions and books of collections of found photographs
have appeared over this time, coinciding with a blurring of the roles between the
artist, collector, and curator.[2] In truth, as Mark Godfrey (2005: 101) has argued,
such images are more often "sourced" than "found." This has produced a rapid
trade in other people's "obsolete" slide collections and family albums, which
now takes place largely online rather than in junk stores or flea markets. If, as
Susan Sontag (1977: 24) suggested, paraphrasing the poet Mallarmé, "[t]oday
everything exists to end in a photograph," now it can seem as if every photo-
graph exists to end up in someone else's artwork. Artists' use of found photo-
graphs started well before the digital era, but it is clearly no coincidence that
so many artists and collectors have been drawn to the found print at a time of
photography's digital recoding. The appeal of the outmoded print is undoubtedly
symptomatic of a set of anxieties—even extending to memory itself—around
photography's exuberant transformation into numerically encoded pixels. By
some reports, 10 percent of the entire photographic output of humanity is now
created in only twelve months ("Media of the Future" 2015). All the millions of
negatives and prints ever developed by Kodak and others now pale in compari-
son to the mother load of JPEGS uploaded to Facebook and Instagram day in
and day out. Since photographs are now viewed predominantly on small LCD
screens, and online sharing has largely replaced traditional modes of archiving
and dissemination such as the photo album, the physicality of photographic
materials becomes newly attractive (Cotton 2015: 13). As French philosopher
Jean Baudrillard (2005: 111) once wrote:

old objects, being obsolete and hence useless, automatically acquire an aes-
thetic aura. Their being distant from us in time is the equivalent of Duchamp's

artistic act; they too become "ready-mades," nostalgic vestiges resuscitated in our museum universe.

While the future of the photograph as a material object is by no means certain, physical prints can also fascinate because they reveal different histories of paper and chemical processes, while some carry the additional historical residue of signs of previous use. All of this stands in contrast to the shiny, seemingly ever-present and malleable digital image flow.

Of the various species of found photography, the personal snapshot is by far the most abundant and widely reused by artists. The launch and promo-tion of inexpensive cameras such as the Kodak Box Brownie after 1900 turned everyday life in the twentieth century—at least in the developed world—into an unending succession of photo opportunities. The family snapshot has thus come to represent the epitome of photography at its most basic and seemingly demo-cratic. Traditional art-historical categories, such as originality, intentionality, and style are almost useless in the face of such photography (Batchen 2000: 77). This is not to say that such photographs cannot be collected in terms of the "latent artistry" of their usually anonymous, amateur authors; that is, their formal resemblance to modernist photographs (Zuromskis 2013: 158). As photography historian Geoffrey Batchen (2008: 124) puts it, "an eye educated by art history can … find traces of avant-garde sensibility wherever it looks." Thus we find such "happy accidents" and "successful failures" framed as individual prints in a process of aestheticization of vernacular photographs initiated by the influen-tial MoMA curator John Szarkowski and formalized by exhibitions likes *Other Pictures: Anonymous Photographs from the Thomas Walther Collection* at The Metropolitan Museum of Art in 2000.[3] In this highly selective artistic recuperation of the snapshot, collectors and curators sometimes stand in for the master artist, as Catherine Zuromskis (2013) has convincingly argued. For the connoisseur of modernist photography, the avant-garde aesthetics of chance details, strange postures, freak exposures, and the like are part of found photography's unique appeal, based on the medium's well-established contingent link to the real. Together with the mistake (the out of focus, poorly framed, strangely developed or those shot at the wrong moment), many collectors of snapshots also prize the pathos of damaged photographs (particularly those that have been intention-ally crossed out, scratched or drawn on), underlining the point above about the appeal of the print's physical materiality and its previous handling.

That amateur snapshots possess so many qualities now admired in con-temporary art—amateurism, everydayness, intimacy, and immediacy—is dem-onstrated by the reception of Tacita Dean's *Floh* (2001). The work comprises nothing more than a series of 163 photographs collected by the artist in flea mar-kets and carefully published, without words, in a hardcover book.[4] While it would be a mistake to consider snapshots naïve (they are certainly not innocent), it is

precisely their artless quality, their lack of self-conscious expression or ambition, that gives them their assumed authenticity. Such is the appeal of the amateur (Cross 2015: 47–8). Recontextualized en masse in art projects, snapshots can also highlight the pretense of so much "fine art" photography. Within idiosyncratic collections, anonymous snapshots are by turns poignant and humorous, ordinary and eccentric, but above all enigmatic—a word often used to describe them. For the viewer, a mysterious charge comes from the unsolicited "invitation to speculate" (Batchen 2008: 125) on the circumstances in which they were taken. This invitation, in the absence of any knowledge about the subject or author of the photographs, clearly constitutes an important part of their storytelling appeal. For the curator Kate Bush (2003a: 63), found photographs focus our attention on the "pure value of what is depicted, of what is there to be uncovered in the picture," rather than "the artist as the source of meaning." In the artistic act of recontextualizing found imagery, a dialectical relationship is thus forged between authorship and anonymity (Berrebi 2014: 56). Found photographs generate a creative exchange, as fragments of visual information that ask viewers to use their imaginations to fill in the missing gaps in the story.

In what sense can an artist's use of found personal photography be considered collaborative? Many artists re-present and reimagine found photographs with a strong authorial voice, and it could be argued that questions of authorship in found photography are beside the point, since private images of unknown provenance, re-circulated in public, necessarily acquire meanings unrelated to their original context. Arguably, given their inherent and potentially conservative appeal to nostalgia, the meaningful recontextualization of found photographs by artists should be our exclusive concern, and ethical considerations around authorship forgotten.[5] In fact, the approach of contemporary artists using personal photography in their work varies dramatically. Sometimes, the authors and/or owners of the "found" photographs are directly involved in the project, as in British artist Phil Collins's remarkable work *Free Fotolab* (2004–10). Made at the end of the era of popular film photography, the artist posted advertisements in selected European cities offering people free processing and prints from their undeveloped rolls of 35mm film, on the condition that they agreed to give him the copyright to their images. The final work is exhibited as a nine-minute slideshow, borrowing the familiar intimacy of the family format to display a selection of holiday snaps, family gatherings, babies, and drunk teenagers—ranging from the amusing to the banal to the inexplicable. The exchange, giving the artist the right to use any of the images however and whenever he likes, served to emphasize both the ethics of using other people's photographs in artworks and the complicated commercial elements that can underpin "free" participation (a topic the artist has pursued in other works). The work also raises complicated issues around privacy and class, particularly in relation to cities in the former Eastern European country of Yugoslavia. Collins claims he came up with the idea when he

was working with asylum seekers and offered to use his account with a photolab to develop their rolls of film. He was struck that some people were not sure if they were ready to recover whatever memories resided in the celluloid.

Similarly consensual, Dutch artist Fiona Tan's *Vox Populi* is a series of exhibitions and books based on people's private photo albums collected in various cities and countries she visits—*Norway* (2004), *Sydney* (2006), *Tokyo* (2007), *Switzerland* (2010), *London* (2012). The artist—whose perambulations may be explained by noting that she was born in Indonesia and raised in Australia before moving to Amsterdam—asks individual people if they would be prepared to lend their photo albums for her collective country/city portraits. By contributing their albums, selected images of which are scanned and exhibited as photo installations—animating as it were, an already dead form—lenders give the artist unique access to their personal lives. As the title of the work suggests, Tan conceives her work as the voice of the people in what she has described as "an interaction between the poetic and the documentary" (quoted in Kent 2006: 266). To be sure, Tan's simple action of selecting the images and dividing the books into chapters such as portraits, home, and nature is an authorial one. Langford (2008: 75) argues that the "vigor of intentionality" is such that:

> Transferred into the hands of artists, ordinary people's pictures are being re-authored and re-signed. The vernacular is possessed and translated as a relic by these gestures; one might say that the *idea* of the vernacular is being honored.

In Collins's and Tan's work, the owners of the original photographs have at least participated in the realization of an artistic idea, and are invited to view the resulting work.

Working with found images is certainly not always conceived as an act of sharing, especially in the case of commercial or public image forms.[6] German artist Thomas Ruff expresses a common approach when he claims that "finding" a JPEG on the web is as much of an authorial decision as taking an image himself, since they are effectively anonymous readymades (Lane 2009: 140). Ruff's conventional affirmation of authorial control echoes the logic of appropriation that characterized postmodern photography, notably Sherrie Levine and Richard Prince's early work (Chapter 1), even if his intention, to expose the data sublime, is different. An appropriative logic also characterizes the digital quotations and erasures in projects such as Pavel Maria Smejkal's *Fatescapes* (2009), Ken Gonzales-Day's *Erased Lynching* series (2002–11) and Mishka Henner's *Less Américains* (2012)—all of which involve the artists taking famous photographs from the history of photography and modifying them using Photoshop. Such works effectively function to challenge the original authorship, relying on the

fact that the images are already in public consciousness for their effect. However, it is my contention that artists' re-use of found photography can be more than an appropriative act. The British collage artist John Stezaker, for instance, has described the images that he finds as neglected "orphans" that he "adopts," giving a "second life" to images he says are "overlooked, treated with indifference and abandoned" (Stezaker 2012: 126). While Stezaker's source images are commercial rather than domestic, his metaphors of orphans and adoption, and the parental responsibility it suggests, aligns with Karen Cross's argument that family photographs can be conceptualized as "transitional objects." In Cross's view (2015: 47, 58), the personal photograph is "an experience of relation," capable of invoking new associations, constantly in the process of being found, inevitably pointing "to worlds beyond its own frame." This sense of ongoing discovery by new viewers is highly important when it comes to the use of found photography (and does not necessarily require a relationship based on the permission to reuse the images). It is in this sense that I want to argue, in relation to the projects of the three artists I address below, that the original authors and even subjects of found personal photographs continue to exist as absent presences, and therefore as unconscious collaborators.

Joachim Schmid: The egalitarian recycling of other people's photographs

While many artists have used found photography in their work, none have focused on the technique as thoroughly as Joachim Schmid (1955–) (Weber 2007a: 11). Starting as a photography critic, Schmid has been working with found photographs since 1980—in a practice that spans both analogue and digital photography and includes such actions as the collecting and patient re-assembling of damaged photos found in the street, the collection of Brazilian ID photographs, the capturing of images from Internet sex webcams, and the immense sampling of groups of images from Flickr. Like a lot of artists who use found photography, Schmid does so with a mixture of rigor and a good dose of irony and humor—or what the photography historian Stephen Bull (2007: 65) describes as "an amused distance." Schmid has been described as an "image scavenger" and even an "image predator" (Fontcuberta 2007: 149). As Joan Fontcuberta (2007) notes, an aesthetic of salvage and recuperation runs through his projects. By intervening in the life of photographs that are past their original use-by date, Schmid's work underlines that a photograph's meaning is never fully contained in either its original or later manifestations. In other words, Schmid's work underscores a conception of the photographic event that involves multiple agents who engage with photographic objects over an extended period—extending well

beyond the original moment of capture or reception. As such, I want to propose that Schmid's work can also, and fruitfully, be considered as collaborative.

It is undoubtedly instructive that Schmid studied visual communication rather than fine art or photography.[7] He began his career as a freelance critic and the publisher of *Fotokritik*. Founded in 1982, this self-published journal is often described in biographies of Schmid as "iconoclastic" in its contribution to discourse on West German photography. Both in the journal, and in his regular lectures and articles for other publications, Schmid argued against prevailing notions of "art photography" in favor of photography as a form of cultural practice. As John S. Weber (2007a: 12), writer and co-organizer of a major Schmid retrospective in 2007, describes, the journal increasingly became a "hybrid of artist's project and visual anthropology" and by the end of the 1980s Schmid was publishing various selections of his snapshots, clipped newspaper photographs, personal ads, and other photographic ephemera in the form of "small, short run artist's books." After *Fotokritik* ceased publication in 1987, Schmid focused on his own art production, based primarily on found photography and public image sources. It so happened that the artist lived near one of the largest flea markets in Berlin, whereupon he had amassed a significant and varied collection of found photographs, which came to form the raw material for much of his work. In other words, Schmid's career as an artist evolved in a certain sense accidently, out of his practice as a critic and publisher. As Schmid has said in retrospect, he found it "more interesting to work visually" because he came to believe that the photographs he was "fascinated by" were "stronger" than anything he could write about them (Schuhmacher 2013). Exhibitions of his work soon followed, and ironically, as Weber (2007a: 18) puts it, "setting out to examine everything photographic beyond art photography, Joachim Schmid accidentally became an artist himself."

Schmid's first major body of work is called *Bilder von der Straße* [*Pictures from the Street*] (1982–2012), a sprawling document made up of a chronological sequence of every lost or discarded photograph he picked up off the ground over thirty years (Figure 5.1). The title is an ironic reference to the great tradition of street photography, in which a photographer hunts for images through the camera's viewfinder. By contrast, Schmid kept his eyes trained on the pavement, eventually finding a total of one thousand photographs over the course of his travels, many of them badly damaged and faded by the rain or sun, and more than half of them ripped to pieces by their former owners, for reasons unknown. The prints range in format from black and white photobooth prints to Polaroids, and crucially, if they were torn up, Schmid searched for all the individual pieces and then attempted to physically piece the print back together. This material quality of the images is crucial to their cumulative effect, as we are invited to speculate on the reasons for their sometimes violent abandonment. Although Schmid says he was unaware of the precedent (Walker 2010: 30), in all these

Figure 5.1 Joachim Schmid, *No.140, Belo Horizonte, August 1992*, from *Bilder von der Straße*, 1982–2012. Original in color. Courtesy of the artist.

respects the work resembles a prescient piece by the young British artist Dick Jewell who in 1978 had self-published a seminal small book of discarded photo-booth pictures called *Found Photos*, which he had been collecting over several years.[8] When Schmid's series was exhibited or published, which occurred at various stages in the collecting process, each image was mounted on A4 boards that were pinned to the wall and labeled with the location and date of the finding. Thus, when it was shown in London in 2007, Schmid's most recent find was a Polaroid image found when the exhibition was being installed. The artist applies no criteria to his selection, and the result is that various very disparate styles of image—passport portraits of children to hardcore pornography—are juxtaposed with one another. If the work will not fit in a particular exhibition venue, the series is never broken up, but simply sampled.

The emphasis on the chronological sequencing of the work, and the geographical location of the found images, provides a certain biography of Schmid, preempting the spatial mapping enabled by today's geo-coded digital snapshots on smart phones. As Weber (2007b: 22) notes, *Bilder von der Straße* served

as a "route-marker" in the artist's "journey as an international photo-flâneur."
However, as Weber also notes in the introductory text to a 1994 book of the
project, by presenting an otherwise unadulterated compilation of random photo-
graphs found by chance, "Schmid deliberately explodes the notions of personal
style and expression that we normally associate with [artistic] photo authorship"
(quoted in Bull 2007: 61–2). And although nearly all the images depict people,
the pictures do not lead to Schmid. As Weber (2007b: 22) puts it, "Where the
viewing of most works of art leads to speculation concerning the intentions of the
artist, that speculation is here transferred and dispersed." This happens through
Schmid's intervention into the life of these images, which testify to the "imprint
left by photography on the modern city" (Weber 2007b: 22) as much as the
"scars" left by the city's activity on discarded photographic prints. To be sure,
one of the most interesting aspects of this work is that by carefully putting back
together photographs that have been torn up by someone, Schmid is working
against the intentions of that previous owner. It could be said that Schmid is act-
ing in defiance of those owners who wanted the images destroyed, but perhaps
in defense of the subjects pictured. The series reached a conclusion in 2012 with
"the 1000th finding," at a time during the rise of digital photography when phys-
ical prints were becoming increasingly rare.

In *Arcana* (1995), Schmid performed a related act, based this time on find-
ing negatives on the ground, which he then printed in his home darkroom.
As Dutch curator Frits Gierstberg (2007: 223) observes, this act represents a
reversal of the usual situation where a master photographer instructs a dark-
room printer:

> In "serious" photography, prints from someone else's negatives generally
> occur when a darkroom assistant prints according to the instructions of the
> "master photographer." With Schmid something else is happening: the artist
> brings an unknown private world to light through making the latent (or nega-
> tive) image visible. In this act, which takes place within the intimate sphere of
> the darkroom, the old magic of photography, as an optical-chemical proced-
> ure that conjures up images, coincides with its classic function as a voyeur-
> istic medium.

Gierstberg makes a good point, even if the damaged negatives complicate the
conventions of voyeurism. Once again, what stands out in Schmid's work is the
richness of the material itself, through which we can speculate on other peo-
ple's lives. In an earlier black-and-white series using negatives, *Belo Horizonte,
Parque Municipal* (1993), Schmid collected and developed the negatives thrown
away by Brazilian street photographers who produce photographs on the spot
for people to take away for ID purposes. He enlarged and placed them on a grid
format, giving the portraits a more monumental dimension.

Schmid's series *Archiv* (1986–99) emerged out of a general process of stock-piling found photographs, which he then grouped into different "species" (Bull 2003). Like a zoologist of the photograph and an anthropologist of photographic practice, Schmid's taxonomies reveal shared camera habits and "a commonality of human photographic instinct" (Weber 2007b: 71). As Weber (2007b: 98) suggests, through this series Schmid in a sense "invented the relevant method-ologies through which to trawl the landscape of contemporary and historical photographic production." The categorization is far from a precise science, more one of "discoveries rather than certainties" (Lundström 2007: 99). However, one of the lessons of the archive is that even the most seemingly personal of photo-graphs, the most seemingly idiosyncratic of gestures or topics, has likely been done by many others. This is both potentially "unsettling" but also in the end comforting (Weber 2007b: 71). Jan-Erik Lundström (2007: 98) invokes Vilém Flusser, noting that in his terms, Schmid "imitates, explores, structures and cre-ates … the entire and complete output of the programme producing technical images or photographs." Once again, as Lundström (2007: 98) argues, he is not concerned with judging the quality of the "pre-determined image-repertoire of the amateur photograph" and its "repeated stereotypes and clichés." Instead he delves beneath to uncover "other narratives," as Lundström (2007: 98) con-cludes: "Something leaks between the personal and the collective, between the individual and anonymous commune, something spills over from original to copy, and the copy begins to live its own life."

The year 1989 marked a milestone in the history of photography, with its 150-year anniversary coinciding with the introduction of Photoshop (which became commercially available the following year). The same year, Schmid made a con-troversial proclamation in the title of an essay: "No new photographs until the old ones have been used up." Although this claim has since been updated to the rather different "Please do not stop taking pictures," it was such thinking that was behind another archive: *Die Erste Allgemeine Altfotosammlung [The First General Collection of Used Photographs]* in 1990. To enact this ruse, Schmid placed small ads in photographic magazines and daily newspapers asking for readers to send him used and unnecessary pictures of all kinds for the "environmentally sound recycling of old photographs" (Weber 2007a: 14). The "Institute for the Reprocessing of Used Photographs," as Schmid also called it, offered to safely recycle or re-use dangerous film and photographs. The advertisement was "an immediate and unexpected success" (Sachsse 2000: 256), the "institute" was publicized worldwide, and Schmid was inundated with parcels of photos and negatives—photographic possessions that people wanted to dispose of safely. In one series of parcels, Schmid received the entire archive of a commercial por-trait studio in Bavaria. Exploring its contents, he discovered decades of medium format negatives, all of which had been sliced in half in an effort to destroy their value and prevent further use (Weber 2007b: 113). Schmid discovered, however,

Figure 5.2 Joachim Schmid, *#10,* from *Photogenetic Drafts*, 1991. Courtesy of the artist.

that the images had been uniformly lit and the camera had remained in the same position in relation to each model. As a result, he could shuffle the left half of a negative with the right half of another negative to come up with uncanny composites. He called these combined portraits, which speak to the conventions of portraiture, *Photogenetic Drafts* (1991) (Figure 5.2). This artistic recycling, reminiscent of the work of Stezaker, demonstrates perhaps most clearly how Schmid can be said to collaborate with the original author(s) of photographs *over time*. His images constitute a form of rebirth in which Schmid is the midwife.

Schmid obviously appropriates for his own ends images made by others for other purposes. However, as various writers have observed, Schmid's attitude towards his material is elusive, and, his role as the "author" is "shifting and hard to place" (Weber 2007a: 13). As Weber puts it, Schmid's work "deftly questions the nature of authorship and artistic intention in the post-romantic, post-Duchamp western tradition" (11). More specifically, it at once expands and short-circuits "inherited notions of the photographic canon" (11). Schmid himself is very aware of the slippery nature of authorship in photography, and the

tenuous conventions of artistic authorship in particular. This is explored in various works—including several that playfully reference the father of "readymade" photography, Ed Ruscha.[9] Most overtly, Schmid assembled a series of found images called *Meisterwerke der Fotokunst* [*Masterpieces of Photography*] (1989), made up of images that look like August Sander, Ansel Adams, or Cindy Sherman and others. The images are actually attributed by Schmid and his collaborator, the Berlin artist Adib Fricke, to the famous artists whose work they resemble. As Bull (2007: 63) reflects, he was completely fooled when when he saw the Sander imitation reproduced as a postcard in Serpentine Gallery's bookshop in London. As he notes, the series also comes with "a text by a sham Helmut Gernsheim to further cement the legitimacy of the images" (2007: 63–4):

> Schmid's meddling with ideas of attribution, together with the suggestion that an amateur snapper in the right place at the right time can create a "masterpiece," makes for a salient reminder of the fragile nature of authorship when it comes to any photograph, found or otherwise.

As we have seen repeatedly in this book: "Authorship and originality, the flimsy foundations which prop up so much of art history, are brought into question by the exhibition of these lost masterpieces" (Bull 2003). At the same time, the images can only have been sourced and presented in this way by the mediating agency of Schmid's connoisseurial eye. Along the same lines, Schmid has also taken photographs "in the spirit of Martin Parr."[10]

As Bull (2007: 61) points out, Schmid is acutely aware of "the elusive nature of his position in anchoring the meaning of the images," and the degree of that authorship varies from project to project. If recognizing patterns is his main activity, in certain cases his intervention extends only to re-presenting whatever work he finds. As he says, "Sometimes it's also just adopting something that I think is worth being saved and being looked at" (Schuhmacher 2013).[11] Schmid's interest lies in photography as a medium and practice—rather than individual images or photographers—and thus he wants to examine it analytically and socially (primarily through taxonomies of found images). Overall, then, it would be fair to conclude that Schmid refuses the "auteur principle, the authorial voice, the signature style" (Lundström 2007: 98). Or rather, Schmid refuses to offer up artistic self-expression as we normally understand it, since as Bull notes (2007: 69) "one of the great strengths of found photography is that it can provide an escape from the fixation of meaning through biographical attribution." And yet, he has nevertheless often inserted himself into the work in surreptitious ways. His own baby picture even appears in one of the panels, as well as "images of himself and his wife secreted amidst its hundreds of photos and panels" (Weber 2007a: 17). Arguably, Schmid's most diaristic series is *Tausend Himmel* [*Thousand skies*] (2005), which is slightly anomalous in that it consists of a thousand photographs the artist took

of helicopters flying over Berlin after he was diagnosed with a hearing problem that led to hypersensitivity to certain noises. However, in a technique reminiscent of Douglas Huebler (Chapter 4), the photographs were sometimes taken only from the sound when he was unable to see the source. That is, their automatic sonic cue and serial structure link them to anti-authorial conceptual practice.

It has been proposed that Schmid's work merges from out, but departs from, the great tradition of German taxonomic photography from Karl Blossfeldt and Sander to Bernd and Hilla Becher (Weber 2007a: 18). Quantity is undoubtedly crucial to his work. As Schmid puts it, "[F]ive pictures from the street are rather uninteresting, but fifty are interesting and five hundred are extremely interesting. The quantity adds to the quality" (Weber 2007a: 18). While prints may now be hard to find, the quantity of photographic images has been massively enhanced by the advent of digital photography, which Schmid has embraced.[12] The Internet—and the photosharing site Flickr, in particular—has provided an extraordinary space for Schmid to hunt for images. If *Archiv* constituted an analytical survey of found photographs based on similarity to one another (Figure 5.3), his collection of ninety-six books called *Other People's Photographs* (2008–11) reveal recurring patterns and themes within the vast archives of popular photography online. As he describes the mammoth project on his website:

Figure 5.3 Joachim Schmid, *Archiv #321*, from *Archiv*, 1986–99. Courtesy of the artist.

Assembled between 2008 and 2011, this series of ninety-six books explores the themes presented by modern everyday, amateur photographers. Images found on photo sharing sites such as Flickr have been gathered and ordered in a way to form a library of contemporary vernacular photography in the age of digital technology and online photo hosting. Each book is comprised of images that focus on a specific photographic event or idea, the grouping of photographs revealing recurring patterns in modern popular photography. The approach is encyclopedic, and the number of volumes is virtually endless but arbitrarily limited. The selection of themes is neither systematic nor does it follow any established criteria—the project's structure mirrors the multifaceted, contradictory and chaotic practice of modern photography itself, based exclusively on the motto "You can observe a lot by watching."

(Schmid 2011)

The various themes include Fridge Doors, Self, Parking Lots, and, perhaps most famously, Currywurst (the local fast-food of his hometown). Geoffrey Batchen refers to it as an "anecdotal, surrealist ethnography of global photography" (2013: 47) and notes that Schmid spent up to six hours a day "perusing and grabbing images" in a form of "hunting and gathering" (47).

No human can hope to trawl through all the millions of images uploaded daily. From Schmid's point of view, his unauthorized publication of other people's images exposes a kind of collective authorship, as he notes that "we all more or less take the same photographs … you have a limited number of patterns" (Schuhmacher 2013). However, Schmid's commentary—and he does under-stand it as commentary rather than simply collating—is neither pessimistic nor patronizing. In this sense it may be distinguished from the superficially similar work of Dutch art director Erik Kessels, who since 2001, has been publishing *In Almost Every Picture*, a series of books of anonymous photographs found at flea markets in which a common person or object appears: the same middle-aged woman in different holiday-like settings (a dozen years of vacation photo-graphs taken by a husband of his wife), parked taxis amid alpine settings and a series dedicated to one family's photogenic Dalmatian. Kessels claims to be interested in drawing out narratives in photographs that their original authors are unaware of (Kessels 2013). However, he has become best known for *24hrs in Photography* (2011), a sprawling room-sized installation comprising printouts of twenty-four hours worth of photographs uploaded to Flickr, with no attempt to filter or sort, turning photographic excess into rubbish. Schmid's interest in pho-tography's social histories is more modest, his projects are "anti-monumental and egalitarian" and borne out of "social conviction" (Weber 2007a: 17–18). This egalitarian attitude extends to his publication of books "on demand," which keep costs low even if it jars with the increasingly fetishized market for "photo-book" collecting. As Batchen puts it in relation to Schmid, "Everyone concedes

that photography is now a medium of exchange as much as a mode of documentation" (2013: 46). In his poetic exploration of the grammar of popular photography, Schmid takes this point more seriously than most—necessitating his various collaborative authorings.

Penelope Umbrico: Distributed authorship and collective desire

> My focus on collective practices in photography has led me to examine subjects that are collectively photographed. I take the sheer quantity of images online as a collective archive that represents us—a constantly changing auto-portrait.
>
> (Umbrico 2015a)

North American artist Penelope Umbrico (1957–) has never considered herself a photographer, although she sometimes claims to be a "documentary photographer" who goes not to the street but to the Internet (2015b). Above all, she is an artist whose subject is photography, about which she has been making work since the early 2000s. Her best-known work, *Suns (from Sunsets) from Flickr* (2006–), consists of a large wall of small prints of sunsets, arranged in a grid formation. As the title suggests, the ongoing aggregation of images is generated by searching for the word "sunsets" on the photosharing site Flickr (Figure 5.4). Umbrico (2015b) says that she chose sunsets because in 2006 it was the most popularly tagged term among the millions of user-submitted photographs on Flickr. As with Schmid's work, Flickr here stands for a collective image database, within which sunsets are apparently a universal icon. However, Umbrico does not reproduce the images she chooses whole, but carefully crops them such that the setting sun is the central feature, and "the specificities of particular locations are eliminated" (Albers 2013: 5). Moreover, Umbrico does not print the grid of images herself. Instead, mingling the digital world of sharing JPEGS with the previously dominant economy of personal prints, she uploads her cropped images and orders 4 x 6-inch prints through Kodak's website, as it existed in 2006, dubbed EasyShare. This standard size of the commercially printed photographs is important to the project; it is the popular format that her generation largely grew up with, and distinguishes the look of her work at a time when large-scale photographic tableaux were far more common on the walls of art galleries. Rather than a singular object, Umbrico's is a conceptual aggregation of many small parts. In other words, through a series of actions, she produces physical prints of parts other people's photographs which, collectively assembled, form a new work authored by the artist.

Suns has become one of the iconic artworks associated with digitally networked photography. Like Kessels's *24hrs in Photography*, it offers a witty

Figure 5.4 Penelope Umbrico, *"541,795 Suns from Sunsets from Flickr (Partial) 1/23/06,"* 2006, Detail of 2000—4" x 6" Kodak Easy-Share machine c-prints. Original in color. Courtesy the artist, Mark Moore Gallery, Culver City, and Bruce Silverstein Gallery, New York.

comment on photosharing by way of a simple yet dramatic gesture. Images of the work have been reproduced in numerous books and exhibition catalogues about digital photography. As the series has grown, each time it is retitled with the current number of suns. Thus, the 2006 version of the work claimed 541,795 images tagged as sunsets, but only a few years later there were several millions. By 2007 the work was called *2,303,057 Suns From Flickr (Partial) 9/25/07* and by 2009 it was *6,069,633 Suns from Flickr (Partial) 8/27/09*. Aside from acknowledging the impossibly incomplete sampling at work in the action, Umbrico's inclusion of the word "Partial" in parenthesis in the title once again evokes conceptual practices such as Huebler's. And yet the work also offers visual pleasure, with the installation engulfing viewers in something of a dazzling, even sublime spectacle of abstracted color (Umbrico's original training as a painter is perhaps evident here). As the art historian Kate Palmer Albers notes (2013: 5), *Suns* "encapsulates several of the seemingly contradictory aspects of digital abundance and accumulation in the realm of aesthetics." The earliest inventors of photography recognized that the medium was a way of cataloguing the world. As Susan Sontag (1977: 3) put it, calling for an "ecology" of images, "The inventory started in 1839 and since then just about everything has been photographed."

The sun is a particularly compelling object for photography, since it is also the primary source of photography itself. Indeed, photography was initially conceived as being authored by the sun (Chapter 1). Recall that in 1827, Joseph Nicéphore Niépce gave the name *héliographie* to his earliest photographic experiments, from the Greek *helios*, meaning "sun" and *graphein*, meaning "write." William Henry Fox Talbot, in *The Pencil of Nature* of 1844, started with a notice to the reader that "The plates are … sun-pictures themselves." In his Salon review of 1859, the poet Charles Baudelaire memorably dismissed the new class of pseudo-artists flocking to the camera as "sun-worshippers" ([1859] 1980: 87). Umbrico became fascinated to understand what it means for millions of images of an object that provides us with warmth and life to appear online—a "warm object viewed through the artificial light" of the computer or television screen (2015b). Indeed, Umbrico used 365 images of the sun to produce a frenetic screen-saver work called *Sun Burn* (2009), in which the suns appear in quick succession over an explosive, looped twenty-four seconds.[13] The original and now unnecessary idea of screen-savers was to preserve the life of screens; in Umbrico's work, the sun continually keeps the computer awake, and also suggests the seemingly accelerated tempo of daily life. As it happens, the sun features in another work of art produced around the same time that also involves a collaboration with other people's photographs. Lisa Oppenheim's *The Sun is Always Setting Somewhere Else* (2006) is a 35mm slide show consisting of a sequence of fifteen images of photographs of sunsets taken by soldiers in Iraq which the artist has rephotographed as she holds them up with her outstretched arm to obscure the view of a sunset in New York. This elaborate, performative work involves the curious act of downloading and then printing images of sunsets taken by the soldiers found on photo sites such as Flickr, and then a further act of documentation to produce the slide show. In her artist statement Oppenheim says she wants to "examine the ways in which certain visual clichés function to displace representations of violence." In order to do this, she fuses a specific group of other people's snapshots and presents them in a format familiar from family life. The authorship of the photographs is thus both collaborative and critical.[14]

My interest here, of course, rests with how Umbrico's work explores the issue of authorship. At one level, the combination of camera phones and social networking has oriented photographic production towards the self. Individuals own camera phones—not families, as was previously common—and images are often deployed in the service of self-presentations on sharing sites like Facebook and Instagram. The prefix "i" in the iPhone and, until recently, in Apple's photographic software iPhoto (now Photos) signals this individualized image universe. The structure and rhetoric of dominant photo-sharing services also appears to support an individualist ideology—as Flickr's recent taglines "picture your life" and "share the world you see" indicate. At the same time Flickr has promoted

itself as an "amazing photographic community, with sharing at its heart."[15] To be sure, sharing is not in itself collaborative, and nor is the mere aggregation of content. Nevertheless, as Susan Murray enthusiastically describes:

> Flickr has become a collaborative experience: a shared display of memory, taste, history, signifiers of identity, collection, daily life and judgement through which amateur and professional photographers collectively articulate a novel, digitized (and decentralized) aesthetics of the everyday.
>
> (2008: 149)

Most importantly, social networking software facilitates the collaborative input of large numbers of people through the all-important process of tagging. As Daniel Rubinstein and Katrina Sluis (2008: 19) suggest:

> Tagging, commenting, titling and annotating of images are essential elements of participation in the social aspects of photo sharing which play a role in creating communities of users interested in specific images.

Even though tagging is motivated by the often self-interested desire to appear in searches, services like Flickr and Instagram have given rise to collections of images by multiple authors, and the moment of capture increasingly merges with their distribution and the re-publishing of photographs taken by others. Although uploaded digital photos might begin in autobiographical streams, the flow of images through the Internet is chaotic and unpredictable. Image metadata such as semantic tags causes individual images to easily become decontextualized and disassociated from their origins. As a result, as Rubinstein and Sluis suggest (2008: 22), networked snapshots often exhibit an "authorless" quality.

Umbrico (2015b) is the first to note that exhibitions of *Suns* have generated some angry responses from viewers who claim the work represents a blatant disregard for copyright of the original photographers. However, Umbrico (2011: n.p.) points out that attribution of individual images would make no sense:

> I don't ask for permission. I only use a tiny fragment of each image (the sun is often less than five percent of a much larger picture). What I end up with is not at all recognizable in relation to its original source. My cropping eliminates the point of view of the photographer—no context remains.

To this she adds (2011: n.p.): "[T]hey are all practically indistinguishable from each other to begin with. It is the collective practice of photographing the sunset that I work with, rather than the individuality of the image." Indeed, Umbrico is fascinated by the collective practice of viewing the sunset, and the fact that there

is only one sun whose light and beauty we necessarily all share. This quality is more pronounced in *Sunset Portraits* (2011), a grid of snapshots showing the silhouettes of people looking at sunsets. Umbrico's attachment to a deconstructive strategy is apparent in this work just as it is in earlier works such as *Honeymoon Suites (From Honeymoon Resort Brochures)* (2005), in which she scanned the candy-colored horizons and skies seen through the window of the suites to comment on the marketing of romance. As in *Views from the Internet* (2003–9), which borrows images from home décor and home improvement sites, these works seem directly indebted to the forms of postmodern appropriation associated with a figure like Richard Prince. It is worth noting, however, that even in this work, like *Suns*, Umbrico is especially attentive to photography's role in blurring the private and public.

One way to interpret Umbrico's *Suns* is to view the assembled images as a collective portrait of anonymous photographers. This idea underpins another work by Umbrico, *TVs from Craigslist* (2008–09), which collects a series of TVs for sale on the popular online market site in which the screen displays a camera's flash, giving us an inadvertent glimpse of the seller and, by dint of the reflection, their interior space. The pictures are then enlarged to the televisions' actual size, in black frames, and hung together as an installation. In this way, as Umbrico suggests (2011: n.p.), the photographs become "self-portraits of the sellers" in which the flash "announces their presence in each image." The flash, in effect, becomes a symbol of the photographer's personal presence in otherwise impersonal images (whose authorship is irrelevant to their purely functional purpose). There is a connection here to Umbrico's fascination with the fact that people take pictures of themselves in front of the *Suns* work, "as though they are in front of the sunset itself" (2011: n.p.). Not long after she first exhibited the work, she discovered an image from the Gallery of Modern Art in Brisbane on Flickr that featured people in front of the work taking pictures. Umbrico managed to trace a series of these photographs that had been uploaded on Flickr, of people smiling and even kissing in front of her work, which she then arranged in an installation titled *People in front of Suns (From Sunsets) from Flickr* (2011–). The mirror-like endlessness of the Internet fuses here with a play on authorship, but as Albers (2013: 12) points out, Umbrico is not dismissive of our collective rituals: the work obviously speaks to "the un-originality of photographing a sunset," but it does so while "ultimately affirming our own participation in the collective practice."

Given her interest in the circulation of popular photography, Umbrico was an interesting choice to be invited to intervene in the Aperture Masters of Photography series of books in 2012, as part of their sixtieth anniversary. The result, *Moving Mountains* (1850–2012)—which included a physical book also available as a free download—questioned the whole idea of "masters" of photography. Umbrico came to realize that the mountain represented the

most stable subject for photography, for male photographers in particular. In response, she rephotographed all the mountains she could find in the Aperture Masters of Photography books with an iPhone, deploying all the various filters she could find from fifty-eight different photo "apps." Umbrico was attracted to the fetishization of analogue photography that so many of the filters seek to simulate through digital algorithms, including light leaks and chemical burns, which were traditionally considered mistakes. Having thus "processed" the images, she outputted them as photographic prints, as a digital slideshow, and as a book. The book lists all of the filters, and presents the images in a disordered accordion book, which seems to fall apart as you are reading it. Like the proliferation of *versions* of the mountain, which speaks to the variable condition of photography today (the images seem to become increasingly abstract with each new filter), the book format is intended to destroy the assumed stability of authorship (Umbrico 2015b). As Charlotte Cotton surmises (2015: 4), "technologies themselves are 'authoring' the images we see," given that "the pervasive automation of photographic rendering has made software the dominant photographic medium."

Umbrico has expressed a fascination with the equalizing dimension of online images. Echoing Rubinstein and Sluis, she has said that on the web "all images (artful, authored, pedestrian or unauthored) become unassignable and anonymous in this unlimited exchange of visual information, and function as a collective visual index of data that represent us" (Umbrico and Nader 2013). As she puts it, when "recontextualized on the web" an individual picture "goes from being an individual and authored image to a collective anonymous image that regards no author at all" (Umbrico and Nader 2013). This is certainly a disputable claim, given the degree to which, for example, copyright holders attempt to restrict the flow of images. Nevertheless, it is an idea that preoccupies Umbrico, who is clearly inspired by the renegade actions of popular photosharing online, which often takes no account of authorship or copyright. It is precisely this sharing— both before and after the Internet—that inspired her work *Four Photographs of Rays of Sunlight in Grand Central Station* (2013) (Figure 5.5). This work comprised 512 prints based on an iconic photograph of light streaming through the windows and pooling on the main concourse of the Grand Central terminal. However, the authorship of that photograph is already multiple from the start; the "iconic image" turns out to be taken not by a specific photographer but by four photographers who took almost identical images between 1913 and 2010. Moreover, online, these four images appear in slightly different forms: people have added color or sepia tone, made them grainy, introduced high contrast, enlarged and cropped them, reversed them, and so on. In other words, the images have been subtly modified over time by multiple end users before they are sold as posters, "vintage" prints, mouse pads, coffee mugs, and the like. This process of repetition and variation has exploded in the digital context, with

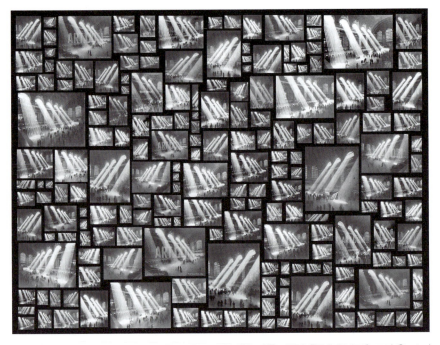

Figure 5.5 Penelope Umbrico, *Four Photographs of Rays of Sunlight in Grand Central Station, Grand Central Terminal, 1903–13, 1920, 1926, 1928, 1929, 1934, 1937, 1940, 1930–40, 1935–41, 1947, or 2010, by John Collier, Philip Gendreau Herbert, Edward Hulton, Kurt Hulton, Edward Lunch, Maxi, Hal Morey, Henry Silberman, Warren and Wetmore Trowbridge, Underwood & Underwood, Unknown, or Anonymous (Courtesy: Associated Press, the author, Bettmann/Corbis, Hal Morey / Getty Images, Getty Images, Hulton Collection, Hulton-Getty, Hutton Collection, New York City Municipal Archives, New York Transit Museum, New York City Parks and Landmarks, Royal Geographical Society, SuperStock/Corbis, Underwood & Underwood, Warren and Wetmore, or Image in Public Domain)*, 2013. Duratrans, 30 x 40 in. Courtesy the artist, Mark Moore Gallery, Culver City, and Bruce Silverstein Gallery, New York.

graphic framing and "watermarks" among other additions. Moreover, the original four images are attributed online to at least eleven different photographers as well as to "anonymous" and "photographer unknown" (Umbrico and Nader 2013). Exhibited at a gallery in Grand Central Terminal on the occasion of its centenary celebration the press release referred to the complex relationship between photography and memory.

Umbrico has herself initiated and facilitated collaborative processes of image proliferation and differentiation. For instance, in *Mountains, Moving: Of Swiss Alp Postcards and Sound of Music* (2013), Umbrico created outdoor billboards situated in the mountainous Swiss Alps village of Rossinièr (as part of the 2013 Alt+ 1000 Festival de Photographie) (Figure 5.6). Part of the work involved a public

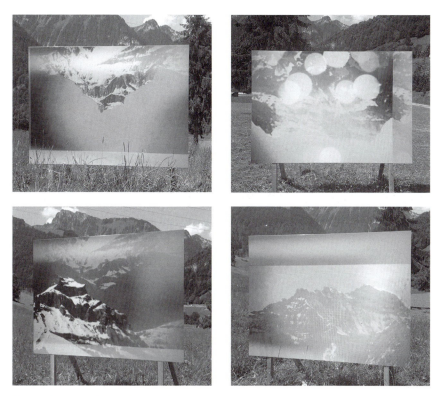

Figure 5.6 Penelope Umbrico, *Mountains, Moving: Of Swiss Alp Postcards and Sound of Music*, for Alt+1000 installation, outdoor billboards, Rossiniere, Switzerland, 2013. Original in color. Courtesy the artist, Mark Moore Gallery, Culver City, and Bruce Silverstein Gallery, New York.

collaboration called *A Proposal and Two Trades* (2013–). As Umbrico describes (Umbrico and Nader 2013), the two "trades" or exchanges were:

1 Take this "already seen" picture with a smartphone—the ancient mountain and the new smartphone/technology trade information, and

2 E-mail me the picture, I receive it and process it with various smartphone camera filters and send it back.

On this basis, Umbrico received, altered, and emailed back 659 images of the mountain. Once again evoking conceptual art practices involving maii art, and Huebler in particular, she then invited the participants to print out two copies of the artist-altered file and mail this print edition back with a self-addressed and stamped envelope in which to receive a "certificate of authenticity" (Figure 5.7). Albers (2015) observes that the first "trade" was not merely the collaboration

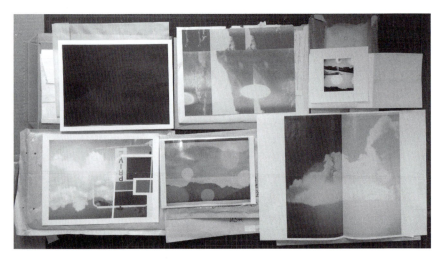

Figure 5.7 Penelope Umbrico, *Responses to the Print Edition for "A Proposal and Two Trades,"* a project for Alt+1000 Photography Festival, Rossiniere, Switzerland, 2013. Original in color. Courtesy the artist, Mark Moore Gallery, Culver City, and Bruce Silverstein Gallery, New York.

between the festival visitor and the artist, but conceptualized as one "between the initial digital photograph the viewer made and the filters in Umbrico's apps." As she (Albers 2015) notes of this "provocative abdication of authorial control," the technology of the smartphone camera and the makers of the filter apps were "the most active participants" in this trade.[16] The images are "co-authored" by Umbrico, with the assistance of the non-human agency of software.[17]

Photography critic Fred Ritchin (2009: 131) has proposed that networked digital media is transforming photography into a hypertextual medium, enabling a multiplicity of perspectives and a "more sustained collaboration with the reader." For Ritchin (2009: 141), this development promises to reinvent the authorial image as an evolving conversation among people with different points of view, a "hyperphotography" that is inherently social and collaborative. Ritchin chronicles the emergence of citizen journalism in which everyone is a potential eyewitness to historical events. The idea of crowdsourcing photographs was pioneered by projects such as Susan Meiselas's *akaKurdistan*, an online site of exchange for collective memory in 1998, for a people who have no national archive.[18] Its potential was also demonstrated by the success of *Here is New York: A Democracy of Photographs* (2001), a spontaneous physical exhibition of photographs made in the wake of the 9/11 terrorist attacks, based on an open online call that some commentators saw as realizing photography's unfulfilled democratic promise. Earlier mass photography projects (Pollen 2015) have since been adapted for participatory online documentation, with activists, researchers, and governments all encouraging citizens to use camera phones to record everything from graffiti

to weeds to poor bicycle paths (Palmer 2015b). Crowdsourced catalogues of images contributed by thousands of photographers have transformed the stock photography industry. More unusually, crowdsourcing has been explored in projects such as Magnum photojournalist Thomas Dworzak's *Instagram Scrapbooks* (2013), which offer him a way to document events by taking Instagram screenshots and through the use of specific hashtags, such as #receiptporn, which he then turns into physical books (Lehan 2014). Meanwhile, Jamila Mohamad Hooker's *Foreign Postcards* (2013) invited people from around the world to pose with postcards featuring their name in Arabic in an act of visual activism against xenophobia and Islamophobia (Hooker 2013).[19] In a more experimental work utilizing the potential of pattern recognition algorithms, the Greek-born UK-based artist Erica Scourti used Google's "search by image" command to process her own personal archive of snapshots for "similar" images available online, with the assistance of online taggers, for her work *So Like You* (2014), which emphasizes the tension between individual and collective authorship of photographs online (Sluis 2014).[20]

In popular and commercial culture, collaborative photographic "conversations" tend to be more frivolous, such as popular Photoshop memes in which social media and blogs enable certain popular images to be endlessly modified by end users (think of the "Botched Ecce Homo Painting" in 2012 or "Scarlett Johansson Falling Down," based on an exploitable cutout of the American actress tumbling on a Glasgow footpath in 2013). Meanwhile, algorithms are enabling more complex forms of collaboration online.[21] Microsoft's Photosynth software, unveiled in 2006, pulls images from databases, creating links between images to generate collective images of tourist sites and what has been called "pluriform" authorship (Uricchio 2011: 33). Photosynths, as Albers (2014: 14) writes:

> enable viewers to "wander" through photographic images and their typically collaborative authorship undermines any one point of view and thus a conventional photographic relationship predicated on a single authorizing view of any particular subject. Rather than a viewer simply looking at a still photograph, Photosynths encourage viewer participation.

Photosynths may encourage participation at the level of the computer user, but they generate media attention with choreographed promotional projects, which operate at a commercial and spectacular level.[22] Adopting a different approach, Nadav Hochman, Lev Manovich, and Jay Chow produced *The Aggregate Eye: 13 cities / 312,694 people / 2,353,017 photos* in 2013, which, as the name suggests, used digital software to analyze a huge number of photographs over a three-month period to produce patterns and new urban representations. Such work supports the idea that "the networked photograph is always in the process of becoming" (Bushey 2014: 39). Meanwhile, the Swiss–French artist

Corinne Vionnet used a similar logic to Photosynth to produce a more modest and poetic series called *Photo Opportunities* (2005–13). She conducted keyword searches of famed monuments in photo-sharing websites in order to cull thousands of tourists' snapshots. Weaving together numerous photographic perspectives and experiences, the artist then built her own impressionistic interpretations of sites like the Eiffel Tower—now presented as ethereal structures floating in a dream-like haze.

For Umbrico, *A Proposal and Two Trades* begins by asking people "to think about looking collectively, and what it means to take a picture they've already seen of the mountains in front of them" (Umbrico and Nader 2013). As Albers (2015) notes, the project also touches on "mobility, exchange, and the visual, emotional, and psychological effects of our intimately handheld devices on viewing images today," thereby revealing "the complexity of how we read, make, exchange, consume, and circulate photographic images today." Invoking Sontag by reference to a "new image ecology," Albers (2015) concludes that the project "underscores a certain kind of beauty to its movements, a humanity within the collective identification and shared desire that is facilitated by algorithms and digital networks." This might be a slightly romantic interpretation of digital networks whose infrastructural underpinnings are based on standardization, commercialism, and surveillance. Nevertheless, in taking the sun we all share, or Grand Central Station, or a Swiss mountain, photographed repeatedly by millions of photographers, Umbrico's work draws attention to both the commons and the collective. In exploring distributed authorship across digital networks, she engages largely anonymous photographers in often-unconscious collaboration, which takes place unknowingly and involuntarily. Umbrico has referred to her work in general as a "conversation with things," which she eventually owns (2011: n.p.). However, her project is driven by shared desires that no individual can own, and to which single photographs can only hint.

Richard Prince: *New Portraits* or stolen selfies

The origins of Richard Prince's (1949–) approach to photography are by now the stuff of myth: working in the basement of the Time-Life building—cutting out and filing articles from their various magazines for the library—he became aware of the possibilities of advertising imagery in his art (Spector 2007: 26–7). His earliest works, such as *Untitled (Three Men Looking in the Same Direction)* (1978) and *Untitled (Three Women Looking in the Same Direction)* (1979–80) were comprised of found advertising images, rephotographed and juxtaposed with one another. Prince has said that he "thought of the camera at the time

as sort of an electric scissor" (Shukur 2014). It was not collage, however, but the act of rephotography that was crucial. By turning images reproduced on paper magazine pages into glossy color photographs, Prince has said that he was returning them to "their former self" (Shukur 2014). He presented them in a matted frame, as if they were original photographs, repeated in a series, which allowed them to hover between the possibility of them being documentary or fictional. As Prince reflected later (2012–), "the ads didn't have an author and seemed to suggest something I could believe in. I was struggling in those days with identity and truth and anger and the ads provided an alternative reality." Inspired by the lesson of Andy Warhol, but without the aestheticization of the silkscreen print, Prince's work took existing images as a readymade, or at least an "already seen" (Crimp 1980: 99). It was an activity he shared with other post-modern artists, such as Sherrie Levine and Barbara Kruger, who also engaged in visual appropriation.[23]

In the early 1980s Prince started to make his *Cowboys* series, in which he appropriated the iconic Marlboro Man from the cigarette company's advertising imagery (Figure 5.8). Together with a controversial appropriation of a nude image of Brooke Shields aged ten which he called *Spiritual America* (1983), after a 1923 photograph by Alfred Stieglitz, these cowboys are the images for which he is best

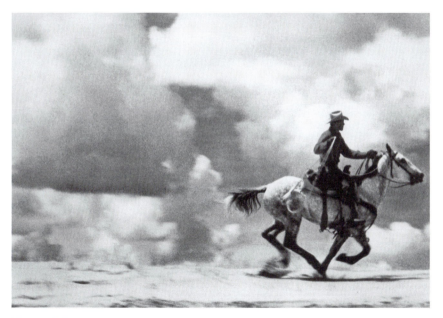

Figure 5.8 Richard Prince, *Untitled (Cowboy)*, 1989. Ektacolor photograph, 50 x 70 inches / 127 x 177.8 cm. Original in color. ©Richard Prince. Photography by Rob McKeever. Courtesy Gagosian Gallery.

known. In 2005 one of them became the first photograph to ever sell for more than US$1 million at auction, even though Prince had used a commercial lab, and "never went into a darkroom" (Lafreniere 2003: 70). Whereas, in the early 1980s, Prince focused on the common styling found in advertisements for luxury goods such as watches, pens, and jewelry, by the end of the decade he had turned to appropriate images from subcultural fields—most famously the biker chicks he collected from magazines that became his series and book *Girlfriends* (1992) (Figure 5.9). Prince also makes paintings, and in all of his work he abstracts or enlarges, and consequently makes uncanny, American consumer mythologies, however marginal, and their commodification of desire.[24] But Prince is equally well known for his radical approach to authorship. In his initial technique, according to Abigail Solomon-Godeau (1991: 96), Prince rejects "traditional notions of authorship" by virtue of his borrowing and stealing. Nevertheless, as Stephen Bull (2007: 66) argues, Prince's images are "highly authored, with a clear central theme evident throughout his work: stripping bare the American mythologies of

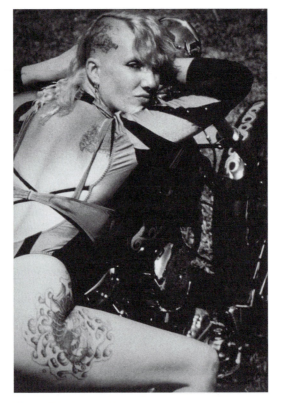

Figure 5.9 Richard Prince, *Untitled (Girlfriend)*, 1993. Ektachrome photograph, 65 x 45 inches / 165.1 x 114.3 cm, edition of 2. Original in color. ©Richard Prince. Courtesy Gagosian Gallery.

figures such as cowboys and half-naked biker chicks through selection and pairing of their image." As I have signaled already, postmodern artists did not abandon authorship, their authorial techniques just took different forms—challenging a legal construction of authorship that "assigns authority to originality" (Harrison 2015). Arguably, as Nate Harrison (2015) has recently suggested, by taking individual control of mass-authored images, artists such as Prince actually "reaffirmed the ground upon which the romantic author stands." In any event, art institutions and the market have validated Prince as an author with "a deeply personal vision" (Harrison 2015).

For my final example, I want to focus on Prince's 2014 work *New Portraits*. This series consists of thirty-seven images taken directly from his Instagram feed, printed poster size on a smooth canvas surface, which serves to accentuate the digital world's intensely saturated colors and vibrant whites. To make them, Prince took a "screen shot" of other people's Instagram images—including models, artists, people both unknown and known—and enlarged them. The inclusion of celebrities, including Kate Moss, Pamela Anderson, and Taylor Swift, link the work to an earlier body of publicity photographs of celebrities Prince made in the 1980s, and beyond that of course to Warhol. Some of those featured are friends of Prince—and one, Alberto Mugrabi, is one of the biggest collectors of his work—but none of them gave permission for their image to be used in this way. There are many more women than men, and several of them fall into the sub-cultural category of self-described "fetish glamour girl models"—sexualized, tattooed, and pierced—which links the work to *Girlfriends*. At the most basic level, the work draws attention to the generic looks, poses, and attitudes found on Instagram, including but not limited to the selfie. Crucially, Prince also entered himself into the thread of the conversation below the image, adding obscure, sometimes pervy "comments" below equally salacious images. For instance, below Anderson posing on the beach in a sheer white swimsuit he has written "T-Shirt bathing suit! Nice. Let's hook up next week. Lunch, Smiles, R," and below a girl lying on a bed with her tongue stretched out he adds "Now I know." According to the artist, a simple hack (reporting comments as spam) enabled him to swipe away other comments so that his own text appeared directly under the image post as the last word. He calls such writing his "bird talk" and describes the comments as "Non sequitur. Gobbledygook. Jokes. Oxymorons. 'Psychic Jiu-Jitsu'" (Prince 2012–). It has been claimed that the addition of Prince's own words and emojis provides a legal loophole to claims of image theft, since it "transforms" the work (Morgan 2014).

Prince was sixty-five years old in 2014, hardly a cultural outsider, and many writers have pointed to the sexism of the project—offering his comments as proof (Furtado 2015). However, the awkwardness of Prince's comments is clearly a pose, seemingly calculated to signal his generational, sexual, and social difference from the young people portrayed. Some include the copyright

and registered trademark symbols—such as "Don't du anything. Just B Urself © ®"—which read as sardonic references to issues of authenticity and authorship. The artist describes his actions in a self-reflexive and self-justificatory text written for the first exhibition of the work in 2014, in which he tells of how his daughter introduced him to social media, and how his niece taught him the pleasure of the "screen save"—which he views as a convenient update to rephotography. In the text, he describes Instagram as "advertising" and as a "bedroom magazine" (Prince 2012–).[25] When the series was first shown at the prestigious Gagosian Gallery in New York, the portraits dramatically reflected in the gallery's shiny black floor, art critic Jerry Saltz (2014) called it an act of "genius trolling," in which Prince's appropriation "twists" the original images "so that they actually seem to undergo some sort of sick psychic-artistic transubstantiation where they no longer belong to the original makers." Saltz, himself an avid user of social media, praised the work as an exploration of "the new unreal-real spaces we all live in" (2014). Not all critics have been so complimentary. In a scathing critique, Paddy Johnson (2014) stated, "Copy-paste culture is so ubiquitous now that appropriation remains relevant only to those who have piles of money invested in appropriation artists." There is obviously a degree of irony in ending a book on collaboration by discussing what is clearly a willfully exploitative act of appropriation of other people's photographs. Moreover, the kind of glamour images featured in Prince's insight into Instagram, even if made for sharing, are more obviously interpreted as a narcissistic symptom of popular photography in the age of the radically individualized, celebrity-obsessed, and performative self. My aim here is not to engage in the ongoing debates about the value or otherwise of selfies and other forms of self-branding, but rather to consider New Portraits in terms of the arguments I have developed around photography and collaboration.

Prince's intervention into Instagram is arguably a further instance of "hyperphotography" (Ritchin 2009: 141). For, regardless of his intentions, Prince is responsible for generating a collaborative photographic event, involving various photographers, subjects, and viewers as active participants. Although the work generated a certain outcry from some of the subjects and photographers whose images were appropriated—even though they had already put them into the "public" domain of Instagram—it is difficult to think of a better example that demonstrates both the irrelevance of photographic authorship on social media and the fetishized signature of the artist in the art market. People's Instagram user names are included, but the photographers remain unknown. They might have been taken by the users, a friend, a commissioned professional photographer, or appropriated from someone else entirely (all we really know is that Prince has not taken them). Inevitably, when an artist appropriates a photographic image, issues of authorship, copyright, and permission come to the fore. Prince is no stranger to controversy around this issue. His practice has "placed him consistently at

the edge of copyright infringement" (Israel 2014), and even his paintings have tested the meaning of "fair use" in the courts (Kennedy 2014). Such controversies underline the complex status of authorship in photography and art—indeed, the passing of the US Copyright Act in 1976 came at a significant moment, specifically allowing work that "recast, transformed, or adapted" the original, just a year before Douglas Crimp's 1977 *Pictures* exhibition (Harrison 2015). Still, many people quite reasonably assume that Prince's photographic work is copied rather than "recoded," to use Hal Foster's influential term (1985).[26]

If issues of copyright are pronounced in the appropriation of commercial photographs—returning us to the legal debates around authorship discussed in Chapter 1—the action takes on a more ethical dimension in relation to personal images. While a few of the original Instagram photographers expressed anger— and a commercial photographer, Donald Graham, even sent a cease-and-desist letter to Prince in relation to an image of his that had appeared on the Instagram feed of a third party, undoubtedly in a bid for publicity—what drew most attention is that Prince's portraits reportedly sold for at least US$90,000 each (Schuessler 2015). This, and the fact that Prince is by now a wealthy artist, made headlines and fueled the Twitter hashtag "#PrinceofAppropriation." One of the subjects, Instagram user Doe Deere, wrote a post:

> Figured I might as well post this since everyone is texting me. Yes, my portrait is currently displayed at the Frieze Gallery in NYC. Yes, it's just a screenshot (not a painting) of my original post. No, I did not give my permission and yes, the controversial artist Richard Prince put it up anyway. It's already sold ($90K I've been told) during the VIP preview. No, I'm not gonna go after him. And nope, I have no idea who ended up with it!

Other unwilling subjects of his art, notably members of alternative pin-up group Suicide Girls, started selling their own derivative works based on Prince's images. Founder Selena Mooney ("Missy Suicide") posted on the group's website that she would sell prints of their image for $90, with proceeds going to charity. The only change to the poster was an additional comment at the end, from Suicide Girls, saying "true art." A promotion for the sale of the image exclaimed indignantly that Prince's image was "sold by fat cat artists and millionaire gallery owners" with profits going to a "millionaire 'artist.'" However, the website post was written in more conciliatory tones: "Richard Prince is an artist and he found the images we and our girls publish on Instagram as representative of something worth commenting on, part of the zeitgeist, I guess? Thanks Richard!" (Needham 2015).

New Portraits' affinity with *Girlfriends* extends to both the marginal lifestyles depicted and the fact that the photographs are in some sense "personal" pictures used for the purpose of public bragging (even as *New Portraits* blurs the distinction between personal and commercial genres, and privacy and publicity).

As Prince has said of *Girlfriends*, in which semi-naked women are pictured with motorbikes, and unable to use social media to talk back:

> Boyfriends would take a picture of their girlfriend and send it to the magazine and the magazine would reproduce it … I like the idea of trying to present work that's factual, that's based in reality, even though it's still somewhat unbelievable.
>
> (Shukur 2014)

Both *Girlfriends* and *New Portraits* present images of people packaging themselves for public consumption. In the new work, our performance and authenticity-obsessed culture fuses with a desire for fame, or at least followers, in the form of the Instagram post as self-advertisement.[27] It is Prince's disruption of this process that seems to matter, since his act of recontexualization and monumentalization of such vanity-fuelled image posts brings with it the inevitable reminder of death.[28] Photographic portraiture has long been compared to embalming and spectralization, and not even Instagram filters and poses can repress this link.[29] Susan Sontag (1977: 15) declared that all photographs are memento mori by allowing us "to participate in another person's (or thing's) mortality, vulnerability, mutability" and Roland Barthes ([1980] 1981: 96) insisted that by "giving me the absolute past of the pose … the photograph tells me death in the future." For Siegfried Kracauer ([1927] 1993: 433), writing in the 1920s, "[P]hotographs by their sheer accumulation attempt to banish … the recollection of death."

Prince's own advanced age gives the work a voyeuristic quality. Moreover, as a celebrity, following in the footsteps of Warhol, Prince has become something of a performance artist, and it has become nearly impossible to separate his work from his persona (Darwent 2008). Thus Prince revels in his "bad boy" image, in which nobody seems to know whether to take seriously what he claims, and he is now a prolific and risqué user of Twitter and Instagram himself.[30] On Twitter he engages in the conversation the *New Portraits* have generated, regularly retweeting attacks on his work.[31] "Nightcoregirl," a subject in Prince's exhibition pictured sticking out her tongue, even posed provocatively in front of her portrait in the gallery, sending the resulting image back to Instagram, which Prince in turn forwarded, and on it goes. In other words, like Umbrico, Prince both articulates and participates in our collective image environment, which has been called one of the hallmarks of contemporary art photography (Cotton 2015: 18). Prince's appropriative act underlines the asymmetrical relationship of all uses of other people's photography, while also drawing attention to the fluid nature of photographic authorship on social media. Prince has complained via Twitter that it is no longer possible for him to produce Instagram portraits due to changes to the company's "terms of service" agreement, but with no sense of irony his

gallery refused permission to reproduce any of the *New Portraits* in this book.[32] Notwithstanding this fact, the series represent a fascinating instance of forced collaboration in social media that further pushes the question of what photographic authorship now means.

Conclusion

The artists I have discussed in this chapter are examples of what Fred Ritchin (2013: 38) has called "metaphotographers." They sort through photographs that already exist in the world, and make those images visible in a different way by providing them with a new context. They aggregate, which is to say they collect related photographs so as to display their connections. They reveal the always incomplete, repetitive, and socially coded nature of personal archives, but also extract and concentrate value from large bodies of photographs made by many anonymous authors. The work of Joachim Schmid, Penelope Umbrico, and Richard Prince obviously represents three very different approaches to "found photography," nevertheless their aggregations each explore the idea of photography in circulation. Notably, the ghost of Warhol continues to haunt each of the artists in their effort to arrest the ephemeral and seemingly banal image; a teenage encounter with Warhol made Schmid want to be an artist; Umbrico appropriated Warhol's iconic flower image from Art.com, complete with a gigantic text watermark in 2015; and Prince is often compared to the pop artist.[33] Like Warhol's *Death and Disaster* series from the early 1960s, in which he repeated traumatic newspaper photographs as silkscreen paintings, their work underscores photography's rampant reproducibility—thus raising questions about both the culture of images and conventions of authorship. Specifically, by working with already existing personal photographs, the artists insert themselves as coauthors of photographs taken by others for private reasons, and thereby reinvest those images with a new social life, and a different, more public authority.

The projects of Schmid, Umbrico, and Prince are driven by what is happening in the broader field of popular photography, which has been so radically reshaped by digital media over the past two decades. It is hard to underestimate the significance of the convergence of cameras and digital networks in the smart phone, and its ramifications for personal photography are still unfolding. At some important level, personal photography has become just another form of "user-generated content," another form of data to be exchanged. More broadly, evolving collaborations between photographers and viewers through social networking software seem to be transforming snapshot photography "from a personal to a community experience" (Keegan 2006). And yet, far from representing an absolute rupture from photography's past, contemporary photosharing can also be seen as part of an alternative tradition of photography's collaborative

manifestations that I have sketched out in this book. In this context, the artist working with photography is increasingly not the one who is able to take better photographs than the amateur, according to the nineteenth-century dynamic between Pictorialists and Kodak snapshooters, but one who is able to reassemble existing photographs in a way that produces a new understanding of the medium and the worlds it claims to picture. As we have seen, nineteenth-century ideas of authorship may continue to dominate the mainstream art world, but the authorship of photographs online is increasingly unstable and even inherently unfinished (Rubinstein 2009: 139).[34] More and more, it seems that artists contribute to photography's future by collaborating with its historical residues, revealing in the process, once again, that the photographic event is anything but past.

CONCLUSION

[T]he event of photography ... is made up of an infinite series of encounters.

<div align="right">(AZOULAY 2012: 26)</div>

In this book I have sought to analyze the prevalence of collaboration in photographic art since the late 1960s. Starting with an account of why photography is generally assumed to be an art of individuals, my aim has been to rethink this idea through an expanded sense of what authorship and collaboration means in relation to the photograph. In particular, I have wanted to question the emphasis on the act of photographic seeing, particularly in the framing of photography as a modernist art, which privileges individual artists and autonomous pictorial forms, in favor of an understanding of the photographic event informed by the writing of Ariella Azoulay. Accordingly, this book is not an alternative history of the medium—it is not an account that seeks to recover neglected photographer collaborators from the margins—even as it nevertheless seeks to make connections between more prominent and less well-known artists. The work of documenting the bigger history of collaboration in photography is a task that remains to be done. This book instead examines a small selection of artists, and exposes a crucial capacity for collaboration running through all photographic practice, including some of those that form what we think of as the canon. As Azoulay (quoted in Thompson 2014: 55) has observed, in what has become a motto for this book, "[C]ollaboration has always existed in photography but it is usually denied or not acknowledged." My focus, of course, has been directed to photographic art made over the past fifty years in which artists have consciously and even conspicuously engaged with the medium's collaborative potential.

According to an influential account, the prevalence of collaboration and participation in contemporary art practice merely echoes the consumerist logic of neoliberalism (Bishop 2012). For Claire Bishop (2012b), such practices are also related to the protocols of the participatory Web 2.0, with its "language of platforms, collaborations, activated spectatorship, and 'prosumers' who coproduce content (rather than passively consuming information devised for them)." By this

logic, artists who work individually to produce autonomous works of art may seem to represent some kind of resistance against the imperatives of a conformist age and its enforced collaborations. One can have some sympathy for this perspective. My purpose is not to argue that collaborative modes of photographic practice are superior. It is more simply a case of recognizing that the photographic act is composed of multiple agents, and that the artist who conceptualizes the release of the shutter is only one. Photographs are relational, not necessarily in the sense of Nicolas Bourriaud's ([1998] 2002) casting of contemporary art in terms of the intersubjective relationships it elicits, but in the sense that photographs are the product of an encounter and the start of a dialogue (Azoulay 2008: 11).[1] These qualities are everywhere in evidence in the artworks discussed in this book. Through a close analysis of the motivations behind their production, I hope to have demonstrated that photography is a complex medium with particular qualities—quasi-automatic, often occasioned by chance encounters, deceptively easy, accessible to anyone—whose prodigious capacity for circulation and profound openness to interpretation challenges even the most determined artist to control its meanings.

It is a truism that the meaning of a photograph is dependent on its contextualizing discourses (Stimson 2008). In the face of the huge volume of digitally produced photographs circulated globally, the meaning of photographs becomes increasingly fluid as they change contexts online. Fred Ritchin (2009) describes the online image as a sort of "quantum" photography, in which pictures exist simultaneously in multiple contexts, often with contradictory meanings. As some have found to their cost—when family snapshots of children turn up on pedophile sites, or "sexting" goes wrong—the sharing of personal photographs online makes it extremely difficult to maintain control over their access and use. On social media platforms, photographs often float freely without attribution. Image-sharing user agreements abound, and copyright still matters, but arguably, beyond the rarefied aesthetic realm of fine art photography, and the increasingly indistinguishable domain of high-end fashion photography, photographic culture appears increasingly authorless. Individual photographs made by individual photographers are not likely to disappear anytime soon; but as cameras are increasingly automated and ubiquitous, the meaning of such photography is gradually changing. Most photographs are redundant in Vilém Flusser's terms; they add no new information to the world (Palmer 2013b). Increasingly it is only through the aggregation of images, their difference from one another, that new meaning is produced. While the romantic idea of "photography visionaries" persists as a marketable title for coffee-table books (Marien 2015), the idea is not only historically misleading but simply cannot account for so much photographic practice today.

The future of photography is by no means certain. As Adam Broomberg and Oliver Chanarin suggest (quoted in Andreasson 2014), one dark image is that of overtly "non-collaborative" algorithmic imaging, a world of machine-readable data

in which human involvement is rendered unnecessary. Against such developments, others are investing effort in developing platforms for collaborative meaning making and participation within the world of professional photojournalism.[2] In an age when the circulation of photography online is driven by commercial platforms engaged in endless attempts to monetize individual participation, forging alternative approaches can feel like a losing battle. And yet this is precisely why rethinking photography through a collaborative lens may be valuable, and why the experiments of artists remain important. Artists working with photography can help us to understand how photography functions in the world more broadly, pinpointing the exigencies of the present and anticipating futures to come. If this book has succeeded in its goal, it should now be clear that collaboration has not only been a latent potential within the history of photography, but that artists who have explored this potential have often done so unknowingly. Perhaps it has taken the fluid forms of authorship mobilized by digital photography to cast light on the collaborative prehistories that this book begins to describe.

NOTES

INTRODUCTION

1 Griselda Pollock (1980: 57–96) provides one of the best accounts of how "the artist" becomes the mythic locus of invested fantasies of authorship and intentionality.

2 In a publisher's note at the end of *The Decisive Moment* (1952), Richard L. Simon from Simon and Schuster acknowledges "another partner in the collaboration ... the printing firm in Paris which made the engravings and printed this book" (n.p).

3 As David Campany (2014: S3) has observed in a recent discussion of editing, "Many a landmark photographic book has resulted from collaboration between photographer and editor. This complicates the presumption of the singular authorial voice that still dominates discussion of photographic books."

4 The detailed and repetitive nature of retouching and hand coloring has also been attached to women's labor. For instance, as an 1873 report in *British Journal of Photography* speculated, "It is an occupation exactly suited to the sex" (quoted in Gernsheim 1955: 287).

5 Wall, for instance, has worked over long periods with particular Photoshop operators during his career, as he has acknowledged: "One paradox I have found is that the more you use computers in picture-making the more 'handmade' the picture becomes. Oddly, then, digital technology is leading, in my work at least, towards a greater reliance on hand-making, because the assembly and montage of the various parts of the picture is done very carefully by hand by my collaborator and operator, Stephen Waddell, who is a painter" (Wall [1994] 1996: 134).

6 The years immediately prior to and during the writing of this book have witnessed clear signs of interest in the topic of collaboration in photography. Susan Bright's curated exhibition *1+1=3: Collaboration in Recent British Portraiture* at the Australian Centre for Photography in 2007 explored collaboration in the context of identity. In November 2010, Ben Judd and Anthony Luvera organized a series of discussions in London at The Photographers' Gallery on the topic of "Photography and Participation." In 2013, Adam Broomberg and Oliver Chanarin became the first collaborative team to be awarded the prestigious Deutsche Börse Photography Prize for their collection *War Primer 2*, based on poet and dramatist Bertolt Brecht's 1955 publication. Also in 2013, Ariella Azoulay, Wendy Ewald, and Susan Meiselas developed "the first draft of a research project that reconsiders the

story of photography from the perspective of collaboration." In conjunction with graduate students, and appropriately inviting the public to participate in their effort to create a complex and rich timeline of collaboration in photography, they mapped out a timeline of approximately one hundred photography projects—in which photographers "co-labor" with each other and with those they photograph. They also held a discussion in December 2013 titled "Collaboration: Revisiting the History of Photography" at Aperture Foundation in New York. Their approach to collaboration focused on documentary projects as a political act of retrieval: "In this project we seek to reconstruct the material, practical, and political conditions of collaboration through photography and of photography through collaboration. We seek ways to foreground—and create—the tension between the collaborative process and the photographic product by reconstructing the participation of others, usually the more 'silent' participants. We try to do this through the presentation of a large repertoire of types of collaborations, those which take place at the moment when a photograph is taken, or others that are understood as collaboration only later, when a photograph is reproduced and disseminated, juxtaposed to another, read by others, investigated, explored, preserved, and accumulated in an archive to create a new database" (http://aperture.org/blog/call-for-participation-collaboration-revisiting-the-history-of-photography). In 2014 the national conference of the Society for Photography Education in the United States was titled "Collaborative Exchanges: Photography in Dialogue." The same year, the Department of Photography & Imaging at NYU's Tisch School of the Arts hosted an exhibition called "Social in Practice: The Art of Collaboration," which focused on themes of community building and social activism (http://www.tisch.nyu.edu/object/Social_in_Practice.html). Also in 2014, the Brighton Photo Biennial 2014, titled "Communities, Collectives, Collaboration," responded to what they called "the prominence of collaborative modes of production, dissemination and reception encountered across areas of photography in recent years" ("Brighton Photo Biennial 2014," *Photoworks*, 2014: 1).

7 In the 2016 Tate Modern exhibition *Performing for the Camera*, various photographers involved in documenting performance acts are mentioned by name. However, the status of the collaboration is sometimes ambiguous. For instance, the wall panel for one work, *Eye Body: 36 Transformative Actions* (1963), informs us that it is "the result of a collaboration between Carolee Schneemann and photographer Erró," but also states that "[a]lthough Erró was essential to the production of the work, Schneemann is very much the author of the series which reflects on her own practice." Indeed, the lot notes for a 2015 Christie's auction of the work fail to mention the Icelandic artist Erró at all.

8 Green mentions that the photographs of Christo and Jeanne-Claude's *Wrapped Coast, Little Bay, Australia* (1969) were taken by Harry Shunk, who was brought out to Sydney for the purpose. Indeed, the German photographer Shunk documented and collaborated with a wide range of experimental artists between the 1950s and 1970s, in partnership with the Hungarian János Kender. Their most famous image is undoubtedly the iconic photomontage of Yves Klein's *Leap into the Void* (1960). Shunk-Kender's work has recently achieved fame on its own terms, including an exhibition at The Museum of Modern Art in New York in 2015, "Art on Camera: Photographs by Shunk-Kender, 1960–1971."

1 IDEOLOGIES OF PHOTOGRAPHIC AUTHORSHIP

1 As Molly Nesbitt (1987: 245) notes of the situation in France, "by 1900 most of the important court decisions gave the photographer his *droits d'auteur* ... to call oneself an *auteur* meant that one was actively laying claim to them [*droits*]. The title could designate a photographic practice like pictorialism with all the cultural ambitions of painting; it could just as well be used as a cover to gain economic privilege for more technical pictures that served the material needs of production."

2 See David Mellor (1978) for an edited collection of essays by worker photographers, such as Edwin Hoernle's "The Working Man's Eye" (1930).

3 Steichen's approach to photography at MoMA still generates debate. *The Family of Man* exhibition has been widely critiqued for its imperialism, most famously by Roland Barthes (1972) in his review of its Paris iteration. However, as Blake Stimson (2006) has argued, the exhibition also contained within it an affective appeal to collective belonging within what he calls "photography's nation."

4 Heartfield claimed to have invented photomontage together with George Grosz in the latter's studio in 1916, and Raoul Hausmann and Hannah Höch were also using photomontage by 1919. But as Benjamin Buchloh (1984: 96) points out, since photomontage was already commonly used in advertising imagery, "the question of who actually introduced the technique into the transformation of the modernist paradigm is unimportant."

5 Roland Barthes's theories about photography varied considerable over several decades, from a Marxist and semiotic approach to the phenomenological approach of *Camera Lucida*. In *Camera Lucida*, Barthes revels in the photograph's evidential power, the *punctum*, the accidental mark or detail of the photograph that pricks individual viewers in an irreducibly subjective manner, and is skeptical of artists who contrive to control everything that happens within the frame, and therefore wish to *tame* the medium ([1980] 1981: 115–19).

6 Azoulay continues (2010: 252–3): "The renewal of this encounter is a constant capacity of spectators who acknowledge the photographed persons and see themselves as their actual or potential addressees or partners. Historically, indeed, the photographer assumed the artist's position and monopolized the power of the individuals with whom he was gathered for the photography session, making the photograph 'his own'. But this did not seal the space of relations between the photographer and the photographed; the photographer only fixed an instant of this encounter in the image. Beyond the image's aesthetic existence, the photograph preserves traces of other people's gaze and action, and thus becomes a kind of singular point in which these are stored and might be linked one to the next and moved anew at any point in time, in unforeseen directions."

2 IMPERSONAL EVIDENCE: PHOTOGRAPHY AS READYMADE

1 *Dust Breeding* made its first public appearance in the October 1922 edition of the Surrealist journal *Littérature*, which included a willfully confusing caption whose last lines read: "View taken from an aeroplane by Man Ray—1921" (Fardy 2008: 1).

2 Marcel Duchamp's installation *1200 Bags of Coal* (1938) is an important precursor to the interest in quantification among conceptual artists. See Brian O'Doherty (1999: 57).

3 As the 1970 exhibition *Information* at The Museum of Modern Art in New York underscored, the notion of information was central to conceptual art at this time. Clearly influenced by contemporary ideas of cybernetics, the artist Douglas Huebler explained in 1971 that "repetition (or redundancy) of information was a fundamental, constitutive aspect of culture and the social fabric" (Chevrier 2003: 123).

4 Susanne Lange's *Bernd and Hilla Becher: Life and Work* (2007) is the primary reference on their working methods, and includes biographical notes, personal documentation, authoritative explanations of shooting techniques, and an exhaustive chronology of works.

5 As Bernd Becher revealed in an interview (Ziegler 2002: 98): "All my ancestors on both my father's and mother's sides were employed in the mining and steel industries. I knew the conditions, the vocabulary. For me, it was a real extension of childhood—looking for places that are similar to what I grew up with."

6 Even as late as 1971, the Bechers' photographs were included in a book that contained detailed examinations or descriptions of the technical development of winding towers written by Heinrich Schönberg and Jan Werth. As Zweite (2004: 27) notes, the Bechers were not pleased by the inclusion of these texts, since it brought the independence of the photographs into question.

7 As Hilla Becher (Ziegler 2002: 99) spelt out: "Our idea of showing the material has much more to do with the nineteenth century, with the encyclopedic approach used in botany or zoology, where plants of the same variety or animals of the same species are compared with one another on the individual pages of the lexicon."

8 In 2013, Hilla suggested that their approach was more organic than has often been suggested: "I never really considered the things we photograph as typologies. Of course there are different groups of things, but Bernd and I always thought of them instead as objects that reappeared in different countries" (Weaver 2013: 66).

9 In January 1968 Bernd visited Los Angeles (without Hilla) on the occasion of the first exhibition of the Bechers' work in America, at the University of Southern California—later taking the couple's first photographs of American iron and steel plant, *McKeesport, Pittsburgh, Pennsylvania*, 1968 (see Zweite 2004: 37).

10 As Hilla recalled, "When Kricke [the Dean] rang the first time, I answered the phone. He explained the situation, and I said, 'Yes, I'll do it.' And he said, 'No, no, no! We want the master!'" (Ziegler 2002: 140).

11 Stefan Gronert (2003: 95) notes that "German law did not permit the photographer couple to be appointed in tandem to a university post." A few years prior, at the Kunstakademie in Hamburg, Hilla Becher had been a guest lecturer in 1972–1973.

12 Larry Sultan (Mandel et al. 2008) made this point: "It really is a book about men; I think there are two females in the book. It's what men do in nature."

13 Parr and Badger (2006: 220) describe it as "one of the most beautiful, dense and puzzling photobooks in existence, an endless visual box of tricks."

14 Collier's book, *Visual Anthropology: Photography as a Research Method* (1967) is one of the earliest textbooks in the field. In the 1930s he served as an informal guide to the photographer Paul Strand while he was working in the Taos region in New Mexico.

15 Benjamin Lord (2015) describes the essay, written by Robert Forth, as "a rambling, disjunctive pastiche of personal anecdotes, quoted verse, shaggy dog tales, pop philosophy, non sequiturs, evolutionary psychology, and just plain mumbo-jumbo." Robert Heinecken had initially written a jovial essay comparing *Evidence* to curatorial activity, which the artists rejected for being too literal (Cotton 2012: 23). Heinecken's text was eventually published in *Afterimage* as a book review.

16 Huebler's quotable phrase was first put forward in his 1969 artist's statement for an exhibition at New York's Seth Siegelaub Gallery.

17 In certain respects *Evidence* echoed the aestheticizing tendency that John Szarkowski was criticised for at MoMA, "treating all photography alike, and only in formal terms" (Parr and Badger 2006: 208). In 1973, Szarkowski had published a controversial book called *From the Picture Press* (1973), which removed the original captions from the *New York Daily News* in order to focus on the ambiguous formal qualities of news photographs.

18 For Ratcliff (2006: 58), viewing the work in 2003 at its restaging, "the exhibition is haunted by a sense of highly sophisticated futility—or worse."

19 In a short appreciation of *Evidence*, Parr and Badger (2006: 208) refer to "undertones of unease and menace," but strangely make no mention at all of the historical period in American culture from which the photographs were taken, which might account for those feelings.

20 Ratcliff resists reading *Evidence* as simply "an indictment of technology." Sandra Phillips (2003: n.p.), in her concluding remarks in the 2003 reissue of the book, informs us that "it is not a strictly political book; it is not a critique" in the sense that we tend to understand by postmodern appropriation.

21 The artist statement for *Evidence* on Larry Sultan's website is clear on this point: "It's in their isolation from their original context that these images take on meanings that address the confluence of industry and corporate mischief, ingenuity and pseudo-science" (Sultan n.d.).

22 *Colors* magazine was set up in 1991 by Oliviero Toscani and Tibor Kalman, funded by high-street fashion store Benetton, and has been produced at the Fabrica research centre in Treviso, Italy, since 1997. Dubbed "a magazine about the rest of the world," and indelibly associated with Toscani's controversial advertisements for Benetton of dying AIDS victims, newborn babies, and images of slavery, *Colors* sought to revive a global, humanistic outlook familiar from the golden age of *LIFE* magazine but updated for the MTV generation. When Broomberg and Chanarin took over in 2000, among their innovations was to send fashion photographers into zones more familiar to reportage photographers (Armstrong 2002).

23 Broomberg was born in 1970, in Johannesburg, South Africa, and moved to London when he was seven years old to study. Chanarin was born in 1971, in London, and moved back to South Africa when he was young, finally leaving when he was twenty.

24 As the artists note: "Working together in a team is significant. We tend to conceptualise our ideas before taking our photographs. Each image is the result of a conversation, a process of research and discussion. There are a million decisions that are taken along the way and because we work together this decision making process has to be more self-conscious. When it comes to actually taking a photograph, the clicking of the shutter becomes almost immaterial. This is not in the least bit contentious in the realm of fine art. But it sits uncomfortably with the mythology of the lone, photojournalist, responding to events in the world and recording reality" (Lehan 2006).

25 *The Day Nobody Died* was included in the 2008 Brighton Photo Biennial, *Memory of Fire: The War of Images and Images of War*, curated by Julian Stallabrass, and an exhibition titled *Antiphotojournalism* at La Virreina Centre de l'Imatge, Barcelona in 2010 and FOAM, Amsterdam in 2011, curated by Carles Guerra and Thomas Keenan.

26 Email to author, June 25, 2015.

27 The book was published by Steidl/Photoworks (2007), and includes a critical introduction by Julian Stallabrass and a concluding essay by Gordon MacDonald.

28 As Broomberg states (Foster 2007), "the documentary process does mimic that original kind of colonial impetus to go out and collect and to map and to quantify and to possess, in a way. And there's this kind of manic energy in . . . documentary photography about going out and seizing your evidence and bringing it back. And I think it's very much a kind of male practice traditionally, and very much a kind of colonial and European one."

29 As their artists' statement reveals (Broomberg and Chanarin 2011: 111): "The marks on the surface of the contact strips over the image itself allude to the presence of many visitors. These include successive archivists, who have ordered, catalogued and re-catalogued this jumble of images. For many years the archive was also made available to members of the public, and at times people would deface or otherwise manipulate their own image with a marker pen, ink or scissors. So, in addition to the marks made by generations of archivists, photo editors, legal advisors and activists, the traces of these very personal obliterations are also visible."

30 As one of the Bechers' students, Thomas Ruff, recently put it, "I'm always present in my photographs as the author because I point to something" (Bush 2003b: 262). Ruff eventually took over from Bernd Becher at Düsseldorf.

31 Stimson elsewhere notes that "the Bechers' undertaking had something demonstrably melancholy about it" (2007: 67).

3 COLLABORATIVE DOCUMENTS: PHOTOGRAPHY IN THE NAME OF COMMUNITY

1 The film is sometimes mistakenly called *Through Navajo Eyes,* which is the title of the book that Worth and John Adair wrote, published in 1972 (the full title is *Through Navajo Eyes: An Exploration in Film Communication and Anthropology*).

2 The photographs appear in Ewald's book *Portraits and Dreams: Photographs and Stories By Children of the Appalachians* (1985).

3 Australian art critic Robert Nelson articulates a common response when he writes that the pictures are powerful for "the process of their creation rather than as pictures in their own right" (Nelson 2013). For her part, Ewald writes that: "I get frustrated with critical writing about collaborative art or photography that views the process and the product differently. By working with others, the finished piece contains several layers that wouldn't exist if it was made by a solo artist. Even when people try to write sensitively about collaborative work they often focus on process only, which can be another way of marginalizing it" (Luvera and Ewald: 53).

4 Indeed, nearly forty years later, Ewald returned with a filmmaker to track down the participants and document the long-lasting effect of the time they worked together.

5 Freire—who in turn was influenced by earlier thinkers such as Bertolt Brecht—has proven influential for more recent thinkers of contemporary art such as Grant Kester (2004).

6 Olin (2012: 140) draws a distinction between *documentary* and *empowerment photography* that hinges on reading the former as entreating the viewer to look at the depicted subjects, while the latter asks the viewer to "look through someone else's eyes, to identify with the photographer." More broadly, Olin (2012: 15) is interested in "how photographs participate in and create relationships and communities." She writes of the "community-building effect of photographic practices" such as "Kids with Cameras" and the online community generated by Susan Meiselas's *akaKurdistan* project, "as groups seek to use the practice of taking, displaying, and communing with photographs to help the disadvantaged or traumatized develop communities for healing or political change" (Olin 2012: 129).

7 Ewald is currently Director of the Literacy through Photography Project at the Centre for Documentary Studies at Duke University, Durham, North Carolina.

8 Indeed, in 2011 Ewald coordinated a project in Israel with Ariella Azoulay in in which she gave cameras to owners of stalls and stores at the Machane Yehuda marketplace in Jerusalem, Arab women and gypsies in Jerusalem's Old City, schoolchildren in Nazareth, residents of Hebron, Negev Bedouin, and high-tech company employees in Tel Aviv.

9 The scale of the banners evokes another artist who has worked in collaborative and political ways with communities, the French "photograffeur," or street artist, JR.

10 See, for instance, the Canadian photographer, popular educator, and social justice activist Deborah Barndt's work, such as *Wild Fire* (2016) and "Naming, Making and Connecting" (2001), as well as her work *Getting There* (1982) with Ferne Cristall and Dian Marino. See also Campbell and Burnaby (2001).

11 PhotoVoice's vision is described on their website as being "for a world in which no one is denied the opportunity to speak out and be heard. PhotoVoice's mission is to build skills within disadvantaged and marginalized communities using innovative participatory photography and digital storytelling methods so that they have the opportunity to represent themselves and create tools for advocacy and communications to achieve positive social change" (PhotoVoice n.d.).

12 "What was it, finally, that I was doing? Was it some kind of visual anthropology? Was it education? Photography? Could I combine these elements and be an artist too?" Ewald reflects in the catalogue of her retrospective survey *Secret Games* (2000: 325).

13 Between 1971 and 1973, Ewald was one of the Founders and Directors of Half Moon Gallery—which later became Camerawork—in East London. Peter Marshall (n.d.) suggests that "[v]isiting US photographer Wendy Ewald provided the catalyst" for the gallery and workshop.

14 As Braden notes (1983: 29), "[T]he idea of the [Half Moon] gallery was to show pictures of London's East End and other working communities in the East End environment."

15 For an account of *Camerawork* and its relation to community photography, see Jessica Evans's Introduction to *The Camerawork Essays* (1997).

16 Spence cofounded the Hackney Flashers collective (1974 to the early 1980s), a group of women working with education and media who defined themselves as feminists and socialists. As the limitations of documentary photography became apparent, Spence developed what she called "phototherapy," which sought to invert the traditional relationship between the photographer and the subject. As John Roberts (1998: 202) has observed, "participants had to be willing to engage with questions of sexuality, family and so on in relation to their identity." In short, the work was "the result of an extensive intellectual and psychological collaboration with the subject" (Roberts 1998: 206). See Jo Spence, *Putting Myself in the Picture: A Political, Personal and Photographic Autobiography* (London: Camden Press, 1986).

17 Another source of inspiration for Luvera may have been *Down But Not Out: Young People, Photography and Images of Homelessness* (Dewdney et al. 1994), which was the last production of the Cockpit Cultural Studies Team.

18 The work was later exhibited as billboards at FotoFreo 2006, an international photography biennale in Fremantle, Western Australia, and in *1+1=3: Collaboration in Recent British Portraiture* at the Australian Centre for Photography in 2007, curated by Susan Bright.

19 At times Luvera (2013: 47) even sounds resigned to the problems: "Perhaps there can't ever be a perfect form of documentary, and I'm certainly not striving to find one. I'm just interested in hearing and telling stories about other people and to try to say something about the process of undertaking this work at the same time."

20 For a history of Belfast Exposed and its changing relationship to earlier British community photography and its original mission, see Mathilde Bertrand (2015), who notes that the earlier notion of "community photography" has given way to "photography in the community," as the emphasis has evolved from overtly political practices to a looser notion of "community engagement." Belfast Exposed has prioritized its role as a "centre for excellence in contemporary photography," primarily working with art photographers.

21 Luvera (2010: 238) cites Rosler's "Post-Documentary, Post-Photography?" essay in an article for *Photographies* journal: "Self-representations will always be framed, directly or indirectly, by the artist or organization facilitating the processes employed to generate and circulate the material. Issues of context, reception, authorship, ownership, commissioning and the historiography of what or who is depicted, may have the effect of reinstating the inequality of the power balance that was removed from the photographic methodology employed to create the image in the first place."

22 Luvera was commissioned by Photoworks, Pink Fringe and New Writing South for the 2014 heritage project *Queer in Brighton* (www.queerinbrighton.co.uk).

23 Luvera also coedited *Queer in Brighton* with Maria Jastrzebska, an anthology of creative writing, commissioned essays, photography, documentation of cultural ephemera, and extracts from over 100 oral-history interviews.

24 Luvera expressly rejected the therapeutic dimension of his practice in a discussion with Andrew Dewdney at The Photographers' Gallery on November 23, 2010, while acknowledging that it is sometimes framed this way by the agencies he works with.

25 "Children nowadays photograph things compulsively," observes critic Robert Nelson (2013), when recently reviewing Ewald's work. "When Ewald began, it was a cultural achievement to get children to take photographs. Now it's an achievement to get them to stop."

26 In 1972, Willats founded a Centre for Behavioural Art, dedicated to fieldwork in a variety of contexts, from housing projects to underground clubs. Many of the projects involved a dialogue between the artist and participants mediated through photographs. Thus, in *A Moment of Action* (1974), he asked viewers to complete a questionnaire about a series of photographs. The photographs document a few moments in the life of a middle-aged woman—fragmented into movie-like stills—while a multiple-choice questionnaire offers viewers different interpretations for the actions in each frame. As Rudolf Frieling notes in *The Art of Participation* (2008: 128), "The artwork thus becomes an agent for addressing and reflecting upon the production of value and meaning."

27 Terrill's later work, *Bow Cross* (2011), addressed a process of regeneration in a street in London's East End with a documented history of social unease. In this instance, in addition to a single staged portrait image, Terrill supplemented the display with moody video and audio as well as a series of photographs taken on the street. One can interpret this as an acknowledgment of the inability of the single image to "capture" the event. Indeed, viewed after the London riots in August 2011, it became difficult not to read the video imagery, tracking through a smoke-filled crowd, in ominous terms as a sign of a lack of social cohesion.

28 In the first exhibition of "Crowd Theory," the two images (*Footscray* [2004] and *Braybrook* [2004]) were accompanied by a computer-based interactive that allowed viewers to roam around and into one of the images, hearing the sounds and snippets of conversation captured during its making. This focus on the production of the images can easily function to fetishize the spectacular and elaborate nature of the staging, as in the case of cinematic art photographers such as Gregory Crewdson, who reproduces images of his extras, makeup artists, cherry pickers, and so on, at the back of his books. In Terrill's case, the behind-the-scenes production shots provide a context for the production of the image event.

29 Other work by Melanie Manchot may have more in common with Terrill. In *Celebration (Cyprus Street)* (2010), a two-part project for Whitechapel Gallery, Manchot examines the traditions of group portraiture in conjunction with the street parties that were common in postwar East London. The first part of the project was an exhibition on the history of the street group portrait. This was followed by the Cyprus Street party itself, organized and filmed by Manchot. She also took a series of still portraits of members of that community (Hawker 2013: 341–52).

30 Needless to say, advertising has long set up real-life situations to be photographed with the involvement of various "actors." Indeed as Jo Spence observed of her time in advertising (quoted in Williams 1986: 160): "If we wanted to photograph a block

of flats, my job would be to ask all the people in the flats to come out and stand on their balconies; once we had to hire a bus and fill it with extras."

31 "The Australian Aboriginal Flag was designed by artist Harold Thomas and first flown at Victoria Square in Adelaide, South Australia, on National Aborigines Day, 12 July 1971. It became the official flag for the Aboriginal Tent Embassy in Canberra after it was first flown there in 1972. Since then, it has become a widely recognised symbol of the unity and identity of Aboriginal people" (NAIDOC n.d.).

32 Samstag Museum Director Erica Green (quoted in Watson 2014) explains that the aim of the museum's commission was to capture the square's last moments in its familiar shape, before its transformation: "Over the years Victoria Square has evolved into a somewhat down-at-heel, diamond-shaped parkland, surrounded and bisected by the city's churning traffic."

33 Maynard's use of the term "convivial photography" echoes the language of Nicolas Bourriaud's relational aesthetics, formulated around the same time in France ([1998] 2002).

4 RELATIONAL PORTRAITURE: PHOTOGRAPHY AS SOCIAL ENCOUNTER

1 As the curator Thomas Weski (2012: 312) puts it, "Nixon's approach is based on participation, and so this series of portraits could only be produced as a collaboration between photograph [*sic*] and model."

2 Huebler had been teaching art for over twenty years when he was included as one of four artists in the famous conceptual art exhibition organized by Seth Siegelaub at his New York gallery in January 1969. Huebler taught at Bradford Junior College outside of Boston, at Harvard, and for more than twenty years at CalArts, where he was Dean of the School of Art and influenced a generation of artists from Mike Kelley to Christopher Williams.

3 Initially put forward in a 1969 artist's statement for an exhibition at New York's Seth Siegelaub Gallery.

4 As Huebler describes it: "The language I use is very, very ordinary ... However, I write sometimes for five days to get the one sentence I want which will carry an enormous load" (Auping 1977: 41). Jeremy Gilbert-Rolfe (1974: 59) argues that Huebler's work illustrates "the incompleteness" of "ordinary perceptual experience" and "the 'deconstruction' of the familiar," via what he calls "phenomenological linguistics—language in the real world."

5 As Mark Godfrey suggests (2011: 61), in this and other works Huebler made while travelling, he seems to have willfully decided not to take on the role of the "American exoticizing the European city." Godfrey makes this point in relation to a series in Paris in which Huebler chose five locations on the map, each near picturesque Parisian scenes, took one photograph pointing toward the scene, and one away from it, and then scrambled the photographs together.

6 As the text explains: "[D]uring a ten minute period of time on March 17, 1969 ten photographs were made, each documenting the location in Central Park where an

individually distinguishable bird call was heard. Each photograph was made with the camera pointed in the direction of the sound. That direction was then walked toward by the auditor until the instant that the next call was heard, at which time the next photograph was made and the next direction taken. The ten photographs join with this statement to constitute the form of this work."

7 John Miller (2006: 223) makes a link between Huebler and Flusser: "It is within such a pointless teleology that Huebler takes on the role of photographer-functionary, dutifully reenacting the camera program. The role is performative and mimetic, nothing less than mummery. Documentation is only the pretext for such a charade— Huebler does not and cannot fully enact all the elements in the camera's program. His enactments are reduced to gestures."

8 Huebler described himself as "a second-rate Zen Buddhist" (Onorato 1988: 38). This no doubt helps to account for his stated aim of suspending value judgments about appearance (Auping 1977: 42), and desire to refresh people's "experience with phenomena," and to get people "to really pay attention" (Auping 1977: 28, 41).

9 Shannon (2014: 231) argues that Huebler's work is part of what he calls "factualism," art practice as an ambivalent inquiry—concerned with indifferent fact rather than truth—into "the feasibility and morality of disinterested reason" in the context of technocracy.

10 The thirteen photographs represent the states traversed. Shannon (2014: 232–3) makes the link to Stieglitz's cloud work, suggesting it constitutes an attack on his idealism. As Peter Wollen notes (1999: 39), these works evoke the Situationist aesthetic of the *derive:* "Unlike the Situationists, however, Huebler presented his journeys completely dispassionately."

11 The MoMA press release for *Information* stated that:

Location Piece #6 specifically involves the transfer of the "location" or context of the material as it involves photographs taken by local photographers in various small towns across the country which have been "transferred" to an altogether other location than the small town newspaper for which they were taken—namely, the walls of The Museum of Modern Art.

12 As Huebler put it, "I want to open the situation up to the person seeing the work. I feel very obliged to allow the perceiver all the space he or she can use. Therefore my distance is a necessary posture so that I don't get in the way" (Auping 1977: 38).

13 The work underscores Gilbert-Rolfe's (1974: 59) understanding of Huebler as interested "in phenomena whose significance is latent but not fully apparent to direct perception." For Gilbert-Rolfe (1974: 59–60), Huebler's "best work" aims to "find a way of way of documenting in which the act of documentation preserves and accounts for the partial accessibility of that which is documented."

14 Sundell's (2012) review questions Mark Godfrey's framing of Huebler as a humanist through the focus on portraiture in his Camden exhibition in 2002, and argues that the artist's approach to the human condition may in fact be "posthumanist."

15 According to Mark Godfrey (2002: 9), this work has a more serious note, exposing societal prescriptions about fashion and the ideal look, not to mention social pressure at university, even as it lures us through "comedy and surprise."

16 *Duration Piece #16, Global, 1969* consisted of a single typewritten statement, which as Onorato (1988: 34) notes, seems to combine a legal contract and "a satire of all such officious documents." The text reads: "Global: This piece is designed to begin

on the occasion of the death of the owner and continue from that time into infinity. The owner himself will enter into an authentic physical existence that will actually constitute the work."

17 The example in the Tate Gallery "belonged to the artist until it was sold to the Tate so he appears as an owner until 1974. The Tate is represented by a photograph of the current Chairman of the Tate Trustees during the six remaining years" (TATE 2004).

18 In an interview from 1978, Allan said: "I saw photography as a form of social encounter—that what happened at the time between you and who you photographed was extremely important. In that sense, in comparison with painting, it is much more integrated into what is actually going on" (Davies 1978–9: 49).

19 Allan started taking photographs in 1974 after joining a loosely formed collective at Melbourne's Pram Factory in Carlton, then a center for experimental and feminist theater. While designing sets and posters, Allan learnt photography from the darkroom of Virginia Coventry. Concurrently, Allan's art-school training in painting had led her to the unconventional practice of hand-painting her photographs, which she continued over several years. Her 1975 series of her friend, *Laurel*, shown in *Three Women Photographers* at the Ewing and George Paton Galleries in 1975, with Sue Ford and Coventry, marked the first of a wave of contemporary hand-colored photographs exhibited in Australia. Traditionally, hand coloring was women's work, and its use by Allan was fundamentally antagonistic to the prevailing male-dominated aesthetic of modernist black-and-white photography. It should be noted that Allan's approach to photography was far from homogeneous. She was interested in places as much as people, and worked on a number of documentary projects.

20 Allan's concerns extended more broadly, although she attended a "consciousness raising group" and admits that feminism was important to her aims (personal email to the author, October 24, 2012).

21 Drawing on a version of the feminist slogan "the personal is political," personal histories were identified in the 1970s as a rebuttal of the values of formalist art criticism as codified by Clement Greenberg in New York.

22 As Allan put it in 1978 (quoted in Davies 1978–9: 52): "*My Trip* ... is about what people think about photography—just anyone and everyone; there was a huge range of responses to being offered the chance to take a photograph. Hardly anyone said no—most people loved it. How much they wanted to know technically varied a lot and I just let them define that."

23 Wearing's video work treads a similarly fine ethical line in its exploration of individual and social problems, including people getting drunk on camera and victims of sexual abuse offering frank confessionals—described by one critic as driven by a "frank admission of ... amoral curiosity" (Hopkins 2003: 350). Most recently, Wearing has taken her participatory ethos into social media with projects like *Self-Made* (2010) and *Your Views* (2013). The latter is a film made up of views from windows all over the world, based on an open, global call for submissions. Wearing invited anyone who has a window to film their view as they open the curtains, resulting in a collaborative record of the ordinary on an epic scale.

24 Huebler notes that people "have the right to have their face covered. They must let me use the photograph, but they can cross out their face that they are not identified or associated with the statement if it's too unbearable" (Auping 1977: 43).

25 As Margaret Iversen explains (2009: 851, n. 36), "Calle has insisted that she was unaware of Acconci's *Following Piece* when she made *Suite Vénitienne*. However, after she'd taken the photos a friend told her about it. She made a trip to New York to visit Acconci who 'gave her his blessing'."

26 This work is alternatively known as *The Shadow*, *The Detective*, and *The Shadow (Detective)*, the latter of which I have adopted here.

27 As Stuart Morgan (1992: 20) suggests, Calle's work seems to parody "the conceptualist approach of ignoring the self," by "presenting the reader with a fictional self about which nothing is learned."

28 Gill wrote this text for inclusion in curator Hans Ulrich Obrist's *Do It*, an experiment into how exhibition formats could be rendered more flexible and open-ended. Started in Paris in 1993, by 2015, nearly 400 artists have contributed instructions to the ever-evolving project, which asks an important question related to collaboration more broadly: is an artist's work transformed if others make the artwork? See Obrist (2004: 110–11).

29 In a related project called *Strangers* (1999–2001), a young Japanese photographer Shizuka Yokomizo sent a series of British householders an anonymous letter proposing that they stand in the front window of their home at a specified date and time in the evening. The subjects were instructed to turn on all their lights and remain still—or, if they chose not to participate, to signal this by drawing their curtains. The artist simply arrived outside the houses, set up her tripod and camera, exposed her film, and left. This momentary confrontation between observer and observed represents a profound instance of anonymous and unspoken collaboration, based on an implicit sense of trust.

30 In another collaborative project of the same year, *Identity* (1973), Eijkelboom wrote a letter to girls he used to go to school with, asking what they thought had become of him. People wrote back to say they thought he might now be working as a pilot or a barfly. He then dressed up to match these descriptions, and sent a picture back with a letter that said, "you were spot on" (O'Hagan 2014).

31 Lucy Soutter makes a similar point in relation to what she calls "hybridized versions of portraiture." As Soutter (2013: 28) puts it, for female photographers, "identity is something to be negotiated rather than assumed."

32 As Calle (2010: 14) writes: "If the work to be done was more in the performance domain, and entailed relationships with other people, I would take the photos myself. In such cases, their quality wasn't crucial. If—but this was rarer—no relationship with others was involved, and graves or stolen pictures or lifeless objects were the subject, I would take a bad polaroid, decide on the format and the angle, and ask a more technically proficient photographer to take the same picture, but better. And if, as in the case of certain autobiography photos, I was using myself as the model, I would ask the fashion photographer Jean-Baptiste Mondino to take the pictures. Indeed, I should like to take this opportunity to thank him for having taken my best pictures."

33 The photobooth has been a productive site for the collaborative generation of portraiture, as dramatically demonstrated in Italian artist Franco Vaccari's *Exhibition in Real Time No. 4* (1972). Vaccari installed a photobooth at the Venice Biennale along with the following phrase: "Leave on the walls a photographic trace of your fleeting visit." Each visitor was invited to make a single strip (four images) and affix

it to the installation. An early example of a participatory installation, the work self-reflexively investigated the photographic image. Vaccari recalled that he wanted to focus on "the eclipses of the author, as an indicator of the broader disappearance of the subject" (Sergio 2011: 170). The exhibition also created a minor scandal, resulting in an intervention by the public authorities and the removal of certain images considered obscene (a familiar problem for galleries currently exploring the use of social-media enabled photobooth-style participatory photography, now usually a brainchild of the marketing department).

34 Azoulay speaks of the potential that has always been latent within the technology of photography "to deviate from the familiar forms of image production which assumed a single author" (Azoulay 2012: 11–12).

5 AGGREGATED AUTHORSHIP: FOUND PHOTOGRAPHY AND SOCIAL NETWORKS

1 These instructions were compiled in Hans Ulrich Obrist's book *Do It* (2004). Even as Christian Boltanski's installations explore unsettling histories of Holocaust victims, he also plays with the confessional nature of the autobiographical, by introducing fiction and ambiguity.

2 Well-known titles include Thomas Walther and Mia Fineman, *Other Pictures: Anonymous Photographs from the Thomas Walther Collection* (2000); Robert Flynn Johnson, *Anonymous: Enigmatic Images from Unknown Photographers* (2004); and Stacey McCarroll Cutshaw and Ross Barrett, *In the Vernacular: Photography of the Everyday* (2007). Martin Parr and Gerry Badger's *The Photobook: A History, Volume II* (2006) includes a special section on personal photos.

3 Zuromskis (2013: 157) argues that the rationale for *Other Pictures* is closely aligned with John Szarkowski's formalist vocabulary of The Thing Itself, The Detail, The Frame, Time, and Vantage Point.

4 The German word *floh* means "flea" as in flea market. As Godfrey (2005: 102) writes, "[Dean] was not using found photographs to de-skill photography, nor was she reflecting on the difference between family photographs and other kinds of photographs. She was not appropriating formerly well-known images to change their established signification, nor was she producing an anthropological study. This was not an archive that claimed a false documentary status, nor was it in any clear way a fictional enterprise or an investigation of fiction. The photographs, in other words, were not really found or presented for any immediately apparent ulterior motives. 'What you see is what you see': they are just there, collected in the book."

5 Claire Bishop (2013), for instance, observes that: "Contemporary art that incorporates the archival, and/or leans heavily upon the proper name of historical precedents, is therefore replete with questions about the redoubling and appropriation of authorship. Depending so heavily upon pre-existing culture as the starting point for art, this work blurs the (already hazy) line between installation art and curatorial practice. But is re-presentation enough?" She goes on: "Ultimately,

I wonder if this particular strand of retrospectivity risks lapsing into a myopic form of aestheticism, wherein a fetish for the autographical trace and the aura of history erodes the bigger picture of collective meaning through a reluctance to transform this material wholesale."

6 As Langford (2008: 80) writes: "Originality is sometimes indistinguishable from the intense, almost narcissistic, fascination that an artist brings to his or her own processes of discovery. All curatorial practices, private and institutional, participate in some way in this singularizing mode of self-validation by removing an object from one context and placing it in another. This act of authorship is by definition subjective and self-serving."

7 Schmid studied at Fachhochschule für Gestaltung Schwäbisch Gmünd and Berlin University of the Arts from 1976 to 1981.

8 Walker incorrectly dates the book to 1977, as does Stephen Bull, who notes that 1977 was a particularly significant year for artists working with found photography, since in addition to *Evidence*, Richard Prince exhibited four advertisements he had rephotographed from a *New York Times* Sunday supplement, beginning his career in appropriation, and Douglas Crimp curated the influential *Pictures* exhibition (Bull 2007: 66). In 2015, Jewell updated his approach with the release of a book *Four Thousand Threads* (2015), amassing a vast archive of online photographic "threads," from planking to animal selfies.

9 Schmid made a modern remake of Ruscha's famous books entirely in his Berlin studio, one of the categories of his books of Flick photography is "parking lots" and he has also produced a book of photographs taken from a car window in Los Angeles, *Sixty-Eight Minutes on the Sunset Strip* (2014).

10 "In September 2009 Martin Parr sent me his VIP pass to the Berlin Art Forum, that he had recently received. He thought nothing of this, as he was sending Joachim something else anyway and knew full well he would be unable to attend. I saw this as an opportunity to visit the fair and take photos in the spirit of Martin Parr. I was to be Martin Parr for the 23rd September." The playful exchange of styles did not end there. "I then invited Martin to be Joachim Schmid, and he decided to trawl through the 'Martin Parr, We Love You' group on Flickr. This was established a few years ago as a forum for photographers who had been seemingly influenced by his photographic language. So in the spirit of Joachim Schmid, Martin looked for the most 'Parr-like' images. He then wrote to all the selected photographers and invited them to participate in this project, in exchange for a copy of the book." The result is a collaboratively authored set of images that look as if they have been taken by one famous photographer. See the artist's promotion for the book *Joachim Schmid Is Martin Parr—Martin Parr Is Joachim Schmid* (2009) on his website: https://schmid. wordpress.com/2009/11/29/new-books-6 (accessed June 20, 2015).

11 Such is the case in the series *Estrelas amadas* [*Beloved Stars*] (2013), black-and-white photographs of movie stars found in a Portuguese magazine from the 1950s, in which the former owner of the magazine colored the lips of stars in the brightest red, some decades before her copy ended up in the Lisbon flea market where Schmid found it. In this case, where someone has carefully worked manually on an image—in a related but reverse way to the act of tearing up images—it could be said that Schmid's work serves to celebrate the collaborative engagement that can sometimes occur between owners and photographs.

12 With the advent of the Internet, Schmid embraced emerging forms of photography. For instance, he produced a series of pixelated still images grabbed from commercial webcams of sex-chats (*Cyberspace*, [2004]), in which he asked women to leave the space, so the set was empty, and then directed the webcam to take a photograph of their working spaces (empty sofas with an imprint of a body, often childish furnishings, and so on). In a sense, Schmid updated his physical travels to the virtual world (Bull 2007: 69).

13 Umbrico updated this project for The Photographers' Gallery in London in 2014, in a work called *Sun/Screen*, in which she used an iPhone to rephotograph images of the sun directly from the computer screen—creating a series of moiré patterns (The Photographers' Gallery 2014: n.p.).

14 Albers (2013) also writes about another collaborative team, Mark Klett and Byron Wolfe, who made a photographic installation about sunsets called *One hundred setting suns at the Grand Canyon arranged by hue; pictures from a popular image-sharing web site* (2011).

15 In 2010, Flickr's website stated: "With millions of users, and hundreds of millions of photos and videos, Flickr is an amazing photographic community, with sharing at its heart. Groups are a way for people to come together around a common interest, be it a love of small dogs, a passion for food, a recent wedding, or an interest in exploring photographic techniques. And if you can't find a group which interests *you*, it's super-easy to start your own. Groups can either be public, public (invite only), or completely private. Every group has a pool for sharing photos and videos and a discussion board for talking" http://www.flickr.com/tour/share (accessed December 10, 2010).

16 Albers (2015) goes on to suggest that: "[R]ather than pointing to a nineteenth century rift between the painter's labor vs. a photographer's lack thereof, the viewer must consider the authorial contributions of not just artist and unknown human collaborator, but the app makers, filter designers, and automated algorithmic patterns necessary for the subsequent image production."

17 It could be argued that the various artists who have worked with Google Street View images—Michael Wolf, Mishka Henner, Doug Rickard, Jon Rafman, Viktoria Binschtok and others—also collaborate with software to produce their work (Palmer 2015a).

18 In 1997, Susan Meiselas completed a six-year project curating a hundred-year photographic history of Kurdistan, integrating her own work into the book *Kurdistan: In the Shadow of History*, out of which she developed *akaKurdistan*.

19 This work was included in the exhibition *Social Practice: The Art of Collaboration* (2014) at NYU's Tisch School of the Arts. Crowdsourcing can also be used in highly conventional ways, as with photography festivals that recruit the energy of social networks for the old logic of photographic competitions based on individual visions of the world and traditional criteria of photographic merit.

20 The work was commissioned for the 2014 Brighton Photo Biennial, themed "Communities, Collectives and Collaboration."

21 As the speakers at a forum called "Collaborative Images: New Models of Authorship and Aggregation" at Aperture Gallery, New York, on March 18, 2014, suggested: "[activist] photographers are now not only image-makers, but also online community organizers and content curators" (Aperture Gallery 2014).

22 For example, in 2014 Microsoft collaborated with local artists, photographers, videographers, software developers, and editors to produce "the most detailed image ever captured of Seattle" in a project called "Gigapixel ArtZoom": a 360 degree 20,000 megapixel panorama image consisting of nearly 2,400 photos and peppered with "Easter egg" artwork surprises.

23 Although he was not part of the show of that name curated by Douglas Crimp in 1977, Prince is closely associated with the so-called Pictures generation. He appeared in Douglas Crimp's important article "The Photographic Activity of Postmodernism" (1980).

24 Prince's two most famous series of paintings are his *Joke* and *Nurse* paintings; the former feature the texts of jokes against abstract, often monochromatic backgrounds (jokes that largely express the sexual frustrations of middle-class Americans), and the latter were produced by scanning the covers of pulp paperbacks, transferring them to canvas, and painting over the prints.

25 Prince is a writer of some note, often writing under pseudonyms such as Fulton Ryder, and his website collects his various musing under the heading "Bird Talk"— amounting to well over 200 pages.

26 In an interview available on YouTube (Abell and Lang 2008), one of the photographers originally hired to make the cowboy images, Sam Abell, is philosophical about Prince's appropriation, saying that he is neither angry nor amused, and noting that it is "technically legal." Referring to himself as "the originating photographer," Abell says, "I gave it life, I gave it it's first life. And it's my photograph, no one would disagree with that." He goes on to note that "[t]he life of a photograph is a very interesting, deep, complex and ongoing, ever-changing subject … Photographs have lives. This is a curious life." Nevertheless, the commercial photographer cannot conceal his frustration, adding that "it's obviously plagiarism" and that Prince is clearly "a cheeky fellow" who "has to live with … breaking the golden rule." Abell also expresses exasperation at the value of Prince's work, and its celebrated status in the art museum: "A photograph of mine could *never* be in the Guggenheim Museum … because editorial photography … is considered … by the art establishment to be not worthy, but copied by someone else it is worthy, so the art world has something to answer for."

27 As Rob Horning (2014) suggests, "The selfie commemorates the moment when external social control—the neoliberal command to develop a self as a kind of capital stock and serially reproduce oneself in self-advertisement—is internalized as crypto-defiance. *I'm not going to consume their images, I'm going to make one of my own, take control of how I'm seen!*"

28 One reviewer of the work, Peter Schjeldahl (2014), appeared alert to this admittedly morbid reading, observing that they inspired in him "a wish to be dead," and that "death provides an apt metaphor for the pictures: memento mori of perishing vanity."

29 Even Kodak's marketing department were aware of photography's haunting power, as demonstrated by their never-published "death campaign" of 1932, based on pictures of dead loved ones (West 2000: 202).

30 Prince's Instagram account RichardPrince1234 had nearly 26,000 followers by the end of 2015, while his Twitter account @RichardPrince4 had 16,200 followers, in which he regularly forwards screenshots from his private Instagram account, with comments along the same lines as *New Portraits*. Another Instagram account,

RichardPrince_Official, set to "private," and following several thousand people and followed by less, is presumably used for "research." Saltz (2014) alludes to how he "helped reinstate [Prince's] Instagram page after it was taken down due to obscenity. Prince had posted his own *Spiritual America,* his famous appropriated Gary Gross picture of the young naked Brooke Shields."

31 In an additional twist, one of the images Prince appropriated was by an artist, Sean Fader, and the work consisted of a social-media art piece in which he prompted participants to make wishes as they took selfies and rubbed the artist's chest hair. For Fader, Prince's appropriation made him angry, since, "By not communicating with me, by not talking to me, he denied every level of shared authorship" (Sutton 2014). As Sutton (2014) writes, "Fader engineered an appropriation of his own, sending out a press release inviting the public to see his work at Gagosian 'in an exhibition organized by Richard Prince.'"

32 On October 2, 2015, Prince tweeted that "New changes at Instagram doesn't [*sic*] allow me to make Instagram portraits anymore."

33 Umbrico's work, *Flowers C. 1970 (Yellow) Art Print by Warhol on Easy Canvas* (2015), was created in response to a commission by Mark Moore Gallery for an exhibition in May 2015.

34 The instability of photographic authorship online is one reason for the growing importance of metadata, the invisible contextual information embedded within digital image files.

CONCLUSION

1 Margaret Olin (2012: 234) also writes of the *relational* character of photography, arguing that photographs have a certain agency, they can shape relationships and communities, and "motivate us to act." Her use of the term relational is based on Maurice Merleau-Ponty's broader idea that perception itself is relational, and is therefore also distinct from Bourriaud's interest in art practices which "take as their theoretical and practical point of departure the whole of human relations and their social context, rather than an independent and private space" (Bourriaud [1998] 2002: 113).

2 See, for instance, Fred Ritchin's valiant attempt to give more credit to the work of professional photographers online, whereby the "four corners" of an image published online becomes "active" by featuring information that aids its interpretation—including the backstory recounted by the photographer, the subject of the photograph and an eyewitness, and even images or videos showing what was happening just before and after the primary photograph was taken. See the Four Corners and the Authograph platform, a collaboration between Open Lab (Newcastle University), World Press Photo Foundation and the International Center of Photography: http://fourcorners.io.

REFERENCES

Abell, Sam and Daryl Lang (2008), "Photographer Sam Abell on Having His Work Rephotographed by Richard Prince," *Photo District News*, June 14. Available online: https://www.youtube.com/watch?v=Um74DKYlta8 (accessed November 18, 2015).

Adams, Ansel (1968a), *Camera & Lens: Studio, Darkroom, Equipment*, Hastings-on-Hudson, NY: Morgan & Morgan; London: Fountain Press.

Adams, Ansel (1968b), *The Print: Contact Printing and Enlarging*, Hastings-on-Hudson, NY: Morgan & Morgan; London: Fountain Press.

Alberro, Alexander (2001), "Introduction: At the Threshold of Art as Information," in Alexander Alberro and Patricia Norvell (eds.), *Recording Conceptual Art: Early Interviews with Barry, Huebler, Kaltenbach, LeWitt, Morris, Oppenheim, Siegelaub, Smithson, and Weiner by Patricia Norvell*, 1–15, Berkeley; London: University of California Press.

Alberro, Alexander (2003), *Conceptual Art and the Politics of Publicity*, Cambridge, MA: MIT Press.

Albers, Kate Palmer (2013), "Abundant Images and the Collective Sublime," *Exposure: The Journal of the Society for Photographic Education*, 46 (2): 4–13.

Albers, Kate Palmer (2014), "Unseen Images: Gigapixel Photography and Its Viewers," *Photographies*, 7 (1): 11–22.

Albers, Kate Palmer (2015), "Penelope Umbrico: 'A Proposal and Two Trades,'" *Circulation—Exchange*, September 30. Available online: http://circulationexchange. org/articles/proposalandtwotrades.html (accessed October 13, 2015).

Albright, Thomas (1977), "'Retrieved' Photographs as Art?" *San Francisco Chronicle*, April 2: 38.

Amaya, Mario (1975), "My Man Ray: Interview with Lee Miller Penrose," *Art in America*, 63: 54–60.

Anderson, Laurie (1993), *Stories from the Nerve Bible: A Twenty-Year Retrospective*, New York: Harper Perennial.

Andre, Carl ([1972] 2005), "A Note on Bernd and Hilla Becher," in *Cuts: Texts 1959– 2004*, 65–6, Cambridge, MA: MIT Press.

Andreasson, Karin (2014), "Broomberg and Chanarin's Best Photograph: Pussy Riot in 3D," *The Guardian*, February 6. Available online: http://www.theguardian.com/ artanddesign/2014/feb/06/broomberg-chanarin-best-photograph-pussy-riot (accessed March 10, 2015).

Aperture Gallery (2014), "Collaborative Images: New Models of Authorship and Aggregation," panel discussion at Aperture Gallery, March 18, 2014. Available online: http://aperture.org/event/collaborative-images-new-models-authorship-aggregation (accessed April 10, 2014).

Arago, Dominique François ([1839] 1980), "Report," in Alan Trachtenberg (ed.), *Classic Essays on Photography*, 15–26, New Haven, CT: Leete's Island Books.

Armstrong, Stephen (2002), "Altered Images," *The Guardian*, May 27. Available online: http://www.theguardian.com/media/2002/may/27/mondaymediasection4 (accessed April 10, 2014).

Ashford, Doug, Wendy Ewald, Nina Felshin, and Patricia C. Phillips (2006), "A Conversation on Social Collaboration," *Art Journal*, 65 (2): 58–83.

Auping, Michael (1977), "Talking with Douglas Huebler," *Journal of the Los Angeles Institute of Contemporary Art*, 15: 37–44.

Azoulay, Ariella (2008), *The Civil Contract of Photography*, translated by Rela Mazali and Ruvik Danieli, New York: Zone Books.

Azoulay, Ariella (2010), "Getting Rid of the Distinction between the Aesthetic and the Political," *Theory, Culture & Society*, 27 (7–8): 239–62.

Azoulay, Ariella (2012), *Civil Imagination: A Political Ontology of Photography*, translated by Louise Bethlehem, London: Verso.

Barndt, Deborah (2001), "Naming, Making, and Connecting—Reclaiming Lost Arts: The Pedagogical Possibilities of Photo-Story Production," in Pat Campbell and Barbara Burnaby (eds.), *Participatory Approaches in Adult Education*, 31–54, Mahwah, NJ: Lawrence Erlbaum Associates.

Barndt, Deborah (2006), *Wild Fire: Art as Activism*, Toronto: Sumach Press.

Barndt, Deborah, Ferne Cristall, and Dian Marino (1982), *Getting There: Producing Photo-Stories with Immigrant Women*, Toronto: Between the Lines.

Barthes, Roland (1972), "The Great Family of Man," in *Mythologies*, 100–2, New York: Hill and Wang.

Barthes, Roland (1977a), "The Death of the Author," in *Image, Music, Text*, translated by Stephen Heath, 142–8, London: Fontana.

Barthes, Roland (1977b), "Rhetoric of the Image," in *Image, Music, Text*, translated by Stephen Heath, 32–51, London: Fontana.

Barthes, Roland ([1980] 1981), *Camera Lucida: Reflections on Photography*, translated by Richard Howard, New York: Farrar, Straus and Giroux.

Batchen, Geoffrey (1997), *Burning with Desire: The Conception of Photography*, Cambridge, MA: The MIT Press.

Batchen, Geoffrey (2000), *Each Wild Idea: Writing, Photography, History*, Cambridge, MA: The MIT Press.

Batchen, Geoffrey (2008), "From Infinity to Zero," in Marvin Heiferman (ed.), *Now Is Then: Snapshots from the Maresca Collection*, 121–30, New York: Princeton Architectural Press.

Batchen, Geoffrey (2012), "Photography and Authorship," *Still Searching* blog, Winterthur Fotomuseum, October 7. Available online: http://blog.fotomuseum.ch/2012/10/4-photography-and-authorship (accessed January 4, 2013).

Batchen, Geoffrey (2013), "Observing by Watching: On Joachim Schmid and the Art of Exchange," *Aperture*, 210: 46–9.

Baudelaire, Charles ([1859] 1980), "The Modern Public and Photography," Alan Trachtenberg (ed.) *Classic Essays on Photography*, 83–9, New Haven: Leete's Island Books.

Baudrillard, Jean (1988), "Please Follow Me," in Sophie Calle, *Suite Vénitienne*, 75–86, Seattle: Bay Press.

Baudrillard, Jean (2005), *The Intelligence of Evil or the Lucidity Pact*, translated by Chris Turner, New York: Berg.

Baudrillard, Jean (2009), "The Vanishing Point of Communication," in David B. Clarke, Marcus A. Doel, William Merrin, and Richard G. Smith (eds.), *Jean Baudrillard: Fatal Theories*, 15–23, New York: Routledge.

Bazin, André ([1945] 1960), "The Ontology of the Photographic Image," translated by Hugh Gray, *Film Quarterly*, 13 (4): 4–9.

Bazin, André ([1967] 2005), *What is Cinema? Vol. I*, translated by Hugh Gray, Berkeley; Los Angeles; London: University of California Press.

Becher, Bernd and Hilla Becher (1999), *Basic Forms*, Munich: Schirmer/Mosel.

Bembnister, Theresa (2002), "Young at Heart," *The Pitch*, November 7. Available online: http://www.pitch.com/kansascity/young-at-heart/Content?oid=2167375 (accessed August 14, 2015).

Benjamin, Walter ([1931] 1999), "Little History of Photography," in Michael W. Jennings, Howard Eiland, and Gary Smith (eds.), *Selected Writings: Volume 2, Part 2, 1931–1934*, 507–30, Cambridge, MA; London: The Belknap Press of Harvard University Press.

Benjamin, Walter ([1934] 1999), "The Author as Producer," in Michael W. Jennings, Howard Eiland, and Gary Smith (eds.), *Selected Writings: Volume 2, Part 2, 1931–1934*, 768–82, Cambridge, MA; London: The Belknap Press of Harvard University Press.

Benjamin, Walter ([1936] 2002), "The Work of Art in the Age of Its Technological Reproducibility: Second Version," in Howard Eiland and Michael W. Jennings (eds.), *Selected Writings: Volume 3, 1935–1938*, 101–33, Cambridge, MA; London: The Belknap Press of Harvard University Press.

Berger, John (1972), *Ways of Seeing*, London: British Broadcasting Corporation: Penguin Books.

Berger, Lynn (2009), "The Authentic Amateur and the Democracy of Collecting Photographs," *Photography and Culture*, 2 (1): 31–50.

Berrebi, Sophie (2014), *The Shape of Evidence: Contemporary Art and the Document*, Amsterdam: Valiz.

Bertrand, Mathilde (2015), "'A Tool for Social Change': Community Photography at Belfast Exposed," *LISA e-journal*, July 21. Available online: http://lisa.revues.org/8770 (accessed August 15, 2015).

Birnbaum, Daniel (2004), "Bernd and Hilla Becher: K21-kunstsammlung nordrhein-westfalen, Dusseldorf," *Artforum International*, 42 (9): 202–4.

Biro, Matthew (2012), "From Analogue to Digital Photography: Bernd and Hilla Becher and Andreas Gursky," *History of Photography*, 36 (3): 353–66.

Bishop, Claire (2012a), *Artificial Hells: Participatory Art and the Politics of Spectatorship*, London: Verso.

Bishop, Claire (2012b), "Digital Divide: Claire Bishop on Contemporary Art and New Media," *Artforum International*, 51 (1): 434–42.

Bishop, Claire (2013), "3. Archival Myopia," *Still Searching* blog, Winterthur Fotomuseum, October 2. Available online: http://blog.fotomuseum.ch/2013/10/3-archival-myopia/ (accessed November 3, 2013).

Booth Museum (n.d.), http://brightonmuseums.org.uk/booth/ (accessed August 15, 2015).

Bourriaud, Nicolas ([1998] 2002), *Relational Aesthetics*, trans. Simon Pleasance and Fronza Woods, Dijon: Les Presses du Réel.

Braden, Su (1983), *Committing Photography*, London: Pluto Press.

"Brighton Photo Biennial 2014," *Photoworks Annual*, 21 (2014).

Broomberg, Adam and Oliver Chanarin (2008a), "The Day Nobody Died," artists' statement. Available online: http://www.choppedliver.info/the-day-nobody-died/ (accessed September 15, 2015).

Broomberg, Adam and Oliver Chanarin (2008b), "Unconcerned But Not Indifferent," *Foto8: The Home of Photography*, March 4. Available online: http://www.foto8.com/live/unconcerned-but-not-indifferent/ (accessed September 15, 2015).

Broomberg, Adam and Oliver Chanarin (2011), *People in Trouble Laughing Pushed to the Ground*, London: Mack.

Brunet, François (2009), *Photography and Literature*, London: Reaktion Books

Buchloh, Benjamin (1984), "From Faktura to Factography Author(s)," *October*, 30: 82–119.

Buchloh, Benjamin (1990), "Conceptual Art 1962–1969: From the Aesthetic of Administration to the Critique of Institutions," *October*, 55: 105–43.

Bull, Stephen (2003), "Joachim Schmid (2002)," in *Vigovisións: Colección Fotográfica do Concello de Vigo*, Vigo, Spain: Museo de Arte Contemporánea de Vigo. Available online: http://www.americansuburbx.com/2011/06/joachim-schmid-joachim-schmid.html (accessed September 15, 2015).

Bull, Stephen (2007), "The Elusive Author: Found Photography, Authorship and the Work of Joachim Schmid," in Gordon MacDonald and John S. Weber (eds.), *Joachim Schmid: Photoworks 1982–2007*, 61–9, Brighton: Photoworks; Göttingen: Steidl.

Burbridge, Ben (2011), "Interview with Adam Broomberg and Oliver Chanarin," *PH: The Postgraduate Photography Research Network*, September 7. Available online: http://sro.sussex.ac.uk/44199/1/ph-researchcouk-phthepostgraduatephotographyresearchnetwork.pdf (accessed August 15, 2015).

Burbridge, Ben, Anthony Luvera, Matt Daw, Andrew Dewdney, Noni Stacey, and Eugenie Dolberg (2014), "Round Table: Community Photography, Then and Now," *Photoworks Annual*, 21: 126–50.

Bush, Kate (2003a), "Candid Camera: 'Unauthored' Photography," *Frieze*, 73: 58–64.

Bush, Kate (2003b), "The Latest Picture," in Douglas Fogle (ed.), *The Last Picture Show: Artists Using Photography 1960–1982*, 262–66, Minneapolis: Walker Art Center.

Bushey, Jessica (2014), "Convergence, Connectivity, Ephemeral and Performed: New Characteristics of Digital Photographs', *Archives and Manuscripts*, 42 (1): 33–47.

Calle, Sophie (1999), *Double Game*, London: Violette Editions.

Calle, Sophie (2010), *True Stories: Hasselblad Award 2010*, Göteborg: Hasselblad Foundation; Göttingen: Steidl.

Campany, David (2003), *Art and Photography*, London: Phaidon.

Campany, David (2005), "Man Ray and Marcel Duchamp: *Dust Breeding* 1920," in Sophie Howarth (ed.), *Singular Images: Essays on Remarkable Photographs*, 47–53, New York: Aperture Foundation.

Campany, David (2011), "Alias," *Art Review*, 50: 80–3.

Campany, David (2014), "The 'Photobook': What's in a Name?" in "The Photobook Review #007," *Aperture* 217: S3.

Campany, David (2015), *A Handful of Dust: From the Cosmic to the Domestic*, London: Mack; Paris: Le Bal.

Campbell, Pat and Barbara Burnaby, eds. (2001), *Participatory Approaches in Adult Education*, Mahwah, NJ: Lawrence Erlbaum Associates.

Cartier-Bresson, Henri (1952), *The Decisive Moment*, New York: Simon and Schuster.

Chevrier, Jean-François (2003), "The Adventures of the Picture Form in the History of Photography," in Douglas Fogle (ed.), *The Last Picture Show: Artists Using Photography 1960–1982*, 113–28, Minneapolis: Walker Art Center.

"Collaboration" (2014), annual issue, *Photoworks*, 21.

Collier, John (1967), *Visual Anthropology: Photography as a Research Method*, New York: Holt Rinehart.

Collins, Lauren (2008), "Pixel Perfect: Pascal Dangin's Virtual Reality," *The New Yorker*, 84 (13). Available online: http://www.newyorker.com/magazine/2008/05/12/pixel-perfect (accessed January 8, 2009).

Coplans, John ([1965] 2002), "Concerning 'Various Small Fires.' Edward Ruscha Discusses his Perplexing Publications," in Edward Ruscha and Alexandra Schwartz, *Leave Any Information at the Signal: Writings, Interviews, Bits, Pages*, 23–7, Cambridge, MA: The MIT Press.

Costello, Diarmuid and Margaret Iversen (2010), *Photography After Conceptual Art*, Chichester; Malden, MA: Wiley-Blackwell.

Cotton, Charlotte (2012), "Two Guys from Van Nuys," in Larry Sultan and Mike Mandel, *Larry Sultan & Mike Mandel*, 8–37, New York: D.A.P.

Cotton, Charlotte (2015), *Photography is Magic*, New York: Aperture.

Crimp, Douglas (1980), "The Photographic Activity of Postmodernism," *October*, 15: 91–101.

Crimp, Douglas (1993), "The Photographic Activity of Postmodernism," in *On the Museum's Ruins*, 108–25, Cambridge, MA: The MIT Press.

Cross, Karen (2015), "The Lost of Found Photography," *Photographies*, 8 (1): 43–62.

"Crowd Theory—Behind the Scenes with Samstag Scholar, Simon Terrill," June 4, 2013. Available online: https://www.youtube.com/watch?v=tSYpzl8FtII (accessed August 15, 2015).

Cutshaw, Stacey McCarroll, and Ross Barrett (2007), *In the Vernacular: Photography of the Everyday*, Boston: Boston University Art Gallery.

Darwent, Charles (2008), "How Did Richard Prince Produce the Most Expensive Photograph Ever?" *The Independent*, June 22. Available online: http://www.independent.co.uk/arts-entertainment/art/features/how-did-richard-prince-produce-the-most-expensive-photograph-ever-850589.html (accessed September 15, 2015).

Daston, Lorraine and Peter Galison (2007), *Objectivity*, New York: Zone Books.

Davies, Lucy (2013), "The New War Poets: The Photographs of Adam Broomberg and Oliver Chanarin," *The Telegraph*, March 29. Available online: http://www.telegraph.co.uk/culture/photography/9955106/The-new-war-poets-the-photographs-of-Adam-Broomberg-and-Oliver-Chanarin.html?fb (accessed August 15, 2015).

Davies, Suzanne (1978–79), "Micky Allan: Photographer," *Lip*, 4: 49–52.

de Duve, Thierry (1999), "Bernd and Hilla Becher or Momentary Photography," in Bernd Becher and Hilla Becher, *Basic Forms*, 7–20, Munich: Schirmer/Mosel 1999.

Deitcher, David and Wolfgang Tillmans (1998), *Burg*, Köln; London: Taschen.

Dewdney, Andrew, Claire Grey, and Andy Minnion, eds. (1994), *Down But Not Out: Young People, Photography and Images of Homelessness*, Stoke-on-Trent: Trentham Books.

Dezeuze, Anna and Julia Kelly, eds. (2013), *Found Sculpture and Photography from Surrealism to Contemporary Art*, Farnham; Burlington: Ashgate.

Diack, Heather A. (2010), "The Benefit of the Doubt: Regarding the Photographic Conditions of Conceptual Art, 1966–1973," PhD diss., University of Toronto.

Diack, Heather A. (2011), "Nobody Can Commit Photography Alone: Early Photoconceptualism and the Limits of Information," *Afterimage*, 38 (4): 14–19.

Dillon, Brian (2006), "Evidence Revisited," *Frieze*, 96: 149.

Downey, Anthony (2009), "An Ethics of Engagement: Collaborative Art Practices and the Return of the Ethnographer," *Third Text*, 23 (5): 593–603.

Downey, Karen and Anthony Luvera (2007), "Photographs and Assisted Self-Portraits: A Public Archive?" in Sarah Pierce and Julie Bacon (eds.), *Footnotes*,

Belfast: Interface, University of Ulster. Available online: http://www.luvera.com/downey-karen-and-anthony-luvera-photographs-and-assisted-self-portraits-a-public-archive-footnotes/ (accessed August 15, 2015).

Dubin, Zan (1995), "Insights of 'Blind' in Eye of the Beholder," *Los Angeles Times*, October 20. Available online: http://articles.latimes.com/1995-10-20/entertainment/ca-59024_1_sophie-calle (accessed June 15, 2014).

Duchamp, Marcel ([1957] 1973), "The Creative Act," in Michel Sanouillet and Elmer Peterson (eds.), *Salt Seller: The Writings of Marcel Duchamp*, 138–40, New York: Oxford University Press.

Durden, Mark (2000), "Empathy and Engagement: The Subjective Documentary," in Mark Durden and Craig Richardson (eds.), *Face On: Photography as Social Exchange*, 26–37, London: Black Dog.

Durden, Mark and Craig Richardson, eds. (2000), *Face On: Photography as Social Exchange*, London: Black Dog.

Eastlake, Lady Elizabeth ([1857] 1980) "Photography," in Alan Trachtenberg (ed.), *Classic Essays on Photography*, 39–69, New Haven: Leete's Island Books.

Edelman, Bernard (1979), *Ownership of the Image: Elements for a Marxist Theory of Law*, London: Routledge.

Edwards, Steve (1990), "The Machine's Dialogue," *Oxford Art Journal*, 13 (1): 63–76.

Edwards, Steve (2006), *The Making of English Photography: Allegories*, University Park, PA: Pennsylvania State University Press.

Edwards, Steve (2009), "Commons and Crowds: Figuring Photography from Above and Below," *Third Text*, 23 (4): 447–464.

Elkins, James, ed. (2007), *Photography Theory*, New York; London: Routledge.

Enwezor, Okwui (2008), *Archive Fever: Uses of the Document in Contemporary Art*, New York: International Center of Photography; Göttingen: Steidl Publishers.

Evans, Jessica (1997), "Introduction," in Jessica Evans (ed.), *The Camerawork Essays: Context and Meaning in Photography*, 11–36, London: Rivers Oram Press.

Ewald, Wendy (1985), *Portraits and Dreams: Photographs and Stories By Children of the Appalachians*, New York: Writers and Readers.

Ewald, Wendy (2000), *Secret Games: Collaborative Works with Children, 1969–1999*, Zurich: Scalo; London: Thames & Hudson.

Ewald, Wendy (2013), "The Collaborative Art of Wendy Ewald," radio interview on "Books and Arts Daily," the Australian Broadcasting Corporation, November 7. Available online: http://www.abc.net.au/radionational/programs/booksandartsdaily/the-collaborative-art-of-wendy-ewald/5075502 (accessed December 15, 2013).

Ewald, Wendy and Michael Morris (2006), "Wendy Ewald in Conversation with Michael Morris," *Artangel*. Available online: http://www.artangel.org.uk//projects/2005/towards_a_promised_land/a_conversation_with_wendy_ewald/q_a (accessed December 15, 2013).

Fardy, Jonathan (2008), "Double Vision: Reviewing Man Ray and Marcel Duchamp's 1920 Photo-Text," MA diss., Bowling Green State University.

Fischer, Hal (1977), "Sultan and Mandel in Conversation with Hal Fischer," *Art Contemporary*, 2 (2/3): 32–4 and 56.

Flickr (n.d.), available online: http://www.flickr.com/tour/share (accessed December 10, 2010).

Flusser, Vilém (2000), *Towards a Philosophy of Photography*, translated by Anthony Matthews, London: Reaktion Books.

Fogle, Douglas, ed. (2003), *The Last Picture Show: Artists Using Photography 1960–1982*, Minneapolis: Walker Art Center.

Fontcuberta, Joan (2007), "The Predator of Images," in Gordon MacDonald and John S. Weber (eds.), *Joachim Schmid: Photoworks 1982–2007*, 149–155, Brighton: Photoworks; Göttingen: Steidl.

Forth, Robert F. (2003), "Afterword," in Larry Sultan and Mike Mandel, *Evidence*, n.p., New York: Distributed Art Publishers.

Foster, Hal (1985), *Recodings: Art, Spectacle, Cultural Politics*, Seattle: Bay Press.

Foster, Hal (1996), "The Artist as Ethnographer," in *The Return of the Real: The Avant-Garde at the End of the Century*, 171–204, Cambridge, MA: The MIT Press.

Foster, Stephen (2007), "Fig.: Adam Broomberg and Oliver Chanarin," John Hansard Gallery, February 6 to May 31, 2007. Available online: http://www.hansardgallery.org.uk/event-detail/86-fig-adam-broomberg-and-oliver-chanarin/ (accessed August 15, 2015).

Fraser, Virginia (2012), "Time Out: A Different Temporality," *Art Monthly*, 247: 10–13.

Freire, Paulo ([1968] 1970), *Pedagogy of the Oppressed*, New York: Herder and Herder.

Fried, Michael (2008), *Why Photography Matters as Art as Never Before*, New Haven: Yale University Press.

Frieling, Rudolf (2008), *The Art of Participation: 1950 to Now*, San Francisco: San Francisco Museum of Modern Art; London: Thames & Hudson.

Furtado, Will (2015), "Is Richard Prince a Genius Troll, or a Lazy Sexist?" *Highsnobiety*, June 3. Available online: http://www.highsnobiety.com/2015/06/03/richard-prince-instagram-art (accessed August 15, 2015).

Gaines, Jane M. (1991), *Contested Culture: The Image, the Voice, and the Law*, Chapel Hill: University of North Carolina Press.

Gernsheim, Helmut (1942), *Photovision*, London: Fountain Press.

Gernsheim, Helmut (1955), *The History of Photography From the Earliest Use of the Camera Obscura in the Eleventh Century up to 1914*, London; New York: Oxford University Press.

Gernsheim, Helmut (1962), *Creative Photography: Aesthetic Trends, 1839–1960*, New York: Bonanza Books.

Giertsberg, Frits (2007), "The Long Walk," in Gordon MacDonald and John S. Weber (eds.), *Joachim Schmid: Photoworks 1982–2007*, 221–225, Brighton: Photoworks; Göttingen: Steidl.

Gilbert-Rolfe, Jeremy (1974), "Douglas Huebler's Recent Work," *Artforum*, February: 59–60.

Godfrey, Mark (2002), "A Sense of Huebler," in *Douglas Huebler*, exhibition catalogue, 5–15, Camden: Camden Arts Centre.

Godfrey, Mark (2005), "Photography Found and Lost: On Tacita Dean's *Floh*," *October*, 114: 90–119.

Godfrey, Mark (2011), "Across the Universe," in Matthew Witkovsky (ed.), *Light Years: Conceptual Art and the Photograph, 1964–1977*, 57–65, Chicago: Art Institute of Chicago.

Godfrey, Tony (2002), "Douglas Huebler," *The Burlington Magazine*, 144 (1190): 307–8.

Gough, Julie (1997), "Time Ripples in Tasmania," *Art & Australia*, 35 (1): 108–15.

Green, Charles (1999), "Disappearance and Photography in Post-Object Art: Christo and Jeanne-Claude," *Afterimage*, 27 (3): 13–15.

Green, Charles (2001), *The Third Hand: Collaboration in Art from Conceptualism to Postmodernism*, Minneapolis: University of Minnesota Press.

Griffin, Synthia and Anthony Luvera (2015), "What Is the Role of Artists in Defining Place and Creating Change in the World?" *Open Engagement*, April 3. Available online: http://openengagement.info/synthia-griffin-and-anthony-luvera/ (accessed August 15, 2015).

Gronert, Stefan (2003), "Alternative Pictures: Conceptual Art and the Artistic Emancipation of Photography in Europe," in Douglas Fogle (ed.), *The Last Picture Show: Artists Using Photography 1960–1982*, 86–96, Minneapolis: Walker Art Center.

Groys, Boris (2008), "Multiple Authorship," in *Art Power*, 43–52, Cambridge, MA: The MIT Press.

Harford, Sonia (2013), "Seeing the World with Children's Eyes," *The Age*, October 2. Available online: http://www.theage.com.au/entertainment/art-and-design/seeing-the-world-with-childrens-eyes-20131001-2uqmb.html?rand=5989038 (accessed December 15, 2013).

Harris, Jonathan (2013), *The Utopian Globalists Artists of Worldwide Revolution, 1919–2009*, Chichester, West Sussex: Wiley-Blackwell.

Harrison, Nate (2012), "The Pictures Generation, the Copyright Act of 1976, and the Reassertion of Authorship in Postmodernity," *Art & Education*, June. Available online: http://www.artandeducation.net/paper/the-pictures-generation-the-copyright-act-of-1976-and-the-reassertion-of-authorship-in-postmodernity/ (accessed December 4, 2015).

Hawker, Rosemary (2013), "Repopulating the Street: Contemporary Photography and Urban Experience," *History of Photography*, 37 (3): 341–52.

Healy, Chris (2006), "Crowd—Or Community?" *Meanjin*, 65 (2): 167–72.

Hesford, Wendy S. (2011), *Spectacular Rhetorics: Human Rights Visions, Recognitions, Feminisms*, Durham: Duke University Press.

Hill, Paul and Thomas Cooper, eds. (1979), *Dialogue With Photography*, London: Thames & Hudson.

Hobbs, Robert C. (1984), "Rewriting History: Artistic Collaboration Since 1960," in Cynthia Jaffee McCabe (ed.), *Artistic Collaboration in the Twentieth Century*, 63–87, Washington, D.C.: Smithsonian Institution Press.

Holloway, Memory (1978), "The Many Faces of Woman," *The Australian,* June 6.

Holloway, Memory (1987), "In the Tracks of Isis," *Micky Allan: Perspective 1975–1987*, 3–9, Clayton: Monash University Gallery, 1987.

Holte, Michael Ned (2006), "The Administrative Sublime, or The Center for Land Use Interpretation," *Afterall*, 13: 18–26.

Hooker, Jamila Mohamad (2013), "Foreign Postcards." Available online: http://www.jamilamohamadhooker.com (accessed November 10, 2015).

Hooper, Chloe (2013), "Chloe Hooper on Three Visual Art Exhibitions," *The Wheeler Centre*, October. Available online: http://www.wheelercentre.com/projects/criticism-now/the-morning-after-making-models-the-collaborative-art-of-wendy-ewald-the-somali-peace-band-and-disarm (accessed August 4, 2015).

Hopkins, David (2003), "'Out of It': Drunkenness and Ethics in Martha Rosler and Gillian Wearing," *Art History*, 26 (3): 340–63.

Horning, Rob (2014), "Selfies Without the Self," *The New Inquiry*, November 23. Available online: http://thenewinquiry.com/blogs/marginal-utility/selfies-without-the-self/ (accessed December 15, 2014).

Hubert, Renée Riese (1994), *Magnifying Mirrors: Women, Surrealism, & Partnership*, Lincoln: University of Nebraska Press.

Huebler, Douglas (1969), "Artist Statement," in Konrad Fischer and Hans Strewlow, *Prospect 69*, exhibition catalogue, Kunsthalle Düsseldorf.

Huebler, Douglas ([1969] 2001), "Douglas Huebler: July 25, 1969," in Alexander Alberro and Patricia Norvell (eds.), *Recording Conceptual Art: Early Interviews with Barry,*

Huebler, Kaltenbach, LeWitt, Morris, Oppenheim, Siegelaub, Smithson, and Weiner by Patricia Norvell, 135–54, Berkeley; London: University of California Press.

Huebler, Douglas and Gary Neill Kennedy ([1973] 2004), "Douglas Huebler: April, 1973," in Peggy Gale (ed.), *Artists Talk 1969–77*, 218–49, Halifax: Press of the Nova Scotia College of Art and Design.

Hughes, Gordon (2007), "Game Face: Douglas Huebler and the Voiding of Photographic Portraiture," *Art Journal*, 66 (4): 52–69.

Hughes, Gordon (2009), "Exit Ghost: Douglas Huebler's Face Value," *Art History* 32 (5): 894–909.

Hyde, Adam, Mike Linksvayer, kanarinka, Michael Mandiberg, Marta Peirano, Sissu Tarka, Astra Taylor, Alan Toner, and Mushon Zer-Aviv (2012), "What is Collaboration Anyway?" *The Social Media Reader*, 53–67, New York: New York University Press.

Irish, Sharon (2004), "Tenant to Tenant: The Art of Talking with Strangers," *Places: Forum of Design for the Public Realm*, 16 (3): 61–67.

Israel, Matthew (2015), "Your Instagrams Are Richard Prince Artworks," *The Huffington Post*, October 2. Available online: http://www.huffingtonpost.com/matthew-israel/your-instagrams-are-richa_b_5908264.html (accessed November 15, 2015).

Iversen, Margaret (2009), "Auto-maticity: Ruscha and Performative Photography," *Art History*, 32 (5): 836–51.

Jaar, Alfredo (n.d.), "Alfredo Jaar Lecture." Transcript available online: http://concreteculture.wordpress.com/alfredo-jaar-lecture/.

James, Sarah (2009), "Subject, Object, Mimesis: The Aesthetic World of the Bechers' Photography," *Art History*, 32 (5): 874–93.

Jeffrey, Ian (1981), *Photography: A Concise History*, London: Thames & Hudson.

Jerrems, Carol and Virginia Fraser (1974), *A Book About Australian Women*, North Fitzroy: Outback Press.

Jocks, Heinz-Norbert (2004), "Bernd and Hilla Becher: Die Geburt des Fotografischen Blicks aus dem Geist der Historie," *Kunstforum International*, 171: 158–75.

Johnson, Paddy (2014), "Richard Prince Sucks," *Artnews*, October 21. Available online: https://news.artnet.com/art-world/richard-prince-sucks-136358 (accessed November 15, 2015).

Johnson, Robert Flynn (2004), *Anonymous: Enigmatic Images from Unknown Photographers*, London: Thames & Hudson.

Kahmen, Volker (1964), "Bernd Becher," *Die Sonde. Zeitschrift für Kunst und Versuch*, 4 (2): 42ff.

Kahmen, Volker (1965), "Die Industrieaufunahmen Bernhard Bechers," information flyer from the Galerie Pro, Bonn–Bad Godesberg.

Kaplan, Louis (2005), *American Exposures: Photography and Community in the Twentieth Century*, Minneapolis: University of Minnesota Press.

Keegan, Victor (2006), "Snapshot of the True Content Generators," *The Guardian*, November 30. Available online: http://www.theguardian.com/technology/2006/nov/30/newmedia.comment (accessed August 15, 2015).

Kelly, Jane (1997), "Stephen Willats: Art, Ethnography and Social Change," *Variant*, 4, http://www.variant.org.uk/4texts/Jane_Kelly.html (accessed August 15, 2013).

Kelsey, Robin (2009), "Eye of the Beholder," *Artforum International*, 47 (5): 53–58.

Kelsey, Robin (2011), "Hazarded into the Blue: John Baldessari and Photography in the Early 1970s," in Matthew Witkovsky (ed.), *Light Years: Conceptual Art and the Photograph, 1964–1977*, 133–44, Chicago: Art Institute of Chicago.

Kennedy, Randy (2014), "Richard Prince Settles Copyright Suit With Patrick Cariou Over Photographs," *The New York Times*, March 18. Available online: http://artsbeat.blogs. nytimes.com/2014/03/18/richard-prince-settles-copyright-suit-with-patrick-cariou-over-photographs (accessed August 15, 2015).

Kent, Rachel (2006), "Fiona Tan: Vox Populi," *Zones of Contact: 2006 Biennale of Sydney*, 266–7, Sydney: Biennale of Sydney.

Kessels, Erik (2013), "Les gens recherchent l'authenticité," *Photographie.com*. Available online: http://www.photographie.com/news/erik-kessels-les-gens-recherchent-lauthenticite (accessed November 14, 2013).

Kester, Grant H. (2004), *Conversation Pieces: Community and Communication in Modern Art*, Berkeley: University of California Press.

Kester, Grant H. (2011), *The One and the Many: Contemporary Collaborative Art in a Global Context*, Durham; London: Duke University Press.

Köhler, Michael (1989), "Interview mit Bernd und Hilla Becher," in *Künstler. Kritisches Lexikon der Gegenwartskunst*, Munich.

Kosuth, Joseph (1997), "Times of Our Lives," *Artforum International*, 36 (3): 15–6.

Kotz, Liz (2006), "Image + Text: Reconsidering Photography in Contemporary Art," in Amelia Jones (ed.), *A Companion to Contemporary Art Since 1945*, 512–33, Malden, MA: Blackwell.

Kracauer, Siegfried ([1927] 1993), "Photography," translated by Thomas Y. Levin, *Critical Inquiry*, 19 (3): 421–36.

Krauss, Rosalind (1977), "Notes on the Index: Seventies Art in America," *October*, 3: 68–81.

Krauss, Rosalind (1982), "Photography's Discursive Spaces: Landscape/View," *Art Journal*, 42 (4): 311–19.

Krauss, Rosalind (1985), *The Originality of the Avant-garde and Other Modernist Myths*, Cambridge, MA: MIT Press.

Kuhn, Stefan (1995), "Bernd und Hilla Becher: Werk und Rezeption in den Sechziger und Siebziger Jahren," MA diss., Ruhr University Bechum.

Kwon, Miwon (2002), *One Place After Another: Site-Specific Art and Locational Identity*, Cambridge, MA: MIT Press.

Ladd, Jeffrey (2013), "The Holy Bible, Appropriated: An Illustrated Scripture by Broomberg and Chanarin," *TIME Lightbox*, June 6. Available online: http://time.com/3800126/the-holy-bible-appropriated-an-illustrated-scripture-by-broomberg-and-chanarin/ (accessed August 15, 2015).

Lafreniere, Steve (2003), "'80s Then: Richard Prince Talks to Steve Lafreniere," *Artforum*, 41 (7): 70–1.

Lane, Guy (2009), "Thomas Ruff: Space Explorer" *Art World*, 12: 136–43.

Lang, Doug (2000), "Photographer, Brew Master, Publisher: Bill Owens Comes Full Circle," *Art a Gogo*. Available online: http://www.artagogo.com/interview/owensinterview/owensinterview.htm (accessed August 15, 2015).

Lange, Susanne (2007), *Bernd and Hilla Becher: Life and Work*, trans. Jeremy Gaines, Cambridge, MA: MIT Press.

Langford, Martha (2001), *Suspended Conversations: The Afterlife of Memory in Photographic Albums*, Montreal; Ithaca: McGill–Queen's University Press.

Langford, Martha (2008), "Strange Bedfellows: Appropriations of the Vernacular by Photographic Artists," *Photography and Culture*, 1 (1): 73–93.

Lass, Julian and Diane Smyth (2010), "Together we are Stronger," *The British Journal of Photography*, 157 (7774): 42–49.

Lehan, Joanna (2006), "Ecotopia: Interview with Adam Broomberg and Oliver Chanarin," Second Triennial of Photography and Video, International Center of Photography, New York. Available online: http://www.broombergchanarin.com/ecotopia-text-by-joanna-lehan/ (accessed September 15, 2015).

Lehan, Joanna (2014), "Thomas Dworzak Instagram Scrapbooks," *Aperture*, 214: 66–75.

Lemagny, Jean-Claude and André Rouillé (1986), *A History of Photography: Social and Cultural Perspectives*, New York: Cambridge University Press.

Lewallen, Constance (1983), "Mike Mandel and Larry Sultan: MATRIX/BERKELEY 61," exhibition catalogue, May 7–June 7, 1983, Berkeley Art Museum Pacific Film Archive. Available online: http://bampfa.berkeley.edu/images/art/matrix/61/MATRIX_61_Mandel_and_Sultan.pdf (accessed August 15, 2015).

Lifson, Ben and Abigail Solomon-Godeau (1981), "Photophilia: A Conversation about the Photography Scene," *October*, 16: 102–18.

Lightfoot, Alexandra and Wendy Ewald (2002), *I Wanna Take Me a Picture: Teaching Photography and Writing to Children*, Boston: Beacon Press.

Lind, Maria (2007), "The Collaborative Turn," in Johanna Billing, Maria Lind, and Lars Nilsson (eds.), *Taking the Matter into Common Hands: On Contemporary Art and Collaborative Practices*, 15–31, London: Black Dog.

Lippard, Lucy ([1973] 1997), *Six Years: The Dematerialization of the Art Object from 1966 to 1972*, Berkeley: University of California Press.

Lobel, Michael (2016), "Lost and Found: On Susan Weil and Robert Rauschenberg's Blueprints," *Artforum International*, 54 (6): 184–96.

Lord, Benjamin (2015), "Perspectives on *Evidence*," *X-TRA Contemporary Art Quarterly*, 17 (3). Available online: http://x-traonline.org/article/perspectives-on-evidence/ (accessed October 15, 2015).

Lowry, Joanna (2000), "Negotiating Power," in Mark Durden and Craig Richardson (eds.), *Face On: Photography as Social Exchange*, 11–20, London: Black Dog.

Lugon, Olivier (2015), "Photography and Scale: Projection, Exhibition, Collection," *Art History*, 38 (2): 386–403.

Lundström, Jan-Erik (2007), "Matters of Life and Death: The Immersive Aesthetics of Joachim Schmid," in Gordon MacDonald and John S. Weber (eds.), *Joachim Schmid: Photoworks 1982–2007*, 97–101, Brighton: Photoworks; Göttingen: Steidl.

Luvera, Anthony (2006), "Photographs and Assisted Portraits," *Source: Photographic Review*, 47. Available online: http://www.luvera.com/photographs-and-assisted-self-portraits/ (accessed August 15, 2014).

Luvera, Anthony (2010), "Residency," *Photographies*, 3 (2): 225–41.

Luvera, Anthony (2013), "In Conversation with Christopher Wright," in Arnd Schneider and Christopher Wright, *Anthropology and Art Practice*, 45–52, London; New York: Bloomsbury Academic.

Luvera, Anthony and Wendy Ewald (2013), "Tools For Sharing: Wendy Ewald In Conversation With Anthony Luvera," *Photoworks*, 20: 48–59.

Lyden, Anne M. (1999), "Introduction," in *In Focus: Hill and Adamson*, 5–10, Los Angeles: J. Paul Getty Museum.

Lyon, Danny (1971), *Conversations with the Dead: Photographs of Prison Life, with the Letters and Drawings of Billy McCune #122054*, New York: Holt, Rinehart and Winston.

MacDonald, Gordon (2007), "Editor's note," in Adam Broomberg and Oliver Chanarin, *Fig*, n.p., Brighton: Photoworks; Göttingen: Steidl.

MacDonald, Gordon and John S. Weber, eds. (2007), *Joachim Schmid: Photoworks 1982–2007*, Brighton: Photoworks; Göttingen: Steidl.

MacDonald, Richard Lowell (2015), "'Going Back in a Heartbeat': Collective Memory and the Online Circulation of Family Photographs," *Photographies*, 8 (1): 23–42.

Mandel, Mike (2013), "Evidence, Mike Mandel and Constance Lewallen at Kadist," *Kadist Art Foundation*. Available online: https://vimeo.com/69524584 (accessed August 15, 2015).

Mandel, Mike, Larry Sultan, Jim Goldberg, and Constance Lewallen (2008), "Artist and Curator in Conversation," *MATRIX 61*, Berkeley Art Museum and Pacific Film Archive (BAMPFA), June 22, http://larrysultan.com/archives/wp-content/uploads/2013/10/Goldberg_Lewallen_Mandel_Sultan.pdf (accessed August 15, 2015).

Manovich, Lev (2013), *Software Takes Command: Extending the Language of New Media*, London: Bloomsbury.

Marcoci, Roxana, ed. (2010), *The Original Copy: Photography of Sculpture, 1839 to Today*, New York: Museum of Modern Art.

Marien, Mary Warner (2002), *Photography: A Cultural History*, Upper River Saddle, NJ: Prentice Hall.

Marien, Mary Warner (2015), *Photography Visionaries*, London: Laurence King.

Marshall, Peter (n.d.), "The Camerawork Essays," *London Photos*. Available online: http://londonphotographs.co.uk/pm/lip/mar98/camerawk.htm (accessed August 15, 2015).

Martins, Susana S. (2014), "Photography as Anti-Museum? Conflicting Museological Concepts in the Work of Joachim Schmid," *Photographies*, 7 (2): 131–48.

McCabe, Cynthia Jaffee, (1984), "Artistic Collaboration in the Twentieth Century: The Period Between Two Wars," in Cynthia Jaffee McCabe (ed.), *Artistic Collaboration in the Twentieth Century*, 15–44, Washington, D.C.: Smithsonian Institution Press.

McCauley, Anne (2007), "The Trouble with Photography," in James Elkins (ed.), *Photography Theory*, 403–30, New York; London: Routledge.

McFarlane, Kyla (2005), "Landscape and the Renewal of Social Space," *Photofile*, 76: 28–31.

McLuhan, Marshall (1964), "The Photograph: The Brothel-without-Walls," in *Understanding Media: The Extensions of Man*, 188–202, New York: McGraw-Hill.

McQuire, Scott (2013), "Photography's Afterlife: Documentary Images and the Operational Archive," *Journal of Material Culture*, 18 (3): 223–41.

"Media of the Future: A Storytelling Evening," National Audiovisual Institute, Warsaw, Poland, September 9, 2015. Available online: www.nina.gov.pl/en/events/media-of-the-future-a-storytelling-evening (accessed September 27, 2015).

Mellor, David, ed. (1978), *Germany, The New Photography, 1927–33: Documents and Essays*, London: Arts Council of Great Britain.

Michaels, Walter Benn (2007), "Photographs and Fossils," in James Elkins (ed.), *Photography Theory*, 431–50, New York; London: Routledge.

Miller, John (2006), "Double or Nothing: John Miller on the Art of Douglas Huebler," *Artforum International*, 44 (8): 220–7.

Milliard, Coline (2011), "Adam Broomberg and Oliver Chanarin," *Modern Painters*, 23 (4): 15–16.

Mitchell, William J. (1992), *The Reconfigured Eye: Visual Truth in the Post-photographic Era*, Cambridge, MA: MIT Press.

Moholy-Nagy, László ([1932] 2003), "A New Instrument of Vision," in Liz Wells (ed.), *The Photography Reader*, 92–95, London: Routledge.

Morgan, Stuart (1992), "Sophie Calle: Suite Vénitienne," *Frieze*, 3: 20.

Morgan, Tiernan (2014), "Richard Prince, Inc," *Hyperallergic*, October 9. Available online: http://hyperallergic.com/152762/richard-prince-inc/ (accessed August 15, 2015).

Murray, Susan (2008), "Digital Images, Photo-Sharing and Everyday Aesthetics," *Journal of Visual Culture*, 7 (2): 147–63.

Naef, Weston J. (2004), *Photographers of Genius at the Getty*, Los Angeles: J. Paul Getty Museum.

NAIDOC (n.d.), "Indigenous Australian Flags," *National Aborigines and Islanders Day Observance Committee*. Available online: http://www.naidoc.org.au/indigenous-australian-flags (accessed August 15, 2015).

Needham, Alex (2015), "Richard Prince v Suicide Girls in an Instagram Price War," *The Guardian*, May 28. Available online: http://www.theguardian.com/artanddesign/2015/may/27/suicide-girls-richard-prince-copying-instagram (accessed September 15, 2015).

Nelson, Robert (2013), "When Models Drive the Creative Process," *The Age*, October 23. Available online: http://www.theage.com.au/entertainment/art-and-design/when-models-drive-the-creative-process-20131022-2vzc7.html (accessed December 15, 2013).

Neri, Louise (2006), "Portrait of a Praxis," in Wendy Ewald, *Towards a Promised Land*, 29–33, Göttingen: Steidl; London: Artangel.

Nesbitt, Molly (1987), "What Was an Author?" *Yale French Studies*, 73: 229–57.

Newhall, Beaumont (1949), *The History of Photography from 1839 to the Present Day*, New York: The Museum of Modern Art.

Obrist, Hans Ulrich, ed. (2004), *Do It*, New York: e-flux; Frankfurt: Revolver.

O'Doherty, Brian (1999), *Inside the White Cube: The Ideology of the Gallery Space*, Berkeley: University of California Press.

O'Hagan, Sean (2014), "Arles 2014: Hans Eijkelboom and the Unbearable Dutchness of Being," *The Guardian*, July 11. Available online: http://www.theguardian.com/artanddesign/2014/jul/11/arles-2014-hans-eijkelboom-dutch-group-show (accessed August 11, 2014).

Olin, Margaret (2012), *Touching Photographs*, Chicago: University of Chicago Press.

Onorato, Ronald J. (1988), *Douglas Huebler: La Jolla Museum of Contemporary Art*, exhibition catalogue, May 27 to August 7, La Jolla, CA: The Museum.

Osborne, Peter (2002), *Conceptual Art*, London: Phaidon.

Owens, Craig (1992), "From Work to Frame, or, Is There Life After 'The Death of the Author?'" in *Beyond Recognition: Representation, Power, and Culture*, 122–39, Berkeley: University of California Press.

Palmer, Daniel (2013a), "A Collaborative Turn in Contemporary Photography?" *Photographies*, 6 (1): 117–25.

Palmer, Daniel (2013b), "Redundant Photographs: Cameras, Software and Human Obsolescence," in Daniel Rubinstein, Johnny Golding, and Andy Fisher (eds.), *On the Verge of Photography: Imaging Beyond Representation*, 49–67, Birmingham: ARTicle Press.

Palmer, Daniel (2015a), "Google Street View and Photography in Public Space," in Anne Marsh, Melissa Miles, and Daniel Palmer (eds.), *The Culture of Photography in Public Space*, 168–84, London: Intellect.

Palmer, Daniel (2015b), "Lights, Camera, Algorithm: Digital Photography's Algorithmic Conditions," in Sean Cubitt, Daniel Palmer, and Nate Tkacz (eds.), *Digital Light*, 144–62, London: Fibreculture Book Series, Open Humanities Press.

Papastergiadis, Nikos (2004), *Metaphor and Tension: On Collaboration and Its Discontent*, Woolloomooloo, NSW: Artspace.

Parr, Martin and Gerry Badger (2006), *The Photobook: A History, Volume II*, London; New York: Phaidon.

Phillips, Christopher (1982), "The Judgment Seat of Photography," *October*, 22: 27–63.

Phillips, Sandra (2003), "A History of the Evidence," in Larry Sultan and Mike Mandel, *Evidence*, n.p., New York: Distributed Art Publishers.

The Photographers' Gallery (2014), "Penelope Umbrico: Sun/Screen," *The Photographers' Gallery*, December 4, 2014, to January 18, 2015. Available online: http://thephotographersgallery.org.uk/umbrico-suns (accessed August 15, 2015).

PhotoVoice (n.d.), "Vision and Mission." Available online: https://photovoice.org/vision-and-mission/ (accessed August 15, 2014).

Pollen, Annebella (2015), *Mass Photography: Collective Histories of Everyday Life*, London: I.B. Tauris.

Pollock, Griselda (1980), "Artists, Mythologies and Media: Genius, Madness and Art History," *Screen*, 21 (3): 57–96.

Prince, Richard (2012–), "Birdtalk." Available online: http://www.richardprince.com/birdtalk (accessed October 15, 2015).

Ratcliff, Carter (2006), "What 'Evidence' Says about Art," *Art in America*, 94 (10): 57–67.

Ribalta, Jorge (2008), *Public Photographic Spaces: Exhibitions of Propaganda, from Pressa to The Family of Man, 1928–55*, Barcelona: Museu d'Art Contemporani de Barcelona.

Ribalta, Jorge, ed. (2011), *The Worker Photography Movement, 1926–1939: Essays and Documents*, Madrid: Museo Nacional Centro de Arte Reina Sofia.

Ritchin, Fred (2009), *After Photography*, New York: W.W. Norton.

Ritchin, Fred (2013), *Bending the Frame: Photojournalism, Documentary, and the Citizen*, New York: Aperture.

Roberts, John (1998), *The Art of Interruption: Realism, Photography, and the Everyday*, Manchester: Manchester University Press.

Roberts, John (2007), *The Intangibilities of Form: Skill and Deskilling in Art After the Readymade*, London; New York: Verso.

Roberts, John (2014), *Photography and its Violations*, New York: Columbia University Press.

Rogoff, Irit (1990), "Production Lines," in Susan Sollins and Nina Castelli Sundell (eds.), *Team Spirit*, 33–9, New York: Independent Curators Incorporated.

Rosler, Martha ([1981] 2004), "In, Around, and Afterthoughts (On Documentary Photography," in *Decoys and Disruptions: Selected Writings, 1975–2001*, 151–206, Cambridge, MA: MIT Press.

Rosler, Martha ([1999] 2004), "Post-Documentary, Post-Photography?" in *Decoys and Disruptions: Selected Writings, 1975–2001*, 207–44, Cambridge, MA: MIT Press.

Rothman, Lily (2012), "'Larry Sultan and Mike Mandel': Collaborative Semantics," *TIME Lightbox*, August 31. Available online: http://time.com/3791310/larry-sultan-and-mike-mandel/ (accessed August 15, 2015).

Rubinstein, Daniel (2009), "Towards Photographic Education," *Photographies*, 2 (2): 135–42.

Rubinstein, Daniel and Katrina Sluis (2008), "A Life More Photographic: Mapping the Networked Image," *Photographies*, 1 (1): 9–28.

Sachsse, Rolf (2000), "Joachim Schmid's Archiv," *History of Photography*, 24 (3): 255–61.

Saltz, Jerry (2014), "Richard Prince's Instagram Paintings Are Genius Trolling," *Vulture*, September 23. Available online: http://www.vulture.com/2014/09/richard-prince-instagram-pervert-troll-genius.html (accessed October 20, 2014).

Scharf, Aaron (1976), *Pioneers of Photography: An Album of Pictures and Words*, New York: H.N. Abrams.

Schjeldahl, Peter (2014), "Richard Prince's Instagrams," *The New Yorker*, September 30. Available online: http://www.newyorker.com/culture/culture-desk/richard-princes-instagrams (accessed October 15, 2014).

Schmalriede, Manfred (1984), "'Subjektive Fotografie' and its Relation to the Twenties," in *Subjektive Fotografie: Images of the 50s*, exhibition catalogue, Essen, Germany: Museum Folkwang.

Schmid, Joachim (2011), "Other People's Photographs (2008–2011)," artist statement. Available online: https://schmid.wordpress.com/works/2008%E2%80%932011-other-people%E2%80%99s-photographs/ (accessed August 15, 2015).

Schmid, Joachim and Martin Parr (2009), *Joachim Schmid Is Martin Parr—Martin Parr Is Joachim Schmid*, San Francisco: Blurb.

Schuessler, Jennifer (2015), "A New Copyright Complaint Against Richard Prince," *The New York Times*, February 16. Available online: http://artsbeat.blogs.nytimes.com/2015/02/16/a-new-copyright-complaint-against-richard-prince (accessed March 15, 2015).

Schuhmacher, Søren and Joachim Schmid (2013), "ASX Interviews Joachim Schmid," *American Suburb X*, December 2. Available online: http://www.americansuburbx.com/2013/12/asx-interview-interview-joachim-schmid-2013.html (accessed August 15, 2015).

Schuman, Aaron (2011), " 'Open See'—In Conversation with Jim Goldberg," *See Saw: An Online Photography Magazine*, 14. Available online, http://www.seesawmagazine.com/jimgoldberginterview/jimgoldberginterview.html (accessed June 15, 2015).

Schwarz, Michael (1978), "Becher/Becher," *Kunstforum International*, 28 (4): 78.

Sekula, Allan (1978), "Dismantling Modernism, Reinventing Documentary (Notes on the Politics of Representation)," *The Massachusetts Review*, 19 (4): 859–83.

Sergio, Giuliano (2011), "Art is the Copy of Art: Italian Photography in and after Arte Povera," in Matthew Witkovsky (ed.), *Light Years: Conceptual Art and the Photograph, 1964–1977*, 163–71, Chicago: Art Institute of Chicago.

Seymour, Tony (2015), "Hilla Becher at the Düsseldorf Photo Weekend," *British Journal of Photography Online*, March 25. Available online: http://www.bjp-online.com/2015/03/hilla-becher-at-the-dusseldorf-photo-weekend/ (accessed 26 March, 2015).

Shannon, Joshua (2011), "Uninteresting Pictures: Photography and Fact at the End of the 1960s," in Matthew Witkovsky (ed.), *Light Years: Conceptual Art and the Photograph, 1964–1977*, 89–97, Chicago: Art Institute of Chicago.

Shannon, Joshua (2014), "Uninteresting Pictures: Art and Technocracy, 1968," in Timothy Scott Brown and Andrew Lison (eds.), *The Global Sixties in Sound and Vision*, 227–44, New York: Palgrave Macmillan.

Shapiro, David (1984), "Art as Collaboration: Towards a Theory of Pluralist Aesthetics 1950–1980," in Cynthia Jaffee McCabe (ed.), *Artistic Collaboration in the Twentieth Century*, 45–62, Washington, D.C.: Smithsonian Institution Press.

Shea, Daniel (2009), "Mike Mandel and Larry Sultan: *Evidence*," *ahorn Magazine*, 3, http://www.ahornmagazine.com/issue_3/review7_shea_mandelsultan/review_shea_evidence2.html (accessed August 15, 2015).

Shukur, Natalie (2014), "Richard Prince," *Russh Magazine*. Available online: http://www.russhmagazine.com/arts-music/artists/Artist-Profile-Richard-Prince (accessed December 15, 2014).

Sluis, Katrina (2014), "Authorship, Collaboration, Computation? Into the Realm of Similar Images with Erica Scourti," *Photoworks Annual*, 21: 150–59.

Smith, Roberta (1997), "Douglas Huebler, 72, Conceptual Artist," *The New York Times*, July 17. Available online: http://www.nytimes.com/1997/07/17/arts/douglas-huebler-72-conceptual-artist.html (accessed June 2, 2013).

Sollins, Susan and Nina Castelli Sundell, eds. (1990), *Team Spirit*, New York: Independent Curators Incorporated.

Solomon-Godeau, Abigail (1983), "The Armed Vision Disarmed: Radical Formalism from Weapon to Style," *Afterimage*, 19: 9–14.

Solomon-Godeau, Abigail (1991), *Photography at the Dock: Essays on Photographic History, Institutions, and Practices*, Minneapolis: University of Minnesota Press.

Sontag, Susan (1977), *On Photography*, New York: Farrar, Straus and Giroux.

Soutter, Lucy (1999), "The Photographic Idea: Reconsidering Conceptual Photography," *Afterimage*, 26 (5): 8–10.

Soutter, Lucy (2013), *Why Art Photography*, London; New York: Routledge.

Spector, Nancy (2007), "Nowhere Man," in *Richard Prince*, 20–56, New York: Guggenheim Museum Publications.

Spence, Jo (1986), *Putting Myself in the Picture: A Political, Personal and Photographic Autobiography*, London: Camden Press.

Spence, Jo ([1976] 1995), "The Politics of Photography," in *Cultural Sniping: The Art of Transgression*, 31–36, London; New York: Routledge.

Spence, Jo and Rosy Martin (1995), "Phototherapy: Psychic Realism as Healing Art?" in *Cultural Sniping: The Art of Transgression*, 164–80, London; New York: Routledge.

Stallabrass, Julian (2007), "Fig," in Adam Broomberg and Oliver Chanarin, *Fig*, n.p., Brighton: Photoworks; Göttingen: Steidl.

Steele, James and Martyn Jolly (2011), "Generating a New Sense of Place in the Age of the Metaview," *Journal of Australian Studies*, 35 (4): 461–74.

Stezaker, John (2012), "John Stezaker (biography)," in *Deutsche Börse Photography Prize 2012*, exhibition catalogue, 126, London: The Photographers' Gallery.

Stieglitz, Alfred ([1889] 1980), "Pictorial Photography," in Alan Trachtenberg (ed.), *Classic Essays on Photography*, 115–24, New Haven: Leete's Island Books.

Stimson, Blake (2004), "The Photographic Comportment of Bernd and Hilla Becher," *Tate Papers*, 1. Available online: http://www.tate.org.uk/research/publications/tate-papers/01/photographic-comportment-of-bernd-and-hilla-becher (accessed July 15, 2015).

Stimson, Blake (2006), *The Pivot of the World: Photography and its Nation*, Cambridge, MA: MIT Press.

Stimson, Blake (2007), "A Modern Man," *Artforum International*, 46 (2): 67–70.

Stimson, Blake (2008), "A Photograph is Never Alone," in Robin Kelsey and Blake Stimson (eds.), *The Meaning of Photography*, 105–17, Williamstown, MA: Sterling and Francine Clark Art Institute.

Stimson, Blake and Gregory Sholette, eds. (2006), *Collectivism after Modernism: The Art of Social Imagination after 1945*, Minneapolis: University of Minnesota Press.

Stimson, Blake and Thomas Struth (2007), "A Modern Man: Blake Stimson and Thomas Struth on Bernd Becher," *Artforum International*, 46 (2): 67–69.

Strand, Paul ([1917] 1980), "Photography," in Alan Trachtenberg (ed.), *Classic Essays on Photography*, 141–4, New Haven: Leete's Island Books.

Strand, Paul ([1922] 1980), "Photography and the New God," in Alan Trachtenberg (ed.), *Classic Essays on Photography*, 144–51, New Haven: Leete's Island Books.

Sultan, Larry (n.d.), "Evidence: Larry Sultan and Mike Mandel," http://larrysultan.com/gallery/evidence/ (accessed August 15, 2015).

Sultan, Larry and Mike Mandel (2003), *Evidence*, New York: Distributed Art Publishers.

Sundell, Margaret (2002), "Douglas Huebler: Camden Arts Centre, London," *Artforum International*, 41 (1): 200.

Sutton, Benjamin (2014), "A Young Artist Debuts at Gagosian, Thanks to Richard Prince," *Hyperallergic*, October 21. Available online: http://hyperallergic.com/157548/a-young-artist-debuts-at-gagosian-thanks-to-richard-prince/ (accessed August 15, 2015).

Szarkowski, John (1966), *The Photographer's Eye*, New York: The Museum of Modern Art.

Szarkowski, John (1977), "Evening Lecture at Wellesley College," *American Suburb X*, July 9, 2012. Available online: http://www.americansuburbx.com/2012/07/john-szarkowski-evening-lecture-at-wellesley-college-1977.html (accessed July 15, 2015).

Szarkowski, John (1994), "The Museum of Modern Art Oral History Program: Interview with John Szarkowski," June 23. Available online: https://www.moma.org/momaorg/shared/pdfs/docs/learn/archives/transcript_szarkowski.pdf (accessed August 15, 2015).

Tagg, John (1988), *The Burden of Representation: Essays on Photographies and Histories*, Minneapolis: University of Minnesota Press.

Talbot, William Henry Fox ([1844] 1969), *The Pencil of Nature*, New York: Da Capo Press.

TATE (2004), "Variable Piece No. 44, 1971," *Tate Gallery*, September. Available online: http://www.tate.org.uk/art/artworks/huebler-variable-piece-no-44-p07234/text-display-caption (accessed May 15, 2015).

TATE (n.d.), "Sophie Calle, born 1953," *Tate Gallery*. Available online: http://www.tate.org.uk/art/artists/sophie-calle-2692 (accessed May 15, 2015).

Taylor, Penny, ed. (1988), *After 200 Years: Photographic Essays of Aboriginal and Islander Australia Today*, Canberra: Aboriginal Studies Press.

Terrill, Simon (n.d.), "Crowd Theory." Available online: http://www.simonterrill.com/Crowd-Theory (accessed August 15, 2015).

Terrill, Simon (n.d.), "Balfron Project." Available online: http://simonterrill.com/Balfron-Project (accessed August 15, 2015).

Terrill, Simon (2013), "Crowd Theory Adelaide." Available online: http://www.crowdtheoryadelaide.com (accessed August 15, 2015).

Thompson, Nato (2014), "Photography and Its Citizens: Interview with Ariella Azoulay," *Aperture*, 214: 52–7.

Tuchman, Mitch (2004), "Supremely Wilde," *Smithsonian Magazine*, May. Available online: http://www.smithsonianmag.com/arts-culture/supremely-wilde-99998178/?no-ist (accessed June 15, 2009).

Umbrico, Penelope (2011), *Penelope Umbrico: Photographs*, New York: Aperture.

Umbrico, Penelope (2015a), "Some Notes on my Work," artist statement. Available online: http://www.penelopeumbrico.net/Info/Words.html (accessed December 1, 2015).

Umbrico, Penelope (2015b), "Unpublished Lecture," The Photographers' Gallery, London, January 16.

Umbrico, Penelope and Zach Nader (2013), "A Conversation with Penolope Umbrico," *Lavalette*, October 28. Available online: http://www.lavalette.com/a-conversation-with-penelope-umbrico/ (accessed July 7, 2015)

Uricchio, William (2011), "The Algorithmic Turn: Photosynth, Augmented Reality and the Changing Implications of the Image," *Visual Studies*, 26 (1): 25–35.

Vasey, George (n.d.), "Jo Spence: Biography." Available online: http://www.jospence.org/biography.html (accessed July 7, 2015).

Walker, Ian (2010), "Dick Jewell's *Found Photos*," *Image & Narrative*, 11 (4): 20–34.

Wall, Jeff ([1994] 1996), "Restoration: Interview with Martin Schwander 1994," in *Jeff Wall*, 126–39, London: Phaidon.

Wall, Jeff ([1995] 2003), "'Marks of Indifference': Aspects of Photography in, or as, Conceptual Art," in Douglas Fogle (ed.), *The Last Picture Show: Artists Using Photography 1960–1982*, 32–44, Minneapolis: Walker Art Center.

Walther, Thomas and Mia Fineman (2000), *Other Pictures: Anonymous Photographs from the Thomas Walther Collection*, Santa Fe: Twin Palms.

Watson, Bronwyn (2014), "Simon Terrill's Crowd Theory in Adelaide Freezes a Community Moment," *The Weekend Australian*, January 4. Available online: http://www.theaustralian.com.au/arts/review/simon-terrills-crowd-theory-in-adelaide-freezes-a-community-moment/story-fn9n8gph-1226794281657 (accessed July 7, 2015).

Weaver, Thomas (2013), "Hilla Becher in Conversation with Thomas Weaver," *AA Files*, 66: 17–36.

Weber, John S. (2007a), "Joachim Schmid and Photography: The Accidental Artist," in Gordon MacDonald and John S. Weber (eds.), *Joachim Schmid: Photoworks 1982–2007*, 11–18, Brighton: Photoworks; Göttingen: Steidl.

Weber, John S. (2007b), "Bilder von der Straße," "Archiv," and "Photogenetic Drafts," (artwork notes), in Gordon MacDonald and John S. Weber (eds.), *Joachim Schmid: Photoworks 1982–2007*, 21–2, 71–2, 113–14, Brighton: Photoworks; Göttingen: Steidl.

Weinberg, Adam D. and Urs Stahel (2000), "Preface: If Complications Arise . . ." in Wendy Ewald, *Secret Games: Collaborative Works with Children, 1969–1999*, 6–12, Zurich: Scalo; London: Thames & Hudson.

"Wendy Ewald," *Literacy Through Photography Blog*, hosted by the Center for Documentary Studies, Duke University, n.d. Available online: https://literacythroughphotography.wordpress.com/wendy-ewald/ (accessed July 7, 2015).

Weski, Thomas (2012), "Beyond the Pleasures of a Flawless Narrative: Photography in the Museum," in Beatrice von Bismarck, Jörn Schafaff, and Thomas Weski (eds.), *Cultures of the Curatorial*, 307–17, Berlin: Sternberg Press.

West, Nancy Martha (2000), *Kodak and the Lens of Nostalgia*, Charlottesville: University Press of Virginia.

Willats, Stephen (1983), "The Camera as an Object of Determinism and as an Agent of Freedom," http://stephenwillats.com/texts/camera-object-determinism-and-agent-freedom (accessed July 7, 2015).

Williams, Val (1986), *Women Photographers: The Other Observers, 1900 to the Present*, London: Virago.

Williams, Val (2008), "No Statistics: Adam Broomberg and Oliver Chanarin," in Frank van der Stok (ed.), *Questioning History. Imagining the Past in Contemporary Art*, 120–5, Rotterdam: NAi Publishers; New York: D.A.P.

Witkovsky, Matthew, ed. (2011), *Light Years: Conceptual Art and the Photograph, 1964–1977*, Chicago: Art Institute of Chicago.

Wolf, Erika (2011), "The Soviet Union: From Worker to Proletarian Photography," in Jorge Ribalta (ed.), *The Worker Photography Movement, 1926–1939: Essays and Documents*, 32–46, Madrid: Museo Nacional Centro de Arte Reina Sofia.

Wollen, Peter (1999), "Mappings: Situationists and/or Conceptualists," in Jon Bird and Michael Newman (eds.), *Rewriting Conceptual Art*, 27–46, London: Reaktion.

Wright, Karen (2014), "Adam Broomberg & Oliver Chanarin Artists: 'I've never been able to put anything together. Ollie is the one with the screwdriver,'" *The Independent*, August 8. Available online: http://www.independent.co.uk/arts-entertainment/art/features/adam-broomberg-oliver-chanarin-artists-ive-never-been-able-to-put-anything-together-ollie-is-the-one-9654387.html (accessed June 17, 2015).

Ziegler, Ulf Erdmann (2002), "The Bechers' Industrial Lexicon," *Art in America*, 90 (6): 92–101, 140–43.

Zuromskis, Catherine (2013), *Snapshot Photography: The Lives of Images*, Cambridge, MA: MIT Press.

Zweite, Armin (2004), "Bernd and Hilla Becher's 'Suggestion for a Way of Seeing': Ten Key Ideas," in Bernd Becher and Hilla Becher, *Typologies: Bernd & Hilla Becher*, 7–35, Cambridge, MA: MIT Press.

INDEX